TO ELLA

An Eye for the Tropics

OBJECTS | HISTORIES

Critical Perspectives on Art, Material Culture,
and Representation

A series edited by Nicholas Thomas
Published with the assistance of the Getty Foundation

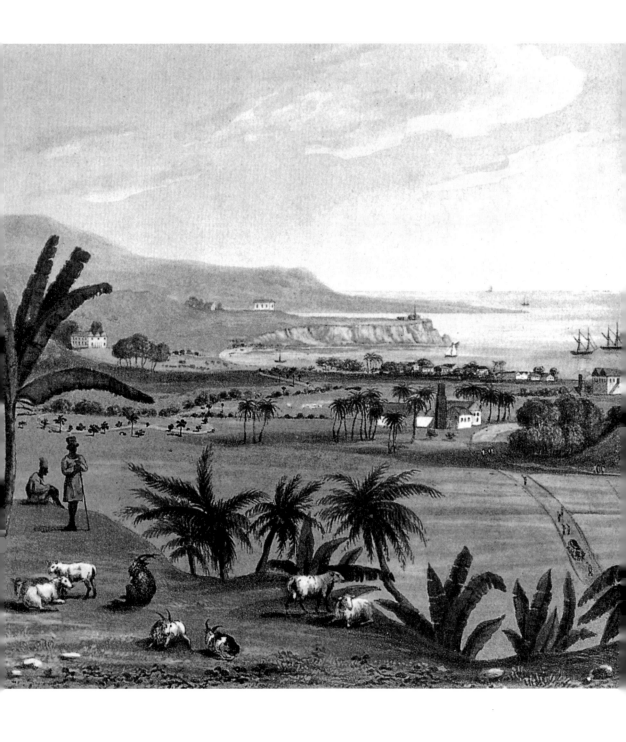

AN EYE FOR THE TROPICS

Tourism, Photography, and Framing the Caribbean Picturesque

KRISTA A. THOMPSON

DUKE UNIVERSITY PRESS

DURHAM AND LONDON 2006

338·479 THD

Designed by Jennifer Hill
Typeset in Janson by Tseng Information Systems, Inc.

Library of Congress Cataloging-in-Publication Data
appear on the last printed page of this book.

CONTENTS

ILLUSTRATIONS

FIGURES

ABBREVIATIONS

CT *Citizens' Torch* (Nassau, Bahamas). 1951.

DE *Daily Express* (London). 1953.

DG *Daily Gleaner* (Kingston, Jamaica). 1889–1915.

ED *Entertainment Design* (New York). 1994.

GC *The Golden Caribbean* (Boston). 1903–7.

JP *The Jamaica Post* (Kingston, Jamaica). 1889–1915.

JR *Jamaica Record* (Kingston, Jamaica). 1988.

JT *The Jamaica Times* (Kingston, Jamaica). 1889–1915.

LP *The Liverpool Post* (Liverpool, England). 1900–1905.

NG *The Nassau Guardian* (Nassau, Bahamas). 1885–1940.

PIN *Paradise Island News* (Paradise Island, Bahamas). 1994.

PO *Public Opinion* (Kingston, Jamaica). 1930–50.

PP *Planters' Punch* (Kingston, Jamaica). 1920–50.

RCW *Record Christian Work* (East Northfield, Mass.). 1894.

SP *Spotlight* (Kingston, Jamaica). 1930–50.

TR *The Tribune* (Nassau, Bahamas). 1885–1940.

TTR *Trinidad and Tobago Review* (Port of Spain, Trinidad). 1991.

UT *USA Today* (Washington, D.C.). 1994.

WIR *West Indian Review* (Kingston, Jamaica). 1930–40.

ACKNOWLEDGMENTS

Like the many travelers chronicled in this book who scribbled messages to loved ones on postcards from far-flung destinations, I would like to pen thanks to the many persons who supported the long journey leading to this publication. The acknowledgments listed here, in a similar fashion to the inevitably impoverished post-card messages, cannot begin to express the depth of my appreciation.

I would like to thank Ivan Karp at the Institute of Liberal Arts at Emory University for his constant support and stern counsel. Richard Long also provided quiet but invaluable mentorship. In the Department of Art History David H. Brown and Judith Bettelheim opened the world of African diasporic arts to me, while Judith Rohrer introduced me to the miniature world of postcards. Deepika Bahri, Natasha Barnes, and Corrine Kratz also greatly contributed to the content of this book. I was fortunate enough to be at Emory University, and in "the woods," when a group of bright young scholars working on Africa and the Africa diaspora came together to form more than an intellectual community but a supportive family. The friendship of Petrina Dacres, Pamela Franco, Jacqueline Francis, Peri Klemm, Heidi Ernst-Luseno, Mike McGovern, Stacy Morgan, Serigne N'Diaye, Michelle Wilkerson, Veerle Poupeye, and Jay Straker continues to support and sustain me.

I thank faculty in the Department of Art History at the University of Illinois at Chicago for making the department such a collegial and spirited place. I especially acknowledge Ellen Baird, Bob Bruegmann, Deborah Fausch, Heather Grossman, Peter Hales, Hannah Higgins, Mary Johnson, Virginia Miller, David Sokol, Woodman Taylor, and Susanne Uslenghi. I truly grew as a scholar and educator by being in your midst. Special mention must also be made of Judith Kirshner, dean of the Department of Art and Architecture, for her leadership and support. Thanks to Carlene Camardo, my research assistant, for her invaluable assistance with the preparation of this book. My appreciation to Mary Beth Rose, Linda Vavra, and fellows at the Institute of Humanities at the University of Illinois, who created the stimulating environment of cross-disciplinary dialogue that informs this book.

Thanks to my colleagues in the Department of Art History and African American Studies at Northwestern University for their support, especially Sherwin Bryant, Hollis Clayson, Huey Copeland, Stephen Eisenman, Hannah Feldman, Darlene Clark Hine,

Lyle Massey, Dwight McBride, Aldon Morris, Claudia Swan, and David Van Zanten. Thanks for making Northwestern so quickly feel like my institutional home. Thanks to Dean Dan Linzer and Sarah Fraser, chair of the Department of Art History, for their enthusiasm, drive, and vision.

I must also acknowledge the hardworking team at Duke University Press, who have shepherded me through the publication process, especially Ken Wissoker and Anitra Grisales. Thanks for your patience and counsel.

I was the fortunate recipient of a postdoctoral fellowship at the David Driskell Center for the Study of the African Diaspora in 2003, which facilitated the writing of the manuscript. My sincerest gratitude goes out to David Driskell, Eileen Julien, and Daryle Williams for making the Driskell Center an invaluable, vibrant, and multi-faceted space of intellectual exchange on the African diaspora. Thanks to my fellow post-doc Stanford Carpenter for his comments on early drafts of the manuscript.

The wider community of scholars and friends working on the African diaspora and the Caribbean in Chicago, especially Mike Hanchard, Richard Iton, and Harvey Neptune, also generously critically engaged my work and more generally made the Windy City a warmer place. I also acknowledge the work of Michael Dash, Gail Saunders, David Scott, Patricia Mohammed, Michel-Rolph Trouillot, Deborah Willis, and the anonymous readers of the manuscript, scholars whose insights profoundly shaped the contours of this book.

Thanks to the many people whose collections and recollections were central to this book, particularly David Bailey, Barbara Blake-Hannah, David Boxer, Michael Cooke, Christopher Cozier, Raymond Brenden, Mark and John Fondas, Ronald Lightbourn, Che Lovelace, Joy Lumsden, John Maxwell, Michael Owens, Sylvia Munro, Irénée Shaw, David Smith, and Fred Wilmot.

Many persons in research institutions and photographic archives on both sides of the Atlantic were invaluable to this project. My sincerest appreciation to the staff of the Department of Archives and Public Records, the Nassau Public Library, and the National Art Gallery of the Bahamas; in Jamaica, the Special Collections Department of the Library at the University of the West Indies, the National Library of Jamaica, the Institute of Jamaica's Museums Division, the National Gallery of Jamaica, the Public Records Office, the Jamaica Tourist Board Library, and the Jamaica Gleaner; in Barbados, the Caribbean Tourism Organization's library and the Barbados Museum and

Historical Society; the Caribbean Contemporary Arts center in Trinidad; the Public Records Office and Botanical Gardens in Kew, U.K.; the Library of Congress, Washington D.C.; and the Schomburg Center for Research in Black Culture in New York. I trust that the research facilitated by your institutions that resulted in this book will in turn contribute to the documentation of your valuable photographic archives. My sincerest gratitude to the interlibrary loan departments at Emory University, Atlanta, the University of Illinois at Chicago and Northwestern University for tirelessly tracking down obscure sources from throughout the world.

Many institutions provided financial support that allowed me to conduct research and write this book. I thank the Graduate Institute of Liberal Arts, the Institute of African Studies, the Fund for Internationalization at Emory University; the Organization of American States; the Prince Claus Fund; and the ovcr Arts, Architecture, and Humanities award at the University of Illinois at Chicago.

Thanks to my friends who in countless ways helped me through the research and writing of this project: Badia Ahad, Rocio Aranda, Hervis Bain, Christin Carole, Magdalene Carey, Ashlar Colebrook, John Cox, Stella and George Cox, Ian Fernader, Kesha Fikes, Khyla Finlayson, Rebecca Haines, Vincent Kegler, Glynn and Bill Lyons, Wayne Modest, Jerry Philogene, Gayatri Reddy, Herb Ruffin, Guha Shankar, Erica Wells, Clyde Woods, and DaCosta Williams. Thanks especially to Harold Rubin, whose passion for learning and life was a source of inspiration.

Finally, I thank my family, who planted and nurtured the seeds of this tropicalization project. My grandmother, Daisy Forbes, shared memories of old postcards with me; my father, Anthony Thompson, enlisted me into his historical projects in my childhood; my mother, Ella Thompson, assumed the role of archivist for me, collecting articles on Bahamian art and culture over the last fifteen years; and my sister Antonia Thompson-Carey, who supported all my endeavors, not only as an older sibling but as a best friend. More than stimulating the consideration of travel investigated in this book, I thank my family for providing a supportive home base, which has sustained me throughout my journeys. Lastly, thanks to my son, Chaz, who inspires me every day to gaze at the world through new eyes.

AN EYE FOR THE TROPICS

TROPICALIZATION
The Aesthetics and Politics of Space in Jamaica and the Bahamas

Our landscape is its own monument: its meaning can
only be traced on the underside. It is all history.

Edouard Glissant, *Caribbean Discourse*, 1989

Clad in fearful and wonderful garments, which they fondly imagined to be ordinary tropical clothing, . . .
they came ashore in the spirit of explorers and seemed quite disappointed to find we wore clothes
and did not live in the jungle.
O who would be a tourist
And with the tourists stand,
A guide-book in his pocket,
A Kodak in his hand!

"Our Friends the Tourists," *Daily Gleaner*, Kingston, 18 January 1901

On a trip to Dunn's River Falls in Ocho Rios, Jamaica, in the summer of 2000, the hordes of tourists and locals alike who had flocked to the falls encountered an unusual sight. Half-clad bodies of every size and variety crowded the scene. Gaggles of children and guide-led human chains of sun-reddened tourists moved by in every direction. Out of this confusion of people, a single element stood still in this heat, haze, and people-filled environment. Like a frozen film frame, against a foreground filled with bodies swooshing by in blurred hurriedness, an older black Jamaican man and his donkey appeared along the side of the walkway. The donkey was no ordinary ass; it had hibiscus tucked behind its ears and sported sunglasses (figure 1). Woven baskets brimming with flowers straddled the animal's back. Its owner lingered close by, with an enormous hat of his own, bellowing into the passing human tide that a photograph with the donkey and/or himself could be bought for the minimal cost of

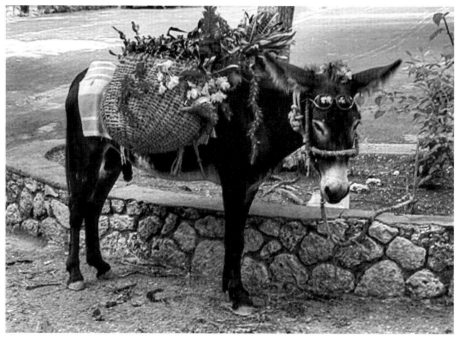

1 Donkey, posed for photographs, at Dunn's River Falls, Jamaica, 2000

40 Jamaican dollars (then approximately US$1). The spectacle of the man and donkey drew the quizzical looks, pointings, and giggles of many passersby, for within the wider north coast resort town of Ocho Rios the sight of a donkey, especially one clad in shades and flowers, was indeed a rare spectacle.

The strange sight recalled a vision from years ago. The "native man with donkey" was a stock character in many photographic representations of the Anglophone Caribbean taken during the late nineteenth century and early twentieth. The icon had been imprinted on numerous photographs and postcards since the start of the tourism industry in the 1890s, in an effort by the colonial government and tourism interests to constitute a new idea of Jamaica. More than a century later, the man at Dunn's River Falls made his living by transforming himself and his donkey into this age-old image

(itself likely based on past representations) in order to elicit the interest of tourists, who would then, in turn, render him into yet another photographic image. In this process the decades-old "man and donkey" icon continued to proliferate in the visual economy of representations that imaged the island both locally and abroad.

The man's vocation as an object to be photographed highlights the complex ways that images and icons from the past, many of which were themselves visual constructions created for the tourism industry, survive in some English-speaking Caribbean islands. The spectacle of the man and donkey in Ocho Rios is not an isolated occurrence, especially in those islands with tourism-driven economies. For nine years a Rasta man, who calls himself "One Love," and his donkey have frequented the main commercial port of St. Thomas, posing for money (One Love 2001).[1] A Junkanoo figure (derived from the local annual masquerade of the same name) also walks the docks of Freeport in the Bahamas, posing year-round for pictures. These characters, who perform a role inspired by early photographic icons of the Anglophone Caribbean, demonstrate that such representations continue to inhabit an intrinsic part of the islands' visual culture and local imaginary, remaining embodied (or even disembodied) within the Caribbean landscape.

In one of those dissonant moments of academic life I snapped the picture. Although self-conscious of my own participation in the visual economy of people as images, on that day in Ocho Rios my scholarly ambitions dictated that I document the "photo-gentrified" donkey. As I did so, I could feel the uneasiness of many Jamaicans as I visually recorded the spectacle. Their displeasure registered in their stares and the audible "kissing of their teeth."[2] A passerby murmured the protest that when such a photo left the island, it would surely make Jamaica seem primitive and backward, like "we livin' in a past time." My critics were concerned that the image—which was being staged solely for the purposes of becoming a photograph and was fairly atypical of contemporary society in Ocho Rios—would in the translation of geographic location become representative of Jamaica as a whole today. I hope to prove them wrong. They were correct in one sense: the image would travel and circulate outside their country. However, my work had the opposite aim. Indeed, this book sets out precisely not to confirm touristic notions of the island's primitiveness or timelessness through this and other photographs but to illustrate the historical roots and the long-term effects of touristic representa-

tions on the island and its inhabitants, while more broadly investigating the implications of tourism on ways of seeing the Anglophone Caribbean and the lived experience of space for local residents.

The incident highlighted several of the aspects of tourism in the Anglophone Caribbean and the politics of visual representation (particularly photographic images) that are central concepts under investigation in this book. What elements of the local populace and landscape were seized on as representative of the West Indies, and which ones have persisted as visual icons of the islands over time? How have such images informed notions of the region as they circulate across geographic boundaries? And importantly, what impact have such representations had on both the physical landscape and "social space" of the West Indies (Lefebvre 1991)?

The origins of how the English-speaking Caribbean was (and is) widely visually imagined can be traced in large part to the beginnings of tourism industries in the British West Indies in the late nineteenth century. Starting in the 1880s, British colonial administrators, local white elites, and American and British hoteliers in Jamaica and the Bahamas embarked on campaigns to refashion the islands as picturesque "tropical" paradises, the first concerted efforts of their kind in Britain's Caribbean colonies. Tourism entrepreneurs faced a formidable challenge. Beyond the region the West Indies were widely stigmatized as breeding grounds for potentially fatal tropical diseases.[3] Yellow fever, malaria, and cholera had claimed the lives of many white civilians and soldiers who ventured to the islands, ensuring what historian Philip Curtin describes as "death by migration" (Curtin 1989). As one industry supporter recognized in 1891, "to many old-fashioned people at home [Britain] to book a passage for Jamaica is almost synonymous with ordering a coffin" (Gardener, quoted in Hanna 1989, 19). Despite the availability of preventive medicines for "tropical" diseases in the 1880s, tourism promoters had to dispel the fear of the islands, which haunted the imaginations of potential tourism clienteles in Britain and North America. They had to radically transform the islands' much maligned landscapes into spaces of touristic desire for British and North American traveling publics.

Photographic images played a constitutive role in this process. To create new and alluring representations of the islands, the colonial government and British and American corporations in Jamaica and the Bahamas (most notably, the British firm Elder, Dempster and Company and the American United Fruit Company) enlisted the ser-

vices of many British, American, and local photographers, artists, and lantern lecturers, including James Johnston, James Gall, Bessie Pullen-Burry, W. H. Hale, and Joseph Kirkpatrick in Jamaica; and Albert Bierstadt, Jacob Frank Coonley, Fred Armbrister, William Henry Jackson, James Sands, John Ernest Williamson, and Stephen Haweis in the Bahamas. Collectively, through photographs, postcards, photography books, illustrated guides, stereo-views, and lantern slides, these image makers created a substantial repertoire of visual representations of the islands. These pictures were instrumental in imaging the islands as tropical and picturesque tourism destinations.

These photographs of the islands, created and circulated by tourism promoters, generated what the sociologist Rob Shields defines as a "place-image," a set of core representations that form "a widely disseminated and commonly held set of images of a place or space" (Shields 1991, 60). Kye-Sung Chon uses "destination image" in a similar vein to characterize a place-image created precisely for the promotion of tourism (Chon 1990). Place-images or destination images can become viewed as representative of the essential character of a place, despite the specificities of, and changes in, local geopolitical environments (Shields 1991, 47). This book is concerned with how certain visual icons of the Anglophone Caribbean created in a particular sociopolitical context—the beginning of the twentieth century in Jamaica and the Bahamas—circulated over time and across geographic boundaries to become symbolic of specific islands and an entire region. Photographs of Jamaica and the Bahamas were particularly significant in that they provided models on which other local governments in the region based subsequent tourism campaigns.[4] Thus, they set the stage for the perception of the wider Caribbean in the popular imagination of British and North American publics. A genealogy of images of the Anglophone Caribbean that continue to inform representations of the region can be traced back to this seminal period in tourism development.

In exploring the creation of place-images as they relate to the Anglophone Caribbean, I use the terms *tropicalization* or *tropicality* (Aparicio and Chávez-Silverman 1997; Dash 1998; Arnold 2000).[5] *Tropicalization* here describes the complex visual systems through which the islands were imaged for tourist consumption and the social and political implications of these representations on actual physical space on the islands and their inhabitants. More specifically, tropicalization delineates how certain ideals and expectations of the tropics informed the creation of place-images in some Anglophone Caribbean islands. It characterizes how, despite the geological diversity within "the

tropics" and even in a single Caribbean island, a very particular concept of what a tropical Caribbean island should look like developed in the visual economies of tourism.

The term *tropics*, from which *tropicalization* is derived, denotes the horizontal band on the earth's surface between the Tropics of Cancer and Capricorn in which many Caribbean islands are located. This region receives the greatest intensity of direct sunlight on the planet. Tropicalization then appropriately draws attention to light in the geography of the Caribbean and, by extension, vision and visual representation in the imaginative geography of the islands. Appropriately, in a region renowned for light, photography—a medium based on the chemical reaction of light particles on sensitive film or glass negatives—would become an important instrument in the imaging of the islands.

Through the exhibition of photographs internationally, the presentation of images and people at colonial expositions, the distribution of photography books, the creation of postcard and stereo-view series, and the delivery of lantern lamp lectures (a precursor to slide lectures) across the United States, Canada, and Britain, tourism promoters literally used photographs to project a new vision of the islands before the eyes of North American and British traveling publics. In these photographs tourism propagandists often visualized and promoted what they deemed to be the islands' picturesque qualities. They typically identified as picturesque parts of the landscape that most readily exhibited ideals of a "tropical island"—those areas of the islands' environments that contained exotic, strange, or grandiose forms of "tropical nature."[6] At the time, tropical nature did not so much signify the geographical derivation of a plant form as it did a "species with strange or 'prehistoric' characteristics . . . prized as exotic, regardless of [its] actual geographical or climatic requirement" (Preston 1999, 195). Hence, numerous photographs of royal and coconut palm trees, silk cottons, and banyan trees, with their enormous wide-spreading roots, became the pictorial focus of early advertising campaigns. In addition, promoters often pictured forms of tropical nature that seemed cultivated or perfectly manicured into orderly displays (banana plantations, coconut groves, and botanical gardens). Human bodies also joined the parade of the picturesque. Many representations also featured "picturesque natives," black and Indian (in the case of Jamaica) inhabitants who seemed loyal, disciplined, and clean British colonial subjects. Such photographs, which commonly pictured washerwomen, policemen, or pris-

oners, aimed to convince primarily white travelers to the majority black colonies that the "natives" were civilized.[7]

In the late 1920s and 1930s, when the touristic interest in tropical forms of vegetation receded somewhat, promoters focused on the islands' seascape as a repository of their "tropicalness." At this time representations of coral reefs, surrounding marine life, and later the beach became increasingly popular. Images of the islands' transparent waters emphasized another tamed aspect of nature in the Anglophone Caribbean, in this instance, the ocean. In sum, while tourism-oriented representations of the Bahamas and Jamaica, whether of land, sea, or human-scapes, often heightened the tropicality of the islands, they also conveyed a domesticated version of the tropical environment and society. Such photographs of tamed nature and disciplined "natives" ensured potential travelers of their safety in a tropical environment. More generally, these images served as visual testaments of the effectiveness of colonial rule and naturalized colonial and imperial transformations of social and physical landscape.

Jamaica and the Bahamas, with their geological differences and particular colonial histories, make compelling case studies through which to understand and complicate the notion of tropicalization. Both colonies were filtered through similar representational lenses, which imaged both landscapes (and even seascapes) as picturesque tropical gardens and as exemplary and disciplined British colonial societies. The Bahamas is an archipelago of flat limestone islands and Jamaica is a more rugged volcanic landmass dominated in parts by some of the most mountainous regions in the Caribbean (reaching heights of up to 7,000 feet in the Blue Mountains). The Bahamas and Jamaica also had very different plantation and colonial histories, despite the fact that they were both British colonies. Whereas Jamaica had extensive sugar plantations since the 1600s, colonists in the Bahamas never successfully sustained a comparable profitable plantation economy on the coral isles in the long term (partly because of the paucity of the topsoil on many islands in the archipelago). However, regardless of these distinct histories and geographies, at the beginning of the twentieth century both islands looked strikingly the same in photographic representations, as a consequence of tropicalization.

Photography and the new tourist trade were even more intimately intertwined. Not only did tourism promoters use photographs to reconstitute an image of the islands, but they marketed their landscapes and inhabitants as picturesque, more specifically, as "like photographs." In doing so, they promoted the touristic activity of creating photographic views. "The tourist who goes to Jamaica without a camera will sadly regret it," one United Fruit Company booklet forewarned visitors, "as the island is one continuous succession of pictures" (United Fruit Company 1904, 17). Industry enthusiasts capitalized on the new innovations in photography, spearheaded by Kodak's development of paper-based photographic film and the invention of celluloid film (replacing cumbersome and fragile glass plates) in 1898, which allowed travelers to tote portable and inexpensive cameras. The first mass-marketed cameras produced at the start of the twentieth century, such as the Browning, put travelers in charge of visually recording their experiences. Indeed, the cover of one guidebook, aptly titled *A Snapshot of Jamaica* (circa 1907), featured a tourist steadily aiming her handheld camera (figure 2). An actual photograph, of an old sugar mill, appeared pasted next to her outline, presumably giving readers an instant snapshot of the scene she framed in her viewfinder. By the turn of the twentieth century, local photography stores on the islands, like Aston W. Gardener Company in Kingston (see advertisement published in Johnston 1903a), doubled as both tourist agencies and Kodak supply stores, demonstrating how closely tourist travel and photography became wed. Photographers opened studios (some only during the tourist season) to cater to this new tourist market in "scenic views" (Boxer 2001, 15–16; Thompson 2003). They stocked a set of images through which travelers could compile their photographic records of the islands and developed tourists' own photographic impressions of their sojourns.

Many travelers hired local men to direct scenic tours of the island, on which they frequently took their cameras (Brassey 1885, 214; Leader 1907, 114). Black male guides often carried the photographic and artistic equipment that tourists needed in "the labor of capturing the perfect view," to use the expression of one traveler to the Bahamas (Brassey 1885, 214). These escorts also sometimes became photographic subjects (Leader 1907, 114) or directed tourists to their own ideals of artistically worthy sites

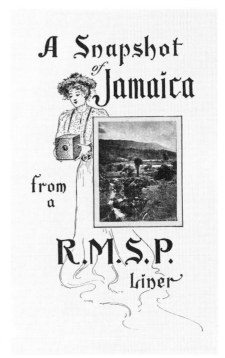

2 *A Snapshot of Jamaica,* guidebook cover, ca. 1907

(Williams 1909, 48). In sum, travelers' "laborious" quests for the picturesque were frequently based on the labor, expertise, and participation of local inhabitants.

Some travelers published accounts of their tropical sojourns through the islands, as was the case with British travel writer Alfred Leader, who published *Through Jamaica with a Kodak* (1907). The title of his account draws attention to the importance of creating and taking photographs in the islands and, more generally, to a touristic way of seeing them, as promoters billed the colonies, as a series of photographic images. Other travelers to the islands showed their photographs in exhibition spaces provided in local hotels. Between 1900 and 1920, more than 200 such exhibitions of travelers' photographs and other art work took place in hotels in Nassau alone.[8]

This promotion of the picturesque landscape in tourism campaigns, of course, did

not only happen in the context of the Caribbean. Travel industry supporters have long sold locales as picturesque, and tourists have clamored to represent these places at least since the popularity of British travel to Italy on the Grand Tour (Redford 1996; Hornsby 2000) and picturesque tours of the British countryside inspired by William Gilpin in the eighteenth century (Gilpin 1792; Andrews 1989; Taylor 1994). Other geographic locations, including the French Riviera (Silver 2001), the South Pacific (Smith 1969), Latin America (Pratt 1992), and New England (Brown 1995), also served as photographic and artistic muses for travelers (Urry 1990; Osborne 2000). Although this kind of pictorial imaging, this place-image based precisely on the islands' ability to become like representations, was not unique to the Anglophone Caribbean, it would distinctively impact the islands' environments and their inhabitants.

Tourism promoters in the islands did more than create an image of Anglophone Caribbean societies solely in the realm of visual representation. Indeed, almost from the inception of tourism industries on the islands, hoteliers, colonial administrators, and local white mercantile elites (re)created or tropicalized many aspects of the islands precisely in the image of these representations. They physically transformed areas of the islands through planting campaigns or cleanliness drives, in efforts to make the islands appear as they did in photographs—orderly, picturesque, and tropical. The importation of "tropical" trees from different parts of the world, for instance, was one way governments in the colonies attempted to re-create a visual ideal of the tropical Caribbean landscape on the islands' environment. Botanical gardens, hotel landscapes, and tourist-frequented ports, in particular, became spaces where ideals of the picturesque tropical landscape were re-created in miniature. Once the islands had become tropicalized in the realm of photography, such representational ideals informed the physical appearance of the islands.

By examining the physical effects of touristic images in Jamaica and the Bahamas, I shift the analytical focus in postcolonial studies, which has developed on how "the West" imagined other cultures and regions, particularly the Orient, Africa, and India.[9] This scholarship has provided keen insights into how colonial representations often supported claims of Western superiority, adversely reflected ideals of Western societies, and justified colonial missions and imperial campaigns. Many of these studies, however, generally conclude that representations of other places reveal more about the West than they do the locations or peoples pictured and described in colonial discourses. As Peter

Mason acknowledges in *Infelicities: Representations of the Exotic*, the "story told here, for better or for worse, is a European one" (Mason 1998, 5). Such interpretations have led to a kind of scholarly narcissism, wherein examinations of images and discourses about "other" places are preoccupied solely with Western ideologies or notions of colonial power. Researchers often look past the subject matter represented or described as if gazing through a mirror's surface, seeing only Western ideologies reflected in these sources. With very few exceptions (Schick 1999; Kahn 2000), these approaches seldom examine the representations as they impacted the environments they sought to represent.

Looking at colonial representations against the backdrop of the specific geopolitical environments they pictured, I direct the analytical gaze of inquiry onto the places and peoples depicted in the representations. By espousing such an approach I am not advocating comparisons between colonial representations and a prerepresentational truth or "reality" of a given society.[10] Rather, I explore how colonial representations became interwoven within the texture of colonial societies. So-called imaginative geographies frequently shaped the physical contours of the very "social spaces" that they "imagined." French scholar Henri Lefebvre uses the phrase "social space" to describe the dialectal relationship between representations of space, the usage of space, and the physical creation of space. It is this dialogic or mutually defining relationship between the spheres of tourism, visual representation, and space in Jamaica and the Bahamas that I examine in this book. Not only did representations inform the subsequent material re-creation of parts of the islands' landscapes, but photographs of these areas naturalized these "tropical" forms of fauna and flora as representative parts of the islands' landscape. In short, colonial representations were frequently not just reflective of colonial views but became constitutive and iconic parts of the colonies' landscape.

"AS OTHERS SEE US": LOCAL RESPONSES TO TOURISTIC REPRESENTATIONS

By focusing solely on the "European story" of these representations, scholars have seldom examined how different local constituencies interpreted and used these images toward their own social, political, or aesthetic ends. Even scholars who call attention to the multiple audiences and complex, heterogeneous, and even ambivalent meanings of

colonial representations frequently restrict their analyses to the reception of colonial imagery in Europe and Euro-America (Lowe 1991; Melman 1992; Lewis 1996), with a few exceptions (Mitchell 1988; Pratt 1992; Lippard and Benally 1992). Few scholars appreciate that colonial representations had widespread visibility within the colonies. In the case of the Bahamas and Jamaica local groups were hypersensitively aware of these images. Before tourism promoters sent photographs abroad to colonial exhibitions, for instance, they would on occasion display the images in the islands.[11] Newspaper articles, particularly a column entitled "As Others See Us," provided a forum through which local elites reviewed prospective international photographic exhibitions, critiqued travelers' representations, reported on the reception of lantern lectures, and assessed the successes or failures of local representation at colonial exhibitions. When the United Fruit Company, an American corporation, embarked on an extensive advertising campaign on Jamaica, a four-page spread appeared in *The Daily Gleaner* in which "many representative men" scrutinized the "scheme to advertise Jamaica abroad" (*DG*, 30 January 1904).[12] Not only were touristic images seen in the colonies, but locals paid acute attention to how these representations were in turn seen by "others," the outside world. In short, images created to project an image to the outside world also shaped how local communities learned to see themselves and their environments.

Tropicalization, however, was a continually negotiated process, supported or critiqued by colonial, local elite, and "subaltern" constituencies. Groups at the top of the islands' social hierarchies—the politically powerful British colonial officials and local white elites—valued tropicalization, for instance, for the modernity they hoped it would bring to the islands. By marketing the islands as premodern tropical locales, and thus attracting modern tourists (and potential white residents) and their capital, elites prophesized that tourism would bring modernization to the islands. An examination of the white elite investments in tropical images will reveal that touristic and colonial images could serve very oppositional purposes. What tourists frequently treasured as tropical, elites often valued as modern. That the islands' tourism promotional boards were often called "Development Boards" testifies that British colonial and white local elites' visions for the development and modernity of the colonies became intrinsically tied up in tropicalization. This wedding of tourism and national progress continues in the contemporary Anglophone Caribbean. While this phenomenon is not restricted to the

Caribbean, the region depends more on tourism as a "development" scheme than any other part of the world.[13]

At the beginning of the twentieth century, local white elites (who I distinguish for the sake of clarity from British colonials) consisted primarily of two groups: the plantocracy and the mercantile elite. The planter classes (descendants of the sugar plantocracy) held the majority of wealth and land in Jamaica and the Bahamas, but in the case of the crown colony of Jamaica their political power was limited. In the late nineteenth century, local white mercantile elite (whose families were originally Loyalists who fled from the southern United States after the War of Independence in the case of the Bahamas and from Syria and Scotland in Jamaica) gained a newfound economic wealth, social prestige, and political clout; this group had the most to gain economically from the anticipated tourist dollar. Both groups, along with British colonial administrators, pursued the industry beyond what it offered as an economic alternative to the islands' formerly agriculturally based economies: they invested in tropicalization as a means to transform the islands from colonial outposts to modern societies. Tourism offered local elites on "the skirts of modern civilization," as one contemporary described the marginal status of Jamaica in 1890, participation in the "civilized world" (DG, 28 September 1889).

In the early twentieth century, black working classes and emergent black middle classes (or "brown" in the case of Jamaica) at times contested tropicalized images, precisely because these representations typically imaged blacks as rural, exotic, primitive, and unmodern, despite their modernizing efforts. A turn-of-the-twentieth-century postcard by photographer H. S. Duperly, for instance, pictures an old black woman balanced precariously on a modern bike—a motif in tourism-oriented photographs from the early twentieth century (figure 3). The very juxtaposition of the new (mode of transportation) and the old (woman) simultaneously spoke to the unnatural and even comical relationship between modernity and black Jamaica. Many touristic images portrayed blacks' marginalized relationship to the project of modernity.

Different local groups also variously related to the "tropicalized" spaces that industry benefactors constructed for tourists, particularly hotel landscapes. Significantly, hotels, although marketed and landscaped to appear as tropical enclaves, frequently represented the epitome of modernity to many elites. As the first spaces in the islands to have

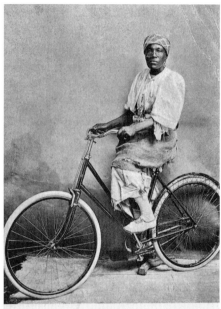

An Expert for a three miles Race, Kingston.
Jamaica.

3 H. S. Duperly postcard,
Kingston, Jamaica, 1907–14

many modern amenities, hotels attained a prized local status and became the center of social life for local whites. Since the turn of the twentieth century, colonial and local elites spared no expense in pouring resources into promoting, creating, and sustaining spaces that were officially for tourists. Areas tourists frequented, in particular, were subject to modernizing schemes: new roads, water and sewage systems, and telegram services.

Tourism supporters encouraged modern improvements in designated locations but not at the expense of "picturesqueness"—its tropical image. They constantly negotiated the relative virtues of implementing modern innovations (for the comfort of the tourist) and their potentially harmful aesthetic effects on the landscape (valued by tourists as premodern and preindustrial). Although elites claimed that tourism would bring modern improvements to the islands, modernization was continually based on and

masked by tropicalization. In sum, while tropicalization was a forward-looking project for elites, a re-visioning of the modern future of these societies, it was based on a re-construction of the islands as existing in the past.

A cycle developed whereby ruling elites invested in modern and picturesque improvements in tourism-oriented locations but neglected the rest of the island, especially the colonies' black districts. This was especially true in the Bahamas. "Public policies [were] . . . shaped by consideration of the traffic's priorities, so that millions have been granted to the Bahamas Development Board for expensive tourist promotion schemes while everything else languished for lack of funds" (Lewis 1968, 327). Despite the advances in health and material conditions in downtown Nassau and the fantastic revenues from tourism in the first half of the twentieth century, sanitary and health conditions for the majority of the population remained dismal (Saunders 1997, 29; Lewis 1968, 320). As historian Gordon Lewis tersely puts it, "For the Negro majority this all meant a grim struggle for existence in a deceptively idyllic Eden" (321).

In societies historically stratified along the lines of color and class, hotels and select tourism improvement and "tropicalization" schemes exacerbated existing racial divisions in the islands. Historian Gail Saunders attests, in relation to the Bahamas, that "in economic terms, the wealth of the white elite, gained through modern developments in tourism and finance, created a wider than ever cleavage between the races" (Saunders 1985, 502). The influence of American hoteliers, valued contributors to "modernization" schemes on the islands, and the presence of American tourists deepened racial fissures in the British colonies. In Jamaica (where inhabitants prided themselves on the absence of race discrimination) and in Nassau, American investors imported practices of race segregation into the islands, throwing newly stringent and *preexisting* racial hierarchies into sharp relief. While Americans were not the sole architects of racial discrimination in the colonies, local elites, particularly in the Bahamas,[14] capitalized on what they identified as American tourists' racial preferences to justify widespread segregation throughout the islands.

As such, many prominent tourist-oriented spaces became off-limits to the island's black inhabitants, including hotels and famous beaches. The most celebrated hotel in Kingston, the Myrtle Bank, for instance, remained closed to the majority of the population until the late 1940s. As one resident recounted to historian Elizabeth Pigou-Dennis, "a little apartheid ruled at the Myrtle Bank in those days" (quoted in Pigou-

Dennis 1998, 6). Similarly, in the Bahamas hotels like the Royal Victoria Hotel and Hotel Colonial remained off-limits to blacks. In Nassau racial segregation was so enforced at the Hotel Colonial that white employees were brought in annually, from New York, for the winter season until the 1940s. The hotel was one of the last spaces on the island to be desegregated in 1956 (*NG*, 26 January 1956). In sum, blacks in the Bahamas and, to a lesser degree, Jamaica were denied access to the spaces that represented tropicality for tourists and modernity for many elites.

Paradoxically, the locations promoted as most characteristic of the islands in photographs became sites where the majority of the colonies' populations could not venture, segregated enclaves from which black inhabitants were restricted or barred. Many of the spaces or places popularized in representations, particularly hotel landscapes, swimming pools, and beach spaces, became designated as exclusive sites for tourist (and elite) occupation only. A complex and obverse relationship then resulted between "sacralization" (when a site is made sacred, the literal and figurative focus of tourists' pilgrimages) (MacCannell 1976, 45) and segregation. The very sacralization of certain spaces through their mechanical reproduction contributed in part to their closely guarded status.

"CHUH!! WHA FOR YOU LOOK 'PON ME LIKE DAT":
PHOTOGRAPHY, VISUALIZATION, AND SOCIAL DISCIPLINE

Photography and the process of making parts of the islands "like pictures" were intrinsically related to the control of space. Much has been written in recent years on photography as a tool of social discipline and regulation. Some historians of photography have viewed photographs as an extension of modern institutions of surveillance and the social control described by Michel Foucault (Foucault 1980, 1995; Crary 1990; Poole 1997; Ryan 1997). Through photographic representations, for example, law enforcers extended a disciplinary gaze beyond the walls of penitentiaries, using the medium to document, visualize, and control criminality (Tagg 1988). Surprisingly, few scholars have examined photographs generated in or for tourism in light of their panoptical and disciplinary potentials (Rosa 2001, 459). Attention to photography's relationship to social hegemony will prove essential to understanding touristic representations of the Anglophone Caribbean.

Tourism promoters' use of photographs and their attempts to maintain the islands' place-image all wrought social controls. In the name of tourism the British colonial and white mercantile elite at various historical moments imposed social regulations based on the rationale that the islands had to sustain their touristic image. The ruling elites often did everything in their power—from the legislation of social policies to the use of the police force—to ensure that the islands presented the best image to travelers. Thus the making of the landscape into "image" was intrinsic to social and spatial control on the islands.

The stated interest in the islands' "picturesqueness" for tourism, however, often masked another motive. Colonial officials and local elites, by enforcing and institutionalizing "picturesqueness," could safely airbrush unwanted, threatening, and undesirable elements, including people, out of the social frame in the name of maintaining the islands' place-image. Photography historian Peter Osborne characterizes this process best when he concludes, "As in the painting's visual descendants, tourist posters, postcards, the resort itself with its themed services and entertainments, it has been made safe and made into image—made safe *by* becoming image" (Osborne 2000, 109). Although Osborne directs his comments at hotel landscapes, in the context of the Bahamas and Jamaica, society as a whole, for the ruling elite, was thus made safe, not just for tourists but for the status quo, by becoming like a picturesque photographic image.

Significantly, one aspect of the islands' picturesque image that promoters had to maintain was precisely the colonies' reputations as disciplined societies. The medium of photography itself became central in the perpetuation and maintenance of this disciplined image; it served as a form of discipline. The very process of representing and deeming parts of the landscape and inhabitants as picturesque marked their incorporation into a disciplinary society. That the islands and their native populations were fit to be photographed offered an additional degree of assurance to travelers that "the natives" and the landscape were tamed, safe, and framed for their visual consumption. Hence, before tourism associations and local governments could transform black Bahamian traditions like Junkanoo (an event where photographing masked participants had long been taboo) into a tourist spectacle, they had to make the masquerade photographable (placing photographs of unmasked participants on the front of the newspaper and in travel guides). In other words, tourism was central in extending a kind of disciplinary gaze onto these colonial societies. The photographs popularized in tourism promotion

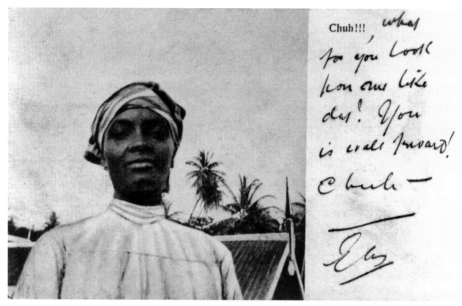

Chuh!!! what fo you look pon our like dis? You is well forward! Chuh — Ely

4 Photographer unknown, "Chuh!!!," postcard, 1907–14

functioned as both evidence of a disciplinary society and a means of exerting social control.

The handwritten captions on several postcards from Jamaica provide several glimpses at how inhabitants may have responded to the "tourist gaze" or, more accurately, the colonial and elite circum tourist gaze. One postcard of a black Jamaican woman who stares down into the camera's lens, carries the printed and added handwritten commentary, "Chuh!! Wha for you look 'pon me like dat? You is well f[o]rward[?]! Chuh—Ely[?]" (figure 4). Another postcard bears a similar statement: "If you look 'pon me so, I gwine choke." Such commentaries, written in dialect no less, suggest that some tourists may have heard such remarks on their own photographic excursions. It is possible that the captioners encountered persons, who, for whatever reasons, did not want to be photographed. These occurrences were not uncommon. Chronicled in travelers' and newspaper accounts, several camera-wielding tourists came on reluctant inhabitants who variously demanded monetary compensation for their photographic

inscription,[15] engaged in "staring contests" (and often won) (*WIR*, 3 December 1949, 13), or physically attacked the photographer (biting the ear of the picture-taker, by one account, literally consuming the tourist devoted to visual consumption) (Defries 1917, 78). Despite these challenges, that commentaries about not wanting to be photographed appear at all on the above postcards (next to snapshots of these persons) suggests that some protests fell on deaf ears. Even in the face of objections, inhabitants could be violently inscribed against their will as objects in tourism's visual economy. The postcards thus encapsulate some of the complexities and tensions that developed in a tourism industry based on viewing and visualization as a form of social discipline in a society where some inhabitants did not want to be "looked 'pon so."

THROUGH NEW CLAUDE GLASSES:
THE PICTURESQUE IN THE WEST INDIES

In addition to examining the social and political effects of touristic representations, I pay attention to the very particular aesthetic criteria tourism promoters formulated to image the Caribbean islands as picturesque. What did the picturesque mean in the context of the British West Indies, and how did it differ from the definition of the picturesque in Britain, where the term originated? How did the Anglophone Caribbean fit into or disrupt the visual language and touristic expectation of the picturesque? Through such an investigation I aim to expand the large art historical literature on the English picturesque landscape tradition, which examines how these representations related to wider social and political issues in Britain, from the dispossession of the rural poor to enfranchisement.[16] These studies testify that landscape traditions can become "operational" (Mitchell 1994) in shaping class relations, social and national identities, and even physical environments. Rosenthal notes, however, that despite the wealth of literature on British landscape, British colonial landscape in the West Indies has yet to be explored (Rosenthal et al. 1997). This book extends the analysis of the picturesque in Britain by testing the elasticity and operation of the term as it spread to Britain's colonies, exploring in turn what its redefinition suggests about the meaning of the picturesque in Britain and other geographic contexts.

In the history of art the picturesque denotes an aesthetic approach to seeing and representing landscapes that first began to be articulated in the 1760s and 1770s, reaching

the height of its popularity in the 1790s (Andrews 1994, 3–4). The Reverend William Gilpin popularized interest in the picturesque in his first tour book, *Observations on the River Wye* (1782), in which he encouraged travelers to the English countryside to "examine the face of a country by the rules of picturesque beauty" (quoted in Andrews 1989, 56). In the context of Britain in the eighteenth century, seventeenth-century landscape paintings of Italy by artists like Claude Lorrain and Gaspar and Nicholas Poussin provided the rules or ideals of picturesque beauty, the preestablished pictorial model through which Britain's landscape was re-presented. While this interest in what art historian Malcolm Andrews describes as the "formalist Picturesque," inspired by Italian landscape paintings, remained popular throughout the eighteenth century, another "more complicated Picturesque, associated with decay" also emerged (Andrews 1994, 5–6). Lovers of the latter form of the picturesque were interested in landscapes that displayed the aesthetically pleasing signs of natural decay, wilderness, rugged terrain, and ruins. While both forms of picturesque beauty did not necessarily reside in the natural world, by looking at the countryside through an optical device known as Claude Glasses,[17] by representing it according to Gilpin's pictorial formula, or by creating gardens, seekers of the picturesque could literally transform any landscape into a picturesque one (Crawshaw and Urry 1997, 185).

Unlike the influence of Italian landscape traditions in picturesque images of Britain, photographers and painters of picturesque landscapes working in Britain's Caribbean colonies (and other "tropical" British possessions) drew on a very different set of aesthetic or representational models.[18] In contrast to historian Jeffrey Auerbach (2004), who maintains that British artists represented landscapes across the empire through the same picturesque lens, I show that ideals of the Caribbean picturesque, the picture-perfect tropical island landscape, were based on another set of artistic, fictional, and imaginative notions of the tropics popularized in the eighteenth and nineteenth centuries (Dash 1998; Arnold 2000; Stepan 2001). Popular travel accounts, like African explorer David Livingstone's adventures through Africa (which were quoted extensively in Nassau's local papers), fictional sources like Edgar Rice Burroughs's *Tarzan* (1912) or French artist Henri Rousseau's "tropical landscapes" (Stabenow 1986), all ignited visions of the tropics as a place of utter difference. Rousseau's naive nocturnal jungle landscapes, populated by a dense frieze of exotic vegetation and inhabited by lurking wild animals, epitomize these tropical ideals (plate 1). In one painting a woman lies in a

flowering landscape, one eerily alive with the eyes of animals visible in the brush. Evident even in the title of the artist's painting, *The Dream* (1907), Rousseau's tropical world was the imaginative concoction based in part on his dream-inducing visits to Paris's botanical gardens. The Frenchman never visited the Americas, as he claimed, before realizing his tropical vision on canvas. Such artistic sources, along with fantastic representations of tropical nature from the natural and human sciences (Stepan 2001), helped to construct an imaginative notion of the tropics or a "dream" of tropical abundance, to use a term travelers frequently employed, which provided a model for the picturesque in the Anglophone Caribbean. One traveler arriving in St. Thomas made this point explicit when she measured the island according to "the ideal we had formed of the wealth and luxuriance of tropical vegetation—an ideal almost unconsciously derived from the old geographies of our childish days in which the picture of a dense jungle, with serpents gracefully festooned from tree to tree and a monkey in one corner, always was a symbol of the torrid zone" (Day 1899, 29). Picturesqueness in the British Caribbean referred to the landscapes' conformity to these exoticized and fantastic ideals of the tropical landscape. The picturesque denoted a landscape that seemed like the dream of tropical nature.

Crucially, "picturesqueness" also frequently characterized parts of the islands that had been transplanted, ordered, or "tropicalized" variously by the British colonial government, planters, British and American corporations, and tourism promoters. As such, the picturesque in the context of Jamaica and the Bahamas denoted the landscape's conformity to these colonial, imperialistic, or touristic ideals of the tropics. Picturesqueness signaled that the islands realized the "dream" of tropical nature. Unlike eighteenth-century travelers who learned to see the landscape as picturesque (as created by Gilpin) (Crawshaw and Urry 1997, 185), in the context of the British West Indies at the threshold of the twentieth century, the picturesque signified a landscape made into the fantastic vision of the tropics. The perceived realism of photographs of the tropics offered tourists a confirmation and reinforcement of the very truthfulness of their cultural expectations of the islands (Lutz and Collins 1993, 29–30). Such images were only realistic inasmuch as they were consistent with travelers' dreams of the tropics.

In contrast to art historical critiques that maintain that the relationship between picturesque representations and "actions on the land" are "questionable" (Michasiw 1992, 77), the tropicalization of Britain's Caribbean colonies demonstrates that the pictur-

esque undoubtedly shaped physical transformations of parts of the islands' landscapes. In Jamaica and the Bahamas the aesthetics of the picturesque were intrinsically connected to the politics of space, the colonial state's governance and control of land and society. Indeed, the case could be made that within the context of British rule the picturesque (the geographically specific meaning of the picturesque) shaped "actions on the land" and its inhabitants more so in British West Indian colonies than in the metropole.

FOREGROUNDING THE CULTURE AND CAPITAL
OF VISION IN CARIBBEAN STUDIES

This book investigates the significance of visual images and visuality generally in the Anglophone Caribbean, an analytical blind spot in studies of the British West Indies (Cummins 1999).[19] As Barry Higman attests in *Historiography of the British West Indies*, "Academic historians [of the British West Indies] . . . rely on words on paper, . . . seeing pictures as mere illustrative devices rather than appropriate vehicles for analytical discourse" (1999, 20). Higman's critiques may be directed across disciplinary boundaries. While scholarship critical of the colonial or travelers' texts on the Anglophone Antilles are commonplace, from the study of history to English literature, no comparable body of contemporary scholarly criticism has deconstructed visual representations of the region.[20] Photographs especially, as I examine in chapter 5, have not only been undertheorized but overly naturalized as transparent representations of the islands' past. Even more commonly, scholars have bypassed visual images altogether in their investigations of the region, even when such materials are pertinent to their subject of study. Peter Hulme, for instance, in his examination of the indigenous people of Dominica, acknowledges that the period covered by his book (1877–1998) is "the era of the camera," yet he restricts his analysis to texts (Hulme 2000, 4). Hulme's work is but one recent example of the analytical neglect of visual images in historical and cultural considerations of the Anglophone Caribbean.

Despite the lack of contemporary scholarly attention to the culture of vision, throughout the first half of the twentieth century Caribbean critics of colonialism, racism, and Western hegemony in the region frequently centered visual representations and touristic ways of seeing the islands in their analyses. No less than the outspoken Jamaican-born black nationalist Marcus Garvey's Universal Negro Improvement As-

sociation (UNIA), as discussed in chapter 1, cited the role of postcards in colonial rule and black oppression in 1915. Guyanese novelist Edgar Mittelholzer also formulated a pointed critique of tropicalized representations of the West Indies. In his book *With a Carib Eye* Mittelholzer maintained that northerners wrote about and pictured the islands with an eye for the strange and "the exotic," "one strongly influenced by the writer's preconceived notions of tropical countries" (1958, 7). He took issue with the traveler who "deliberately falsifies the picture for the sake of creating the impression on his countrymen that he has returned home after an adventure among primitive people" or ardently sought locally made pictorial representations of "something with native huts—grass-roofed huts and palms and jungle trees" (13).[21] Explicit in tourists' insistent quests for tropicalisms, their unrelenting eye for the tropics, Mittelholzer argued, was a refusal to see the islands as intrinsically a part of the modern world. The UNIA's and Mittelholzer's observations, one at the start of the twentieth century and the other at its midpoint, evince signposts in a critical discourse on visual images of the West Indies, one not sufficiently examined in the region and not sustained in contemporary scholarship on the region.

Careful attention to visual representations would provide not only another archival source for scholars of the Caribbean but a means through which to understand the making of the modern Anglophone Caribbean in the post-Emancipation era. Images and ways of seeing the islands have been central to the historical formation of the West Indies since the late nineteenth century. With the decline of "king sugar" and other agricultural industries, visual images and visuality (specifically sightseeing) were crowned the "new sugar," the means through which the islands were subsequently consumed (Sheller 2003). Deeming the sugarless societies tropically picturesque inscribed them with new commercial value. Touristic images were also central to colonial and elite schemes to whiten the islands racially at the start of the twentieth century. By representing the islands as picturesque, authorities hoped that white tourists would become migrants, increasing the dwindling number of whites in the wake of the decline of the sugar industry. Photographs were central to transforming, literally and pictorially, the islands from colonial outposts of exploitation into *societies* that seemed perfectly managed, domesticated, and stable (Lewis 1968).

In addition to their (intended) role in whitening the Caribbean, picturesque images and tropicalized spaces would play a role in black protest. Precisely because touristic

photographs frequently portrayed the success of colonialism in civilizing black subjects, they became central to black critiques of the failures of British colonial rule. Spaces crafted for tourism became locations for acts of civil disobedience against the colonial state. In the context of Jamaica a hotel swimming pool would provide a stage of black contestation, as important in the island as Rosa Park's segregated bus was to the civil rights movement in the United States. In the case of the Bahamas the desegregation of hotels served as the mobilizing cause of black working class and colored middle class Bahamians who aimed to contest racial inequality and segregation in the island as a whole.[22] This broad sketch of the significance of the image world of tourism and spaces of leisure in the Anglophone Caribbean demonstrates that the visual culture of tourism was central to the processes and currents that many scholars have examined in the region: colonialism, racial formation, modernity, underdevelopment, capitalism, and subaltern protest. As even more countries in the English-speaking Caribbean come to depend on tourism in the contemporary era, attention to the politics and aesthetics of tourism will provide not only insight into the past but into Caribbean futures.

CHAPTER SUMMARIES

The first three chapters look at the earliest tourism campaigns in Jamaica and the Bahamas, concentrating on the period between the 1890s and 1930s, the first decades of the travel trade to the islands. This early phase of tourism has typically been neglected in studies of the region, which concentrate on the industry since the beginning of mass tourism (Dann 1988, 261). Collectively, the chapters examine the primary subject matter presented in a variety of photographic media—from the enlarged lantern slide projection to the miniature postcard. While each form changed the physical appearance and experience of the image, and several chapters focus on particular mediums, most of the representations featured in the book circulated in several formats and over decades.

Before we can understand the iconography of these tourism-oriented photographs, it is necessary to trace a longer history of representations of the Anglophone Caribbean. Chapter 1 explores how Jamaica was visually constructed through eighteenth-century plantation estate paintings and naturalists' representations from the nineteenth century, before the dawn of the tourism trade. The chapter examines how the seemingly mimetic medium of photography intersected with and reified this preexisting tropi-

calized image world of Jamaica. Industry promoters chose the medium precisely because they felt it aptly communicated, more so than paintings, the reality of the island's dreamlike tropical landscape. In particular, I trace the specific images and motifs that the two most influential tourism propagandists, the American United Fruit Company and British Elder, Dempster and Company used in their campaigns to promote "The New Jamaica." I document how they attempted to attach very specific meanings to these representations through accompanying texts or oral presentations.

Although I map what Roland Barthes characterizes as "a body of intentions" behind the visual archive these companies created (Barthes 1972, 125), I am equally interested in how photography often proved an inadequate medium in forwarding their commissioners' tropicalizing agendas. The retouching of photographs (to make the landscape seem more tropically abundant and less modern), the dressing up and staging of photographic subjects (to make them seem more picturesque), and the changing of captions for photographs or postcards (to direct the signification of the image) all belie the inevitable shifts in, yet struggle to stabilize, the meanings of these representations.[23]

Chapter 2 traces more explicitly how these place-images informed the subsequent creation (or tropicalization) and use of space in Nassau, paying acute attention to how tourism campaigns affected the particular racial landscape of the island in the 1920s and 1930s. Drawing on local newspaper accounts, government reports, tourism board papers, and commissioned images, I plot the aesthetic, social, and political significance of specific sites and people that became popular photographic icons. In the chapter I also come to terms with what tourism officials refused to represent in the islands' picturesque repertoire—namely aspects of black Caribbean culture on the island. Using travelers' descriptions of what authorities (and locals) would not let them photograph, the chapter highlights the blind spots within the visual economy of tropicalization.

Chapter 3 shifts attention to the relatively late introduction of the ocean into the visual language of tourism in the 1930s. I use the work of John Ernest Williamson, a pioneer in underwater photography and filmmaking who worked in the Bahamas, to explore how photographic images of the sea in the Bahamas transformed local and global conceptions of the deep, rendering the ocean picturesque and safe for tourist occupation. The domestication of even the ocean in the context of the Bahamas demonstrates that, unlike other sites where travelers ventured to experience the sublime, the overwhelming scale and forces of nature, tourist travel to the Caribbean was marketed

as countersublime, as picturesque. Tourism promoters offered assurance that even the most sublime aspects of nature could be controlled in the islands, as the underwater-themed hotel complex in the Bahamas, Atlantis, attests. Although the sea is often framed in tourism promotion and even by scholars as the long-standing natural signifier of the Caribbean, the chapter demonstrates that it was a recently configured trope of the islands, one made possible only after the invention of modern visual technologies.

The last two chapters look more explicitly at local responses to tropicalization. Chapter 4 focuses, for instance, on one popular icon of Jamaica in the first decades of the twentieth century: the pool of Jamaica's premier hotel, the Myrtle Bank. I concentrate on an incident that took place in the hotel, when a black Jamaican journalist, Evon Blake, jumped into the famed but racially segregated saltwater pool of the hotel. I use that event as a point of departure to explore the relationship of different local groups to the pool and, more generally, spaces of tourism. The history of the hotel (described as an "American Hotel" since the 1870s and subsequently owned, managed, and patronized by Americans) also allows us to explore the increasing influence of American interests in Jamaica since the late nineteenth century. How did American image makers inform the picturesque in the British colony? How did different local groups capitalize on the American presence to forward their own social standing and agendas in the British colony?

Although much of the book focuses on tropicalization in the colonial era, chapter 5 explores several postcolonial uses of the tropicalized visual archive, specifically in picture books, historical accounts, and contemporary art. It provides a prologue to the processes examined throughout the book, exploring how images once fashioned for tourists are more recently represented for local audiences. I examine the afterlife of tropical representations, their uses by the formerly colonized more than a century after their creation, and their implications on popular memory, history, art, and imagination in contemporary Caribbean societies.

FRAMING "THE NEW JAMAICA"
Feasting on the Picturesque Tropical Landscape

If you wish to understand that consoling pity with which the islands were regarded, look at the tinted engravings of Antillean forests, with their proper palm trees, ferns, and waterfalls. They have a civilizing tendency, like Botanical Gardens, as if the sky were a glass ceiling under which a colonized vegetation is arranged for quiet walks and carriage rides. . . . A century looked at a landscape furious with vegetation in the wrong light and with the wrong eye. It is such pictures that are saddening, rather than the tropics themselves. These delicate engravings of sugar mills and harbors, of native women in costume, are seen as part of History, that History which looked over the shoulder of the engraver and, later, the photographer.

<div align="right">Derek Walcott, The Antilles, 1995</div>

The photograph as souvenir is a logical extension of the pressed flower, the preservation of an instant in time through a reduction of physical dimensions and a corresponding increase in significance supplied by means of narrative.

<div align="right">Susan Stewart, On Longing, 1993</div>

Like butterflies captured and placed behind a pane of glass, several travelers' photographic albums of Jamaica from the late nineteenth century display physical mementoes of the island's flora and fauna pressed into the sleeves of their pages, embalming literally plant clippings from the island in the seemingly timeless and lifeless world of their collections (figure 5).[1] These plant specimens do not solely occupy the pages of these albums but form a decorative border to centrally positioned photographs of Jamaica's natural environment. A photograph of coconut trees, for instance, appears framed by several leaves of fern. The juxtaposition of photographs of nature and natural specimens combine two representations of Jamaica. Both provide visual evidence of having been there and having "taken," by physical removal or through the camera's

5 A. Duperly and Sons, "Coconut Palms," photograph, ca. 1890, in an album, with foliage

shutter, the island's natural forms. This doubleness of representation conflated two mementoes of Jamaica, which imaged the island primarily as a place where the earth offered forth a spectacle of "tropical nature." These particular albums, as I will argue, blend visual genres previously used to represent the island, including picturesque plantation landscapes from the late eighteenth century and naturalists' detailed drawings of tropical botanical specimens from the nineteenth century. Moreover, they represent a pivotal moment when travelers, tourism promoters, and local photographers, who aimed to cater to the developing tourism industry on the British colony, turned to the comparatively new medium of photography to reify and transform earlier ways of imagining and representing Jamaica.

The albums, poised almost uncomfortably between representational genres, reflect a wider historical moment in Jamaica at the end of the nineteenth century, when Jamaica's

British colonial administrators, mercantile elite, and British and North American business interests very consciously aimed to refashion the image of the island in the eyes of the "modern" or "civilized world," to use terms employed in newspapers in Jamaica at the time (*DG*, 27 January 1903; *DG*, 8 December 1904). In the late 1880s these groups optimistically forecast the birth of what they hailed as "The New Jamaica" or "Awakened Jamaica," a new period of economic prosperity and modernization based on the projected success of the burgeoning tourism trade.[2] Tourism supporters predicted that the industry would bring not only temporary sojourners to Jamaica, with their much-needed expenditures, but would inspire capital investment, trade, land acquisition, and the permanent settlement of white migrants.[3] Through tourism, one promoter predicted, the island would "be 'discovered' in the modern sense, and if we succeed in pleasing the fastidious taste of the class [of tourists] that will shortly visit us we may also in the modern sense be 'made'" (*DG*, 9 January 1893). By creating an image of a "New Jamaica," industry supporters aimed to propel the colony to the forefront of the modern world.

To create a tourism industry on which the New Jamaica hinged, proponents of the tourist trade recognized that the idea of Jamaica would have to be reinvented in the imaginations of North American and British audiences. Photography would play a key role in this process. Since the decline of the sugar plantation system in the colony in the early nineteenth century, in the words of a contemporaneous editorial, "the popular idea of Jamaica at home [in Britain] is of an island ruined by emancipation, a region of derelict estates with a scattered population of negro squatters, paying no rent, living in squalid huts, supporting life on yams and bananas, and indebted to the calabash tree for the household utensils" (*DG*, 2 February 1892). Tourism promoters enlisted photography in an effort to replace the old image of Jamaica as a landscape and population of ill-repute with a new one. The photographs generated to meet these reimaging needs, more specifically, images created from the beginning of the industry in 1890 to 1914 (when the First World War brought a momentary end to the initial thrust of these extensive campaigns), form the investigative core of this chapter. What particular aspects of the island's natural environment or local populace did image makers seize on, figuratively and literally (in the case of the above-mentioned photographic albums), to project a more desirable touristic image of the island's landscape? How did they visualize the New Jamaica?

I argue that photographs created by tourism promoters in this period perpetuated an image of the island as primarily a place of nature and, more specifically, as a landscape in which nature displayed the charms of a "picturesque tropical garden." Photographs and written accounts of the New Jamaica frequently described, visualized, or fetishized parts of the island's vegetation that displayed signs of cultivation—generally aspects of the landscape that had been overhauled and transplanted by various colonial regimes and North American and British business interests for profit. Such images naturalized the island's past and present plantation landscapes and attendant agricultural products of colonial cultivation as indigenous, aesthetically pleasing, and characteristic parts of the island's environment.

Many benefactors of Jamaica's tourism industry at the beginning of the twentieth century were simultaneously involved in the developing fruit trade (primarily in bananas and citrus fruits); hence many of the photographic images disseminated by these companies in the late nineteenth century and early twentieth had dual aims. They sold the picturesque (the seemingly naturally ordered) landscape to tourists, while proffering the products of the land (borne from the cultivated plantation environment) to potential consumers in British and North American metropoles. These competing representational aims often found resolve in photographic representations that portrayed the island as a tropical picturesque Garden of Eden, with its paradisiacal qualities attributed to the natural aesthetic orderliness of its banana and coconut plantations or citrus groves. The New Jamaica was also refashioned as a touristic landscape of desire by presenting the island as a place where the "fruits" of colonialism, both the "benefits" derived from British colonial rule and American enterprise, could be observed and certain agricultural products cultivated on the island could be visually and literally consumed.

The New Jamaica: "Discovering" Jamaica's Picturesque Scenery The new way of representing the New Jamaica or "The Awakening of Jamaica" was intrinsically bound to a new economic vision for the island at the turn of the twentieth century. The New Jamaica was partly the rallying cry of Henry Blake, the island's British governor (from 1889 to 1897), who aimed to inject a new spirit of enterprise and optimism into the economically depressed British colony of Jamaica. Since the mid-nineteenth century, the sugar plantation system, the former economic lifeline of the island, had been in sharp decline.[4] The abolition of the slave trade in 1807, Emancipation in 1834, and the Sugar Duties Act of

1846 had all hammered the final nails into the coffin of an ailing sugar industry. To revive the fledging economy, Blake supported hosting an international exposition in Jamaica. Commentators writing years later about the New Jamaica traced its beginnings to the exhibition, which opened on 27 January 1891 (*DG*, 27 January 1903).

The exhibition was financed by public subscription, an indication of the faith and investment in the event and the promise and possibility of the New Jamaica. It was an impressive affair, drawing participation from as far away as Russia, Holland, and India, along with displays from across the Caribbean. Since the 1860s, colonial exhibitions had provided forums through which many European colonial powers staged spectacles of nationalism, industrialization, and modernity (Maxwell 1999). Colonial administrators on Jamaica, on the fringe of imperial metropoles, also wagered that the colony could purchase currency in the modern world by hosting such an affair. By some accounts the exhibition was successful in this regard. "It was The Exhibition," one commentator reflected in 1903, "which first brought the colony to the notice of the modern world, and since that date there has been a constant accession of interest in the island" (*DG*, 27 January 1903).

The exhibition's organizers had several primary goals, which encapsulate the wider aspirations of the New Jamaica campaigns. In addition to encouraging tourism, the exhibition would bolster the trade of new agricultural products (especially bananas) that the island offered for sale. The exhibition's organizers also aimed to inspire the island's majority black population in the ways of industry and enterprise and, according to a contemporaneous editorial, "open their eyes to the *fact* of their backward condition" (*JP*, 12 February 1891). They reasoned, "It has been found that an Exhibition of the resources of a country is not only the best advertisement for business purposes, but is the most valuable industrial education for the people" (*DG*, 20 January 1889; *DG*, 12 February 1891). Despite these efforts (or because of them) many black Jamaicans steered clear of the exhibition. One newspaper censured the absence of blacks, claiming that "illiterate people are simply too ignorant to come to the Exhibition, [and] their untrodden minds will be dead weight in the development of a New Jamaica" (*DG*, 19 February 1891). Such statements attest that the New Jamaica was both descriptive of the image the ruling elite aimed to project to the outside world and prescriptive, an ideal that proponents hoped to see realized or materialized both on the social landscape ("all classes of Jamaica") and on the physical space of the island.

The New Jamaica, in addition, also entailed a new way of seeing, representing, and marketing Jamaica's landscape. As an editorial, entitled "The New Jamaica" outlined, "there is another new thing connected with Jamaica. *The character of its scenery is not new.* So far from that, it is as old as the hills. *But the recognition of it and of the character of the climate is new*" (DG, 29 January 1891; emphasis added). The article continued, "as Walter Scott was said to have discovered Scotland in respect to scenery, so recent travellers have been discovering the truth of the Governor's [Blake's] words, that Jamaica is one of the loveliest islands in the world."[5] The editorial went on to prescribe that "those who have eyes to see" should take a fresh look at "what is beautiful in [the island's] scenery." The New Jamaica, then, marks a crucial moment in the history of visual culture on the island, when persons in the colony newly reappraised the island's beauty, "discovering" it "in respect to scenery" for the first time.

The Magic Lantern: Projecting Jamaica's New Image Proponents of the tourism industry, however, had not only to see their landscapes with new eyes but to convince would-be travelers to do the same, to "recognize" Jamaica as a landscape filled with "the loveliest scenery in the world." One means tourism promoters employed to initiate this reimaging process was the lantern lamp or magic lantern, a precursor to the slide projector.[6] Originally viewed in Britain as a "magical instrument," by the late nineteenth century lecturers throughout Britain's colonies and the United States commonly used the lantern lamp to project photographic images from glass slides for entertainment and educational purposes. Capitalizing on the popularity of these lectures, tourism industry supporters in Jamaica identified the format as "a splendid way" to bring images of Jamaica's new scenery to light (DG, 1 February 1904). Through a succession of flashing photographic images, coupled with an engaging spoken commentary, lecturers on Jamaica aimed to place prospective tourist audiences "into something like living touch with the scenery and people [of Jamaica]" (DG, 1 February 1904). The luminous larger-than-life photographic images of the island created a tactile sense of being in Jamaica, as "living touch" implies, inspiring lecture audiences to want to inhabit the landscape so tantalizingly presented before them.

At the beginning of the twentieth century hundreds, if not thousands, of these promotional lantern lectures on Jamaica illuminated the faces of audiences throughout Britain, the United States, and Canada (DG, 1 February 1904). Local newspapers

hailed the men and women who "boomed" the island through these presentations as the island's "ambassadors" and avidly reported (and vicariously traveled with them) on their global ventures (*DG*, 9 December 1899). Some of the best-known ambassadors included James Johnston, James Gall, Bessie Pullen-Burry, W. H. Hale, W. G. M. Betton, T. H. Wardleworth, and H. C. Cobbold. Frequently colonial authorities and companies involved in both the tourism and fruit trades sponsored these "ambassadors" and the products (sometimes photographs) they handed out as souvenirs to lecture audiences. In particular, the United Fruit Company (an American company started by Captain Lorenzo Baker) and Elder, Dempster and Company (a corporation based in Liverpool and directed by Alfred Jones [later, Sir Alfred Jones]) were instrumental in promoting the island through lantern lectures. Through these companies' efforts, as a member of the Legislative Council in Jamaica reflected in 1904, "she [Jamaica] has been advertised of late—within the past 10 years—more than she had ever been advertised in her social history in every way" (*DG*, 8 December 1904).

One of the most avid lantern lecturers and promoters of the New Jamaica was James Johnston (1854–1921), a Scottish-born missionary, doctor, and, later, photographer, who settled in Brown's Town, Jamaica, in 1874. Originally a traveler who ventured to the island to escape the winter for health reasons, Johnston, convinced of the pulmonary benefits of the island's climate, decided to stay in the island. He eventually set up the Jamaica Evangelistic Mission, which grew into nine different supplementary churches. Subsequently, he became a legislative representative for his parish, St. Ann. In addition to his efforts to convert the island's inhabitants, the doctor embarked on another type of crusade, preaching to would-be travelers about the virtues of visiting Jamaica, which he billed the "New Riviera" in his lantern lectures. Johnston, under the auspices of Elder, Dempster and Company, delivered these lectures for well over a decade, reaching, by his own account, "large masses of the best class of people—those likely to come to this country" (Johnston, quoted in *DG*, 30 January 1904).

Johnston and other lecturers emphasized Jamaica's "picturesque qualities" through their commentaries, slides, and the overall presentation format of the lantern lecture. Johnston, for instance, would rally at the conclusion of his lectures, "It is only they who have witnessed the manifold glories, become entranced by the thousand and one perfect pictures from Nature's most delicate brush, and refreshing influences of her climate, who can best endorse the justness of her claim to be 'Jamaica, the New Riviera' "

(Johnston 1903b, 28). He presented the island as a series of "Nature's perfect pictures," usurping the picturesque mantel from the French Riviera. The very form of his lantern lecture, composed of 75 slides, reinforced Johnston's description of the island as "one thousand and one pictures." He and other lecturers precisely presented the island *as and through* a series of photographs. In addition to the more ephemeral form of lantern lectures, tourism promoters also used colonial exhibitions, books, and postcards to exhibit and emphasize the island's picturesque qualities.[7] Through these various photographic means the medium became the message: that the island was like a succession of picturesque views.

Tourism promoters, especially those who were also photographers, not only advertised the island as picturesque but helped to define the visual parameters of what was "thoroughly characteristic of the people, their country and its scenery," to use the words of a locally published advertisement for Johnston's photographs (*DG*, 13 February 1899). Photographs presented in the lectures, books, and postcards formed a visual grammar that over time, through successive reproduction and repetition, defined what was characteristic or representative of the island. Some of the roots and routes of still-enduring touristic images of Jamaica (and other parts of the Caribbean) as untouched natural landscapes, populated by coconut and banana trees and contented black "natives," all clothed in Edenic tropical luxuriance, can be traced to these New Jamaica campaigns.

Architects of the picturesque New Jamaica, however, in addition to establishing a visual canon for picturesqueness drew on preexisting representational models and pictorial schemas. Recalling the editorial on the New Jamaica, its author stressed that the scenery of the island was "as old as the hills" but pinpointed that its recognition was new. The choice of the term *recognition*, meaning to know again or to perceive to be identical with something previously known, echoes the meaning of the picturesque, a landscape re-cognized through a preexisting model. In the case of Jamaica at the turn of the twentieth century, although imagers of the New Jamaica concerned themselves with crafting a modern Jamaica, they did so through a purposeful use of images from the past; namely, eighteenth-century plantation paintings and nineteenth-century naturalist representations.

The History of the Picturesque in Britain The picturesque has a much longer history than its use in early twentieth-century Jamaica. Aestheticians, most notably, the Reverend William Gilpin and Uvedale Price, popularized the picturesque and site-seeing in the most literal sense of the term in eighteenth century Britain. Between 1730 and 1830, English poets, travelers, garden landscapers, and aesthetes all became conscripts within the "cult" of the picturesque, a way of seeing the British landscape in pictorial terms.

While meanings of the picturesque changed overtime, becoming generalized, debated, and satirized, Gilpin popularized his brand of the picturesque in his influential tour book *Observations on the River Wye* (1782). Gilpin encouraged travelers to seek out and represent parts of the British countryside that conformed to his "rules of picturesque beauty." A "correctly picturesque" landscape was a natural environment that appeared organized into four pictorial parts, in keeping with the composition of seventeenth-century painters of the Italian landscape like Claude Lorrain and Salvator Rosa (1615–73): a background *area*, a strongly lit middle distance with two *side screens* (such as opposite river banks), a darkened *foreground* with elements that framed the image like a stage set or "an amphitheatre" (Gilpin 1782/1789, 18). A winding path, which led viewers through the composite parts of the work, was another defining feature of picturesque landscapes. Landscapes that bore visual traits of decay or ruin—roughness, irregularity, deformity, curvilinearity, and asymmetry—lent themselves best to this pictorial structure. The picturesque, in contradistinction to the aesthetic category of beauty (which encompassed objects and landscapes that appeared symmetrical and balanced), privileged wild landscapes that were "free from the formality of lines" (17). A crumbling and moss-covered architectural ruin, which "nature has made her own" (48), a humble and dilapidated cottage (12), or a lonely hamlet set among trees all exemplified Gilpin's ideal subjects of the picturesque.

Gilpin's visual ingredients for the picturesque are perhaps as notable for what they excluded as for what they included. Most conspicuously, he disqualified sites that bore visual traces of agricultural cultivation. In his estimation these characteristics "injured the ability to see landscapes in a picturesque light" (Gilpin 1782/1789, 12). Gilpin also discouraged the representation of persons who were actively engaged in the cultiva-

tion of the land, preferring the "loitering peasant" to the "industrious mechanic" (44). Whenever possible he encouraged artists to conceal evidence of human cultivation in representations of both the landscape and its inhabitants.[8]

In recent years art historians have made much of the politics of concealment and the resultant romanticized image of rural life presented in eighteenth-century British landscape and genre paintings (Berger 1972; Solkin 1982; Cosgrove and Daniels 1988). Scholars like John Barrell (1980) contend that such images became popular among the urban-based aristocracy and bourgeoisie in the eighteenth century in aesthetic response to (or denial of) the widespread agricultural reforms, which threatened the way of life of those who traditionally worked in farming. The pictorial harmony of rural land-scape compositions became important precisely as these agricultural reforms resulted in unprecedented social clashes between the rural poor and the aristocracy. Picturesque painting offered another more reassuring vision of England as a stable, unified, almost egalitarian society. From its very inception in the context of Britain, the aristocracy and the bourgeoisie learned to see rural landscapes as devoid of social conflict and exempt from agricultural and industrial change.

Refashioning the Picturesque in Jamaica: Representing Slave Labor and Cultivation on the Plantation
While picturesque aesthetics interceded into the relationship between city and country in Britain, they also structured the visual imaging of Empire and colony.[9] In the con-text of the British colony of Jamaica, the picturesque assumed a form that art historian Jill Casid describes as the "imperial picturesque," an aesthetic intimately connected to British imperialism in the West Indies (2005, 8). Picturesque aesthetics gained popu-larity in the British colony of Jamaica at a time that coincided with the "silver age" of the sugar plantation system in Britain's West Indian colonies, a period of great eco-nomic prosperity for the islands' planters and landowners (1700–1834). At the height of production in 1805, Jamaica's sugar plantations yielded over 99,600 tons of sugar a year, making the island England's most prized West Indian possession.[10] In the 1790s, however, abolitionist groups in Britain began questioning the moral economy of slave-produced sugar. They initiated campaigns in the legislature aimed at abolishing the slave trade (and eventually slavery) and at persuading British consumers not to sup-port slavery's products (Mintz 1985; Sheller 2003, 71–104). Abolitionists used visual images to support their cause, circulating what became the iconic diagrammatic of slaves

stacked aboard a ship (Wood 2000; Finley 2002). In a similar fashion to the emergence of the picturesque in England in response to changes in property ownership and labor, the picturesque in Jamaica began amid heated debates about the ownership of black labor as property.

Beginning in the late eighteenth century, planters penned self-described "picturesque" accounts of the island or commissioned British artists to create picturesque representations of their properties. In 1790, for instance, William Beckford of Somerly (1744–99), formerly one of the wealthiest planters in Jamaica, wrote the book *A Descriptive Account of the Island of Jamaica: with remarks upon the Cultivation of the* SUGAR-CANE, . . . *and chiefly considered in a Picturesque Point of View* (1790).[11] Although he doubted that he could describe the island as eloquently as "that elegant Enthusiast [Gilpin] who has immortalized the beauties of the Wye," he hoped that through his publication the "picturesque and internal appearances" of Jamaica would become better known (Beckford 1790, 1: 42). Beckford arranged for the British artist George Robertson (1748–88) to travel to the colony to paint his numerous holdings in the early 1770s.[12] Other landowners enlisted the services of the British artist and architect James Hakewill (1778–1843) to create representations of their estates in Jamaica. In 1820 and 1821 Hakewill toured Jamaica and subsequently published *A Picturesque Tour of the Island of Jamaica* (1825), which included 21 aquatints of different estates (Beckford's properties among them). Hakewill dedicated the volume to "The Noblemen and Gentlemen Proprietors of the Estates in the West Indies; to the Resident Gentlemen and the Merchants of the United Kingdom, connected with those valuable colonies." Thus, when picturesque views of Jamaica began to be created and circulated, it was initially under the specific employ of "proprietors of Estates," and the images were used to represent the slave plantation system.[13]

Strikingly, the reincarnation of the picturesque in Jamaica, despite Beckford's invocation of Gilpin in his introduction, referred to or visually represented an environment dominated by the plantation. As a landscape of cultivation and manufacture, the plantation doubly violated the "rules of picturesque beauty." Given the plantations' seemingly antithetical relationship to the picturesque landscape, why did the picturesque become such a central mode of description for planters in Jamaica? To what end was picturesqueness wed to "the sugar-cane cultivated landscape," to draw from Beckford's subtitle, in the context of Jamaica at the beginning of the nineteenth century?

Hakewill's paintings may shed light on how and why artists (and the planters they produced views for) reconciled these seemingly incompatible landscapes, the picturesque and the plantation. Hakewill's *View of Port Maria* (1820) (plate 2), for instance, reveals that the artist generally remained faithful to several visual ingredients of the picturesque as commonly portrayed in Britain. The content of the work—the rolling hills, rustic mills, and figure holding a staff—seem very much in line with what Malcolm Andrews describes as formalist picturesque, a style closely adherent to seventeenth-century Italian models. Compositionally, Hakewill also divided the scene into three parts, including a typical darkened foreground framed by trees; a middle area, through which viewers are led by a winding path to a mill; and a background that fades away in a haze. The most noticeable differences between his work and picturesque representations in England are the palms that frame the left side of the image and spring majestically from other parts of the foreground. A field cultivated with sugarcane also colors the background of the work. If not for the palms and cane the image could function as a representation of a British landscape. In other words, crafters of the Jamaica picturesque poured the island's landscape through the screen of picturesque representation, making it seem similar to Britain's own countryside. Only a few botanical signifiers distinguished the island's landscape from its British counterpart.

Hakewill may have closely obeyed the compositional rules of picturesque beauty, but he distinguished his "appropriation," to use his term, of the picturesque from contemporaneous "work[s] intended to convey a general idea of the surfaces and external appearances of a country" (Hakewill 1825, A2). Hakewill specified (as did Beckford), indeed apologized, that unlike other picturesque tours, which typically did not "undertake to develope" a country's "moral and political institutions," his work aimed to offer "a few remarks on the moral condition" of Jamaica (Hakewill 1825, A2). He sought to sketch a moral geography, an ethical appraisal of the political institution that so dominated the landscape—slavery.[14]

Given Hakewill's tribute to proprietors of estates, it is not surprising that he claimed to be an "eyewitness" to the beneficence of the system of slavery (6). "But while its [slavery's] inhumanity is made a favourite topic of invective against a system . . . its practical operation is not destructive of the negro's comfort; that his circumstances are ordinarily easy, and frequently affluent, and that in the scale of physical enjoyment, the

conditions of the slave population of our colonies is equal to or superior to the generality of the working classes of the free communities of Western Europe" (5).[15] Hakewill's picturesque paintings betray these moral views. By representing the island's slave population through Britain's picturesque tradition, Hakewill reinforced the view that slaves differed only in location from Britain's working classes. Accordingly, the black male figure in Hakewill's *Port Maria* more closely resembles the "loitering peasant" than an enslaved laborer (especially as abolitionists would portray them). The artist also artfully concealed many traces of where and how slaves lived behind a hilly slope or thatch of brush (Higman 1988, 114), as Higman demonstrates through a comparison of Hakewill's *Golden Vale* paintings to land surveys of the estate. The aesthetics of concealment, long a central part of picturesque aesthetics, provided a ready-made mask through which planters and the artists they commissioned could disguise the conditions, violence, and brutality of the plantation.

An intrinsic part of the moral imperatives of the picturesque in Jamaica lay not only in romanticized representations of the island's slave population but in the portrayal of the wider plantation as picturesque. Indeed, Beckford boasted that the islands' landscape was naturally more picturesque than the very representational muses of the picturesque, the paintings of Claude Lorrain, Poussin, and Salvator Rosa.[16] Beckford's *Descriptive Account* aimed not simply to appropriate the visual language of the picturesque but to claim it as more applicable, as possessing a natural fidelity to the ideals of the picturesque, than the original signifier of the picturesque, Italy. What were the moral imperatives at stake in this jockeying for picturesque supremacy, of proclaiming a primordial picturesqueness for the island?

The Naturalization of Colonial Transplantation and Slavery through the Imperial Picturesque Claiming that Jamaica was more picturesque than the landscapes of Claude Lorrain served several purposes amenable to Beckford's proslavery cause; namely, it represented the dramatically relandscaped plantation landscape as natural, native, and ideal. First, by framing the plantation as naturally picturesque, Beckford could counter abolitionist efforts to characterize the plantation as a machine that consumed slaves and the natural environment, a trope increasingly used by abolitionists in the 1790s (Sheller 2003, 88–95). Although the plantation system physically transformed many parts of Jamaica

through a process Michael Dash (1998, 14) characterizes as "radical modernization from the outside," viewing Jamaica as picturesque re-presented the island as a place of nature, filled with, to use Beckford's words, "the most grand and lively scenes that the creating hand of nature can possibly exhibit" (Beckford 1790, 1:11).

Such an appraisal of the landscape retracted the hand of planters in the long-standing and extensive history of the "violent relandscaping" of Jamaica's environment, the radical overhauling of many parts of the island (Casid 1999, 16). For centuries successive Spanish and then British colonial regimes and planters razed much of the indigenous environment to the ground, even burning remaining roots, and transplanted it with new agricultural specimens that they deemed beneficial to the propagation of the colony, whether as food crops for settlers, slaves, and sailors or as cash crops for export (Pulsipher 1994, 202; Casid 1999, 14). Most consequentially, sugarcane was first imported into Jamaica from India and then from the Pacific Islands and Malay Archipelago in the seventeenth century. Other plants were also brought into Jamaica from many parts of the world in the eighteenth century and the nineteenth, including bamboo, breadfruit, casuarinas, royal palms, coconut palms, citrus, mangoes, tamarind, banana, bougainvillea, hibiscus, oleander, poinsettia, thunbergia, and even pasture grass (Casid 1999, 15). They also grafted other plant forms onto Jamaica's landscape, like the royal palm tree from Florida and Cuba, purely for their "ornamental quality" (Storer 1958, ix, 2). The palms often marked the boundaries of plantations (Casid 1999, 19). Although such colonial transplants had become a central part of nature on the island by the late eighteenth century, colonial regimes and planters had dramatically forced nature's hand in the creation of the picturesque landscape.[17] This process of physically emptying and recreating the land recalls Dash's observation that Caribbean islands were long conceived by their colonial possessors as "blank slate[s] onto which an entire exoticist project could be inscribed" (Dash 1998, 17).

That parts of Jamaica's natural landscape were a tabula rasa possessed and dispossessed of plant and human life according to the immediate needs and desires of colonists is less important here than the fact that planters like Beckford often focused specifically on these aspects of the island when they made picturesque boasts about the island's environment. Such pronouncements served to "nativize" and naturalize the imperial botanical imports, to reimage them as constitutive parts of the island's landscape. In Beckford's account, for instance, he extolled the plant life:

The variety and brilliancy of the verdure in Jamaica are particularly striking; and the trees and shrubs that adorn the face of the country are singular for the richness of their tints, the depths of their shadows, and the picturesque appearance they make. It is hardly possible to conceive any vegetation more beautiful, and more congenial to a painter's eye, than that which universally prevails through every part of this romantic island. The palm, the cocoa-nut, the mountain-cabbage, and the plantain, when associated with the tamarind, the orange, and other trees of beautiful and vivid dyes . . . all together compose an embroidery of colours which few regions can rival. (Beckford 1790, 1: 31)

In Beckford's description the formerly disparate parts of the colonial landscape formed the most picturesque vegetation imaginable. Despite their global origins they were re-imaged "as an organic outgrowth in harmony with the place" (Casid 1999, 16). They formed parts of the same "embroidery." The planter's choice of "embroidery" aptly characterizes the physical grafting of vegetation on the landscape and the planter's re-conceptualization of these parts as a new singular work of art.

The same could be said of human "imports." In Beckford's estimation the slaves added to the picturesque landscape. He surmised, "There is something particularly picturesque and striking in a gang of negroes, . . . [they] contribute to the moving landscape" (Beckford 1790, 2: 48). Like the colonial botanical transplants, the slaves' presence was too reworked through picturesque aesthetics to seem "natural" components of the landscape.

By filling descriptions or paintings of Jamaica primarily with parts of the landscape that planters and colonists had themselves imported, transplanted, or cultivated, Beckford and the planter-sponsored artists framed this particular "imperial picturesque" vision of the island as representative and ideal. The imperial picturesque, as art historian Jill Casid describes it, was the pictorial image of Jamaica as a cultivated landscape defined by colonial transplants, "*an island of, among other lush fruit-bearing vegetation, coconut palms, citrus, banana, and breadfruits trees*" (1999, 3). It was this variant of the picturesque that developed to reconfigure the plantation as a naturally occurring and aesthetically pleasing landscape. These "imperial picturesque" views would create a visual template for still enduring representations of a "tropical" island. Not only were Beckford's and Hakewill's way of seeing the island circumscribed by moral blinders, but they also perpetuated this ideal as Jamaica's defining characteristic.

Subtly, while planters attributed the island's unsurpassed picturesqueness to nature, they simultaneously claimed credit for their roles in realizing the landscape's ideal form. Beckford could in essence admire his own work (and that of fellow transplanters) in creating such a picturesque masterpiece on the face of the island. By claiming that the island achieved and even surpassed Lorrain's vision of the picturesque, Beckford framed colonial landscaping as the realization of a widely recognized ideal form of nature. Beckford supported the "*fiction . . . that the painter and planter are only producing faithful copies of what is already there*" (Casid 1999, 22; emphasis added). Through such visual poetics planters made the case that the plantation, so vilified in abolitionist debate, was not a violation of nature but its most perfectly imaginable manifestation (Casid 1999, 22; Bohls 1994, 363).

The Naturalist's Voyage into Substance: From "Unreal Space" toward a True Representation of the Tropics In addition to the genre of the picturesque, artist travelers framed Jamaica's landscape through another representational structure—natural history's classificatory schemas. As early as 16 years after the British claimed Jamaica as a possession, a stream of naturalists influenced by Carolus Linnaeus (Carl von Linne) ventured to the island to map and document its flora and fauna. These naturalists included Hans Sloane, who produced *The Catalogue of Plants in the Island of Jamaica* (1687), and Philip Henry Gosse, author of *A Naturalist's Sojourn in Jamaica* (1844). Nancy Stepan in *Picturing Tropical Nature* (2000) points out that Latin America and the Caribbean held a particular allure for naturalists, as the region was singled out as a locale in which nature reigned supreme and manifested itself in ways completely different from vegetation in temperate zones.

In the mid-nineteenth century artists interested in naturalism drew inspiration from Jamaica's environment. The British flower painter Marianne North and the American artist John Martin Heade created naturalist-influenced representations of Jamaica in 1871 and in the 1860s respectively. They traveled to the island 30 or 40 years after Emancipation had ended slavery there, at a time when many of the sugar plantations that had so preoccupied Hakewill and Robertson had been abandoned. Even though their representational aims differed drastically from painters of the sugar plantation, in the post-Emancipation era naturalists substantiated picturesque imaginings of the island landscape.

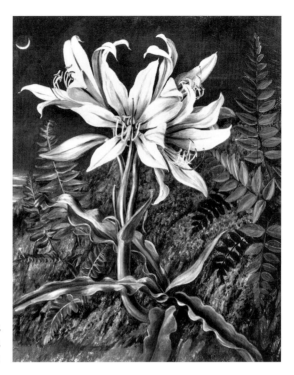

6 Marianne North,
*A Night-Flowering Crinum Lily and Ferns,
Jamaica,* oil on canvas, 1871

Many of North's and Heade's naturalist paintings present an almost microscopic view of specific plant forms on the islands, as is fairly typical of the genre. They magnified the details of nature presented in the more palatial open vistas of plantation representations. North's paintings, for instance, typically focus on close-up views of flowers, while Heade's works provide careful studies of orchids and hummingbirds on the island (and later Brazil). North's *A Night-Flowering Crinum Lily and Ferns, Jamaica* (1871) (figure 6) and Heade's *Cattleya Orchid and Three Brazilian Hummingbirds* (1871) (plate 3) provide two examples of their Jamaica works. Both paintings squarely feature flowers set in nature, which bloom against a nocturnal sky. Their naturalist techniques reified already existent ideals about the tropical difference of nature in the island's landscape.

While the process of magnification and detailed observation of nature is not unique

to naturalist representations of Jamaica, Stepan argues that these representational strategies did have specific consequences in the imaginative geography of the tropics. Many naturalists, like North and Heade, precisely sought out new or eccentric forms of nature in their tropical travels; their representations typically portrayed this exoticized and fantastical vision of these locales. This predetermined quest for new and strange forms of tropical flora is evident in North's autobiography, where on the eve of her trip to Jamaica she wrote, "I had long had the dream of going to some tropical country to paint its peculiar vegetation on the spot of naturally abundant luxurance" (1980, 31). Even before her travels to the island, North had already predetermined that Jamaica would provide the "naturally abundant" and "peculiar" tropical landscape that she had long dreamt about. These quests to find "peculiar" nature would dramatically impact how artists saw and represented the island.

North's dreams of the tropics informed her impressions of Jamaica. When she finally beheld the island with her own eyes, North declared, "I was in a state of ecstasy, I hardly knew what to paint first" (1980, 31). What is particularly fascinating in North's general recollections of her experience of the physical space of the island is that she constantly used the trope of "a dream" or an "imaginary land" to convey her encounter with Jamaica. She described a part of the island known as "fern gully," for instance, as possessing a "fairy tale like beauty" or characterized other areas of the landscape as a "pantomime, too good to be real" (North 1980, 89). Such pronouncements raise a few questions, especially in light of her dreams of tropical abundance and peculiarity before she traveled to Jamaica. Was Jamaica's seemingly fairy-tale landscape precisely the dream of the tropics she set out to find? Did she focus on "tropical" forms of nature because that was what she had anticipated? Or was the physical space of Jamaica itself already a dream realized, an ideal of the tropics already materialized onto the "blank slate" of the island's landscape? How did North (and Heade) as an artist set about the task of rendering the dreamlike tropical island landscape through visual representation, visualizing a supposedly unreal space?

In addition to dreaming of and then seeking out a display of peculiar tropical nature, North and Heade employed certain representational techniques that often heightened the strangeness of nature in Jamaica: they projected this select vision as typical of nature on the island. First, North's and Heade's intimate views of flowers and plants on the island often served to "accentuate their exotic presence" (Stepan 2001, 52). By provid-

ing close-cropped perspectives, they erased many details of the surrounding ecological environment in their paintings. Viewers had few comparative elements to allow them to determine the size and relative scale of natural forms on the island. They had to fill in such details relying on their own imaginings of "tropical nature." Not surprisingly, Stepan has commented precisely on the out of "ordinary time and space" character of North's and Heade's work (53).

The presentation of plant forms from a low vantage point also endowed them with an animated and larger-than-life appearance, exoticizing their presence. This is evident in North's painting, *A Night-Flowering Crinum Lily and Ferns, Jamaica* (figure 6), for example. Drawn from the perspective of the ground, the flower's stem looms over the horizon line. Similar visual strategies also gave Heade's flowers an anthropomorphic appearance (Novak and Eaton 1996, 13) (plate 3). By endowing nature on the island with an animated and living quality, their paintings breathed new life into preexistent ideals about the presence of a distinctly tropical nature on the island.

At the same time that North and Heade heightened and exoticized the island's tropical appearance, they ordered and subsumed the environment into naturalism's classificatory schemas. Hence their representations, their dreamlike comprehension of the landscape, could be interpreted as scientific, objective, and real. North, in particular, channeled the "visual ecstasy" she claimed that she initially experienced into a comprehensible and systematized naturalist's grid. She viewed herself as a naturalist who scientifically studied nature through paint. It could be argued that through the reduction of nature and its classification, North accomplished in the context of Jamaica what the art historian Barbara Stafford (1984) describes as the voyage into substance—the process by which naturalists generally came to visualize the idea of the unseen world. By the same token North's works gave a visual presence to the imaginary world of the tropics, substantiating ideals of the tropical landscape through her painterly dissection of and classification of its numerous forms. Even though verbally North described the island as unreal, in her naturalist paintings she inscribed her vision of the tropical Jamaican landscape as reality.

Bernard Smith's (1969) observations about the typifying tendencies of naturalist representation lend credence to the assertion that such images likely circulated as objective and representative images of the island. Smith points out that a particular paradox seems evident in many naturalist drawings: while these images are based on a detailed

analysis of a particular specimen (with all its individual peculiarities and imperfections), naturalist representations aimed to portray the typical—a generalized botanical type. Reapplying Smith's observations to representations of Jamaica, it is possible to assert that this slippage between the particular and the typical may have resulted when audiences interpreted North's and Heade's animated and larger-than-life versions of the island's flora and fauna, leading some to credit their work as typical and representative of the island's tropical nature.

"Nature as she is in the Tropics"? Debates Surrounding the Truthfulness of Paintings of the Tropics
In 1871, when Heade exhibited his paintings of Jamaica in Boston, they sparked a debate about the reality of paintings of nature in the tropics, in which at least one reviewer defended Heade's work as realistic.[18] After viewing Heade's *Jamaica* (circa 1870–71) and *Mountains of Jamaica* (circa 1870–71) the critic pondered whether Heade's artistic vision or Frederic Church's (another American painter who traveled to Jamaica in the 1870s) representations of the island were closest to reality (Stebbins 1975, 37). Whereas Church depicted the tropics with "brilliant and voluptuous" colors, Heade presented a much more subdued version of tropical nature in his use of "pearl-grey." The reviewer posed the question: "now we in the North know the tropics only as the artists present them to us—are we to believe Mr. Church or Mr. Heade?"

The question alone attests to the lack of consensus on, even suspicion of, portrayals of the tropics. Perhaps the very "unreal" quality of these artists' representations perceived by contemporary scholars similarly sparked such an inquiry into the visual truthfulness of Heade's work in the 1870s. The critic adjudicated that since Heade avoided brilliancy in his tropical images, his works more likely "adhered to nature as she *is* in the tropics." Conversely, the reviewer detected in Church's work the "temptation to let the imagination compromise with the conscience, and to sacrifice truth to popularity" (Stebbins 37). The conclusion that Heade's paintings presented "nature as she *is* in the tropics" illustrates that the tropical imaginings of some artists, their select visions and interpretations of the island, became important means through which many viewers "in the North" came to know the island and the tropics generally. The commentator's fervent interest in a true and singular representation of the tropics also belies a desire to fix and stabilize the meaning of Jamaica and the tropics generally as a region vis-à-vis visual images.

In sum, two predominant modes of representation visualized Jamaica since its "radical modernization" in the sixteenth century, namely picturesque paintings and naturalism's visual schemas. In the eighteenth and nineteenth centuries artists used the picturesque to create an image of the "tropical island." Subsequently, painters used naturalist pictorial models to magnify their predecessors' visions of the island. With each phase of representation the dream of the "tropical island," as articulated by North, for instance, was substantiated and validated. In this process "tropical transplants"—signifiers of Jamaica's landscape in the eighteenth century and the singular visual preoccupation of naturalists—became increasingly representative of the reality (not the dream) of the island.

STABILIZING THE DREAM OF THE TROPICS THROUGH PHOTOGRAPHS: THE CREATION OF THE *NEW* JAMAICA?

Fashioners of the island's tourism industry would define the New Jamaica using a visual vocabulary inherited from imperial picturesque and naturalist traditions. Some promoters consciously aimed to capitalize on the representational ideal of the tropics propagated or "dreamt up," however questioned, in these images. They selectively appropriated both the descriptive and visual language of earlier artist-travelers. The albums, which pair natural specimens and photographs, evince how these earlier forms of representation literally framed representations of the New Jamaica at the turn of the twentieth century. The photograph of the coconut trees, for instance, suggests how tropical colonial transplants, as they did in paintings of sugar plantations, still defined Jamaica. The surrounding pieces of fern explicitly echo the practices of naturalism (recall North's ecstasy over ferns). In addition to providing a useable visual canon, picturesque and naturalist images from the past provided a visual template for the aestheticizing, nativization, and typification of another type of plantation landscape. They offered ready-made visual systems through which proponents of the New Jamaica could re-image a new phase in the history of human importation and botanical transplantation in the island.

To be sure, the picturesque as recuperated in the New Jamaica campaigns also differed from eighteenth-century and early nineteenth-century representations, most explicitly in the adoption of photography. Why did photography assume representational

responsibility for portraying Jamaica's landscape in the late nineteenth century? At a time when critics questioned "the reality" of paintings of Jamaica, their efficacy in representing "the tropics as she is," how did tourism promoters draw on the popularity and perceived "realness" of photography to stabilize, extend, or update the "dream" of the tropical landscape? Could the medium of photography complete the voyage into tropical substance, the visual realization of the island's unreal tropical vegetation?

The United Fruit Company's and Elder, Dempster and Company's Role in Jamaica's Fruit and Tourism Industries Debates about the representativeness of images of Jamaica were not confined to audiences "in the north," to echo Heade's reviewer; local audiences also questioned the characterization of the island in visual images, especially those that garnered attention abroad. The first pictorial stamp of Jamaica, for example, generated a heated exchange in the local papers about how the island should be represented. Local businessman Aston Gardener denounced the British government–issued stamp, which bore an etching of Llandovery Falls (waterfalls located in the parish of St. Ann on the north coast of the island). In his estimation the stamp looked like a "Welsh landscape" as opposed to a Jamaican one (DG, 3 May 1900). The government chose the photograph from among a group of photographs solicited from James Johnston. "Surely, there has been some mistake," Gardener concluded. Why, he enquired, was "a really typical view of our island not given?" He submitted that banana workers would make a far more appropriate visual icon for Jamaica. The protest demonstrates both a local sensitivity to how the island should be represented and a lack of agreement on the issue. The nomination of the banana worker also attests to a shift away from the sugar plantation or naturalist images of flowers and points toward the increased significance and signification of banana fields and banana laborers in the visual economy of the New Jamaica at the start of the twentieth century.

In the 1870s Jamaica's socioeconomic landscape transitioned from sugar's sweetness to the power of the banana trade. At the time the prospect of the banana industry offered one of the few flickers of hope in the island's otherwise dark economic forecast. In the 1880s the small town of Port Antonio, on the northeast coast of the island, in the parish of Portland, started to bustle with commercial life. The story is now legend of how an American by the name of Captain Lorenzo Dow Baker first visited Port Antonio in 1871 and decided to return to Boston with 1,450 bunches of bananas. At the time he

embarked on this business venture, the banana was practically unknown in the United States and western Europe (May and Lasso 1958, 4). The yellow fruit netted Baker approximately $2,000 profit in his first venture (Brown 1974, 83). Inspired by these gains, Baker systematically put mechanisms into place to produce, transport, and market these highly perishable fruits in the United States. In 1890 he incorporated the Boston Fruit Company, coincidentally, the same year of the Jamaica Exposition and attendant New Jamaica campaigns.

When Baker first ventured into the banana business, the fruit had mainly been a crop that black Jamaicans grew in their gardens or provision grounds. The banana variety that became central to the banana trade, the Gros Michel banana, was a relatively recent agricultural introduction into Jamaica's landscape. The plant was likely introduced to the Caribbean via Martinique by a French botanist, Francois Pouyat, around 1836, and was subsequently imported into Jamaica shortly thereafter (Brown 1974, 81; May and Lasso 1958, 3). The fruit was never extensively cultivated in the island until Baker and his competitors actively encouraged its production in the 1870s (Adams 1914, 29). When Baker first embarked on his entrepreneurial pursuits, the white plantocracy on the island dismissed the cultivation of bananas as "Nigger business" (Brown 1974, 186). The underestimation of the potential for the banana trade was short-lived. Baker's small company, by 1898, shipped over 16 million stems of the fruit into the United States. In 1899 the Boston Fruit Company merged into the affiliated United Fruit Company. By 1900 the United Fruit Company owned approximately 12,266 acres in Jamaica, with approximately half of these properties devoted to banana plantations. The company also marketed, produced, and transported other fruits, namely oranges, pineapples, grapefruits, coconuts, cocoa, pimentos, coffee, and rubber, which kept the plantations productive when bananas were out of season.

Crucially, the United Fruit Company's reach also extended to the tourist trade, as their steamships doubled as passenger ships for tourists. The company also acquired two hotels on the island. It built the Titchfield Hotel in Port Antonio in 1897 and assumed ownership of the Myrtle Bank Hotel in Kingston in 1918. Subsequently, the American company controlled a significant percentage of both the fruit and tourism trades.

In 1901 the British company Elder, Dempster and Company (led by Alfred Jones) inaugurated a direct cargo and passenger service to Liverpool, challenging, however temporarily, the United Fruit Company's powerful command on the island's fruit and

tourist trade. While Baker's injection of capital into the Jamaican economy was welcomed and needed by the likes of Governor Blake, some loyal British subjects on the island resented the Americanization of the town in the British colony (Taylor 1993, 84). Elder, Dempster and Company planned to compete with Baker's company by introducing the banana and other fruits to a new market, the British public. Like the United Fruit Company, its Imperial Direct Line ships also transported tourists to and from the island. The company also purchased two hotels, the Constant Spring in St. Andrew and the Myrtle Bank (taken over from the United Fruit Company in 1901).

This brief mapping of the economic landscape demonstrates that the tourist trade came into prominence at the same moment that parts of Jamaica's landscape were replanted with a new crop and its environs overhauled with a new set of plantations. Both these economic changes happened against the backdrop of local declarations of the New Jamaica, a period in which local elites and colonial administrators struggled to redefine Jamaica in the eyes of the "modern world." These numerous overlapping local and imperial initiatives, along with the development of the twin fruit and tourism industries, would all influence how promoters of the New Jamaica visually defined the "picturesque Jamaican landscape."

Selling the Dream of the Island's Landscape in Lantern Lectures In their efforts to market the island, when lantern lecturers took audiences on visual excursions through the New Jamaica, one prevailing metaphor echoed through the darkened auditoriums: the island "was like a dream." Johnston was fond of this analogy. In his presentation, as a slide of the Rio Cobre—a river in Portland—shone before lecture audiences, he waxed poetically that "To anyone who can revel in the beauties of Nature, this is simply dreamland" (Johnston 1903b, 17) (figure 7). The glass slide pictured a river that snaked from the front of the picture plane to the horizon line. It was bordered entirely by coconut trees. Each tree leaned toward the watery path, visually echoing the gentle curve of the river. Johnston led viewers through the "dreamland" with three consecutive images, devoting more slides to different variations of this scene than any other. Similarly, in regard to a single slide of Clifton Falls, on the island's north coast, he mused that the experience of the cascading waters was like "passing through a dream of fairyland" (Johnston 1903b, 21). Other tourism promoters like Governor Blake, in "The Awakening of Jamaica," also lauded "the fairy cascade of nature on the island" (Blake 1890, 538), the colony's

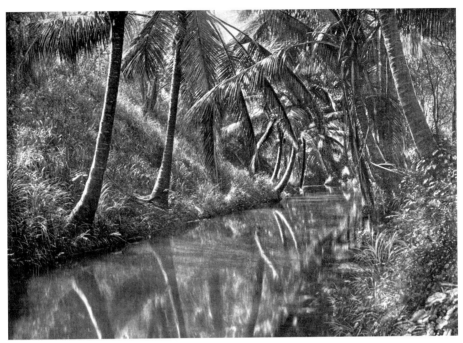

7 James Johnston, "Scene on the Rio Cobre," photograph, ca. 1903

natural dreamlike quality. Such pronouncements of course echo North's autobiographic dreams of the island, although they were uttered in a different public context with the express purpose of encouraging tourist travel.

Generally, touting Jamaica's landscape as a dream served several promotional purposes within the developing discourses of tourism on the island. Supporters of the industry aimed to cast the process of travel to the island as more than simply a journey from one geographic space to the next. Rather a voyage to Jamaica was synonymous with a voyage into the imagination, a dreamscape, an entirely different (tropical) world. As one United Fruit Company booklet put it, in describing the island's landscape, "A visit to another planet would not be more unlike our home surrounding [in the U.S]" (Caffin 1900, n.p.). By deeming Jamaica as an otherworld promoters stressed that only the process of physically journeying to the island could truly convey its beauty, ful-

fill the dream. As W. H. Hale commented in his lantern lectures, "Of the scenery of Jamaica any description falls short of the reality, and we must go there if possible, or, failing that, call to our aid the process of photography and reproduction" (Hale 1914, 4). The slides offered photographic assurance, evidence, of the reality of the island's unreal landscape.

In many of these descriptions of the island's dreamlike qualities the language of the picturesque supported these characterizations. Crucially, in the above citation by Johnston, for example, immediately before he concluded that Clifton Falls looked like a fairyland, he first pronounced that it looked like a "series of paintings" (indeed a series of paintings that would steal the show of any London art season). The landscape was, according to Johnston, both like a dream and like a picture. Regardless of what came first, the dream of the island or its picturesqueness, it is useful to consider exactly what parts of the landscape promoters singled out as possessing dreamy picturesque characteristics.

Lecturers' slides and scripts reveal precisely which parts of the island industry promoters nominated as components of the picturesque view and, equally tellingly, those cast out of such visual frames and verbal poetics. Johnston's lengthy descriptions, how he painted the landscape through words, are particularly illustrative of the emergent picturesque canon.[19] The missionary-turned-photographer, for instance, described the approach to Port Antonio as "picturesque": "On nearing the shores of Jamaica . . . [t]he magnificent foliage of the various kinds of palms, particularly the groves of cocoanuts, mango, bread-fruit, and lignum vitae, backed up by the magnificent range known as the Blue Mountains, formed a picture never to be forgotten" (1903b, 16). Johnston's superlative descriptions of the island's magnificently picturesque tropical foliage were reiterated, at times seemingly verbatim, in the lectures and writings of other tourism promoters.[20]

Hale conjured a strikingly similar picturesque vision of the island in his lecture:

Our route [around Port Antonio] lies close along the *picturesque north shore*, amid innumerable scenes like this, till we reach Annotto Bay, where we turn southward and begin climbing the flanks of the Blue Mountains. The unfamiliar scenery of this part of the trip is a constant source of delight. We note the vivid blue of the Caribbean waters, *the rich green of the foliage, the waving palms and the ragged leaves of the banana plants.*

As we turn away from the sea and begin the ascent of the mountains we pass many scenes like this; the limestone carriage road winding like a narrow, white ribbon among the hills and dales, bordered by rank grasses and banks of luxuriant foliage, with here and there a native habitation or a roadside store. *The fruitful banana and the towering cocoanut tree appear in every field of view and we pass many clumps of the dark green and feathery bamboo.* We see acre after acre of *cultivated hillsides, rockey ravines and running streams* (Hale 1914, 12–13; emphasis added).

Tellingly, Johnston's and other lecturers' detailed inventories of the visual ingredients of the picturesque were almost invariably acre after acre of lands cultivated with colonial transplants. The parts of the island that formed a picture "never to be forgotten"— the coconuts, mangoes, breadfruits, palms, bananas, and bamboos—were all parts of the "embroidery" of colonial transplanting. These lectures betray that the picturesque chord that tourism proponents unanimously struck reverberated with earlier descriptions of the island's picturesque landscape from the eighteenth century.

A New Meaning of the Picturesque, or Selling the Imperial Picturesque? The majority of Johnston's and other presenters' slides literally framed, indeed made into pictures, the imperial picturesque landscape, as identified by transplanted tropical markers. The royal palm, for instance, that enduring icon of the island's tropicality seized on by Robertson and used by Hakewill to signify Jamaica's landscape, was prominently featured in Johnston visual lectures and in his photography book. *Royal Palms, Ravenswood* pictures an avenue ceremoniously lined with what Johnston described as the "stately" and "aristocratic" Royal Palms (figure 8). In such photographs former markers of the plantation circumscribed the "delightful" picturesque view for tourists. Johnston also showed six slides of various phases of sugar cultivation. Other ornamental transplants, like the traveler's tree of Madagascar, with its fountain of limbs, also formed part of Johnston's picturesque pictorial oeuvre. In short, Johnston's photographs literally and figuratively focused on areas of the landscape made picturesque in earlier relandscaping schemes and in imperial picturesque paintings of the island.

That tourism promoters explicitly conjured the muse of the imperial picturesque from the eighteenth century as a preamble for the modern travelers' appreciation of the landscape is evident in the inaugural edition of the United Fruit Company's magazine,

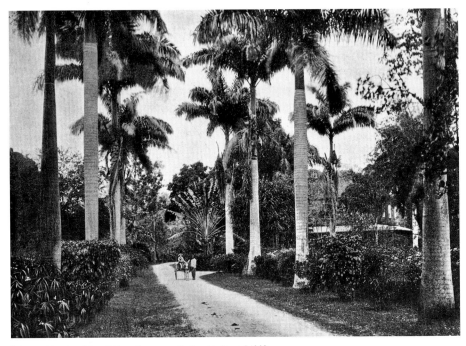

8 James Johnston, "Royal Palms, Ravensworth, Spanish Town," 1903

The Golden Caribbean, published in November 1903. An article, "Jamaica's Scenery," was composed entirely out of a long passage from Beckford's *Descriptive Account of the Island of Jamaica*. The editors of *The Golden Caribbean* framed Beckford's statements with this quote: "We accidentally picked up an old volume published in England, about 1790, by William Bickford [*sic*], an old time English painter. Although somewhat florid, his descriptions are beautiful, and particularly interesting as it seems that the verdure and scenery of *this charming island has not changed in the least in over one hundred years*, and warrants the title some poet has given Jamaica, viz: 'It is a Lost Garden of Eden' " (*GC*, November 1903, 4; emphasis added). Two pages of *A Descriptive Account* followed. Curiously, the account wrongly identifies Beckford as an "old time English painter" (owing perhaps to the planter's artistic license and creative imagination in his descriptions of the plantation). More poignantly, the editor's assurance that nothing had "changed in

54

the least in over one hundred years" confirms that twentieth-century tourism was predi-cated on offering travelers an imperial picturesque landscape, one seemingly unchanged since Beckford penned his account, since the days of slavery. Interestingly, Beckford's reprinted text concluded with his line, "the scenes in, around and about Jamaica, are to me more like a dreamland than real earth and the sky" (*GC*, November 1903, 4), fur-ther illustrating that the United Fruit Company sold the planters' dream to tourists. In this process, to use Osborne's words, the "overseeing stare of the planter with time and space on his hands" metamorphosed into "the ludic, pleasuring gaze of the tourists with time and space on their hands" (Osborne 2000, 113); the planter's vision shrouded the touristic vision of the New Jamaica.

Johnston also made clear the connection between the imperial picturesque and the new picturesque. More generally, he defined parts of the landscape that conformed to the colonial dream of the tropics—aspects of the island relandscaped by colonists and planters—as picturesque. This is evident in Johnston's description of the Rio Cobre, a scene the photographer personally thought should have been selected for the con-tested colonial stamp. After declaring the scene a dreamland, he exclaimed, "Imagine the great Palm house at Kew placed here by some kind of geni of the Arabian Nights alongside the water, the cover taken off, and the contents left standing open, and you have some conception of what the vegetation is like that lines the banks [next slide] on either side. . . ." (Johnston 1903b, 17). Johnston's comparison of the river to Kew Gar-dens (London's botanical gardens and center of colonial transplantation) illustrates that the site he identified as most representative of the island most closely adhered to colo-nial expectations and re-creations of the tropics. The Rio Cobre's picturesque quality derived from its conformity to the ideal of the tropical landscape as created in the seat of colonial power, in places like Kew Gardens, and materialized in various parts of the world, including Jamaica. The lecturer, in turn, sold this realized dream to prospective travelers.

New Plantations and Agricultural Crops as Additions to the Picturesque Photographic View Although photographers such as Johnston trained their viewfinders on botanical specimens fea-tured in imperial picturesque landscapes, they also positioned new parts of the land-scape into the composition of the picturesque: namely, areas populated with the island's newest crop, bananas. In many photographs the banana plantation replaced or sup-

9 Photographer unknown, "Golden Vale," ca. 1913

plemented the sugar plantation, sometimes literally. The United Fruit Company, for instance, transplanted with bananas the very sugar plantation, Golden Vale, that Hakewill had painted and proffered the images as representative of picturesque Jamaica (figure 9). The island's "ambassadors" devoted many slides to this newest crop, showing various stages from its cultivation to transportation.[21] Even when the island's inhabitants populated picturesque photographs (typically only blacks or Indians appeared in tourism-oriented photographs), they frequently served as peripheral props to the main photographic subject: bananas and other agricultural crops. A photograph entitled "Domestics, with Yams, Cocoanuts Etc.," featured in Johnston's lectures and book, dramatically illustrates this preoccupation with the island's agricultural products (figure 10). The photograph pictures three black "domestics" posed rather formally,

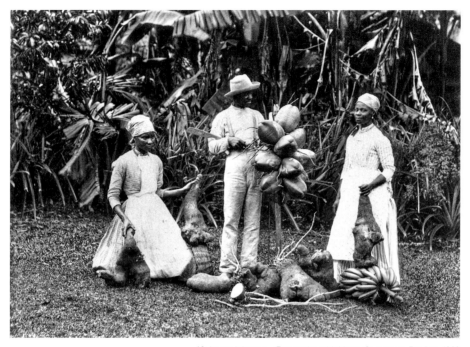

10 James Johnston, "Domestics with Yams, Cocoanuts, Etc.," ca. 1903

who hold up yams, coconuts, and bananas. The agricultural products they hold form the pictorial focus of the image. Like the relegated role of black servants in eighteenth-century aristocratic family portraits, the black Jamaicans serve as peripheral props to the main photographic subject: bananas and other transplanted crops.

In essence, the picturesque face of the New Jamaica seemed much like the old. It reconfirmed a view of the island's landscape as one dominated and signified by the plantation, as was first visually formulated in eighteenth-century paintings. However, travelers' eyes were redirected to new crops, most notably the banana plant. Despite the pronouncements of the New Jamaica as a new way of seeing, the newly introduced fruit in many ways simply filled in the blank spaces in representational ideals of the tropical landscape that the icon of sugar had vacated.

"Feasting" on Jamaica's Scenery: Consuming Views of the Island's Agricultural Products Where the picturesque New Jamaica differed most dramatically from the imperial picturesque was not in picturing tropical commodities but in being commodities. The photographs presented the island's newest agricultural exports while simultaneously fulfilling the role of tourism's product. Lantern lecturers sold the picturesque landscape and the act of looking at the island's cultivated environments in their presentations. They peddled a tourist experience in the island that was increasingly organized around facilitating travelers' visual consumption of the landscape. The United Fruit Company, as Johnston explained in his lecture, set up a special wagon along its railway for tourists to take in the "exhilarating" sites of its banana estates, a view "second only to the Rio Cobre" (1903b). In short, the United Fruit Company turned the areas it cultivated with fruits into commodities for tourists with a taste for the picturesque.

This rendition of the landscape as consumable through literal and visual means perhaps explains why some tourism promoters conflated the act of viewing or taking pictures of the island's scenery with a kind of oral consumption. Johnston, for instance, characterized parts of the island as "some of the richest bits of scenery the eye ever feasted on" (Johnston n.d., 15). Another travel writer, Forbes Lindsay, employed a similar consumptive analogy, proclaiming, "The photographer may reap a rich harvest from this trip [to Jamaica]" (Lindsay 1912, 58). Eyes "feasting on" the landscape or "reaping the harvest" of photographic views speak to the complex configurations of the island in New Jamaica campaigns. Such images fed metropolitan desires for both eating tropical fruit and visually consuming tropical landscapes.

One photograph of the island, published by the United Fruit Company, which pictures travelers posed at a river's edge consuming the fruits of the landscape, seems indicative of this conflation of the oral and visual consumption of tropicality on the island (figures 11 and 11a). In the image a group of standing white males and sitting females, who turn decisively to face the camera, all hold or bite into tropical fruits. The man in the center of the picture displays a pineapple. A black man stands at the periphery of the image, gazing at the posing party and the photographer. The decision to record this moment of tropical consumption through a photograph is significant in that the image is both a feast for the eyes and a document of a feasting on the fruits of the tropical landscape. The image is reminiscent of the photographs that geographer James Ryan describes of colonial hunting expeditions in the African continent. In that con-

11 and 11a Photographer unknown, "Rafting on the Rio Grande—
A Stop for Lunch," albumen print, ca. 1910

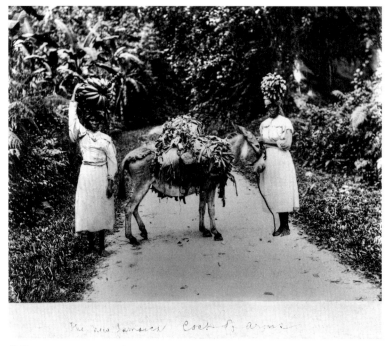

12 Photographer unknown, "The New Jamaica. Coat of Arms," ca. 1909

text a photograph would be taken to commemorate the hunter's kill, his/her moment of triumph over the forces of nature in "Dark Africa" (Ryan 1997, 99–139). The photograph taken in Jamaica offers a different but comparable photographic record of the tropics conquered, with the consumption of fruits wrought from the "wilds of Jamaica" signifying another marker of taming the tropics and rendering them—delectable. The image commemorates the consumption of the landscape's fruits, while simultaneously creating another product, the photograph.

The twin impact of the fruit and tourism trades on the visual definition of the New Jamaica is encapsulated in a photograph that garnered the handwritten caption "The New Jamaica. Coat of Arms" in a travelers' album (figure 12). The same photograph was published in the *Daily Gleaner* under the designation "The New Coat of Arms of Jamaica" in 1909 (*DG*, 18 December 1909). The photograph pictures two black women

balancing bananas on their heads next to a donkey, in a composition that indeed echoes a coat of arms. The unidentified photographer positioned the women against a winding path, crowded with vegetation. The women, in a similar fashion to how tropical botanical specimens buttressed imperial picturesque views, frame each side of the scene. The designation of the banana laborers as representative of the New Jamaica visually echoes Gardner's prescription of a typical stamp view. Moreover, the choice of subject matter points more powerfully to the overlapping impact of the banana and tourism industries on the visual economy of the New Jamaica. The photograph was "typical" because it could fulfill the representational needs of both trades at once, picturing the newest tropical fruit and the island's photographic offerings (the very posed image calls attention to its status as a photograph). It performed a double function as a promoter of tropical fruit and tropical sceneries.[22] The "new coat of arms'" double signification made it epitomize the New Jamaica.

A studio photograph, "Banana Carriers," further demonstrates how icons of the New Jamaica proliferated in a new market for photographic views that sprung up to cater to the tourist and fruit industries (figure 13). In the image photographer John W. Cleary attempted to re-create the central ingredients of the picturesque New Jamaica within the interior landscape of his studio. The photographer's studio, "brim[ming] over with connotative signs" (Alloula 1986, 21), demonstrates how one photographer went about re-creating the island's new picturesque image. The resultant photograph encapsulates the visual formulation of the new picturesque, which updated the imperial picturesque sugar plantation with bananas and replaced slaves with banana workers. The backdrop of Cleary's image appears nonspecific in its geographic locality, with its flowers and hazy river or lake. The physical additions of a banana plant and bunch of bananas in the foreground of the studio, however, bring the backdrop out of representational obscurity. The banana props recall the botanical specimens placed in the foreground of imperial picturesque paintings, which distinguished the island from British picturesque counterparts. Two black women command a central position in the photograph, one of whom physically attaches herself to the new signifier of tropicality, the banana tree. The other woman, seated, holds a bunch of bananas squarely in front of her, with her fingers spread in such a way that the banana stems seem an organic extension of her body. In a similar way to Beckford's pronouncement that blacks "went with the scenery," the black women in this photograph become part of the tropicalizing elements included in

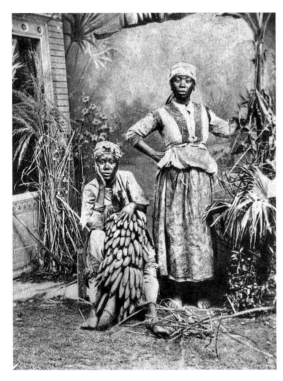

13 J. W. Cleary, "Banana Carriers—Jamaica," postcard, ca. 1907

the foreground. They similarly "go with" the tropicalized new landscape of Jamaica, as signified by the banana.

Tellingly, one print of this image reproduced in *Negro de corpo e alma* (*Black Body and Soul*), included a handwritten caption that assured viewers that the photograph represented "a real scene" (Aguilar 2000, 184). This assertion of the reality of the photograph seems particularly significant in light of late nineteenth-century speculations about the truthfulness of the painted image of the tropics. Although the studio environment is very explicitly a visual construction, in its owner's estimation it presented "a real scene." The inscription suggests that the photograph accomplished a visual truthfulness that earlier painted representations had not. It reconfirmed through the interior landscape of the studio the reality of Jamaica's tropically abundant exterior environment.

Its status as a photograph likely rendered it "truthful." Since the invention of the photographic medium in Britain, France, and Brazil in the late 1830s, audiences, even those once skeptical of the painterly arts, subscribed to the universal truth of photography (Pinson 2002). Unlike photography's painterly predecessors (such as the diorama), which critics dismissed for their deceptive illusionism, many aesthetes celebrated the photographic medium as an unerring reproduction of nature, "a true creation . . . [with] which nothing in the arts can compare," to echo the sentiments of a reviewer of inventor Daguerre's photographic process (Jules Janin, quoted in Pinson 2002, 6). While photography had its early detractors, who pointed to the medium's ineptitude at rendering color, their skepticisms were eclipsed by enthusiasts who deemed photographs "magic mirrors" of reality (Pinson 2002, 6). Tourism promoters likely chose the medium because of the widespread belief in the ability of the photograph to reproduce nature faithfully. It was the perfect medium to promote the island's dreamlike landscape. Although Jones did send one artist to Jamaica, Joseph Kirkpatrick, who captured the island's banana plantations in paint, this was an exception to the photographic rule (Cundall 1928, 78). Jones consistently relied on photographers and lantern lamp lecturers to present the island's tropical landscape to wide-eyed audiences as real.

Despite the photographic posturing of the newly planted banana plantation as indicative of the "real" tropical landscape of Jamaica, new picturesque photographs focused on only a small part of the island's environment to the decided exclusion of the island's indigenous vegetation and its urban landscapes. In Johnston's photographs, for instance, native trees like the bastard cedar tree, birch, dogwood, lignum vitae, mahogany, park nut, logwood, sandbox, santa maria, or trumpet never illuminated his presentations, with few exceptions.[23] Johnston also seldom showed images of the island's built urban environment. The only self-serving exceptions to this rule were slides of the Elder, Dempster and Company's hotels (for whom Johnston lectured) and an image of a monument to British Admiral Lord Rodney. Otherwise, the city and indigenous vegetation factored little in his visual lexicon of the picturesque landscape.[24]

Travelers who ventured to Jamaica, perhaps seduced by the picturesque re-creation of the island, remarked on how marginal the banana and other fruit plantations were within the island's overall landscape. In fact, one traveler expressed surprise, given the prominence of the banana in touristic representations of the island, that relatively few banana estates existed on the island when he visited in 1903 (*DG*, 20 February 1903). That

less than 10 percent of the island's environment was utilized for the purpose of agricultural cultivation by the start of the twentieth century belies the very select visual scope of picturesque representations.

A scrapbook by two travelers, Elizabeth and Helen Riley, on a United Fruit Company vessel that traveled throughout the Caribbean in 1934 provides a comparative perspective on the select imaging of Jamaica within a wider regional touristic visual economy (plates 4 and 5). (The scrapbook, containing many postcards that first circulated at the turn of the century, also reveals something about the longevity of these representations.) The vast majority of postcards of Jamaica focus on colonial transplants—Paw Paw, A Coconut, Harvesting Sugar Cane, Going to Market with Yams and Canes—with only one image out of ten focusing on the urban environment of Kingston. The pages following the section on Jamaica contain postcards of Cuba and Panama that picture almost exclusively architectural structures, historic monuments, and urban landscapes.[25] Both the above travelers' observations and postcard collection stress the myopic scope of what photographic representations visualized in the context of Jamaica, both their general focus on the "natural" environment in Jamaica and on the newly cultivated crops, especially the banana, within this landscape.

"Conquest of the Tropics": Ordering the Tropical Landscape Although lecturers aimed to appeal to travelers' dreams of tropical nature, they had to tame or, at the very least, prune the island's cultivated tropical image. In a fashion reminiscent of naturalist artists, who eagerly sought wild tropical nature and then set about the task of ordering it, lecturers presented prospective travelers with slides of the island's tropical vegetation but emphasized that it was ordered, tamed, and domesticated. In photographs bananas and other fruit crops did not randomly occupy the environment but seemed to follow an aesthetic patterning. The low perspective or high perches from which photographers took many of the images further enhanced the geometric patterning and organization of the island's vegetation. In case the composition of the photographs alone failed to convey the landscape's ordered character, postcards sometimes carried captions to emphasize this point. A Cleary and Elliot postcard, for instance, described the image of a banana plantation as "a well laid out field of Jamaica Robusta bananas" (plates 6 and 6a). These artistically "laid out" environments differentiated Jamaica from characterizations of the tropics as places of wild and threatening nature.

The very presence of bananas on the landscape signified that the tropical had been tamed. As an early biography on the United Fruit Company, *Conquest of the Tropics* (1914), by Frederick Upham Adams, laid out, the banana and the earlier visual marker of the plantation, palm fronds, represented visual order amid tropical nature. In describing the base of the Blue Mountains on which many banana plantations rested, Adams explained, "below these dizzy altitudes tumbles a sea of hills, a tumult of smaller mountains without plan or order, and twisting about them sprawls a bewildering labyrinth of valleys lacking seeming end or purpose, but *all of this anarchy of nature is subdued and mellowed by the glittery fronds of the palm and banana*" (Adams 1914, 130; emphasis added). Adams's comments betray that bananas and palms were likely such central components of touristic images in part because in addition to being recognizable markers of tropicality, they signified that the "anarchy" of tropical nature had been tamed or subdued through their cultivation and imperial transplantation. The very title of Adams's publication, *Conquest of the Tropics*, places emphasis on the United Fruit Company's role as conquistadors of the wildness of tropical nature. The banana and palm fronds presented visual assurance that the tropical landscape had been conquered.

This tamed ideal of tropical nature presented in lectures and touristic photographs exemplifies what Nobel Laureate Derek Walcott characterizes as the civilizing tendencies of colonial representations of the Antilles, "with their proper palm trees, ferns, and waterfalls. They have a civilizing tendency, like Botanical Gardens, as if the sky were a glass ceiling under which a colonized vegetation is arranged for quiet walks and carriage rides" (Walcott 1995, 33). The "proper" palm, banana trees, and "colonized vegetation" that populate early photographs precisely convey this "civilized" version of tropical nature. Walcott continues: "A century looked at a landscape furious with vegetation in the wrong light and with the wrong eye" (33). His observations resonate with the image world of Jamaica that developed at the threshold of the twentieth century wherein the photographs did not visualize a landscape "furious with vegetation." Rather the camera's eye presented a tamed, civilized, and *inhabitable representation* of the island. In picturesque photographs tropical nature seemed arranged precisely for travelers' "quiet walks" and "carriage rides," like botanical gardens sculpted under glass skies.

Indeed, Jamaica's own botanical gardens became important sites in the configuration of the New Jamaica. This is not surprising since British colonial botanical gardens in many ways epitomized the civilization and control of tropical nature. Historian Donald

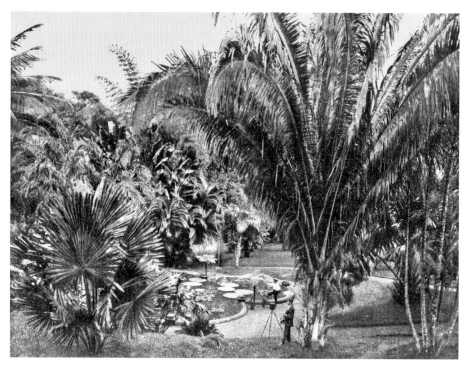

14 A. Duperly and Son, "Castleton Gardens," photograph, ca. 1908

McCracken attests that many British colonial gardens in the tropics were created precisely out of plants from around the Empire to seem like a tamed wilderness, to have a carefully cultivated "jungle effect" (1997, 112). A photograph of Castleton Gardens by A. Duperly and Sons conveyed this sense of a curated jungle, presenting a shallow lily pond surrounded by a profusion of tropical coconut and travelers' palms (figure 14). The image, which features a photographer posing before his camera, doubly calls attention to the picturesqueness of the scene, that the gardens were the perfect picture of a civilized tropical landscape.

A postcard by Johnston, "Motoring with a 'Stanley'" in Jamaica, encapsulates the prerogatives of the island's image makers, the balance they struck between order and

CHAPTER ONE

tropicality (plate 7). Johnston's tourist, mounted on a "Stanley" motorcar on a road and with a black attendant in watchful tow, was a new breed of tropical traveler. Jamaica's touristic adventurer explored a different, indeed a paved, tropics. Unlike the Anglo-American journalist-turned-explorer Headley Stanley's penetration "into darkest Africa," to echo the title of one of his accounts published in 1890, Jamaica's ordered and orderly "tropical" society lie sprawled out for travelers. This emphasis on orderly and inhabitable forms of tropical nature must also be contextualized in light of one of the main prerogatives of tourism, to encourage the permanent settlement of whites.

"The People Are Picturesque and Orderly": Representations of Civilized Black Natives Contiguous with tourism promoters' projection of Jamaica's landscape as ordered, many lantern lecturers and travel writers similarly fashioned the island's ethnoscape, its black inhabitants particularly, as civilized. As Johnston put it, "The scenic vistas are fascinating and the people are picturesque and orderly" (*DG*, 31 January 1903). This pronouncement cast picturesque natives as the representational counterpart to the island's scenic touristic image, and for good reason. Promoters' strenuous efforts to image the landscape as domesticated would be futile if travelers (prospective residents) feared the inhabitants that lurked amid the island's tropical nature.

To image the New Jamaica, promoters had to counter associations of the island's black inhabitants with a history of insurgency and insurrection, in short, "uncivilized behavior." As the head of passenger promotion for the United Fruit Company informed tourism interests on the island in 1904, in "western cities . . . many seem to have the impression that the whole Caribbean Sea Country was one of earthquakes, volcanoes, insurrections, and terrible heat" (*DG*, 7 March 1904). The potentially explosive behavior of blacks was here classed as but one of the potential "natural disasters" of the tropics. The Haitian Revolution of 1798 and Morant Bay Rebellion in Jamaica of 1865 certainly loomed large in the imaginations of prospective travelers to the island.[26] The more recent Cuban War of Independence (1895–98) on neighboring Cuba and riots that took place in Montego Bay, Jamaica (1902), likely revived fears of insurgency (Bryan 1991, 274). Johnston would directly readdress "alarmist reports" of uprisings on the island through his lectures (*DG*, 23 January 1899). Some of his photographs, such as *Young Jamaica* (plate 8), in which a black child brandishes a machete, perhaps aimed to de-

fuse, through the use of children, tourists' anxieties over the potential of black violence. Tourists were not the only people for whom these threats of rebellion loomed large. The white elite on the island lived in constant fear of black insurrection.[27]

Lecturers had to allay tourists' fears and to instill confidence that the island's inhabitants were content, peaceful, and law-abiding people, in essence that they were civilized and obedient British subjects. Pullen-Burry, an anthropologist, author, lantern lecturer and white woman who spent considerable time among the "natives," spoke from a position of authority when she assured lecture audiences that "any visitor could roam all over the island in perfect security" (*DG*, 10 March 1906). She directly readdressed the "memorable" events of Morant Bay, when the British governor unleashed martial law to "suppress native discontent." Dispelling the specter of Morant Bay the moment she invoked it, Pullen-Berry guaranteed audiences that "the present day blacks of Jamaica represented the most loyal and law-abiding of King Edward's subjects" (*DG*, 10 March 1906).

Pullen-Burry credited two features of British colonial society with the production of the island's exemplary and lawful black subjects. The absence of race segregation in the British colony had taken away an incentive toward crime and rebellious behavior. Unlike the "abnormal crime statistics for black of the United States," in Jamaica "the negro's impunity from gross crime was a striking feature." The influence of "white religious teachers" had also "been distinctly beneficial to this childish African people." It should be kept in mind that Johnston was also a missionary on the island and had himself been credited with "civilizing the natives." *The Record of Christian Work* reported that "finding that the negroes of that island were to all intents and purposes savages . . . [Johnston] applied his energies and versatile abilities to civilizing and Christianizing them" (February 1894, 38). In essence Pullen-Burry made a case that British colonial race-blindness and religious conversion had created the proverbial "good negro" in Jamaica, not to be confused with other tropical black natives, black Africans, and negroes of the United States.

To lend visual credence to the civilization of the island's black subjects, representations of Benthamian institutions of modern discipline and surveillance became a part of the lecture circuit and touristic representations more generally. It was not enough to show representations of the island's inhabitants and say that "they are peaceful and content" (Hale 1914, 22). Lecturers offered additional visual *evidence* of the very

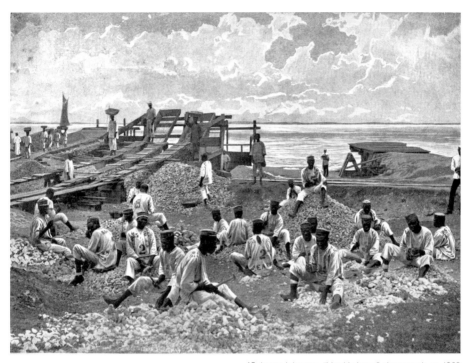

15 James Johnston, "Hard Labour," photograph, ca. 1903

processes and institutional structures that created the island's law-abiding subjects.[28] Pullen-Burry would add in her lectures, for instance, that she had undertaken "anthropological studies" in the "prisons, hospitals and asylums" in Jamaica, that she had indeed observed the disciplining and punishment of the island's black subjects.

Johnston photographed these panoptical spaces, extending and reproducing the surveilling gaze of disciplinary institutions through his printed and projected images. This is most explicit in his photograph entitled "Hard Labour" (figure 15), which pictures black males in prison uniforms during the course of their punishment. They had to break stones in a rock quarry. The prisoners actually wear the term of their sentences on their uniforms, literally embodying the process of discipline and punish. The prisoner in the middle of the photograph, with his back turned to the camera, displays "2 years."

To his left the words "penitence" or "penitentiary" may partially be seen on another prisoner's clothing. The photograph strongly conveyed both that blacks were carefully surveilled, controlled, and, if need be, disciplined and reformed. Guards, who surveil the scene from the margins of the image, provide assurance of this disciplining gaze. Even more watchful than the pictured guards (yet panoptically invisible in the photograph) is the photographer. Many of the men register an acute awareness of the camera and not their pictured overseers. In the image Johnston became a part, indeed the most central trajectory, of the disciplinary gaze. How did prisoners regard the photographer and the process of having their pictures taken? Subsequently, when Johnston displayed such a view in tourism promotion, did he invite surrogate viewers, namely tourists, to reengage, retrace, and reinforce this disciplinary gaze? How would the island's black inhabitants, outside of penitentiaries, view camera-wielding travelers? While the specific responses of residents and travelers to the camera in the matrix of tourism relations is hard to assess, it is certain that industry promoters, in addition to the planter's gaze, encouraged travelers to see the island through the surveilling gaze of the island's disciplinary institutions.[29]

The Aesthetics of Native Cleanliness In addition to stressing "goodliness" (good negro behavior), lecturers also praised the black inhabitants' cleanliness. Throughout Johnston's lectures he would pause to draw viewers' attention to the "cleanliness" in "personal appearance" of the island's black population (1903b, 22). In his postcards such as "The Morning Toilet," in which one black woman combs another's hair, he pictured blacks engaged in the very process of grooming (plate 9). The image conveys the natives' acquiescence to colonial instilled mores of grooming and hygiene, despite their humble outdoor and tropical surroundings. Such assurances about native cleanliness served to abate concerns about the tropics as breeding grounds for diseases. They also provided further testimony to the civilization of the natives.

The most recurrent image of native cleanliness was photographs of black women washing clothes. Johnston showed the group version of this genre in his lecture (Johnston 1903b, 73). Gall spotlighted a lone black woman engaged in this activity, "A Native Washerwoman, Jamaica" (plate 10). The lecturer likely used a studio image by Cleary. The photograph, which was also a popular postcard, depicts an old black woman with a wash bucket buttressing her pyramidal form. She appears very posed and perhaps

slightly annoyed at being momentarily interrupted from her activity. Her skirt and sleeves are up-drawn, her hands and wet cloth downward bound. The re-created washing scene also includes accessories, a small bucket and bar of soap, both inscribed (in the development process) with the words "Sunlight Soap." The sheer number of washing scenes and even the interest in staging such a scene in the studio evinces an investment in these images: beyond stressing cleanliness these images emphasized godliness, the divine sanction of imperialism.

By the 1890s, representations of washing, particularly in British soap advertisements, had become tied to the iconography and ideology of the civilizing mission, likely accounting for the popularity of such photographs in the New Jamaica campaigns. Postcolonial studies scholar Anne McClintock argues that in advertisements in Britain, "soap was credited not only with bringing moral and economic salvation to Britain's 'great unwashed' but also with magically embodying the spiritual ingredients of the imperial mission itself" (211). Promoters of tourism, who lectured during the same time that these ad campaigns reached their height, would borrow, very literally, the icons and messages of these campaigns. The words, "Sunlight Soap," which appear on the bucket in Cleary's photograph, for instance, refer to a product advertised in Britain at the time (McClintock 1995, 213). The literal inscription of the Cleary photograph with "Sunlight Soap" transposed the associations with soap in England onto the colonial context and the body of the black Jamaican. In doing so the series of washerwomen images spoke generally about colonialism's transforming role in instilling the values of cleanliness and social discipline generally on the islands. Unlike other "tropical natives," whom travelers and colonists long characterized as "dirty," "indolent" (Stepan 2001), and in need of colonial reform, images of clean "natives" assured prospective visitors that the island's inhabitants (in much the same fashion as the island's orderly nature) were civilized through colonialism.

While soap-washing images attested to the success of the imperial mission, a few such representations introduced an element of sexual innuendo into the otherwise chaste image world of Jamaican blacks. Several photographers pictured "beautiful washerwomen," with their skirts raised to their thighs and their legs open, wearing smiles for the camera (figure 16). In late Victorian Britain, viewing women's knees was considered seminudity, acceptable only on black or "tropical" bodies (Lutz and Collins 1993, 172–78; Steet 2000). At the same time, however, this sexual suggestion was tem-

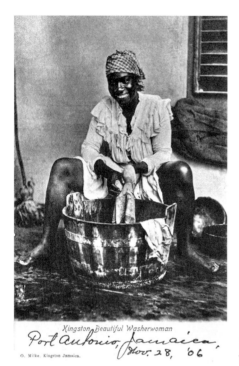

Kingston, Beautiful Washerwoman

Port Antonio, Jamaica,
O. Milke, Kingston Jamaica. Nov. 28, '06

16 O. Milke, "Kingston, Beautiful
Washerwoman," postcard, 1906

pered by the presence of a wash bucket, which, in some instances, concealed the black women's private parts. The knee-revealing images of washerwomen evince the constant unintended oscillation of the island's carefully orchestrated images from the register of civil and civilized to "not quite" (Bhabha 1990, 85); the natives were still a work in (the civilizing) process.

The Universal Negro Improvement Association's Critique of Postcards Unsurprisingly, some of the island's black inhabitants took exception to many of the postcards "purporting to depict native scenes." Indeed, the members of a newly formed group devoted to the island's black working classes, the Universal Negro Improvement Association (UNIA), found the images so offensive that they dominated the agenda of one of their meetings in 1915. The UNIA was founded by Marcus Garvey, the Jamaican-born political leader, edi-

tor, and businessman, a year earlier. At one gathering of the association the mayor and Garveyite, H. A. L. Simpson commanded the lectern and rallied against the "methods employed by a good many in this island in the making [of] advertisements," particularly postcards and written sketches (*DG*, 18 January 1915). In other countries, Simpson observed, advertisers chose the best representative person to feature in their images. "Admirable infants with rosy cheeks" adorned advertisements abroad. Films did not feature "the great unwashed." In Jamaica, however, things were "done differently." In the island photographers selected the most "repulsive" and least model representatives of the population to feature in their postcards. In a thinly veiled reference to the postcard inscribed with Sunlight Soap, Simpson questioned why "some ill-clad, deformed cripple" would be pictured in an advertisement. Whereas in other countries in advertisements "there was nothing which tended to make out his race or nationality with anything which the nation or nationality could be ashamed of," in Jamaica such images created a shameful and bad impression of the island's inhabitants.

Simpson denounced photographers for paying blacks "to pose in almost any manner they [the photographers] wanted" and for selectively focusing on the most economically disadvantaged persons: "Whether it was true or not that some of their people tied their heads with red kerchiefs or not and sat before a basket or not (and he would admit that they did) they did it because they had no means to provide themselves shoes and stockings; they did it because they could do no better." The meeting offers a rare glimpse at how members of the black and colored population viewed and contested their pictorial configuration in the New Jamaica. Although these critiques do not provide insights into precisely how they would have constructed their ideals of race and nation, they do indicate that there were alternative, if only imagined, configurations of the New Jamaica. Some blacks, although pictured as conscripts within British civilization in many photographs, resented that such images did not represent them as full participants, modern subjects, in the civilized world.

Significantly, at least one of the attendees at the meeting was less concerned with critiquing the content of the postcards than with assessing how these images would be seen abroad: "The question is not whether these . . . postcards give an accurate representation of our people or not. Personally, I have no hesitation in saying that in many instances they are a gross misrepresentation of our people and a wicked libel on them. What impression will these productions make on people abroad, and what will be the

consequent effect on this country? But one answer is possible:—The impression will be decidedly unfavorable and the effect undesirable" (*JT*, 18 January 1915). The critic feared that photographers' select and "libelous" visions of the island's inhabitants (in a similar fashion to the narrow focus on the landscape cultivated with bananas) would be interpreted as real and indicative of the population once it circulated beyond the boundaries of the island. These misgivings about the reception of such images were perhaps justified, as we examined above, on the photograph of the two black female banana carriers (taken by the same photographer of the Sunlight Soap photograph); someone had indeed inscribed under the studio image that the representation was real.

The United Fruit Company and Elder, Dempster and Company as Creators of the Garden of Eden?
In a culmination of promoters' idyllic characterizations of nature and society on the island, lecturers deemed the aestheticized and tropical display of nature as a Garden of Eden and, by extension, its peaceful inhabitants as denizens of God's earthly paradise.[30] James Gall actually entitled his slide presentations, "Jamaica as a winter Eden" (*DG*, 9 December 1899). The author of *Conquest of the Tropics* speculated that the banana, not the apple, was the forbidden fruit referred to in the biblical description of the Garden of Eden (Adams 1914, 32). In a tourism industry (and, lest we forget, fruit trade) based on the dream of tropical nature and a black societal utopia, no fantasy of nature and society surpassed the originary Garden of Eden.

Lecturers attempted to use photographs to support the paradise myth; their efforts, however, illustrate how at times the medium of photography on its own failed to bolster the promoters' most fantastic claims. To emphasize the island's almost pregnant Edenic nature, lecturers would take pains to stress that the displayed images of fruits were ripe for the picking, "in bearing" or "ready for cutting" (Gall 1899, n.p.). It was not sufficient to show a picture of bananas, but lecturers instructed audiences to take note of their state of perpetual fecundity. These verbal captions evince not only lecturers' explicit attempts to direct the interpretations of the photographs, to counteract the possibly contradictory meanings of their photographic representations, but reveal a lack of confidence as it were in the ability of some photographs to visualize the island's purported Edenic state.

That the favored medium of promoters could not consistently sustain these biblical myths is reiterated in a popular postcard by Cleary and E. Wells Elliott. In fact,

two postcards derived from the same photo by the photographers stress how the camera alone at times failed to adequately capture ideals of the island's Edenic ideal of tropical abundance. In one version of the photograph, captioned "Types of Jamaica Peasantry," a line of black Jamaicans are pictured uniformly poised holding fruits in their hands or near their mouths at the side of the street (plate 11). In another version of the postcard, captioned "Jamaica Peasantry" (credited to Cleary and Elliott) (plate 12), through hand painting, the fruits were greatly enhanced and even added into the image. Whereas they are barely visible in the other version of the card, in this image the fruits are large, plump, and colorful. Equally noteworthy, the electrical lines in the former image were erased in the latter version of the card, creating a more "natural backdrop" for the Jamaica postcard. The removal of signs of modernization was necessary to sustain Jamaica's paradisiacal image in the realm of visual representation. The more embellished photograph visually supported the ideal of a tropically abundant and fruitful Garden of Eden.

Black Laziness in the Garden of Eden: Representing Black Labor The tropically enhanced photograph also supported written accounts and oral presentations that described the natives' ability to simply live off the fruits of the land that proliferated in the Garden of Eden.[31] With the credit for the island's bearing fruits given to nature, even God, the black population assumed the role of the enviable inhabitants of paradise, who, in the words of historian Frank Taylor, "had neither to toil nor to spin to make a living, since little effort was required to maintain human sustenance in the tropical Garden of Eden" (Taylor 1993, 107). The Cleary and Elliot photograph, in which the "types of Jamaican peasantry" all simultaneously take bites from their undoubtedly ripe fruits, portrays the island's inhabitants synchronically enacting their Edenic roles.

Significantly, in some of the travel literature published by the fruit companies, the perceived "paradisiacal abandonment" of blacks took on a harsher moral tone, resulting in the condemnation of black slothfulness. Such literature singled out black men in particular as "loitering peasants." This was particularly the case in lectures and materials published by the American-owned United Fruit Company. A writer for the company's *The Golden Caribbean*, for example, censured the prevailing laziness of blacks in post-Emancipation Jamaica: "The freed Negro, ignorant and long accustomed to hardship and compulsory labor, would not work even for hire; . . . yet the wonderful abundance

of wild growing native fruits permitted him to exist with but little effort" (GC, 1903, 2). In an article in the same United Fruit Company periodical, A. M. Kellogg also commented on "the stationary civilization of the black population" in Jamaica (quoted in DG, 26 January 1904). He maintained, "They [the black population] are no longer slaves, but they remain much as they were at the time of their Emancipation in 1834. . . . Upon them falls the manual labor needed but it is done slowly and clumsily. The truth is that the languor that seizes at once on us [tourists] when we land has permanently affected them, and they have become constitutionally lazy" (quoted in DG, 26 January 1904). Interestingly, similar to the earlier contention made in another issue of *The Golden Caribbean* that the island's landscape had not changed since Beckford's day, Kellogg reasserted that blacks had remained much as they were during the days of slavery, that the civilizing process and developmental progress had halted at that time. Jamaica's naturally Edenic state supported the island's inhabitants despite their laziness.

Kellogg's condemnation of the black population immediately drew rebuke in a local paper. A resident, who signed his letter M. F. Johns, felt compelled to readdress, as the newspaper put it, the "strictures unjustly passed by visitors to the island" (DG, 2 February 1904). He suspected that Kellogg "in true American style" prejudicially deemed all "non-white elements on the island" as "black," "with the contemptuous meaning implied by the American term 'nigger.'" Coincidently, Johns drew on "The Honorable Dr. Johnston's" public defense of Jamaica's black population made at a Commission on Education of 1898 as proof that blacks possessed more redeeming characteristics than Kellogg gave them credit for.[32] Johnston submitted that "the people of Jamaica were in every respect superior" to a "similar class in the South of England or West of Scotland" (DG, 2 February 1904). Johns concurred. This response to Kellogg's "libelous" indictment of the black population evinces another instance of local contestation of some touristic representations, particularly images created by "scribblers," John's term for "transient visitors to our shores." The letter writer's redress also underscores further that while American and British corporations, the British government, and local elites shared an interest in promoting the picturesque New Jamaica, at times they differed on the precise representational ingredients through which to do so.

The most factious component of the island's image world, its representational fault line, ran through representations of black labor and split for the most part along British and American lines. In contrast to "American scribblers," who denounced blacks as

lazy, lecturers for the British Elder, Dempster and Company and those "who live[d] in Jamaica" stressed the industriousness of the island's black population.[33] Gall, a Scottish newspaperman who lived in Jamaica for decades, for instance, in his lecture "threw many a pleasant sidelight on the race characteristics and industrial and educational advancement of the people" (*LP*, 13 October 1899).

Lecturers used a series of images of blacks pictured in the context of their labor to emphasize the centrality of black industry to the island's agricultural trade.[34] As Johnston described against a succession of the scenes of black banana laborers in his lecture, "if a steamer is loading, you see bananas being hurried along in wagons, in cattle trucks, mule carts, and by the peasantry on mule and donkey back, while everyone in charge of an animal carries a bunch or two on his or her head. Bananas! Bananas! everywhere" (1903b, 38). In some representations the laborers are completely subsumed by the burden of the banana, made literally invisible beneath the banana stems. This is evident in a Duperly postcard where little more than the bare feet of the banana carrier is visible (plate 13). In other photographs, such as A. Duperly and Sons' "Cane Cutters," black workers seemingly interrupt their activity to strike poses for the camera (figure 17). The very process of formally positioning laborers against the photographic backdrop of cane—explicitly evident in the postures of the three women who bend or kneel before the camera, rendered the laborers tourist commodities. This process recalls very literally Peter Osborne's observations that "the work of imperialism metamorphoses into the dreamwork of tourism and, in at least the poorer countries, it remains an unequal exchange, a form of possession, the possession of other people's labor and resources and the possession of other people's appearances—their visibility. . . . The land and the people who work in it must still submit themselves to be looked upon" (Osborne 2000, 113). Johnston's characterization of the black laboring classes in his lectures as sights that "charm the eye" signals this entrance of the laborers' visibility into the dreamwork of touristic representations. One worker, in 1905, complained precisely about the aestheticization of his/her labor, remarking, "An when de tourists come up de country and see we working in de ground, dem is not going to do anything fa we, but take picta and laugh at we" (quoted in Pullen-Burry 1905, 30).

Even presenters for Elder, Dempster and Company, however, who showed these photographs of black workers were not exempt from making pronouncements of black laziness. Some accounts stressed both these sentiments, without them seeming to

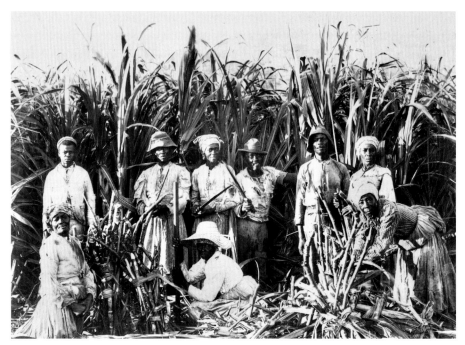

17 A. Duperly and Sons, "Cane Cutters," photograph, ca. 1890–1900

contradict each other (Johnston 1903a, 1903b). The lack of consensus or consistency on the issue attests to the different American and British investments in the New Jamaica and the sometimes unwieldy and contradictory character of the island's image world.

The Moral Purposes of Imperial Picturesque Aesthetics in the New Jamaica To pull all the threads of the island's image world (its "embroidery") together, promoters of the New Jamaica defined as picturesque parts of the island that had been cultivated and ordered by colonialists and planters and, more recently, by American and British imperial interests in the fruit trade. They also deemed as picturesque inhabitants who had been "civilized" and disciplined by British colonial rule. These aspects of the island seemed, and indeed were, the dream of the tropics realized; even more ideally, they appeared like a Garden of Eden where natives wanted for nothing. While these boasts of "the dream,"

"Garden of Eden," or even "the picturesque" may be viewed as rhetorical and internationally recognizable tropes used strategically by the island's savvy tourism promoters, it should not be forgotten that these terms also had more specific histories in the context of Jamaica. They were terminologies, especially the picturesque, that their creators "appropriated" in the past to support their economic imperatives and political causes. In Jamaica the picturesque was not simply about "appearances," as Hakewill had articulated; picturesque aesthetics had historically carried moral weight. When the fruit plantation owners and tourism promoters re-cognized the island as picturesque, did it similarly encourage a way of seeing (and not seeing) that was amicable to their varying local and imperial political interests and economic objectives? Were similar processes of aestheticization at work to naturalize another phase in the long history of the botanical and human transplantation of the island?

Not coincidentally, the promotion of the island's environment as naturally picturesque and its inhabitants as constitutionally lazy (by some accounts) occurred amid debates surrounding the island's newest plantation economy. In the late nineteenth century another controversy arose over the importation of laborers into Jamaica, in this instance, indentured Indians. Indians had been schematically introduced into Jamaica (and some other British Caribbean colonies) since 1845. The surplus of labor they created meant that local planters and owners of large plantation estates could control and manipulate labor wages to their advantage in the post-Emancipation era, enabling them to retain the reins of labor even after the official end of slavery. In the 1890s, after a period when the importation of indentured laborers had tapered off in Jamaica, the fruit companies revived this labor practice (Look Lai 1993, 185). Governor Hemming (Blake's successor) conceded in 1899 that "the development of the Fruit Industry, chiefly in the cultivation of the banana, which is making rapid strides, depends largely upon this class of [Indian] labour" (quoted in Shepherd 1993, 36).

Since the commencement of Indian indentureship in the 1840s, numerous segments of society sounded opposition to the labor importation scheme: these voices reached a new crescendo as the nineteenth century neared its end. In the late 1890s, various groups with different motivations united in opposition to Indian indentureship, including religious missions (Jamaica Baptist Union, Negro Baptists of America, and Baptist Union of Wales), white and colored planters with small holdings, and black working-class organizations. Their complaints found public airing at the West Indian Royal

Commission (1897) and at the extensive Sanderson Commission of Enquiry into Indian indentureship held in London (1909–10). To rally local and international support for their cause, some critics condemned indentureship as a new form of slavery (*DG*, 27 January 1910). Thus, in striking similarity to the rise of the picturesque during debates over slavery, the new picturesque gained currency amid opposition to a "new slavery," Indian indentureship.

The increasingly monopolistic and even predatory practices of some fruit companies, the United Fruit Company in particular, also drew consternation and protest from a range of local residents, including black peasants, small plantation owners, and British colonials in the late nineteenth century. Previously, in the 1870s, even local British loyalists, who begrudged the increasing influence of Americans in the colony, conceded that the United Fruit Company was good for the economic progress and modernization of the island. Indeed, a black landowning class had come of age based in part on their earnings from the tallyman. By the late 1890s, however, as the United Fruit Company grew into a multinational corporation—expanding its operations to Central and South America, buying its produce exclusively from growers who leased their lands, importing indentured laborers, eliminating competitors through price manipulation, and dictating market price to growers—many residents concluded that the company increasingly stifled rather than stimulated the local economy for its own enrichment. The United Fruit Company's operations were scrutinized during an 1897 Commission of Enquiry on the island, when residents ranging from small planters to black peasants testified to the harmful effects of the United Fruit Company's stranglehold on the market (Brown 1974, 101). The company was so suspect that during the Jamaica Exhibition many blacks stayed away from the main exhibition hall because they perceived it as a trap developed by the United Fruit Company's founder in order to enslave them.[35] Hence, images of picturesque banana plantations must be contextualized within these critical reassessments of the American company's acquiescence to the development of the New Jamaica.

Picturesque photographs thus may have served not simply to lure tourists but to present a particular Edenic (a holier-than-thou) image of the work of fruit companies at a time when some local and colonial groups cast their practices as despotic, when a growing number of local constituents started to view fruit companies not as saviors but as enslavers. Not unlike Beckford, who wrote his picturesque description to intercede

into "legislative discussions" surrounding abolition, the fruit companies likely touted the picturesque to counter the criticisms of their practices. By characterizing their own plantations as picturesque the companies made the case that their relandscaping and labor practices realized the island's most natural, native, and ideal form—so ideal in fact that the plantations resembled the Garden of Eden. Although the period in which the companies created these images and the challenges to their practices differed dramatically from when Beckford authored his account (despite the United Fruit Company's insistence that "nothing had changed"), the picturesque provided them with a similar pictorial mask through which they could disguise their practices and defend their moral causes, locally and globally.

The Naturalization of the Fruit Plantation and the Indentured Laborer through the Picturesque In light of the charges against the fruit companies, they may have used a picturesque pictorial model to make the new transplants and laborers seem to belong, to be natural and constitutive parts of the landscape. As manifest in paintings of the sugar plantation or photographs of banana fields, the imperial picturesque provided a visual schema through which newly assembled elements could be absorbed into a prevailing visual field and indeed seem to have always been there. Or, as Mary Louise Pratt aptly describes in another context, the picturesque provided a "system [that] could familiarize ('naturalize') new sites/sights immediately upon contact, by incorporating them into the language of the system" (Pratt 1992, 31).

Perhaps this very ability to immediately incorporate new sites into the island's picturesque visual systems spurred the fruit companies to characterize and represent the Indian indentured laborers as picturesque. Hale, for instance, described a group of Indians as "picturesque orientals, . . . the men brown-skinned, lithe, generally slender, quiet and industrious and dressed—or partly so at least—in their distinctive garb; the women lighter in tint, olive or tan-coloured, turbaned or hooded, and wearing a profusion of silver ornaments" (21). Another United Fruit Company promoter, Mabel Blanche Caffin, touted that "as a result [of 'black laziness'] the planters have been obliged to import coolies on contract from India, and on every large estate there are many coolie families. They are about four feet in height, beautifully formed, with the fine features and ambition of the white race, although the intense heat of their own climate has given them dark skin. . . . The high standard of morals makes them good neighbors, and by their in-

dustry they are able in a few years to return to India" (Caffin 1900, n.p.). Through these descriptions promoters not only cast Indians as picturesque but implied that they were more picturesque than blacks. Indians possessed all the traits of civilized subjects—industriousness, morality, and beauty.

Photographers used some of the same representational genres they employed to picture black women (the more model black inhabitants) to stress that the indentured laborers embodied, if not epitomized, these picturesque qualities. Like the process of inserting faces into carnival cutouts, the black washerwomen images found a counterpart in photographs and postcards of "Coolies Washing Clothes." Through such images promoters offered tourists (and local missionaries) testimony to the effectiveness of the civilizing mission among the island's newest human imports.

Two versions of a "Coolies Washing" photograph reveal the explicit conscription of Indian inhabitants into the aesthetics and politics of native cleanliness. One version of the photograph appeared in a United Fruit Company booklet, *Jamaica: The Summer Land* (1904), and was also reproduced as a postcard, "A Typical Coolie Family" (figure 18). In the postcard a group of Indians appear recently interrupted from their washing activities, gloved hands remain partly immersed in washing, children appear caught off-guard by the photographer's presence. In another more obviously posed version of the photograph, "Coolies Washing," some of the Indian subjects have literally been "washed up," groomed, and bedecked for the image (figure 19). The child to the left of the image has had her hair combed and neatly pulled back behind her ears. The woman in the center of the postcard assumes her squatting position, but her gloves have been replaced by metal bangles. Reminiscent of Hakewill's erasure of slave quarters in his paintings, the photographer cropped out details of the built environment, possibly living quarters, placing the subjects of the photograph instead in nature. It is possible that the Indian sitters, on seeing the camera, readied themselves for the photographer, pulling off gloves and tidying hair. It is more likely, however, that the changes were at the bequest of the photographer, eager to make sure that the washing photograph explicitly conveyed the message of native cleanliness.

In addition to slotting the Indian laborers into the newly formed pictorial models for representing the island's civilized tropical natives, the photograph also ensured that the Indians fit into Orientalist representational genres. The interest in showing the "profusion of silver bangles," to recall Hale, heightened the exoticness of their appear-

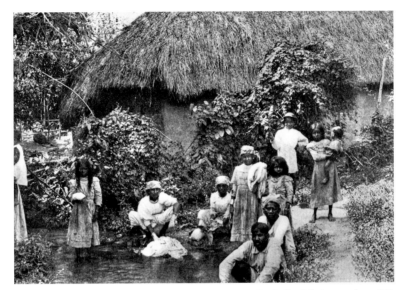

18 C. B. Webster, "A Typical Coolie Family," photograph, ca. 1904

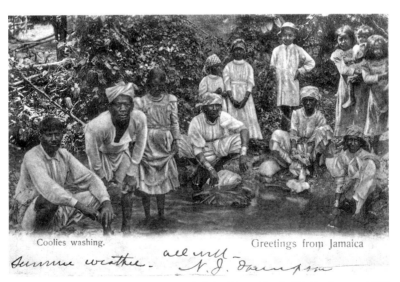

Coolies washing. Greetings from Jamaica

19 C. B. Webster, "Coolies Washing," postcard, 1906

ance, representing them as "picturesque orientals" (Sheller 2003, 107–42). Clean Indian laborers, like black washerwomen, became feasts for the eye, exotic commodities available for visual consumption.

Amid protests over the continued importation of Indians, picturesque aesthetics cast the disputed population in another light, visualizing them as an assimilable and constitutive part of the island's embroidery—the economic, social, and aesthetic fabric of the island. In keeping with the ability of the imperial picturesque system to incorporate new elements into its fold, through picturesque photographs the island's recent migrant laborers could seem to belong and to be model natives, countering oppositional voices that protested their "foreign" presence. The picturesque provided a shifting representational frame that legitimized all elements in its purview, while delegitimizing others, specifically "lazy" black men. The images of picturesque Indians, prefaced by denouncements of black slothfulness (as in Caffin's account), for example, supported the plantation owners' contention that Indian laborers were a necessary economic antidote to black laziness. (Tellingly, at an earlier stage Jamaican blacks were imported into Costa Rica as a surplus labor supply at a moment when Costa Ricans were deemed too lazy to work [Chomsky 1996]). In the fickle constitution of New Jamaica photographs, only elements, humans or plant forms, that contributed to the profit and propagation of the plantation could be incorporated into the folds of the picturesque.

In addition to naturalizing the companies' labor practices, in a similar fashion to its imperial picturesque usages, picturesque photographs represented the plantation as the natural attainment of the aesthetic ideal. This was evident in Johnston's contention that the banana plantations seemed like pictures from "Nature's most delicate brush" (Johnston 1903b,10), which closely echoes Beckford's pronouncements that the island's picturesque landscape "excelled by the hand of Nature alone" (1790, 2: 11). Through such descriptions the increasingly scrutinized forces at work in the maintenance of fruit plantations retreated into the background in such representations, much like the setting sun in many British picturesque paintings. Indeed, by positing that the landscape remained unchanged since Beckford, two phases of relandscaping retreated from view. Instead, the picturesque photograph stood as visual evidence of a seemingly natural and ideal order, nature's work of art.

Importantly, when photographers framed the banana-laden mountains as natural and picturesque, they subtly credited the fruit companies with bringing about the real-

ization of this "natural state." One of the United Fruit Company's travel guides applauded the company's achievements in transforming the island's landscape: "The improvement in even the physical aspect of the island is beginning to be apparent, and soon the wilderness will blossom like the rose" (Caffin 1900, n.p.). In this reconfiguration the company's work essentially brought about an ideal state of nature out of wilderness, as the choice of the word *blossom* suggests. Not dissimilar to how paintings of picturesque sugar plantations signified the beneficence of colonialism and slavery, the fruit companies' enterprising efforts fertilized, by their own accounts, the island's "natural" state as plantation.

"Blossoming Paradise": The Competing Imperial and Colonial Stakes in the Picturesque Both American and British fruit companies enlisted the picturesque photographs to idealize their practices and plantations, but in the context of the British colony at the beginning of the twentieth century boasts about "blossoming" Jamaica's paradisiacal state served diverse and even competing ends. The differences between these narratives were evident in even the opening slides of lantern lectures: Johnston began his picturesque slide tour with a photograph of Jones, head of Elder, Dempster and Company, whereas Baker's visage lorded over audiences at United Fruit Company lectures. Although it is hardly surprising that each of these companies would project their founders as the wellspring from which Jamaica's Garden of Eden sprang, the American and British origins of these companies meant that such narratives carried moral weight in appraisals of the relative virtues of British colonialism and American imperialism. Both sides jockeyed for picturesque authorship at the turn of the American century when, as some lecturers acknowledged, British colonialists and imperialists saw their economic, cultural, and political hold on the colony pried open by American interests. Claims of "blossoming paradise" variously attested to the centrality of British colonialism or American imperialism in the attainment of the island's idyllic state.

The United Fruit Company's descriptions and photographs of their work in the island, for instance, testified to the "Yankee" role in "the modern story of Jamaica," as one contemporaneous article cast it. "Captain Baker's career not only signifies the economic supremacy of Americans, but it has been, and is to-day, the very salvation of the island" (Lyle 1906, 7308). The piece deemed the "American savior" a "missionary by commerce," reemploying the language of the civilizing mission with an Ameri-

can capitalist twist. Baker had saved the island from pauperism, "the modern epidemic throughout the West Indies" (Lyle 1906, 7308), by educating the "shiftless Negroes and discouraged planters" alike in the ways of commerce. In essence, Baker had "harmonized Utopia with modern commercialism" (Lyle 1906, 7305). Such heroic portrayals cast U.S. imperialism as naturally harmonizing with the island's physical and economic landscape. By implication the "American conquest" succeeded where English colonialism in the post-Emancipation period had failed. In the British colony such applause for Americans meant a slap on the face to British colonists and capitalists whose civilizing mission had failed to modernize and industrially develop the New Jamaica (Neptune 2001).

Unsurprisingly, Elder, Dempster and Company lecturers countered such appraisals with representations that highlighted the success of British colonial rule and imperialism in the past and in the present. Indeed, many of the photographs of blacks as industrious in Elder, Dempster and Company lectures served as testaments to the success of British policy in the social and industrial development of the island's black inhabitants. Whereas in the past, images of blacks as "loitering peasants" once served the cause of planters, in the post-Emancipation era nonindustrious blacks were an indictment of British colonial rule. Black laziness signaled the failure of the British to manage the problem of freedom (Holt 1992).

A tour of England by a "native Jamaican choir" sponsored by Elder, Dempster and Company's director, Alfred Jones, illustrates how the company framed its role and that of British colonialism generally on the industrial development of the island's black population. In 1905 a Jamaican native choir dressed in "faultless claw hammer, irreproachable dress shirts, and patent leather boots" embarked on a 36-week tour of the United Kingdom. In a similar fashion to the photographic images used by lantern lamp lecturers, the performers (and the postcards of the troupe) became spectacles through which the benefits of "life under the British flag" for the island's blacks could be projected.[36]

This British propagandizing agenda was evident in the opening remarks of the troupe's "dandy coon" conductor, Mr. T. Ellis Jackson (*The Porcupine*, quoted in DG, 26 February 1906). Ellis paid tribute to "Massa Sir Alfred Jones for all that he had done to develop Jamaica and benefit the natives" (DG, 26 February 1906). He then recited a poem, "The Builders," by Longfellow. A newspaper report described Jones's

reaction to these accolades: "As the Banana King heard this emancipated black declaim them [the words of the poem] with the refinement and finish of an accomplished elocutionist, his mind must have traveled back to the time when the Negro race was in the darkness of slavery, and he no doubt marveled at the educational progress achieved for them under the British flag—a progress to which our great ship-owner has contributed so much" (*DG*, 26 February 1906). Ellis's appearance and ability to recite eloquently a poem served as proof of the success of Britain's educational uplift of the negro race from the darkness of slavery (in marked contrast to the United Fruit Company's assessments that blacks had remained unchanged since slavery). His acknowledgment of Jones attested that British imperialists were continuing the civilizing mission. British audiences should, while applauding the troupe, laud their own colonial achievements and be thanked by black British subjects. Thus, while both British and American companies planted flags in Jamaica's Garden of Eden, they did so to attest to their indispensable roles in realizing the ideal of the New Jamaica.

The Jamaica Exhibition and Campaigns to Make Kingston as Clean, Picturesque, and Tropical as Possible While many lecturers focused on promoting Jamaica's new image abroad, industry supporters also concentrated on creating this new image at home. As the date for the exhibition drew near, colonial authorities and concerned residents sounded concern that parts of the island, especially urban Kingston—site of the exhibition—might not exhibit the ideals of Jamaica's emergent new image. Noting "filth in the streets," "dilapidated houses," "open sewage systems," and "inadequate drainage," they feared that visitors would surely declare Kingston "the dirtiest city in the West Indies" (*DG*, 18 October 1889). Recognizing that all these "blots upon this fair and goodly country" would plague the sustenance of Edenic ideals of the island, officials undertook a number of initiatives aimed at ensuring that Kingston lived up to picturesque expectation (*DG*, 18 October 1889).

The colonial government embarked on several public health and cleanliness schemes aimed at transforming "the dirtiest city in the West Indies" into the loveliest place in the world. These public policies mirrored the fixation with cleanliness evident in many picturesque photographs. Inspired by the upcoming exhibition, authorities initiated major infrastructural improvements to the city's drainage and street systems (*DG*, 18 October 1889). In addition, Governor Blake embarked on a series of islandwide lectures, in a

domestic variant of the lantern presentations, bent on inspiring local residents to take individual responsibility for improving Kingston's sanitation and the cleanliness of its streets. In these forums the governor implored residents:

> There is nothing easier than for nine or ten people to sweep up the broken barrels and baskets and vegetable refuse, etc. we have about our streets. . . . I ask you to help by seeing yourselves to the matter of your own houses. . . . In seeing that the houses of the city and the various other places are properly cleaned, so that when visitors come here we may receive them without being ashamed of Kingston, and seeing that whatever people may have said of Kingston before they have found it healthy, sweet and fair to look upon. (*DG*, 19 November 1889)

Some appreciative residents interpreted Blake's efforts as moral crusades: "Sir Henry Blake's experience in Nassau leads him to believe that if he could talk with the people, he could open their eyes to the enormity of the offence which they are committing against morality, civilization and common sense, by permitting the present condition of things to continue" (*DG*, 9 November 1889). These domestically directed cleanliness campaigns aimed to open the eyes of locals to their "offenses" and to entice travelers to look favorably on the island.

In anticipation of the exhibition numerous other articles called for the island's social and physical improvement (*DG*, 19 November 1889; *DG*, 28 September 1889). One writer urged, for example, the removal of "patches of squalor we find from place to place. I daresay this arises from indolence, or because people looking at these things every day do not realize how bad they are in the eyes of a stranger. . . . If the city is clean it will attract visitors here" (*DG*, 19 November 1889). An editorial in the *Daily Gleaner* similarly encouraged residents to transform the appearance of the island for the exhibition:

> Kingston should be a pattern by which the rest of the island and the rest of its people may be fairly gauged by the stranger. It is from Kingston that the impressions of foreigners are taken, often greatly to the injury of the reputation of Jamaica. It is really the shop window by which passersby are tempted or disgusted or by which they pass with utter indifference. . . . In this shop window of Kingston the people have been content to place all their deteriorated and less attractive stock. They have allowed the cobwebs and dust of neglect, to disfigure the windowpanes, until the passer-by won't take the trouble to peer through

the dirt-be-grimed glass. This must be altered. We must put a new plate-glass front in our tropical store and fill the window with our most attractive articles. (*DG*, 18 October 1889)

The editor's use of the "tropical store" window as an analogy to inspire residents to make the island more attractive to prospective visitors seems particularly apt. It points to how tourism advocates offered the island for sale to prospective visitors as a tropical commodity. The shop window also points to a visibility, an openness to inspection, that tourism would bring to wider society in Jamaica. It recalls Frank Taylor's observation in *To Hell with Paradise* that since the exhibition, Jamaica has been "on perpetual exhibition" (Taylor 1993, 67). The internal campaigns stress that even more immediate than the "tourist gaze" (Urry 1990) were local expectations of that gaze. Authorities aimed to ensure that the island's store front fulfilled travelers' tropical dreams.

The island's image as a disciplinary society also informed the pre-exhibition campaigns. Before the exhibition authorities aimed to heighten the presence of police officers in the island by giving law enforcers helmets to wear. Notably, as a local report describes, the helmets were also added for their "decorative effect," in order to render the officers "as like a picture as possible" (*DG*, 8 November 1890). Through these efforts the police became living manifestations of the island's picturesque image; they served as walking icons of the picturesque, orderly, and disciplined character of the local black and Indian population generally.

Another major part of the island's overall touristic image also had to be addressed by tourism promoters—Jamaica's image as a tropical Garden of Eden. Kingston, however, an urban environment, was in many ways antithetical to the tropical picture of the New Jamaica. Tourism interests attempted to overcome Kingston's tropical deficiencies by building a hotel, the Myrtle Bank, in Kingston, in which they created a tropical garden (see chapter 4). Not only did the garden possess tropical specimens from throughout the world but, as historian Elizabeth Pigou-Dennis points out, "palm and other trees and shrubs were arranged close to the building in a symmetrical layout, with an interesting circular timber gazebo apparently roofed by a shrub—possibly bougainvillea—trimmed into a pitched shape" (1998, 3). In other words, the hotel's gardens reproduced the orderly tropicalized environment through their symmetrical layout. The creation of orderly tropical gardens in the Myrtle Bank's grounds recalls Osborne's observations that hotel landscapes were often built to conform to picturesque ideals. "A resort's

photogenic qualities can determine its fortune. If it lacks them it can be re-invented or re-shaped so as to acquire them: a beach imported, some palms realigned, a Moorish gateway constructed, some viewpoints created. Such places are often photographs materialized in three-dimensional form" (Osborne 2000, 79). Such hotel landscapes, according to Osborne, "*came into existence as a consequence of photography*" (79; emphasis added). The physical construction of a tropical garden in the heart of Kingston may be regarded as a consequence of the island's picturesque photography; the hotel landscape became a physical re-creation of the image of the colony perpetuated in the New Jamaica campaigns.

To further remedy Kingston's lack of tropicality, one letter writer to a local newspaper proposed that a photographic studio be set up in the exhibition building with "many beautiful clumps of ferns, palms, and other tropical vegetation" brought in as a backdrop (*DG*, 24 March 1891). The writer reasoned that visitors could take a photograph of themselves amid tropical nature as a memento of the island. The interior landscape of the tropicalized studio would allow tourists to picture, indeed to confirm the status of, the island as a place of tropical vegetation, despite the urban environment of Kingston.

CONCLUSION

Although it is unclear whether exhibition organizers heeded the writer's call for a tropical photographic studio on-site, the very proposition is provocative given the history of representing "picturesque" Jamaica since the eighteenth century. The proposed studio backdrop, crowded with "tropical vegetation and palms," would locate travelers within a miniature studio landscape, which was the product of a much longer visual history of tropicalizing Jamaica, more specifically, a history of transforming the island into the dream of the tropics. So-called picturesque representations, whether they pictured sugar plantations of old or the banana plantations of the New Jamaica, precisely visualized and confirmed planters', colonists', naturalists', or tourists' dreams of the island, regardless of the limited and self-interested scope of these visions. Art historian Kim Michasiw observes that "the picturesque object is so to the degree it conforms to prior objects lodged in memory, and these objects are likely to be or to have been mediated by representative works of art" (Michasiw 1992, 87). In the context of Jamaica at the be-

ginning of the twentieth century, the island's landscape was picturesque if it conformed to very specific ideals of the "imperial picturesque" visualized in eighteenth-century paintings of the colony and reified in naturalists' imaginatively scientific renditions of the island. The initiative in Kingston to create a photographic backdrop that included ferns, the objects of naturalists' visual ecstasy, and palms, the visual signposts of the plantation landscape, speaks explicitly to the enduring legacy of these old ways of seeing and tropicalizing the island in the New Jamaica era. Exhibition goers, if only in the confines of the tropicalized studio, could step into a miniature re-creation of these long-standing tropical ideals, stand amid the dream of the tropics realized, and enter literally into a picture of Jamaica hundreds of years in the making. Their own photographs would, in turn, continue that legacy. The studio representations, rendered through the realistic medium of photography, would add further visual confirmation that the dreamlike ideal of a tropical landscape did exist; the photographs would offer testimony to the substance, "the truth," of Jamaica's picturesque tropical image.

DEVELOPING THE TROPICS
The Politics of the Picturesque in the Bahamas

Small things can start us off in new ways of thinking, and I was started off by postage stamps of our area. The British administration gave us beautiful stamps. The stamps depicted local scenes and local things; there was one called "Arab Dhow." It was as though, in those stamps, a foreigner has said, "This is what is most striking about this place." Without that stamp of the dhow I might have taken the dhow for granted. As it was, I learned to look at them. Whenever I saw them tied up at the waterfront I thought of them as something peculiar to our region, quaint, something the foreigner would remark on, something not quite modern, and certainly nothing like the liners and cargo ships that berthed in our own modern docks.

So from an early age I developed the habit of looking, detaching myself from a familiar scene and trying to consider it as from a distance. It was from this habit of looking that the idea came to me that as a community we had fallen behind. And that was the beginning of my insecurity.

V. S. Naipaul, *A Bend in the River*, 1979

Even landscapes that we suppose to be most free of our culture may turn out, on closer inspection, to be its product.

Simon Schama, *Landscape and Memory*, 1995

One of the earliest travel guides to the Bahamas, *Stark's History and Guide to the Bahama Islands* (1891), extolled the beauty of Nassau, the capital of the islands, to prospective visitors in these terms: "The view of Nassau from the sea is very striking, but whether it is the beauty of the situation that impresses the visitor so much, or the fact that everything tropical is so strangely fascinating to the unaccustomed beholder, I know not; perhaps it is both. To a person coming from a northern climate, it is *realizing for the first time a picture one has been in the habit of seeing for years in their imagination*" (Stark 1891, 106; emphasis added).[1] Stark described

his immediate impression of Nassau as if he had come upon a familiar ("habit of see-ing") yet an imaginary place, a tendency exhibited in earlier travelers' impressions of the West Indies. Stark registered the beauty of the scene and identified its *tropicality*, "everything tropical," as "strangely fascinating" to a newcomer. He further conveyed that the landscape was like realizing a picture, invoking the aesthetic language of the picturesque to characterize his experience of the island. His invocation of the pictur-esque and his reference to the island's "tropical" appearance reiterate expressions that appear liberally in contemporaneous tourism-oriented materials on the Bahamas from the start of the tourism industry in the late nineteenth century. This chapter seeks to understand what these terms visually define in the context of the Bahamas. How do they intersect? Why and how did "picturesqueness" and "tropicality" become the corner-stones on which tourism promoters constructed the Bahamas' touristic image in the late nineteenth century, and to what end?

I argue that the picturesque and the tropical provided terms or visual frames into which tourism promoters could literally and figuratively reimage the Bahama islands or, more specifically, the city of Nassau on the island of New Providence, the epicenter of the island's tourism trade.[2] Tourism industry supporters used these concepts and photographs that visualized these qualities to structure new ways of seeing Nassau, a flat coral island, which had not undergone the extensive sugar plantation schemes that had radically remade and tropicalized other parts of the West Indies. What tourism promoters often identified or pictured as "tropical" reinforced the idea of the island as a place of wild, overly abundant, and even uncontrolled tropical nature. Many in-dustry supporters deemed the more tamed and ordered view of nature and society on the island as "picturesque." By emphasizing and picturing these characteristics, tourism advocates tried desperately to fit a landscape, which in many ways physically resisted easy assimilation, into what they believed to be tourists' expectations of tropicality and tamed tropicality.

After decades of tropicalizing the island in the realm of visual representation, par-ticularly photographs, tourism promoters directed their energies toward the physical landscape, embarking on extensive campaigns to relandscape or order parts of Nassau in the image of these tourism-oriented photographic representations. Culminating in the 1920s, these initiatives unevenly and adversely affected the island's black communities, which tourism promoters typically designated as the tropical side of Nassau's destina-

tion image. In particular, efforts to make white business and residential areas pictur-esque—orderly, manicured, and clean—would lead to the imposition of social controls on the island's black inhabitants, contributing further to racial stratification and segre-gation. Thus, making Nassau like "a picture in the imagination" or "strangely tropical" prescribed not only a way of seeing and a program of landscaping but a way of gov-erning. These aesthetic concepts became central components of political practices that informed the production and use of social space, especially along the lines of race.

FRAMING THE ANTI-TROPICAL LANDSCAPE AS PICTURESQUE:
EARLY TOURISM CAMPAIGNS IN THE BAHAMAS

As early as the 1850s, the colonial government in the British colony had tried, albeit unsuccessfully, to put Nassau on the map as a tourism destination. In 1857 the admin-istration passed legislation making provisions for a regular steamship service between the islands and New York.[3] The government also helped finance one of the first large-scale hotels in the Caribbean, the Royal Victoria Hotel, with a loan of £125,000 in 1860 (*Guide to Nassau* 1876, 21). In the 1860s and 1870s, industry promoters had some measure of success in attracting invalids and persons afflicted with pulmonary disease, marketing the sea air as a cure for respiratory ailments. Despite these efforts, tourism remained a fledgling industry in the 1880s.

In the 1890s the government and local elites renewed their commitment to the tourist trade as other agricultural industries and fisheries—in pineapples, sisal, and sponges—waned.[4] The legislative council provided a substantial subsidy of £100,000 to Henry Flagler—oil mogul, hotel developer, and railway company president—securing steam-ship services to the island from Florida in 1898. His company agreed to take over the management of the existent Royal Victoria Hotel and to construct an even grander hotel on the island, the Colonial Hotel, which opened in 1900. Tourism advocates hoped that Flagler's services would do for Nassau what he had done for the swamplands of Miami—turning "sand" into "paradise" (*NG*, 15 February 1896).

To transform these "outposts" of the British Empire into "paradise," the colonial government and its new hotelier partner aimed, at first, to change the image of the island in the realm of advertising. The picturesque and tropical, which tourism promoters at-tached like labels to the island's landscape, played a central role in this transformation.

The island's British governor, Henry Blake (who served in the Bahamas before going to Jamaica), encouraged travelers to "Try the Bahamas" because of the islands' "picturesque aspects." He equally lauded the islands' tropical qualities, effusing that "every island is clothed with tropical vegetation" (Blake 1886, 174). Similarly, Northcroft, in his self-described "picturesque and interesting" travel account of the Bahamas, *Sketches in Summerland*, assured travelers that even, "the most persistent 'planet pilgrim' who knows many lands and has gazed on many scenes of natural beauty—feels that this is surely the lotos-land of all his fairest dreams" (1900, 3). The islands' dreamlike tropical beauty and picturesqueness became reasons "to come and gaze upon its marvelous beauty for yourselves" (Hutchinson 1886, 81).

More than simply describing the Bahamas' picturesqueness and tropicality through words, fashioners of the islands' touristic image identified photography as a "usually successful method of advertising" for Nassau. Toward this end, as a report in the *Nassau Guardian* details, a photographer from New York, Jacob F. Coonley, had been "engaged" to "mount a collection of photographic views of the city which we understand will be exhibited in places where they are sure to be seen" (*NG*, 7 December 1895).[5] Coonley's photographs would eventually be seen in the pages of Stark's account, where they provided visual testament to the islands' picturesque and tropical environment.

In addition to Coonley, tourism promoters enlisted the services of other photographers. White Bahamian photographer James "Doc" Sands took over Coonley's studio in 1904 and continued the promotional work of his predecessor (*NG*, 26 January 1898; Coonley 1907, 107).[6] Sands reproduced Coonley's negatives for decades, rephotographed scenes his mentor once memorialized, and replenished Nassau's tourist reputation with his own representations of the island (*NG*, 30 July 1927). For more than half a century, through presentations at international exhibitions, postcards, and photography books, Sands would help to define and redefine Nassau's touristic image.

William Henry Jackson, a well-known photographer of the American Midwest, also added to the photographic corpus of picturesque and tropical Nassau in the early 1900s.[7] Jackson worked for the Detroit Publishing Company (known first as the Detroit Photographic Company), a firm that specialized in creating photographic views and postcards of popular tourism destinations in the United States (Hales 1988). These qualifications likely attracted Flagler to the photographer, who hired him to publicize his Florida properties at the beginning of twentieth century (Carlebach 1998). Subsequently, likely

an extension of his travels to Flagler's hotels, Jackson continued to the Bahamas (and Cuba) in 1900,[8] where he added Nassau to his extensive visual archive of postcard sites.

Collectively, Jackson, along with other local "artists of photography" (as photographers deemed themselves), constructed a visual mirage of the island as a tropical and picturesque oasis. Through displays in international expositions, gallery shows, travelers' albums, and postcards their representations made Nassau a location of touristic desire, spawning the island's most successful industry. While image makers identified photography as a "usually successful" advertising medium, it was even more so when combined with the painterly arts. Promoters frequently supplemented "the realism" of photography by hand painting photographic images.

Tourism promoters and the photographers they "engaged" in the Bahamas faced a unique set of challenges as they sought to market and visualize the island as a picturesque and tropical winter resort. Most insurmountable, as several travelers lamented, Nassau's flat and limestone geography did not exude many of the traits of tropical abundance and fecundity that "planet-pilgrims" expected. Edgar Watson Howe, in his travel memoirs, *The Trip to the West Indies* (1910), for instance, expressed profound disillusionment with the island's physical appearance. He pronounced after a tour of Nassau, "I . . . saw more worthless land than I have ever seen before. The surface is entirely covered with rocks. In the holes, stunted trees have taken root, and made a poor growth" (302). Similarly, in an account predating the advent of tourism, a traveler who had recently arrived in Nassau's harbor was warned not to expect anything visually spectacular on the island: "Go ashore? What for? To see something, eh? There's nothing to see; the island isn't bigger than a nut-shell, and doesn't contain a single prospect.—Go ashore and get some dinner? There isn't anything to eat there.—Fruit? None to speak of; sour oranges and green bananas" (Howe 1860, 14). These assessments that the island offered nothing to see and that, in terms of tropical abundance, it offered only "green bananas" provide more insight into what these travelers deemed worthy of seeing than what they saw. They sought a landscape of tropical abundance, preferably laden with ripe fruit, an ideal that Nassau's rocky terrain did not sustain. Tourism promoters, many of whom were cognoscente of Nassau's antitropical landscape, would have to carefully craft the island's touristic image through photographs in light of these tropical expectations.

For a number of geographical and historical reasons Nassau's environs presented travelers with a landscape that defied tropical enlistment. Geographically, the coral

island, which rose no more than 41 feet above sea level at its highest point, contained no mountains that immediately provided visitors with all-encompassing and panoramic views of nature. Formed from the consolidation of the shells and skeletons of marine organisms over the millennia, even the white or gray-toned calcium carbonate–laden soil stood in contrast to the dark earth of neighboring volcanic islands such as Jamaica. In the porous, rocky, and sandy soil, low-lying forms of vegetation like mangroves and root crops thrived, but the natural habitat was otherwise inhospitable to many other botanical forms (Craton and Saunders 1992, 7). This geography would play a determining role in the colonial history of the islands.

Unlike many places in the West Indies, which became parts of the machinery of the colonial sugar plantation, efforts to assimilate Nassau into the powerful sugar trade fell through the porous soil. Planters' attempts to cultivate sugar, and subsequently cotton, were relatively short-lived. As a result colonists did not extensively transplant to the island with many of the forms of "tropical" vegetation (or indentured laborers) that populated other sugar islands. Even early attempts to establish a botanical garden, that microcosm of tropical nature, had failed (Danforth 2001, 21–28). Thus when travelers declared that Nassau was worthless, in their mind's eye the island had never been made valuable or tropical by sugar cultivation and colonial transplantation.

Tourism promoters, however, would succeed where many planters had failed in creating an industry that would support and enrich the islands economically in the long term. It is perhaps paradoxical that after so many centuries of failures in agricultural industries in the Bahamas the colonial government would ultimately turn the "unproductive" landscape into the islands' most profitable commodity. As a contemporary observer summated, "in worldly goods Nassau is but poor, but in soul satiating beauty no spot in all the world is richer" (NG, 24 March 1909). Photography played a central role in making and marketing the islands' unproductive and untropical landscapes into the Bahamas' most "productive" commodity.

TROPES OF TROPICALITY: PHOTOGRAPHS OF NATURAL
ABUNDANCE ON A CORAL ISLAND

To redress the sighs over Nassau's wanting tropical character, tourism promoters had to refashion and refocus the island's destination image. Photographs would facilitate this

tropical transformation, taunting travelers with visual promises of a landscape clothed in tropical vegetation and directing tourists, through very select representations of the landscape, to perceive its tropical value. Photographers pictured Nassau in such a way that the island appeared to possess many of the traits associated with tropicality—the fertility, exoticism, and overabundance of nature. They selected parts of Nassau's landscape that made the island seem to belong to the imperial picturesque genre, images of plantations clothed in sweet and fruitful tropical transplants. Training their viewfinders on forms of nature that seemed "strangely tropical" (to recall Stark), photographers also associated the island with naturalists' and nature lovers' expectations of sublime and fantastic tropical nature. It was precisely forms of nature and aspects of society that seemed recognizably "tropical"—strange trees, market women, and African settlements—that filled photographers' camera frames. Although Nassau did not have a tradition of picturesque paintings or a history of colonial picturesque relandscaping, photographers aimed to ensure that in their representations the island offered a feast for tropical-seeking eyes.

The Silk Cotton and Palm Tree: Picturing Nature's Exotic Architecture To satisfy touristic tastes for tropicality, the part of the island on which photographers most frequently trained their cameras was the silk cotton (or ceiba) tree. The silk cotton tree offered a spectacle of tropical nature in all its grandiose and visually bizarre forms. As is evident in Jackson's photograph "Ceiba or Silk Cotton Tree, Nassau" (1901), the tree's massive and winding roots fulfilled even the most discriminating traveler's quotient for wondrous and bizarre natural forms (figure 20). Many tourists marveled at the silk cotton, describing it invariably as "the largest tree I ever saw, and by all odds the most curious" (Drysdale, quoted in Ives 1880, 15).

Like naturalist representations, which focused on a lone botanical specimen in isolation, photographers emphasized the tree's monumental size by providing a closely cropped image of the silk cotton, excluding details of the surrounding natural or built environment. Photographers would further heighten its commanding and stoic appearance by picturing it next to a human figure. In Jackson's rendition, for example, a boy stands nestled in and dwarfed by even the roots of the tree. He holds a small basket in a manner that compositionally reproduces how the silk cotton's roots encompass and engulf him. Such juxtapositions stressed the awesome character of nature on the island. By

20 William Henry Jackson, "Ceiba or Silk Cotton Tree, Nassau," photograph, 1900

foregrounding the silk cotton in individual photographs and reproducing these images, photographers lent tropical character to the wider (unpictured) island's environment. Although a rarity within Nassau's landscape (colonists had brought the silk cotton from South Carolina) (Shattuck 1905, 213), the silk cotton became the most frequent inhabitant and representative icon of nature in photographs of the island.

While photographers rendered the human figure next to the silk cotton as inconsequential and minute, tourism promoters portrayed the silk cotton tree as larger than life or full of life. This follows a trend evident in many travel narratives of the region. As the literary scholar Sarah Brown observes, "All living things were viewed as part of the scenery. Plants [were] made more human; people [were] viewed as less than human"

(S. Brown 1995, 243). This anthropomorphization of nature was explicit in William Hutchinson and Ellsworth Woodward's travel account when they described their encounter with Nassau's famous silk cotton tree as if they had come upon another human presence: "the great silk cotton tree behind the government building nodded and said, 'Glad to see you again sir,' and the crimson poinsettia and vermilion poinsettia cordially smiled as we passed" (Hutchinson and Woodward 1886, 84). Nature in the tropics seemed alive and even communicative to the travelers. Interestingly, Hutchinson and Woodward reattributed all the human signs of the welcoming touristic society (speaking politely, bending respectfully in greeting, and displaying the universal sign of welcome and touristic hospitality, a smile) onto nature.

Several travel writers referred to the silk cotton and other natural forms as "nature's architecture," more specifically, as a "Gothic tower" (Benjamin 1878, 27; Northcroft 1912, 114). In this accreditation of nature with the creation of an architectural structure, travelers again bestowed on the natural realm an agency typically reserved for products of humankind. While in the European context a Gothic tower stood as an architectural wonder and testament to the creativity and ingenuity of human endeavor, in the Bahamas, history, culture, and human creativity had only a tree as a comparable landmark. As Ives concluded, "The same air that stimulates into rapid and vigorous growth the vegetable world, operates as an opiate upon animal life, and puts the Genius of History to sleep" (56). Whereas travelers may have journeyed to other lands to fulfill their interest in history and art,[9] in the Bahamas tropical nature subsumed history and genius; indeed, it *was* history and culture.

Photographers also captured other forms of flora, which they recognized as "tropical." The palm tree, for instance, which Stepan identifies as the "ubiquitous sign of the tropics" (19), appeared in many photographs of Nassau. "Images of it instantly signal[ed] less a botanical species than an imaginative submersion in hot places" (Stepan 2001, 19). In Jackson's "Royal Palms, Cumberland Street, Nassau, W.I.," for instance, a royal palm punctuates Nassau's skyline, surpassing the height of the built environment, at least from the photographer's perch at the pinnacle of a sloping Cumberland Street (figure 21). Two children provide a scale by which the heights of tropical nature may be measured and appreciated. The photograph of the towering palm served as a visual marker that the island was a part of the imaginative geography of the tropics.

In the context of the British West Indies the palm tree, especially the royal palm,

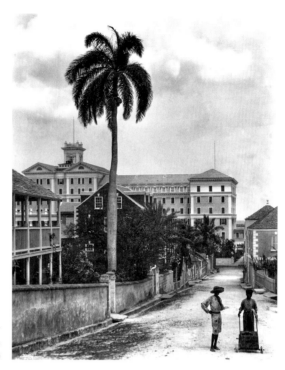

21 William Henry Jackson, "Royal Palms, Cumberland Street, Nassau, W.I.," photograph, 1900

acquired a deeper semiotic resonance than its aesthetic association with hot places. Historically, in the region the royal palm marked the boundaries of the sugar plantations. In a landscape like Nassau, without the history of sugar transplantation, the visual fixation on royal palms also served to attach the island to particular ideals of the imperial picturesque, the aesthetics of the sugar plantation.

The association of Nassau with the "tropics" through select visual signifiers may be historically situated in light of the anthropologist Peter Mason's conclusions in *Infelicities: Representations of the Exotic* (1998): from the earliest pictorial glimmers of the West Indies in the European imagination, artists configured the islands through a preexisting visual vocabulary of the exotic. This is evident in one of the first European paintings of the West Indies, Jan Mostaert's *West Indian Landscape* (1520–30) (plate 18). The Dutch painter, as Mason convincingly deciphers, composed his "West Indian" landscape en-

tirely out of visual tropes used previously to represent "exotic" locations and even past times—from a prelapsarian landscape to satyrs. Mostaert's landscape, in essence, was a mélange of exotic signifiers; the only distinguishing feature that marked the landscape as "West Indian" was its title.

Mostaert's *West Indian Landscape* provides a historical precedent for Nassau's photographic configuration through another form of "exotic genre," signifiers of the tropics. As Mason points out, the exotic genre "conjure[d] up what is exotic, and what is exotic, in turn, can be applied to a variety of distant locations" (26); likewise, tourism promoters on the island drew on global tropes of tropicality, or what Osborne describes as "currencies of paradise" (107) to image Nassau. In the particular coral environment of Nassau such attachments to the tropicalized visual field were essential to the touristic reimaging process, to crafting Nassau's destination image as "a veritable paradise to the lover of nature" (Blake 1888, 691).

Travelers, many of whom used photographs as visual maps on their excursions through the island, certainly viewed the Bahamas in terms of a wider global lens of the tropics. When Lady Brassey, a visitor to the island in 1885, beheld the silk cotton in the Bahamas, she immediately placed the silk cotton within a wider visual economy of tropical nature in other foreign locales: "How glorious such trees must be in Abyssinia and in the South of Africa, where they rear their giant stems to a height of 100 and 150 feet, without a single break" (347). Nassau's silk cotton was but one in a series of other natural signifiers of the tropics also found in Africa and Abyssinia. Its value lay in its similarity to "glorious" forms of tropical nature in other locales. Interestingly, the tree may have also reminded the island's black inhabitants of other places, namely African homelands or sacred grounds. They made the tree the focus of their religious or spiritual practice, as anthropologist and photographer Harry Johnston observed (1910, 127). By collecting photographs of tropical botanical specimens from throughout the world, travelers could systematically collect, classify, and order vastly different locales within their albums as part of a single, knowable, and possessable tropical world. Although Nassau contained many forms of vegetation (such as the indigenous tamarind, mahogany, or cocoa plum trees), visual icons of the tropics like the cotton tree or the royal palm jumped out to tourists (and in some instances even spoke to them), while the rest of the environment (any unrecognizable or unvalued nature) just receded into the background.

The Sexualization of Nature and the Naturalization of the Black Market Woman Icon Given that many tourism promoters conceived of and pictured the landscape in Nassau as a place of tropical nature, what place did and could the island's local population occupy in these configurations? If they bestowed the island's flora and fauna with traits of humanity, how did they regard its inhabitants, particularly Nassau's black majority? Generally, tourism image makers and travelers framed the island's black population as parts of the tropical scenery. According to one tourist's appraisal, which was published in the local paper, the black population, being "bright, cheerful, hard working, especially the women . . . enliven every picture, and form a prominent part of every landscape" (*NG*, 9 December 1908). Similarly, Northcroft appreciated how the "numbers of brawny, barefoot Negroes—men, women, and children—stand out against the green back-ground of trees and shrubs dotted with gorgeous blossoms, *completing the impressions* of southern leisure and tropic sunshine which stamps upon the mind" (1912, 7; emphasis added). He valued blacks for the way they completed the scene of tropicality. In contrast to travelers' endowment of nature with human qualities, many tourists dehumanized blacks as parts of nature.

The figure of the black market woman, more than any other human presence, entered the representational frame as the visual companion of tropical nature. The affiliation of the island's black female inhabitants with nature is evident in one of the most popular photographs of the Bahamas from the early twentieth century, "On the Way to Market" (figure 22). The photograph, taken by Coonley, pictures a turkey vendor, whose name was Lizzie Anderson, calmly and dispassionately balancing a tray of live-fowl on her head. The representation is a very rare studio photograph of the island's black popula-tion. Its content and composition reveal precisely how photographers re-presented the Bahamian black for touristic consumption.

Coonley placed the woman on a photographic backdrop of tropical nature. Palm fronds, the botanical signifier of the tropics, crowd the studio and surround Anderson (covering up a backdrop that pictured a seascape and lighthouse). Coonley re-created and situated the vendor within a natural landscape, which he obviously deemed a more suitable visual setting for a market woman. In the resultant image the market woman and nature are connected, if not equated. They share the visual stage. Yet, in an ex-ample of what Arjun Appadurai describes as "an ambivalence of its [the colonial photo-graph's] documentary authority" (1997, 4), Coonley's photograph provides glimpses of

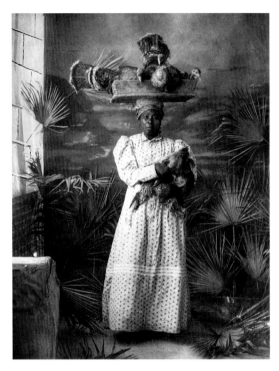

22 Jacob Frank Coonley, "On the Way to Market," albumen print, 1888–1904

the studio environment that undermine the very constructed naturalness of the image. The photo reveals beyond the boundaries of the backdrop. Viewers can see the surrounding studio, including a window and detached palm props. The subject's wooden pose further points to the interior creation of the outdoor scene. Revealingly, perhaps in an effort to overcome "the epistemological uncertainty about exactly what photographs seek to represent," decades later when Coonley reproduced "On the Way to Market, Nassau . . ." as a postcard, he cropped all elements of the studio environment (Appadurai 1) (figure 23). In a confirmation of the successful elimination of the most obvious signs of the photograph's construction, a sender of the later postcard inscribed on the back of the postcard "this picture is natural" (figure 23a). The staging of the photograph in the first instance, its subsequent naturalization through cropping, and its handwritten caption all inscribed and reinscribed the market woman as a part of nature.

On the way to Market. Nassau N. P. Bahamas.

23 and 23a [Jacob Frank Coonley],
"On the Way to Market, . . ." postcard, 1910

POST CARD

1910

This picture is getting
Every thing is carried
around on head on a wooden
tray, turkey, Chicken, vegetables
fruit and laundry

Brilliant Chromo O.L.M. 168:09 205125

24 Winslow Homer, *On the Way to the Market, Bahamas,* watercolor over pencil, 1885

The visual equation of the black market woman figure with tropical nature is even more explicit in paintings of the island, as evidenced in the engravings and watercolors of American artist Winslow Homer. In 1887 *Century Magazine* sent the painter to Nassau to record visually the new "midwinter resort." Homer had previously visited the island in 1885. Market women captured Homer's artistic imagination like no other feature on the island. He did at least six paintings of the island's market women walking down the coral streets of the city, with fruits, vegetables, or live animals on their heads. In one of the paintings, *On the Way to the Market, Bahamas* (1885), Homer depicts a black woman with a foul in her grasp, passing through a lane of tropical nature, including a coconut palm and other trees hung with fruit (figure 24). In its subject matter and title Homer's painting recalls Coonley's work and that of other tourism image makers. Although it's unclear whether artist-travelers like Homer focused on these aspects of the

island because they were popular in tourism promotional images or visa versa, tourists' and industry promoters' gazes frequently locked on the same select features of Nassau's landscape and ethnoscape.

Even more notable than Homer's inclusion of tropes of tropicality as subject matter is the form of his paintings. Art historian Helen Cooper points to a curious change in the artist's style of representation in his Bahamas works. He painted women in such an impressionistic fashion that they became parts of the representation of nature. Unlike the artist's previous "heroic representations" of female cotton pickers in Virginia (1876) or the fisherwomen of Cullercoats (1881), on the island "such monumental female types no longer represented a primary subject for him" (Cooper 1986, 145). Instead, "shown at some distance from the foreground and consequently small in scale, the Bahamian women are but one element in a scene whose real subject is light and color" (Cooper 1986, 145). In Nassau black female figures almost dissolved in the picture plane. In Homer's watercolors black market women gave way to the overall pictorial effects of the scenery.

It is curious that black women in particular would elicit so much attention. Certainly black men also occupied Nassau's city streets, but they failed to occupy a place in the island's new-fangled tropical image.[10] Did the black male figure not provide a suitable visual counterpart to the tropical environment? Curiously, white Bahamians and British colonials, both male and female, were also seldom visualized as part of the Bahamian landscape. Although travelers frequently mingled socially with white Bahamians in the Bahamas, they remained outside the strictures of tourism-oriented photographs. In seeking an explanation for this, literary critic Anthony Dahl concludes that "Bahamian whites are not exotic, in the sense that they look too much like the white visitors, it is the blacks and their customs that are mentioned, along with a major focus on the appealing geographical and physical environment" (1995, 104). The very presence of whites seemed antithetical in a tropical environment,[11] while blacks were natural companions to the landscape of the island. Expectations of what plant forms should occur in a tropical environment extended to encompass *who* belonged in such a landscape. Black market women, frequently depicted balancing fruit on the crowns of their heads, especially completed and proffered the island's tropically abundant image.

Why were black women pictorially equated with nature? What purpose did this serve in the emergent tourism industry? An insight into these questions may lie in travelers'

written accounts of nature. Even in the earliest travel accounts, sojourners described nature in terms suggestive of the female body or even of a sexual liaison with a woman. In 1864 Mackie, for instance, recalled the gentle movement of palm trees in sexually suggestive terms. He selected a particular palm as "his favorite," and described it as "of the coconut variety, tall, and leaning gracefully—such a one as the wild Arab loves to call his bride. The tree seems almost a living form, animate with sense and feeling, and to stand there, its branches waving, and its leaves quivering in an ecstasy of delight" (1864, 332). Such phrases as "harmoniously swaying," "soft caresses, toying and gamboling with the wind," and "deeply impassioned motion" also pepper Mackie's ecstatic account of the movement of the tree suspended in the wind. "Surely, with such grace does a Venus move her limbs when she comes newborn out of the foamy waves; and so dance upon the stage the lithesome Spanish girls of Grenada, and the gypsies of Seville" (332). Like Brassey's comparison of the silk cotton to other botanical exotic varieties, Mackie compares the palm to other exotic and mythically sexual females. A similar sense of sensuality may be read into Stark's description of nature on the island. He was visually captivated by the "groves of palms, lithe and graceful, gently swaying their undulating plumage in the evening wind" (1891, 122). In such descriptions nature is not simply anthropomorphized, as Brown notes, but gendered as female and sexualized.[12]

The multiple images of palm trees and nature can be reinterpreted in light of these sexualized interpretations of nature. Roland Barthes, in deciphering the iconography of the leaning palm tree, suggests that this quintessential image of the tropics is linked to sensual longing. "Most commonly it [the palm] is shown not upright, not erect, but lounging across the frame, often heavy with fruit—as though swooning, yielding, 'falling back' across the path of the viewer; a feminised entity proposing a languorous eroticism" (Barthes, quoted in Osborne 2000, 107). Perhaps not coincidently, Homer's images of coconut trees, succumbing to the pressures of beguiling winds, are some of his best-known images of the Bahamas (figure 25).

Returning to the image of the black Bahamian female so frequently pictured in nature, perhaps she may be interpreted as the visual manifestation of this feminized and sexualized reading of nature in the tropics. Curiously, however, photographers did not represent black women in ways we may readily identify as overtly sexual. There is no comparable counterpart to the images of the exoticized female body that became parts of the visual economy of postcards from colonial Algeria to Zaire, for example,

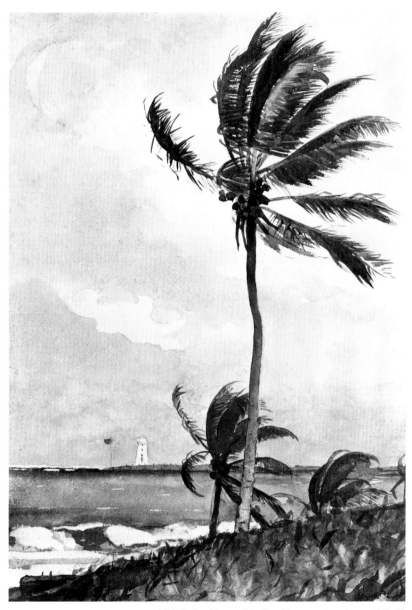

25 Winslow Homer, *Palm Tree, Nassau*, watercolor, ca. 1888–89

where women were often depicted in nude and seminude states (Alloula 1986; Albers and James 1988, 142; Steet 2000). Possibly in the Bahamas travelers and promoters redirected this exoticism onto the landscape. The market woman, with the fruits that she proffered for sale and the graceful sway of her hips, was a subtle but important visual signifier of this sexualized reading of nature. This interpretation may explain why black male figures very seldom accompany images of the landscape; their masculinity would have disrupted many male travelers' sexualized engagement with tropical nature on the island. The market woman also stood as a personification of the fecundity and productivity of nature in the Bahamas. In short, the exotic genre erected in the Bahamas was also an erotic genre.

Over the Hill and into Tropical Africa: Photographing Nassau's Black Communities In addition to fixating on the island's market women, fashioners of the island's touristic image seized on the communities from which the women came for the tropical fidelity they added to Nassau's landscape. The black communities located in an area known as "Over the Hill," south of the main city of Nassau, in particular captured the tropical imaginations of photographers and travelers. Stark, for instance, upheld the island's black community of Grant's Town as "thoroughly tropical": "The drive through Grant's Town is also a novel one, with its bananas and oranges growing in every yard, its African cabins half hidden in foliage, its little stands in the street for the sale of sugar cane, home-made candy and fruits. *It is thoroughly tropical in every respect*" (1891, 122; emphasis added). In every yard in Grant's Town, he assured readers, travelers could find a microcosm of tropical nature—fruits, ample foliage, and even sugarcane.

A photograph by Coonley, published in Stark's account, served as a visual confirmation of the "thoroughly tropical character" of the settlement (figure 26). In the image a winding path leads viewers to a humble thatched-roof cabin, which anchors and forms the focal point of the photograph. The cabin is subsumed by nature as vines and surrounding vegetation claim the structure as part of the natural environment. Coconut palm trees occupy the left side and background of the photograph, clearly marking the scene as part of the tropics. Although no inhabitants populate the image, a pull cart in the right foreground hints at the (momentarily retired) working life of the cabin's inhabitants.

The caption of Coonley's photograph of Grant's Town, "A Native African Hut,"

26 Jacob Frank Coonley, "A Native African Hut," albumen print, 1888–1904

hints at another aspect of the island's tropical configuration. Tourism promoters aimed to link the island to another signifier of tropicality—Africa. Stark, for example, followed his declaration of Grant's Town's "tropicality" by listing its "African characteristics": "the people live out doors, cook their little breakfast over embers in the front yard, and everywhere may be seen women washing their clothes under the shade of orange and almond trees. The people are all Africans, and descendants of Africans, many of them retain their native language and have faces tattooed and their teeth filed to a point, and all feel very free to talk to any stranger who goes through their streets" (1891, 122). Stark and other writers attributed this "Africanness" to the number of Africans, captured from the Portuguese and Spanish slavers on the seas, who were set free on the islands as late as the 1860s. Northcroft credited this influx and renewal of the African population with keeping "the social life of the coloured people picturesque and inter-

esting—it must be said—but crudely civilized" (66). Some producers of postcards of the island seemed attentive not only to the Africanness of the population but to the specific African ethnicities of these black communities. Several captions of postcards identified the island's black inhabitants by their African ethnic group, as "Yoruba" or "Congo." Other postcards called attention to the settlements of these ethnic communities. One postcard of a barefooted elderly black man described its subject as "A Native of Congstown" (plate 19). Like the photographs of tropical nature on the island, images of "African" communities connected Nassau to a wider visual economy of anthropological images of "Africans" circulating at the time.[13]

Ethnographic attention to specific African ethnicities in captioning and images of native African huts served not to promote cultural tourism—for the "crudely civilized" population lacked culture—but to tropicalize the island through association with "the dark continent" (Northcroft 1912, 71). In an island where promoters aimed to create the visual aura of tropicality, Africa had touristic allure. Indeed, some writers aimed to strengthen the connection between the island and the African continent by comparing their experiences in the Bahamas to David Livingstone's expeditions in southern Africa or to journeys in the jungles of Guatemala.[14] Such cross-geographical tropical comparisons allowed Nassau, through the black suburbs south of the main city, to acquire tropical authenticity by association.

The Unrepresentability of African-Bahamian Cultural Practices and Modernity Although tourism promoters readily sought to associate the island's black communities with "Africa," very few images of African-Bahamian customs entered into photographer's tropical frames. While natural forms like the silk cotton (which seemed like culture) frequently populated photographs of the island, the island's African cultural practices (deemed natural) seldom infiltrated the world of photographs. Stark claimed, for instance, to have witnessed fire dances during his Grant's Town adventures; however, no images of blacks engaged in the "savage African dance in half civilized attire" grace the pages of his guide (Stark 1891, 188). This exclusion may at first seem incidental. There are, of course, many aspects of the island not photographed in his account. Another traveler's description, however, of his own thwarted attempts to photograph the same event betrays an intentional photographic blind spot when it came to the island's black cultural expressions.

Hugh Bell's account of his travels to the island in the 1930s provides a rare glimpse

at the photographic prohibitions that surrounded African-Bahamian customs. He unwittingly crossed the prescribed photographic boundaries when he asked a local police commander when and where he could photograph a fire dance. "The reply was brief and the eye behind it very chilly. 'At no time and no place in this colony; if that is what you are here for you had better leave quickly.' " Bell explained the officer's terse response by stating, "This reversion to racial instinct is forbidden, so it is indulged in only secretly" (Bell 1934, 86). The policeman's reaction to the visitor's request may indeed reflect the commander's and authorities' disapproval of black "reversion to racial instinct." The chilly-eyed reception may also have been a specific response to the traveler's photographic ambitions: his desire to photograph an event the lawman deemed unrepresentative of the Bahamas and therefore unrepresentable. Although tourism promoters could highlight "Africanness" in photographs of native huts, images of African customs, which were part of the lived experience and social world of the black inhabitants, seem to have threatened the island's touristic image. Anyone desiring to photograph such a custom had "better leave quickly."

The representational ambivalence toward the island's black inhabitants in promotional accounts (ironically the tourism board actually distributed Bell's account) was echoed in travelers' fascination with and fear of the island's African-Bahamian population. While some adventuresome tourists happily ventured "over the hill," others expressed fear of the island's black inhabitants. One traveler, Ives, for example, viewed blacks as disease carriers (182–83) and expressed concern with how often the potentially contaminating winds blew from their communities in the direction of his hotel. Ironically, many blacks blamed visiting consumptives for bringing disease to the island.[15] Amelia Defries, a travel writer who came to Nassau in 1916, feared not air from black communities but expressed concern that black inhabitants would invade her hotel room while she slept. She self-diagnosed that her fears of blacks derived from the "mental pictures of shows seen in the cinemas, in which coloured people were always creeping in through windows—long hands or grinning black faces—intent upon evil!" (Defries 1917, 56). Promoters' own reluctance to visualize many aspects of Afro-Bahamian society may have stemmed from their awareness of these fears.

The absence of photographic representations may also be the result of local inhabitants' resistance to being "Kodaked." An incident that Defries experienced during the annual Afro-Bahamian masquerade of John Canoe, an event that brought black revel-

ers from over the hill into the white business district of the city, provides a snapshot of local inhabitants' responses to the camera. Defries describes rather enthusiastically taking out her camera to photograph the parade only to be halted by a black woman who warned that the last person who attempted to photograph the John Canoes had his ear bitten off. The woman emphatically explained, "Ma'ma—put your photograph thing away; dey doesn't want to be took. . . . Dere was a fellar takin dose last year—and a man got wild, and bit off his ear. . . . Dey don't want no one carrying away der faces dressed up dis way" (Defries 1917, 78). The incident attests that strict taboos surrounded photographing masqueraders. Participants in the parade, according to Defries's informant, opposed being "taken" by the camera, even violently so. The threat of bodily harm sufficiently scared Defries from carrying her camera. She "sorrowfully" put it away, not wanting "to have my ear bitten off" (78). It is possible that actual incidences of ear biting (or stories about incidences of ear biting) contributed to the absence of black African cultural traditions in photographs.

The purported threat of cannibalism, even though biting does not necessitate eating, as a response to the camera deserves further consideration. The rumor of cannibalism ignited, especially in a traveler like Defries, the specter of the most wild, fearful, threatening, uncivilized tropical native—"cannibals." In an industry manufacturing representations of quaint Africans, the masqueraders defied, literally, this representation of blackness, challenging the very select visual presentation of the island's inhabitants. In an industry based on visual consumption, they refused to be consumed. They refused to be cannibalized or turned into the equivalent of photographic trophy heads by the camera ("Dey don't want no one carrying away der faces"). Indeed, a threat of oral consumption, ear biting, forced some travelers to obey this photographic prohibition. In essence, a combination of taboos from above (police commander) and below (the ear-eating masquerader) led to the masquerade's photographic erasure.

What does the erasure of John Canoe from the visual economy of tourism reveal about the relationship between photography and black Bahamians? What qualities did black inhabitants have to possess to gain admission into tourism promoters' photographic frames? A comparison of the most photographed icon, the black market woman, with the representationally absent John Canoe, will lead to a more precise delineation of who constituted an ideal photographic subject and why. Dahl suggests that the market woman was fetishized precisely because she presented an image of a photogenic and

hospitable black Bahamian, a "picture-perfect or tamed face of the Bahamian black" (Dahl 1995, 64–66). She was a nonthreatening Afro-Bahamian presence, exhibiting the smile of welcome (and not Defries's feared evil grin). There is something compelling about Dahl's equation of deeming something "picture-perfect" with the process of being tamed. The moment the island's inhabitants were rendered Kodakable—the instant they submitted to their photographic inscription—they were defused of their threatening potentiality, their tropical combustibility. The very act of photographing black inhabitants marked them as domesticated, hospitable, and unthreatening. The lack of photographic representations of John Canoe participants was a telltale sign that they operated beyond the boundaries of the colonial state's control. The inability and unwillingness to photograph them stood as testament that they were untamed, hostile, and threatening. By continually featuring blacks like the market women and not the ear-biting black John Canoes, the nonthreatening characteristics of all blacks on the island was continually reinscribed, and the fear of black inhabitants was exorcized. Through the select focus on picture-perfect images of blacks, the wider black population was codified as safe to potential travelers.

Images of the island's tropical nature and tropical inhabitants served not only to associate Nassau with other "exotic" locales, such as Africa, but to disassociate the island from the modern world. Tourism promoters aimed to assure visitors that Nassau remained untouched by modernization. Edith Blake, the governor's wife, for instance, boasted that the island held the "charm" of a country "where railroads and telephones do not exist, and where even tramways and telegraphs have not yet penetrated" (Blake 1888, 40). "Progress," she concluded, "has its monotonous side." By stressing the island's tropicality, tourism promoters also imaged the island as a locale that time, "progress," had left behind.

Photographers, sometimes aided by artists, reinforced this ideal by portraying a town devoid of the visual traces of modernization. Two postcards, based on a photograph by Sands, explicitly demonstrate the perpetuation of this premodern image in the choice of photographic subject and in the postdevelopment process. Both images feature a young black boy on a donkey cart beneath a bougainvillea-christened archway, but they are subtly different. In one version of the card electrical lines cut across the top of the image (plate 16). In the other they have been artfully removed (plate 17). The latter postcard also features tropically enhanced bougainvillea flowers, which, thanks to hand

painting, are more abundant and more colorful. The very pictorial focus of the donkey cart, being a "primitive" form of locomotive, pointed further to the island's premodern status and stasis. Both the postcard's subject matter and its painted form (which simultaneously erased and embellished the pictured subject matter) heightened the island's tropical image.

The "tropicalized" postcard visualizes several components of the island's touristic image. It portrays tropical nature in all its glory. The image also foregrounds a quaint and nonthreatening image of the black population, in the absence of a woman, a child. The postcard's caption, which changed from "A Typical Gateway" to "Two Natives," also evidences the dehumanization of the black Bahamian. It classes both ass and boy as "natives." Its producer also masked traces of modernization. The image, and its manipulation, encapsulates how promoters used photographs and hand painting to represent Nassau's tropicalized and premodern ideals of nature and society. The changing captions and overpainting, however, also betray their efforts and even struggles to craft and recraft the coral island's tropical image.

ICONS OF THE PICTURESQUE: PHOTOGRAPHS OF "BEAUTIFUL" AND CULTIVATED TROPICAL NATURE

Another, less-enthusiastic undercurrent ran through descriptions of the island's tropical appearance. Some travelers expressed discomfort with the wild, tangled, and uncultivated displays of nature on the island and voiced a desire for a more visually ordered landscape. Ives bemoaned the presence of "the wildness of untamed nature" claiming that the island, which had "once [been] made beautiful by enforced slave labor, now looks sadly neglected" (Ives 1880, 129). Interestingly, he chose the word *beautiful* to describe how the landscape had once appeared under slavery. Ives explicitly longed for an imperial picturesque landscape, one "made beautiful" by forced labor. Stark made similar remarks when he encountered the former plantation site of Clifton, proffering that during "the palmy days before the abolishing of slavery . . . this was a *rich garden* producing cotton, coffee, sugar, and many other things that go to stock the markets of the world" (Stark 1891, 125). Stark also expressed nostalgia for the "palmy days" of slavery, which had created a manicured gardenlike landscape.[16] Not only did travelers

desire a landscaped order produced by slave labor, but according to Edith Blake, the island's black inhabitants "pine for the flesh-pots of slavery and deplore the miseries of emancipation" (Blake 1888, 689). In her estimation the island's black inhabitants also longed for the days of slavery. Photographers capitalized on this nostalgia for the pre-emancipation era by offering photographs "of some of the old Africans who were formerly slaves in the Bahamas" (ad quoted in Craton and Saunders 1998, 211). Ives, Stark, and Blake upheld the period of slavery as ideal and decried the wildness of nature as indicative of the state of decline of nature and society in the islands, and in the West Indies generally, after Emancipation.

Several tourists viewed the uncultivated spectacles of nature and overgrown fields as indicative of the slothful lifestyle of the islands' inhabitants and as an indication of waste in these locales. Bell, for instance, saw in the mingled beauty of nature "evidence of waste . . . here in Nassau. . . . I saw great heaps of nuts lying in the unused fields. I asked the owner why he didn't sell them and he replied it was too much trouble" (NG, 27 March 1909). Bell believed the island suffered under the "philosophy of a lazy man in the tropics." The land, he reckoned, was "plentiful in spite of them [the native population]." Although in this land of plenty Bell did see poverty, in such a bountiful environment he concluded that "poverty seems willful rather than necessary" (Bell, quoted in NG, 27 March 1909).[17]

The notion of the picturesque in the context of the Bahamas became tied to this interest in a tamed and manicured environment. While many promoters and travelers heightened the tropicality of the island, its wild nature and African inhabitants, many of them described an ordered view of nature and society as picturesque. These dual approaches to Nassau's landscape may be considered in light of Mason's observations that travelers and colonizers approached and interpreted "exotic" locales "in varying degrees of wildness and domestification" (Mason 1998, 2). These two ways of seeing "exotic" locations generally carry different designations in accounts of the island: the heightening of the island's natural qualities can be described as the wildness or tropicalizing tendency, while the aim to make the landscape more *beautiful* through visual ordering fell under the rubric of the picturesque.[18] Parts of the landscape that qualified as picturesque in photographs included the tree-framed streets of the white suburbs and business district of Nassau and hotel landscapes.

Hotel Gardens: Miniature Ordered Tropical Worlds Given that several travelers bemoaned that parts of the island lacked a "gardenlike" appearance, it is not surprising that gardens would become a favorable feature in photographs of Nassau, particularly the gardens of hotel environments.[19] Indeed, hotel proprietors of the Royal Victoria Hotel and the Colonial Hotel seem to have created their hotels' landscapes to display all the specimens of tropical nature that travelers might expect but in an aesthetically ordered manner. Flagler built the Colonial Hotel and its extensive surrounding gardens on property on the edge of Nassau's harbor in 1901. A traveler to the island during the hotel's construction decried the destruction of "the once-green parade ground with its border of almond trees" to build the structure (Northcroft 1912, 15). To him it seemed like a wound on the "torn and aching bosom" of the island. After completion of the hotel, however, its grounds never drew such lamentations. The re-created landscape seemed to surpass the former botanical splendor of the landscape. The hotel's landscapers carefully oversaw the cultivation of numerous tropical plants within its grounds. Within decades the hotel's cultivated grounds earned the distinguished designation as the only "botanical garden" in the Bahamas (*NG*, 8 April 1922). The classification of the hotel's environment as a botanical garden emphasizes the extent to which it physically embodied the ideal ordered tropical landscape. Interestingly, when the hotel was rebuilt (after a fire) in the 1920s, a "Palm Room" was added to the interior of the building and served as a ballroom for guests of the hotel and for the white elite (*NG*, 17 February 1923).

A popular postcard in Jackson's series of hotel photographs pictured the Royal Victoria Hotel, focusing mainly on its gardens (plate 14). Taken on the hotel's grounds from a low vantage point, unlike some of the earliest images of the hotel, the photographer foregrounded the roots and branches of the trees that surrounded the hotel's main structure. Visually obscured by the trappings of nature, especially a silk cotton tree, the travelers' accommodations appear situated amid nature on the island. Tourists often remarked on the spectacle of tropical nature that the Royal Victoria Hotel's grounds afforded them.[20] As Henry Villard attests in his history of the hotel, "The crowning glory of the Royal Victoria, sparse at first, was to be its world-famous tropical garden. Here the eye could eventually feast on 200 varieties of exotic plants, shrubs and trees, their focal point the huge silk cotton tree, or ceiba" (Villard 1976, 14). Another photograph of the Royal Victoria gardens taken by Jackson, for example, shows the wider manicured garden landscape punctuated by the silk cotton trees and the human signi-

27 William Henry Jackson, "Royal Victoria Gardens, Nassau, Bahama Island," photograph, 1900

fier of nature—a market woman (figure 27). A viewing platform is visible at the right of the image from which visitors could survey their visually ordered hotel surroundings. Although the hotels were located in a miniature "tropical landscape," it was very much a domesticated presentation of tropical nature, one that could be viewed from the vantage point and safety of the observation deck and the hotel's balconies.

Curiously, on the Detroit Photographic Company's postcard of the Royal Victoria Hotel's grounds, a traveler scribbled a handwritten message that Nassau had "alligators, crocodiles, sharks—and niggers to burn" (plate 14). Despite promoters' efforts to create a sedate image of a tropical environment, the postcard's sender heightened the wildness of both nature and society in the Bahamas, by making reference to "crocodiles" and "niggers" in the text. In fact, not only was the hotel's landscape crocodile

free, but it was also devoid of blacks. The hotel was racially segregated. Even vendors who tried to peddle their wares to the hotel's guests were reminded to observe the racial boundaries of the hotel. The hotel's proprietors would at times use a whip to disperse or quiet the sellers.[21] Although the hotel's owners took pains to control the presentation of nature and society in their grounds, the purchaser of the image still viewed the hotel's enclave as a place of tropical danger and adventure.[22]

Nassau's White Streets: Sights of Tamed Nature and Sites of Social Order The streets of the main city of Nassau qualify as the most frequently photographed and most representative sites of the island's picturesque charms. In less-obvious ways than hotel landscapes, streets also offered visitors an aestheticized and ordered display of nature. While in other locales the physical appearance of streets would likely not captivate photographers, image makers designated Nassau's streets as picturesque visual spectacles. Composed of crushed and sanded white limestone (until the 1920s), the streets of Nassau gleamed brilliantly in the sunlight, creating a stunning and even blinding visual effect. The city's streets even inspired Canadian poet Bliss Carman to extol their visual splendor in the poem, "White Nassau":

> I know where there's a city, whose streets
> are white and clean, . . .
>
> She's ringed with surf and coral, she's
> crowned with sun and palm,
> She has old-world leisure, the regal
> tropic calm:
>
> Unmodern, undistracted, by grassy ramp
> and fort,
> In decency and order she holds her modest court.
>
> (quoted in NG, 21 February 1921)

Nassau's white streets were not only a means through which to navigate the city's sites but were themselves also spectacular sights.[23]

Photographs in Stark's guide, approximately one-third of which focused on street scenes, indicate how white Nassau's streets became the nucleus of the island's image

world. Many streets and buildings within downtown Nassau appear in his guide, including Bay Street, Queen Street, George Street, Cumberland Street, Gregory's Arch, and the Queen's Staircase (all names belying the colony's faithfulness to Empire).[24] A road, christened Victoria Avenue in commemoration of the Silver Jubilee of the Queen (in 1904), offered a crowning display of Nassau's picturesque white streets. As one of Sands's photographs illustrates, the avenue was fringed with equidistantly positioned palm trees, providing the epitome of ordered tropical nature (plate 15). The trees, planted by a women's group calling themselves "The Daughters of Empire," offered an imperial picturesque vision of tropical flora.[25] The receding picket fences and nature-fringed archways that line the street reproduce and reinforce the perfect symmetry of the trees. The avenue, which opens along the entire front of the picture plane, invites viewers to take up visual residence in the landscape. Through such "picturesque avenues of trees" (Northcroft 1912, 20) tropical nature was represented in a tamed, ordered, and inhabitable form.

Significantly, the streets of Nassau were even more explicitly linked to the idea of order, social order. Tourism promoters also framed the whiteness of the streets as measures of the island's cleanliness and testaments to the colony's social organization. This was evident in Carman's "White Nassau" poem where she praised the "order and decency" exhibited in Nassau's streets. Governor Blake in his promotional article, after describing the beauty of the island's "wide streets shaded by rows of trees," also assured travelers that "nor is the attraction of Nassau confined to its picturesque aspect. It is one of the cleanest towns in the world. Built as it is on coral rock, everything lends itself to cleanliness" (Blake 1886, 177). To stress this point, Blake guaranteed visitors that the roads were swept daily and tended to with "scrupulous care" each morning. Blake's rhetorical move from describing the picturesque appearance of the streets to testifying about their cleanliness is significant in that the picturesque character of Nassau's streets was being offered as evidence of the cleanliness of the island. By emphasizing this quality, Blake aimed to dispel the islands' association with disease, which still lingered like an ominous cloud over attempts to image the isles as tourism resorts. In other words, images of Nassau's streets did more than picture these brilliantly white locales; they simultaneously promoted the island as a "safe" place for tourists.

The relationship between the icon of the streets and social order is even more explicit in Stark's account. In his guide Stark similarly progressed from describing the

picturesque scene that unfolded when "passing through the streets" to a discussion of the "orderly" appearance and quietness of the roads and the disciplined behavior of persons therein: "Nassau is a very quiet and orderly city. Strangers are much impressed by the absence of scenes of violence, drunken brawls, and profane, abusive and irritating language in public streets and places of public resort. In fact such offences are severely punished in Nassau" (Stark 1891, 107). He immediately went on to point out that the coral surface of the streets was maintained by prison laborers. He applauded the spectacle of "convicts . . . made to labor upon the streets, and the chain gangs in their white prison uniforms" because it "exert[ed] a moral influence which is widely and deeply felt" (107). The scene, supervised by the police, provided a shining example of moral order for residents and tourists alike. The orderly appearance of the streets stood as an indication of an upstanding social order on the island. Nassau's white streets became more than visual icons of the island's picturesque appearance. Their brilliant character was the very product of the colony's disciplinary and penal system.

Stark praised the police department, "with its efficient and fine looking black patrolmen," for "keeping the peace" on the island. One of the few images of black men in Stark's guide was a Coonley photograph of the island's police force (Stark 1891, 193) (figure 28). The subject matter and composition of the photograph reinforce the idea of order. Two rows of black men, one standing and the other kneeling, appear in perfect unison. They form a straight receding line, with feet, knees, torsos, eyes, and guns in a perfect alignment. They appear in uniform and with guns drawn to reiterate their roles as enforcers of order. The rare image of black men is also interesting in that the officers appear acutely aware of the camera, of being photographed. In addition to communicating their discipline in their posture and dress, the very process of posing for the camera served as another testament to the policed behavior of these "fine-looking black patrolmen." The white commander, who stands capped with a bowler hat, inspecting the policemen as they gaze at the camera, reinforced that even these officers (even as they policed) fell under the watchful gaze of colonial authorities. Indeed, the receding line of policemen seems to conform to the perspective of the bearded commander. Would tourists looking at the image assume the commander's viewing position, the only gaze directed into the scene in the photograph? Did the picture taker in the very act of producing the photograph and the consumer of the image participate in the process of disciplining blacks?

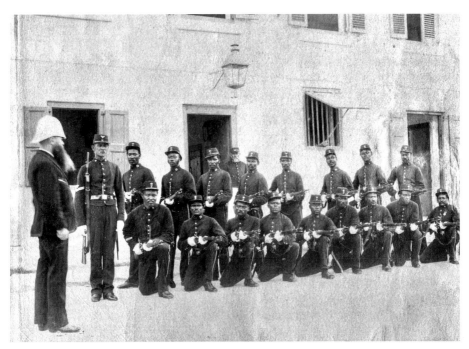

28 Jacob Frank Coonley, "Nassau Police Force," albumen print, 1889–1904

"Fine looking" Black Policemen: Representations of Black Discipline in the British Colony For colonial authorities, the white elite, and tourists, the figure of the black policeman was especially emblematic of colonial law, order, and protection within the predominantly black colony. The colonial government recruited the much revered police force from Barbados to replace members of the West Indies Regiment in the last decade of the nineteenth century.[26] Their mission was the preservation of "internal order," to use Governor Shea's terms (Johnson 1991, 114). By importing a force from outside of the country (Shea also considered bringing in Sikhs from India for this purpose) and housing them in separate barracks, the ruling elite sought to undermine any communal or familial ties these law enforcers might have with the local black population. Historian Howard Johnson argues in "Social Control and the Colonial State" that the constabulary force functioned primarily as a military organization that would suppress social unrest and

secondarily as a police force that patrolled the local population (112). In a way similar to the movement of recognizably "tropical" trees and cash crops, the Barbadian constables served as uprooted and transplantable markers and supporters of British imperialism.

Through representations of black policemen promoters cast the island's black population more generally as civilized British subjects. By presenting Africans and their descendants in police uniform, they stuffed myths of black savagery—even cannibalism—into an icon of British discipline. Many travelers, particularly American tourists, found it hard to reconcile Britishness with blackness. To them blacks speaking in a British accent or wearing British attire seemed comical, even absurd (Northcroft 1912, 58; NG, 8 June 1932). The black police, however, stood as proof that blacks could be assimilated into Britishness. They could be both civilized British subjects and civilizers of other blacks.

A black woman in particular, known locally as Miss Nottage, who frequently walked through Nassau's streets dressed in queenly garb, replete with crown and scepter, presented another popular icon of black Brits (figure 29). Frequently referred to in photographic captions as "the Queen of Nassau," Nottage personified the successful indoctrination of the colonized, that black inhabitants were such faithful and loyal British subjects that they aimed to perform the characteristics and accoutrements of the head of the British Empire. Nottage's unorthodox choice of attire, her persistent desire to transcend Nassau's racial and class hierarchies through dress, if nothing else, in many ways resisted the photographic representation of black females in industry-oriented images, even as she became a part of the visual economy of tourism.

Related to this interest in Britishness, colonial rule, and the black population, many tourists visited the courts in Nassau as a form of entertainment, watching the administration of justice on the island's inhabitants (Brassey 349; Mackie 347). As Defries remarked, "The Police Court in Nassau during the winter takes the place of a theatre for the tourists" (1929, 15). Many travelers also visited the old octagon-shaped prison as part of their site-seeing expeditions. Just as travelers made excursions to view "primitive spectacles," they also savored and photographed spectacles of black law and order.

Like the market woman who accompanied representations of nature on the island, the policeman and other images of black Britishness provided the human counterpart to Nassau's civilized and picturesque image (figure 30). In a photograph by Coonley entitled "Silk Cotton Tree" the key visual tropes in the island's tropical and picturesque

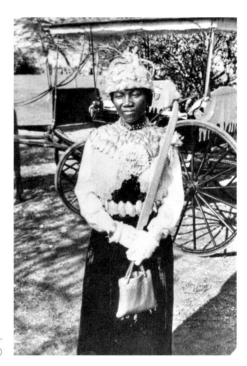

29 Photographer unknown,
"The Queen of Nassau," ca. 1930

genre stand together, illustrating the mutually constitutive relationship of these icons to the island's destination image. The photograph includes signifiers that image the colony as the realm of nature (as signified by the silk cotton and market woman) but nature controlled (as represented by the police who straddle the roots of the silk cotton). The market woman, policeman, and the silk tree all stand as intra-imperial elements of the tropical genre, providing ready-made images that visitors expected to see when they traveled to a tropical British colony.

The Picturesque, Colonial Order, and the Politics of Race on Bay Street Promoters affixed the different representational categories of the picturesque and the tropical onto different parts of Nassau's geography. They conceived of the black settlements as the realm of the tropical, where nature was disorderly in appearance and where tropical diseases lurked.

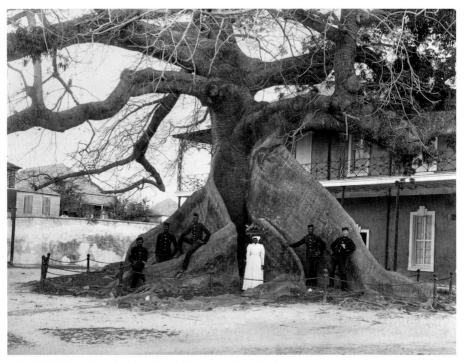

30 Jacob Frank Coonley, "Silk Cotton Tree," albumen print, 1889–1904

The predominantly white-owned business and residential areas of Bay Street offered a more picturesque, ordered, and gardenlike view of nature on the islands. These distinctions between the picturesque and tropical and their attachment to specific parts of the island would have important social and political repercussions. An exploration of the social contours of Nassau's racial landscape will allow a more careful mapping of the geography of picturesqueness and tropicality, its racial signification and significance.

The strict physical separation of the races evident in the Bahamas at the start of the twentieth century has few counterparts in the West Indies. Historians Michael Craton and Gail Saunders point out that Nassau's stark racial divisions more closely resemble the racial segregation of the southern United States than other Anglophone Caribbean islands, where British colonists never legislated segregation: "All Bahamian non-whites

suffered from segregation in housing, education, work, and ordinary social intercourse, and 'crossovers' were extremely limited" (Craton and Saunders 1998, 92). As Saunders and Craton describe it, "the ridge that separated respectable 'white' Nassau from the exclusively black settlements adjacent to the south and in the rest of New Providence was as marked a social divide as that formed by the sea between Nassau and the Out Islands" (101). Stark himself observed, "the coloured population of Nassau live apart from the whites, in the suburbs of the city called settlements" (Stark 1891, 186). Although in close geographic proximity, just "Over the Hill" was socially and politically miles apart from picturesque white Nassau.

The streets of the main city, the principal candidates of the picturesque in photographs, were primarily the business and residential areas of the island's white elite. At the beginning of the twentieth century the white elite was composed generally of two groups: the British colonial elite, including the governor, colonial administrators, and British settlers; and the white mercantile elite, locally born whites, some of whom descended from American loyalists. Together they controlled the political system through a locally elected assembly. As former magistrate and social critic L. D. Powles characterized it in 1888, "The House of Assembly is little less than a family gathering of Nassau whites, nearly all [of] whom are related to each other by blood or marriage" (41). The representative government they formed exercised a level of autonomy from London that was denied other Crown colonies ruled by Britain. In this respect historian Gordon Lewis distinguishes the Bahamas' white elite as "real ruling classes and not mere agents of the imperial centre" (Lewis 1968, 323). Although whites represented a numerical minority, only 10 percent of the population, through an electoral system based on property qualifications they easily controlled the islands' legislative bodies without interference from Britain or local challenge.

The white mercantile elite, in particular, were able to use their monopoly in the political system to consolidate, protect, and expand their economic oligarchy (and limit the size and power of the British colonials). Deemed in local parlance "the Bay Street Boys," this group established "a nearly absolute grip on the import and retail trades" (Craton and Saunders 1998, 95). The economically and politically powerful set of local white families (whose own interests would diverge from the British colonial elite, especially along the lines of race) became synonymous with the geographic space in which they worked and lived. While this group welcomed wealthy whites to join the family, it

maintained its racial integrity by refusing social relations with the colored middle class (Craton and Saunders 1998).

Although Nassau's racial boundaries were rigid, they were not impermeable. Indeed, the same property laws that disenfranchised many blacks opened the doors of political participation to landholding black and colored, mixed-race, males. As early as 1833, a free colored man, originally from Haiti, Stephen Dillet, was elected to the House of Assembly. By 1889 nonwhite representatives held 6 of 24 seats in the House (Craton and Saunders 1998, 96). That blacks held no more than one-fifth of the seats for the next fifty years, however, illustrates the limits of racial inclusion and representation in the islands' political system.

The Over the Hill communities of Grant's Town and Bain Town, designated as the tropical side of Nassau, were home to many liberated Africans and their descendants who, unlike other blacks on the island, owned land and therefore could participate, if only marginally, in the electoral process. In the face of Nassau's rigid racial and social hierarchies these communities formed many semiautonomous social, political, and economic institutions. They created friendly societies, many named after African ethnic groups, which simultaneously served as burial associations, insurance providers, and lending agencies, while providing social, cultural, and kinship ties within and across different ethnic groups in the black community.[27] They were also political organizations with elected leaders—positions of great prestige—who represented the needs of their constituents. Although Nassau's black and white communities necessarily overlapped given that many blacks worked for the island's mercantile elite, in other respects they lived in different social worlds in adjacent physical spaces.

The sites and icons of picturesqueness and tropicality conformed to Nassau's racial contours. Those locations designated as picturesque fell within the bounds of Bay Street and Shirley Street and the surrounding areas, between Fort Fincastle heading south from Nassau's harbor and Fort Charlotte to the west. A map included in Stark's guide delineates the physical parameters of picturesque Nassau (figure 31). Sites deemed worthy of aesthetic contemplation reside within the Bay Street circuit (above the ridge represented at the bottom of the etching). The island's black residential areas fall beyond the boundaries of his tourist map. The omission of these areas from a tourism-oriented geography and the relative absence of visual images of many aspects of these

communities highlight the strict erasure of Over the Hill from Nassau's picturesque ideal.

Bay Street and its surrounding residential communities formed what MacCannell might describe as the "stage set" or the front region of tourism, the spaces geared toward the traveler (1976, 100). It was the stage onto which tourists stepped as they disembarked from their ships and it formed the primary circuit of their site-seeing excursions. As a front region the Bay Street region was under constant surveillance not just by tourists, whose views of the island were frequently recorded in the "As Others See Us" column of the newspaper, but by local authorities who vigilantly aimed to control what travelers saw.

The tourist stage set overlapped with white Nassau beyond the coincidence of space. Socially tourism brought distinguished visitors to the island with whom the British colonial and local white Bahamian elites fraternized. During the late nineteenth century, white residents valued the presence of these wealthy and worldly travelers. As a "colonial outpost," as one former magistrate described it, the presence of prestigious visitors brought local elites a certain imagined wider importance, international currency, and participation in the British Empire and in modern society generally. Stark remarked on the endless hospitality of the white elite who so graciously opened their doors for the tourist (177). The hospitality they extended was mutually beneficial.

The fanfare with which the elite greeted the approach of the tourist season (then from December through April) betrays some of the social enthusiasm that surrounded the industry in white social circles. The local newspapers breathlessly anticipated the arrival of the first steamships and printed a list of arriving hotel clientele, along with where they were from. Celebrations in the hotels, like the annual balls in honor of Washington's birthday, were social extravaganzas for tourists and local elites alike. Papers chronicled these lavish affairs, detailing the type of costumes or garments guests donned. Bands and orchestras from New York and London entertained hotel guests and local whites with musical ensembles, which seldom graced Nassau's performance stages after the season. An Arts Centre also opened for the duration of the season, showcasing art and photography by visiting and local artists. For Nassau's elite circles, socially and culturally, Nassau was like a modern metropolitan center for the months when the tourists were in town.

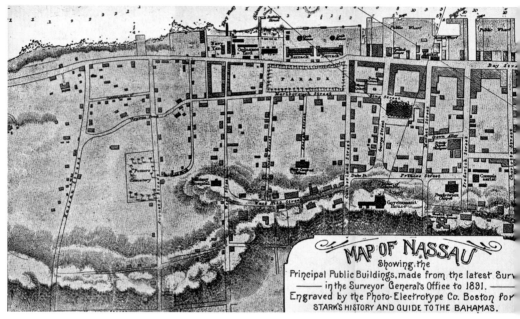

31 "Map of Nassau," ca. 1900

The local elites' social investment in tourism was not lost on some black politicians. In 1900, after taking stock of the first ten years of tourism development in the Flagler era (during a House of Assembly debate about the proposed extension of Flagler's contract with the government), W. E. Callender, an outspoken black politician, questioned the benefits of tourism to the colony as a whole. He suspected that local politicians so eagerly encouraged tourism for self-serving reasons. Callender charged that it was "a mistake to think that because a few benefited the Colony benefited. . . . Some would give him [Flagler] anything because of the plums and treats they got and because they could spend their evenings in the hotel in the winter" (*DG*, 30 May 1908). Callender was one of the few voices to challenge the premise underlying the government's backing of the tourism trade, that it would yield economic fruit for the colony as a whole. "A great deal was said about the poor people benefiting," he charged, "but it could not be denied that the cost of living was higher in winter so that in the end the poor man was no better

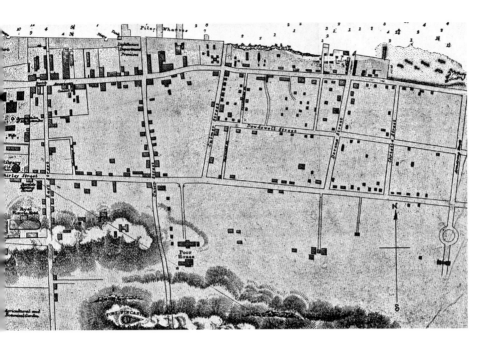

off." In Callender's estimation tourism yielded only "plums and treats" for those who spent their evenings as local tourists in the hotel.

Callender's address to the House was also rare in that he publicly raised the issue of racial segregation in Nassau's hotels, arguing that the government should not subsidize a hotel that denied access to the majority of the population. The practice further undermined the supposed common good of tourism. Although in Nassau three-fourths of the population was black, "not one coloured man was allowed to go into the hotel. It is a shame for the box to be allowed to stay in a British colony." Callender argued that "the box," Flagler's architectural monstrosity, and its policies of race segregation were anathemas in the British territory, affronts to Britain's official policy of racial democracy across the empire. Despite his protests, the white political majority passed legislation extending Flagler's contract for another ten years.

Significantly, the local elite's promotion of tourism was not only about socializing

with and profiting from visitors during the winter season but was equally invested in convincing these temporary sojourners to take up permanent residence. For elites tourism provided a subtle means of encouraging white migration. This unofficial mission of tourism promotion is explicit in the Development Board's publication of a book for "Intending Settlers" (Development Board [hereafter DB] 1919–20). The board encouraged travelers to purchase property and establish summer homes, ensuring that the social cache that these visitors brought to Nassau would continue on a long-term basis. One realtor in particular, Harold Christie, made a fortune selling " 'Paradise' Islands in the Southern Seas," as the *London Sunday Graphic* described it, to British travelers in the 1920s. He persuaded potential buyers that islands in the Bahamas were "the nearest approach to paradise you can get in this world" (NG, 25 August 1936). Interestingly, in marketing the islands for purchase, Christie recognized that "what appeals to people most of all, I think, is that once you are installed *you are monarch of all you survey*" (NG, 25 August 1936; emphasis added). In this way the traveler's gaze extended into a monarch's gaze of his or her own property. Christie's evocation of the term *monarch*, with all its associations with rule and order, is revealing in that travelers' desires for order could be implemented or fully realized when they were "installed" as master of their own territory. In a reinvention of the planter's appraisal of their picturesque properties, for potential residents land in the Bahamas acquired new value as possessable picturesque commodities.

PRODUCING AND POLICING THE PICTURESQUE IN THE INTERWAR YEARS

The selling of Nassau's picturesque landscape, as tourist sights and property, had social repercussions that reverberated beyond white Nassau, particularly when the numbers of tourists traveling to the island increased dramatically in the interwar wars (1919–39). By 1938 tourist arrival figures reached almost 60,000.[28] The legislation of the Volstead Act in the United States (1919), banning the production, importation, and consumption of alcohol, made the nearby Bahama Islands particularly popular vacation escapes for American travelers in the 1920s. When tens of thousands of visitors started to flood Nassau's shores inspired by photographs (or so industry supporters thought), how would promoters' efforts to ensure that the island lived up to its picturesque and tropical image

inform social space, especially in the front region of tourism? What were the social and political effects of these efforts on Nassau's racially segregated landscape and on the island's black inhabitants?

The Development Board and the Consolidation of Icons of the Bahamas In the 1920s, capitalizing on the newfound popularity among American visitors, benefactors of the travel trade moved to further consolidate and structure the tourism industry. Led by Governor Sir Bede Clifford (1932–37), the ruling elite oversaw and facilitated the building of new hotels (including the Fort Montagu), a golf course, a harbor, customshouse, and a warehouse on the dock, as well as updated and expanded telephone and telegraphic services, water, sewage, and electrical facilities. They also secured air services from Pan American airways and new steamship services through the Munson Steamship Lines (the company also took over management of the Colonial Hotel). Most of these infrastructural improvements affected the main thoroughfares of Bay Street, in particular, the locus of white businesses, hotels, and main sites of tourist occupation.

Another manifestation of the increasing organization of the tourism machine was the constitution of a government-funded promotional board rather optimistically called the Development Board in 1920 (first authorized in 1914). The primary aim of this agency was the marketing of the island through international publicity. The board, composed entirely of Nassau's mercantile white elite, assumed a very powerful position in Bahamian society as the islands grew increasingly economically dependent on tourism. By the 1930s the colony relied so heavily on the tourist trade for its future development that Governor Clifford concluded that the colony had to choose one of two economic fates—tourism or bankruptcy (Saunders 1997, 23). By 1939 the House of Assembly committed 12 percent of the colony's income to the Development Board (or in numerical terms approximately £50,000), reflecting the confidence placed in tourism and the overseers of the industry (DB 1939).

Empowered by one-eighth of the colony's fiscal budget, the Development Board systematized the island's image-making machinery. Expressing confidence "that pictures will sell Nassau more effectively than anything else" (NG, 25 September 1935), they increased the production and visibility of Nassau's touristic image. Through the placement of photographs in exhibitions, albums, colonial expositions,[29] passenger ships,[30] art galleries,[31] colonial offices,[32] tropical balls,[33] store-front windows in metropolitan

cities,[34] and "class" periodicals,[35] the board further developed and disseminated the island's touristic persona. The board also published its own illustrated periodical, the *Nassau Magazine*, which it distributed to various travel agencies and also planted in the waiting rooms of doctors' offices on Park Avenue. In these multifaceted campaigns the board frequently seized on the visual lexicon of the islands developed in the first decades of the tourism industry.[36] Tropes such as street scenes, policemen, and market women were further "sacralized" as defining icons of the islands (MacCannell 1976, 45).

Although the Development Board reproduced many of Nassau's long-standing picturesque sites, its photographs reveal a significant new trend in photographic representations of Nassau: tourists at this point began to have a presence within the landscape of the island. Whereas in the late nineteenth century and the early twentieth century photographers seldom pictured tourists within industry-oriented photographs of the island, they occupied a central space within the iconic sites of Nassau in the 1920s and 1930s. A postcard by P. M. Lightbourn, a local photographer whom the board retained in 1934 (DB March 1934), provides an example of these trends (plate 20). In the postcard, captioned "Just a Pause under the Royal Poinciana Tree, Nassau, Bahamas," the same sites and visual formulae from the late nineteenth century appear—a mule-driven dray on the island's streets surrounded by a Poinciana tree. Instead of black "native" inhabitants, however, a white female appears poised on the carriage's edge, holding the hand of a white male companion. In the image all the ingredients of the island's premodern and tropical landscape remain, but the inhabitants of the landscape have changed to tourists. In a later postcard, reproducing a scene similar in composition and subject matter, the white male was replaced by a black policeman (plate 21). The image attests that when natives did appear as inhabitants of picturesque Nassau in the Development Board's representations, they were the island's "picture-perfect blacks," so disciplined that they could be trusted with the hand of a white female tourist.

The addition of tourists to iconic island scenes may be the result of the Development Board's encouragement of what it dubbed "social photography," photographs of travelers, capturing them in situ in the islands (DB March 1934). The board reasoned that picturing persons, "particularly titled persons," enjoying their touristic experiences in the island would go far in advertising the islands abroad. Generally it is possible to date tourism-oriented photographs to the 1920s or later based on whether tourists appear in the representations. More broadly, this representational shift signals a pictorial and

social initiative to nativize the presence of tourists (desired future settlers) within the landscape of the Bahamas, as Bahamian society became increasingly oriented toward this group.

In approximately 30 years of the publication of the *Nassau Magazine*, from the 1920s to the 1950s, with the exception of waiters, entertainers, and policemen, blacks rarely graced the pages of the magazine. So at the same time that tourists gained a representational presence in images of the island, black Bahamians did not occupy a pictorial position in the island's destination image (or occupied a very particular configuration in touristic representations). In other words, whereas white tourists were socially naturalized as parts of the Bahamian landscape through "social photography," blacks were pictorially dispossessed from the island's environment by hardly being pictured at all.

"Tourism Improvements," or Making Nassau as "It Is Represented to Be" In the 1920s and 1930s members of the Development Board changed more than the inhabitants of Nassau's tourism-oriented photographs; they transformed Nassau's landscape in the image of these picturesque and tropical representations. These initiatives were presaged by Stark in a letter the author directed to tourism industry promoters on the island in 1913. Although he devoted much energy in his guide to describing and exhibiting photographs of Nassau's picturesque and tropical splendors, he later wrote to the local newspaper, recommending the implementation of several measures that would make the island look more tropically picturesque. The letter ran under the title, "The Improvement of the City: Words of Advice from an Old Visitor to the Bahamas" (*NG*, 12 March 1913). Stark proposed that the main landing dock for incoming passenger ships should be made into a "tropical garden." He specifically recommended that this garden should look like the Colonial Hotel's grounds. The placement of a tropical garden within one of the first spaces of touristic encounter with the island would allow visitors to see immediately the utterly different yet orderly forms of tropical nature many travelers expected in a "tropical environment." Visitors like Stark would immediately be met with the "picture" of the island that many of them had in their imaginations.

Stark also felt that Nassau would benefit from a botanical garden "where plants and trees of every description that are of value should be propagated and given to the peasantry." Paradoxically, in his guide Stark had previously described the whole island as

a botanical garden, which exhibited natural forms that metropolitan travelers "might find in a conservatory" (Stark 1891, 106). Stark's earlier writings and his "improvement" schemes demonstrate the complex relationship that developed between touristic images and the actual physical landscape of the island. Travelers set forth requests or demands that the island should perform its picturesque and tropical photographic character. The landscape was held increasingly hostage to the ideals propagated through the island's destination image. As a result, Stark, who had already advertised the island as tropically picturesque, later encouraged changes to make the landscape conform to his earlier already tropicalized description.

Stark, in addition, called for the establishment of a local "Improvement Association," composed of "a half-dozen efficient members . . . for the purpose of making Nassau more attractive to visitors." His words of advice did not fall on deaf ears but immediately struck a chord with the local newspaper editor, Mary Moseley. She "gladly endorsed" Stark's recommendations (*NG*, 12 March 1913). The immediate public advocacy of Stark's proposals illustrates how the vision of an "old visitor" for the colony started to reverberate in the social space of the Bahamas, informing "improvement schemes." It is possible that the seeds for the Development Board (founded the year after Stark's letter was published) were planted in Stark's call for an Improvement Association.

Regardless of its derivation, when the Development Board was established, it was not only a publicity machine, but its mission rested in "affecting improvements in the appearance of the streets and adding to the attractions for the entertainment of visitors" (*NG*, 30 December 1924). In many respects the island's turn-of-the-century photographs provided the visual measuring sticks for these "improvements." The board's directive revolved around making Nassau conform to the image that had become sacralized through decades of tourism advertising campaigns. Moseley, who became a member of the Development Board, made this imperative explicit when she admonished, "[It] is all very well for the Development Board to advertise Nassau as a 'Land of Delight' and a 'Nature-Blessed spot,' . . . but efforts must be made to make Nassau appear as attractive to visitors as it is represented to be" (*NG*, 13 February 1923). The board was thus charged with making Nassau physically mirror the island's destination image.

Making Nassau a "Nature-Blessed Spot" One of the mainstays of the island's touristic image was its reputation as a place of bountiful and strange tropical vegetation. In contrast

to this ideal of tropical abundance, however, as "The Observer" (a columnist in a local paper) pointed out in 1913, the streets most commonly traveled by tourists were, "well nigh the dreariest roads one can imagine, [where] there ought to be [the] most beautiful tree-lined and shaded drives around the island . . . reaching every spot of interest in the island. Instead of 20 miles of narrow scrub-lined roads that an automobile can cover in an hour" (*NG*, 8 February 1913). The writer rallied for citizens to make "the dear island the loveliest spot in the West Indies, and in all the wide world" (*NG*, 8 February 1913). "Our islands," the columnist submitted, "should be made park like drives, *flanked with typically tropical trees*, such as Cocoa and Royal Palms, Mango, Sapodilla, Silk Cotton etc. In bends and view spots there should be groupings of decorative plants, rest groves of clusters of trees, and vista points arranged with a charming, restful and picturesque effect" (*NG*, 8 February 1913; emphasis added). In the writer's estimation displays of "typically tropical trees," including royal palms and silk cottons, should be arranged in bends and view spots to have a picturesque effect. The Observer, whose pseudonym recalls the prevalence of local surveillance in the industry, aimed to transform the island into an orderly picturesque landscape.

By the 1920s, in response to many calls to "Beautify Nassau," to cite the title of an article, the island's industry promoters embarked on a number of landscaping schemes to make the island look more "nature-blessed." They transplanted tropical trees, of the variety the Observer inventoried, along many streets throughout the island (importing some plants from Jamaica's botanical gardens), especially in the Bay Street and northern parts of the island (*NG*, 6 July 1924). The landscapers arranged these botanical specimens "with the intent of so blending the colours of the blossoms that a regular and most effective display can be attained" (*NG*, 9 March 1934). Local converts to the cult of tourism also commenced an annual Arbor Day and sponsored local gardening competitions (*NG*, 27 September 1924; *NG*, 7 July 1921). They fervently believed that "of the advertisements which Nassau has to offer there is no more effective one than a proper exploitation of these natural beauties of our flora. There are those who travel far in order to regale [in] their artistic sense of the beautiful" (*NG*, 9 March 1934). Through these initiatives Nassau, which had previously escaped the process of extensive tropical transplantation during the period of slavery, was drastically transformed in the service of another industry, tourism.

Given the high touristic value placed on tropical flora, it is not surprising that one

of the key iconic signifiers of the island's tropical nature, the silk cotton, would assume great importance in the Bahamian landscape. In 1924, when an advertiser placed a sign on the silk cotton tree, likely having recognized the captive viewership that the tree attracted, the Development Board met the act "of vandalism" with immediate criticism. The board, as protectors (and perpetrators) of the iconicity of the islands, promptly called for the removal of the sign (*NG*, 7 August 1924).

The placement of the sign on the silk cotton tree drew censure because critics deemed such evidence of commercialism "too modern." "In a town like Nassau," one letter writer argued, "it is essential that the appearance of the streets should not be modernized" (*NG*, 7 August 1924; see also *NG*, 14 September 1927). The sign visually obstructed the premodern and natural appearance of the island. In line with earlier promoters' assurances that the island did not display signs of modernity, tourism supporters also moved to protect or reinforce Nassau's premodern status. Newspaper reports detailing the social life of the tree (when it got a disease or when someone put a sign on it), however, demonstrate what an important place the silk cotton assumed in the life of the colony (*NG*, 3 December 1921; *NG*, 14 September 1927).

Modernity via the Premodern: Preserving and Producing Nassau's Old World Charm This safeguarding of the island's premodern image presented authorities with, as one writer described it, "a very delicate problem" (*NG*, 12 May 1928). Certain modern infrastructures needed to be put into place for residents and tourists alike, but Nassau's destination image was constructed on its premodern appearance, as the overpainted electrical lines in Sands's postcard demonstrate. "Nassau is essentially attractive by reason of its old-world charm, its general atmosphere which is redolent of the past, ignorant of the present, and regardless of the future" (*NG*, 12 May 1928). Thus no modernization scheme should blemish the "old-world charm" of the island.

Another writer to the *Nassau Guardian* argued that essential utilities like electricity should not "blot" the beauty of the city: "the climate may be extolled and the bathing may be cried up but the greatest attraction will always be the wonderful colouring of the sea and the colours and picturesqueness of the town. The greatest care should be taken to preserve the latter and the artists are emphatic in the opinion that the unsightly electric lines should be removed" (*NG*, 28 March 1921). While in other contexts, the opinions of local politicians or civil leaders may be appealed to in support of infra-

structural changes, in the case of the tourism-oriented Nassau the "emphatic opinion" of artists, traveler artists, carried heavy weight.

Frequently, the Development Board and the Board of Works, the government department charged with supplying public utilities and roadworks, stood in different corners on this "delicate problem." While the Board of Works serviced the public's water and electrical needs, the Development Board served as guardians and gardeners of the island's premodern appearance. When the Board of Works proposed a power station on the wharf in the downtown area near Vendue House, a former auction house and market, the Development Board criticized the measure as "colossal vandalism" by perpetrators "who care not a jot about the importance of 'conserving the beauty, quaintness and attractiveness of Nassau' " (*NG*, 30 May 1908). When Works constructed a wall near the silk cotton tree, the Development Board lampooned the lack of aesthetic sense (*NG*, 20 June 1922). When it erected an "ugly stand" in the vicinity of a "the picturesque landmark," industry promoters decried that the Board of Works had "completely destroy[ed] the beauty of the scene" (*NG*, 30 May 1934). The clashing portfolios of these boards evince the debated and conflicted status of the tourism campaigns even within the same government; different departments often envisioned the island's modernization and tropicalization in opposing ways.

Differences of opinion regarding the Development Board's improvement schemes also sounded in the local press. One letter writer to the *Nassau Guardian* made the astute observation: "It is, of course, very proper that the Bahamas should be made attractive to winter visitors and that everything possible should be done for their comfort and pleasure, but is it not high time that the comfort of those who are *resident* in these islands should be considered?" (*NG*, 13 March 1924). Another commentator pointed to the lopsided expenditure on the welfare of the temporary visitor versus the local resident, complaining, "We spend £400,000 to attract tourists here and on the other hand do nothing to exterminate mosquitoes and ensure the health of the community" (*NG*, 16 June 1923). These complaints demonstrate that while some residents were not averse to expenditures for the pleasure of winter visitors, they felt that these efforts should not take precedence over the health of the island's resident community.

These concerns that Nassau should remain premodern in appearance seem particularly paradoxical even from the standpoint of the Development Board, since many tourism advocates publicly supported the industry based on the anticipated modern

improvements the trade would bring the colony. Since the 1890s, tourism supporters maintained that there was "no better scheme for the improvement of the condition of our people" (NG, 9 April 1898). The very name "Development Board" reflects these redemptive beliefs in tourism as the vehicle of progress and modernity. Yet, recalling Edith Blake, promoters precisely cast the island as unaffected by progress.

Paradoxically, most modern utilities, like electricity, came to the island first to service the industry. In 1889 the Royal Victoria Hotel became the first building on the island to display the modern wonder of electricity. Nassau's white elite gathered on the building's grounds to witness the turning on of the hotel's lights. The image that the newspaper report paints of the upper echelons of society dressed in their finest watching the momentous bringing of electricity to the island illustrates the blinding faith the elite had in the industry and the modernity that it would bring to the island (NG, 21 January 1899). It is also significant that the utility's first use was to light a hotel for visitors, instead of being directed toward a more publicly accessible structure or space. Rather, it was used to light a building on the forefront of the "tourist stage." Of course, to the island's elites, blinded by the glamorous flash of tourism, the projected modern improvements and economic gains from tourism were socially beneficial to the island on the whole.

Hence, while tourism enthusiasts encouraged certain aspects of modernization to add to the comfort of the visitor, they frowned on any modern improvement that detracted from the picturesqueness of the island. Tourism brought with it the dream of modernity and modern infrastructures, but such "advancements" had to be wrapped in a premodern guise. Ironically, by the 1920s and 1930s the colony's future development suddenly depended on how much it could mask its modernity. In this way the islands became frozen in time, like a photographic image, as a world "resonant of the past."

An interesting cycle developed whereby (unobtrusive) modern improvements were made on spaces that housed or catered to tourists and the island's local elites, while the rest of the island languished in a premodern condition, especially the black districts of the island. In the 1920s, as Saunders observes, "despite the great advances in health and material conditions in down-town Nassau, sanitary and health conditions for the majority of the population remained dismal until the 1960s" (1997, 29). In short, tourism enthusiasts sank government revenues into the modernization of major spaces of tourist occupation in particular, while the rest of Nassau and the surrounding islands of the Bahamas languished in comparatively poor living and social conditions. No wonder

that a contemporary observer from the Colonial Office, S. E. V. Luke would discover as late as 1950, "behind Nassau's picturesque façade old-world streets and the princely mansions along the East and West shores are slums as bad as in any West Indian Colony, and far worse than anything Bermuda can show" (Luke, quoted in Saunders 1997, 30). Indeed, underdeveloping the Over the Hill communities was in keeping with industry promoters' much-touted tropicality, their tropical difference and primitiveness.

Marketing the Market Woman: On Becoming Color and Light These tropicalizing campaigns extended beyond the landscape to its inhabitants, who were also ensnared in the Development Board's efforts to bring the island's destination image to life. Unsurprisingly, the board's chairman called on market women, the longtime human companion of the tropical landscape, to perform the role of tourist icon. In 1936 he asked the local Vendor's Union, composed of women who sold goods in Rawson Square (located near the tourist-frequented ports), to "purchase coloured umbrellas to shade their stalls. At his suggestion also the vendors have had uniforms made of brightly coloured plaids and are wearing gay Madras bandannas; thus a picturesque setting for the sale of native wares has been created" (DB 1936, 20). These measures set out to make market women even more colorfully picturesque in appearance. Recalling Cooper's observations that Winslow Homer's paintings of black market women were primarily an exploration of color and light, the addition of "coloured umbrellas" and "plaid clothing" rendered the market women more faithful to these color-saturated images.

The agency did not confine its initiatives to the vendors' colorful appearance; it also espoused that the market women should exhibit a certain type of behavior. Vendors should, the board stressed, be "polite and courteous, to preserve order and keep the grounds clean" (DB 1936, 20). The vendors' surroundings should also be "picturesque": orderly and clean. The Development Board's charge to the vendors' association evinces further that what promoters deemed worthy of being like a picture or a suitable attraction for the tourist's gaze was inextricably linked to the idea of order and cleanliness. This seems especially the case when aspects of the island's black population entered these regimes of representation.

Market women were not the only inhabitants costumed to be picturesque: the board also employed black men to dress in West India Regiment costumes and stationed them near popular tourist sites (*NG*, 7 September 1927). It is curious that the primordial icon

of black order, the soldier rather than the constabulary force, was enacted as a tourist spectacle. Perhaps the men dressed in West India Regiment costumes served simultaneously as an icon of the past, a picturesque site, and personification of black discipline.

Cleansing and Controlling Nassau's White Streets These preferences for, or what can more rightly be described as obsessions over, order and cleanliness explicitly came to bear on the island's picturesque streets, the gleaming emblems of Nassau's visual charms. The issue of preserving and policing the appearance of the city's streets, and inhabitants therein, became the paramount concern of tourist advocates in the 1920s and 1930s. More articles were devoted to this subject than any other in the local *Nassau Guardian*, the organ of the white elite.[37] More than simply serving as the visual centerpiece of tourism promotion, the doctrine of maintaining and enhancing the picturesqueness of Nassau's streets became a governing social, political, and economic philosophy.

Before the tourist season began every year, the rhetoric of cleansing the island, particularly its streets, ran throughout the local papers. As a columnist in a local newspaper prepped readers, "the winter season is approaching and it is well for one and all to think of putting our house in order. Not that everything is to be done because of the visitors, but, after all, we do want to attract visitors to our islands, and it is by giving thought to the details that contribute to comfort, cleanliness, health and beauty that we can best retain and increase tourist traffic" (*NG*, 28 September 1922). "Every blot in the city should be removed," chimed another writer on the eve of tourist arrivals. "Nassau cannot afford to be careless" (*NG*, 30 October 1934).

Some self-appointed guardians of Nassau's white streets set about the task of reporting on any affronts to the island's picturesque thoroughfares. The placement of an "unsightly wagon" on "one of the most picturesque residential streets" (one "admired by tourists") drew protest (*TR*, 23 February 1921). The appearance of "filth" in the island's streets summoned a chorus of complaints: "We have referred to it time and time again in our columns and it would appear from the disgraceful condition on our principal streets that the combined carelessness of the householders, shop keepers and street sweepers is more than the scavenger can deal with" (*NG*, 18 January 1921). When local residents' criticisms failed to inspire "the proper authorities" to action, letter writers would pull out of their arsenal a traveler's indictment of the streets: "It is extremely distasteful to us to have to be continuously drawing attention to these matters . . . but many of our old

visitors have remarked on the difference in the appearance of the streets" (*NG*, 25 January 1921). An "old visitor's" criticisms of the island's streets, how the much-courted traveler negatively viewed the island, carried additional political weight. Interestingly, several protectors of the streets signed their letters simply as "A Lover of Cleanliness" (*NG*, 28 September 1922) or "White Nassau" (*NG*, 28 June 1918). The use of these pseudonyms erased the personal and singular perspective of the author, attributing the cause to some higher moral order, an idea to which all government agencies and all lovers of cleanliness should subscribe.

The virtues of cleanliness and orderliness applied not only to the cosmetic appearance of Nassau's white streets but to the behavior of the island's black inhabitants within them. As the Development Board's publicity director, Major Bell, stressed in regard to the expansion of tourism marketing to Canada in 1936, the board should " 'Sell Sunshine to Canada,' and to tell Canada that we are clean, sanitary, and sunny, that we are in every way British in our conduct" (*NG*, 12 May 1936). In Bell's assessment, continuing a trend in tourism that had been in force since the nineteenth century, "conduct" was as much a selling point in tourism as cleanliness and sunshine. Given the companion interest in conduct and cleanliness, perhaps unsurprisingly campaigns to maintain Nassau's streets extended to policing the conduct of persons within the spaces of white Nassau.

Stark's "improvement schemes" also presaged this development, this interest in transforming the ethnoscape as well as the landscape. The fastidious travel writer also recommended that human beings who begged or presented an unsightly spectacle for visitors should be removed. A legless man, in particular, who was a regular feature on the streets of the city, Stark maintained needed to be "put into some institution." "It is not a pleasing sight to visitors to see two stumps of legs thrust before them every time they go out for a walk." This cavalier logic that inhabitants should be banished from the landscape for the sin of "unsightiness" found new application among defenders of Nassau's clean and orderly image.

Throughout the 1920s and 1930s the legislature, frequently at the urging of the Development Board, institutionalized the control of local residents in the streets in the vicinity of Bay Street based on the rationale that the island had to maintain its picturesque touristic image. Beggars and loiterers (who were invariably black persons) were picturesque enemy number one. Many of the measures aimed to remove these twin

offenders from tourist-frequented, and lest we forget, white elite areas. A 1935–36 Development Board report about begging and loitering urged that "Eternal vigilance and firm action is required if certain things are to be eliminated and kept out of the community" (DB 1935–36). The Development Board mobilized the police, that icon of touristic safety and British conduct, to rid the streets of such persons. In 1937 the board reported that "extra constables [had been] employed when cruise ships are in port . . . to mitigate possible annoyances, such as begging by children" (DB 1937, 8). Newspaper editors supported these initiatives, since visitors complained "of black urchins begging them in Nassau . . . the police must keep them over the hill" (NG, 2 August 1930). It is possible that begging presented not only an "annoyance" but also an indictment more generally of the British colonial society. Beggars, especially legless ones, were stubborn visual reminders of the failures of post-Emancipation society to meet the economic, social, and health needs of the population that lived beyond the picturesque facade of Bay Street. By keeping them over the hill, white Nassau could preserve its picturesque image.

Beggars' unrelenting pursuits of tourists were also testament to the failure of British governance, its inability to control conduct. In addressing the problem of disorderly beggars one tourism supporter proposed that they should be properly instructed on how to act. They should be taught, for instance, to display the appropriate signs of gratitude when visitors were kind enough to offer them "coppers," as many tourists described their offerings to beggars (NG, 30 March 1935). Through such measures beggars, who presented an affront to the island's disciplinary image, could be properly reformed. Even beggars could become exemplars of the island's British conduct.

Promoters' efforts to remove or reform offenses to tourists' visual experience of the island extended to the control of sound. A local columnist called for authorities to abate street noises from gangs of laborers, stating, "Nassau must have clean quiet streets if it is to be a first class tourist resort" (NG, 11 January 1936). The Development Board also "approached the Commandant of Police with respect to the annoyance caused by bootblacks, the use of profane language on the streets and the tooting of cabmen, the Board being of the opinion that the remedying of the above would further enhance the reputation of the Colony as a winter resort" (DB 1920–21, 5). Even the music emanating from a friendly society dance hall onto the streets was sanctioned in a "civilised community, and also for the sake of encouraging a desirable class of Tourist to visit our shores" (NG, 17 March 1909). This inventory of calls to "quiet" a range of activities engaged in

by blacks demonstrates that any practice deemed antithetical to "encouraging tourism" could be criminalized or subjected to social controls.

Many of these measures to "enhance the reputation of the colony as a winter resort" for "tourists" reified the racial boundaries that separated white Nassau from Over the Hill. Although promoters concentrated their cleansing landscape campaigns on the picturesque parts of Nassau, namely Bay Street and vicinity, their focus on human reform and removal targeted the island's black inhabitants, those who physically or musically made incursions into white Nassau. Almost in keeping with the relative absence of blacks in the Development Board's advertising campaigns, some black Bahamians were removed from the main tourism thoroughfares. Through these initiatives Nassau's long-standing racial boundaries were not only reinforced but also rationalized and naturalized as necessary for the common good of tourism promotion. The mantra of keeping Bay Street picturesque became an indefensible strategy, which deepened firmly entrenched racial segregation and justified the imposing of social controls on the island's black population, particularly its working class ("bootblacks," "laborers," "cabmen"). Even the semiautonomous friendly societies were not immune to its sanctions. In this way creating Nassau's touristic image was as much about promoting the island abroad as it was about the local politics of race. Creating and protecting the island's picture-prefect persona allowed the maintenance of the status quo. In the context of racially stratified Nassau, hegemony wore the guise of the picturesque.

The self-serving logic of the elite's use of the picturesque to reify and strengthen racial boundaries in the name of tourism is epitomized in their efforts to maintain segregation in hotels, the other locus of the island's picturesqueness. Although segregation had long existed in many parts of the public sphere, from schools to theaters, nowhere did the ruling elite legitimize the practice as essential to the economic well-being of the island more than in hotels. Local white elites again laid out the trump card of tourist expectation, specifically American tourists, as the raison d'être for the segregation of hotels and other spaces on the tourist stage. Simply put, white American tourists did not want to be in the company of blacks. In the interest of meeting the desires of these visitors and maintaining the economic lifeline of the colony, segregation in hotels had to be maintained.

As the number of American tourist arrivals increased in the 1920s, elites with the aid of American hoteliers hardened Nassau's already palpable racial boundaries. "Nas-

sau's hotels were even more rigidly segregated than ever before" (Craton and Saunders 1998, 244–45). The mercantile elites found an ally in American steamship-line owner and hotelier Frank Munson, whom Saunders and Craton describe as anti-Semitic and negrophobic. Munson purchased the New Colonial Hotel in 1922 and not only supported racial segregation among the island's guests (local residents and tourists alike) but also refused to hire black workers. The New Colonial Hotel, as was the case with the Royal Victoria Hotel, imported most of its staff from New York or hired (presumably light-skinned) Cuban and Latin Americans for all but the most menial jobs (*NG*, April 4 1928; Craton and Saunders 1998, 245). The hoteliers banished blacks from leisure and work in the island's enclaves of picturesqueness.

These policies drew protest from black inhabitants, tourists, and British colonial administrators alike, although the white mercantile elite would successfully shield themselves from criticisms behind the island's picturesque touristic image. A group of black Bahamians, led by Cleveland Eneas, formed the Citizens' Committee, the first organization (so they believed) devoted to eliminating racial discrimination and segregation in 1951. Perceptively, Eneas critiqued the ruling elites' equating of the black race with bad behavior and their implementation of policies of segregation instituted in the name of preserving touristic order. "In our town, the insults leveled against us, brand us all as being ill-bred, ill-mannered, and lacking in good behaviour" (*CT* March 1951, n. p.). The committee "begged the help of every citizen [black and white] . . . to destroy race discrimination" (*CT* March 1951, n.p.).

The Citizen's Committee's calls for support were answered by an unlikely ally: British colonial administrators on the island and in London. Throughout the 1940s and 1950s, policies of racial discrimination in Nassau's hotels increasingly became an embarrassment to British colonial administrators, especially when several international diplomats and officials found themselves subject to Nassau's racial segregation policies. Although segregation still existed in parts of the United States at the time, as a part of the British Empire, the racial segregationist polices in Nassau were viewed by some members of British Parliament as an affront and threat to the purported racial democracy of their colonies. Even pressures from the House of Commons did not persuade the white elite to change their policies; they adamantly maintained that "the colour bar was essential to the [American] dollar tourist trade" (*DE*, 17 December 1953). Letters written by tourists who wanted "to meet people of various countries and colours" (*TR*,

6 January 1956) did not dissuade them from their course of argument. That Miami was racially desegregated without losing tourist revenues also failed to compel changes in discrimination policies (*TR*, 10 January 1956). These various voices of dissent, which did not grow loud until the 1940s and 1950s, demonstrate that practices of segregation purported to be for the tourist trade served the purposes of the white elite, who for decades successfully warded off challenges to these policies of racial discrimination by refracting them through the rationale of maintaining the island's much vaunted picturesque image.

Africanisms in Picturesque Nassau? Photographing and Taming John Canoe Directly connected to the obsession over Nassau's orderly and picturesque image, the annual masquerade, John Canoe, long held in the Bay Street district, also drew criticism from the white elite and from segments of the island's growing black middle classes in the 1920s and 1930s. Letter writers to the *Nassau Guardian* complained that the presence of John Canoe in this main thoroughfare was antithetical to Nassau's orderly touristic persona. One commentator asked plainly whether John Canoe could be allowed to persist in "a well-ordered town" (*NG*, 26 December 1934). Another asserted that during the event, "it was hardly safe for women and their children to be out upon the streets" (*NG*, 27 December 1933). The presence of black masqueraders on Bay Street also offended the sensibilities of members of the colored middle classes. Dupuch, a champion of black inclusion in hotels and editor of *The Tribune*, also conceived of the parade as an event wherein "the customary noise of horns, bells and drums and the grotesque masqueraders disported themselves along Bay Street with an energy and vigour" (Bethel 1991, 41) and called for an end to the ritual. His use of *grotesque* and *distorting* cast the Junkanoo participants as oppositional and antithetical to a presumed normative ideal of the island.

For many writers to the local papers the presence of these black masqueraders from Over the Hill—with their costumes of rags, masked identities, and "customary noise"—in the main white business district and tourist stage posed a two-pronged assault on Nassau's picture-perfect, clean, orderly, and British image. During the parade black lower-class inhabitants inserted themselves and their traditions and music (associated with Africa in the minds of the elite, and perhaps in the minds of the parade's participants as well) into the heart of racially segregated white Nassau. It was not the simple fact that the masqueraders performed the "African ritual" that drew consternation; it

was precisely *where* they chose to perform the masquerade that was the subject of criticism. The editor of the *Nassau Guardian* suspected that the use of Bay Street held some special significance for the performers: "Is it essential to the full enjoyment of those who take part in the aboriginal exhibition that its performance must take place in Bay Street? Almost we believe that this very fact gives spice to the occasion; almost we believe that if the mummers were asked to mum and posture and scream and jangle their cow-bells and render the night hideous in another part of the town, the occasion would lose a great part of its importance in the eyes of participants" (*NG*, 27 December 1933). While the editor condoned "ordered enjoyment," she argued that the "undisciplined, unlicensed, unlovely displays" of John Canoe should not be allowed to persist on Nassau's main streets (*NG*, 27 December 1933). John Canoe became so contested because competing visions of the island clashed with its occurrence: touristic ideals of order, British conduct, and whiteness went head to head with a black-Bahamian tradition long denounced precisely for its disorder, its "Africanness," and its transgression of racially segregated Bay Street.

Perhaps the editor was astute in her observation that the occupation of Bay Street in particular was intrinsic to the significance of the parade. The performers did annually leave their communities to take the masquerade into the main streets of the city. It is tempting to speculate that the racialized segregation and policed environments of Bay Street made this space an especially enticing target for participants. Regardless of the participants' motivations for occupying Bay Street in particular, the response to this incursion of the black inhabitants in this space is of interest here. The island's white elites viewed the parade as bringing disorder into the main thoroughfare and called for its prohibition on these grounds. Consequently, throughout the 1920s authorities attempted to ban the parade under the auspices of the Street Nuisances Act (1889).

By the 1930s some promoters would cast a more favorable eye on the John Canoe parade, despite continued local denunciations. The more generous appraisals of the event stemmed in large part from what they perceived to be tourists' tastes for "tropical" performances, black cultural performances that provided a mix of Africa, the primitive, and exotic in various doses. Since the 1920s, black culture and music had been in vogue from the stage of Les Folies Bergère in Paris, where a banana-skirted Josephine Baker performed, to the pit of the Cotton Club in Harlem, where black musicians appeared in front of a jungle backdrop. Indeed, the fame of Bahamian performers on the interna-

tional entertainment stage may have led some tourism industry promoters to reevaluate what they had until that time referred to as "noise" or "racial instinct" as culture, a marketable product. Bahamian dancer Paul Meeres, for instance, appeared with Baker on stage in Paris, and a group of local black musicians and dancers starred on Broadway in anthropologist Zora Neale Hurston's play *The Great Day*.

While previously hoteliers had flown down orchestras from New York to entertain visitors on the island, by the 1930s even the Development Board recognized that "*it would be good business* to encourage local customs, costumes, and colourful surroundings which have *given distinction* to Nassau in the minds of visitors" (DB 1934; emphasis added). Another contemporary observer commented on the absurdity of importing North American performers into the island, when "the sophisticated lover of music from northern climes will find his rhythmic sensibilities titillated by our own special brand of West Indian music. The visitor is always seeking for something new, unusual, and even bizarre" (NG, 29 January 1936). This concerted interest in bringing Afro-Bahamian aspects of culture onto the tourist stage was most dramatically signaled by the introduction of "Native Nights," which featured local talent in hotel clubs. Ads for the Hotel Colonial called on "native Bahamians with any kind of talent for entertaining . . . 'native goombay' dancers, conch shell blowers and players of native instruments" (NG, 2 January 1936), signaling a new era of acceptance of black cultural expressions on the island and interest in their traditions for the sake of tourism.[38]

One club in the Fort Montagu Hotel, which contemporaneous accounts hailed as a "center of Nassau night life," was called the Jungle Club. The hotel sought to capture a jungle atmosphere, a key trope of tropicality, in its decor. It was "designed to simulate the stygian darkness of a jungle night lighted by tropical stars in the interior of the club" (NG, 17 January 1939). The Jungle Club presented another version of the tropical jungle environment rendered safe, where tropical drinks were served, and where the black inhabitants of the tropical environment performed at a safe distance onstage. One article about the fashionable club reported, "The popularity of 'Native Nights' at The Jungle Club was proved beyond doubt when the players made their initial appearance of the season last night. The native tom-tom drummer and fire dancer transplanted their audience into the mystery of the jungle in a unique style" (NG, 3 February 1936). The creation of a "Jungle Club" with "native" entertainment transporting audiences into "the mystery of the jungle" seems the logical conclusion to the various attempts

to represent and restage an ordered tropical landscape on the island. In the hotel environment not only was nature domesticated and made safe, but the formerly fearsome "native customs," which travelers had to wander far afield and over the hill to witness, were brought into the hotel environment and performed for the tourist.

So how did John Canoe fare when native performances became a part of the domesticated tropical environment in this period? Importantly, in the 1930s the Development Board turned to John Canoe for its potential as a tourist spectacle. The only way that it could become assimilated within Nassau's touristic image, however, was if the parade was ordered, cleaned up, and made "picturesque," to quote the Development Board (DB 1934). Toward this end the board created an organizational committee that aimed to prettify the costumes through the introduction of prizes. The committee set up two prizewinning categories: the best "Fancy Costume" and the "Most Original" costume. The Development Board, according to its annual report of 1934, "offered prizes for the best costumes worn by the 'John Canoes' in the annual New Year's morning parade on Bay Street. This event was warmly applauded by the cruise passengers from the ships which were in port that day and the fact that several of our distinguished visitors acted as judges of the costumes added to the general interest. It is hoped that this quaint and picturesque custom may be made increasingly interesting each year" (DB 1934, 6). By awarding "fanciness" and "originality" in costumes the board hoped to make the physical appearance of the masqueraders more spectacular and visually appealing to visitors. The board also made arrangements to have a "police Band to head the Procession" (NG, 19 December 1925, quoted in Bethel 54). By institutionalizing the parade through sanctioned meetings and by inserting the police in the forefront of the performance, the organizers aimed to create order where they deemed there had been none.

The government also encouraged the rescheduling of the parade from Boxing Day, the day after Christmas, to New Year's Day, a date removed from the celebration of Christ's birthday. At this time the Street Nuisances Act was suspended on New Year's morning only, allowing John Canoers to enter "the suburbs and a portion of Bay Street between East and Frederick Street between 6–10 pm Tuesday Dec. 31st and 5–9 am on Jan. 1st" (NG, 13 December 1935). By setting new parameters around when the masqueraders could appear and how masqueraders would look, parade organizers aimed to control and domesticate the event.

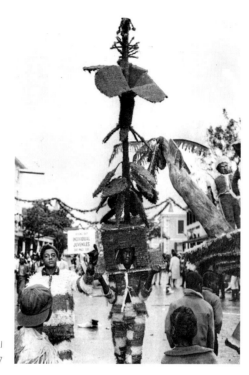

32 "First Prize Junior Division Individual Entry, Hibiscus," Nassau, photograph, 1967

The introduction of prizes had one more important effect on the parade. While previously taboos existed about taking pictures of John Canoe participants, with the introduction of prizes the winners were not only photographed but appeared on the front page of the newspapers (figure 32).[39] The papers frequently revealed the identity of masqueraders by printing their names in the accompanying caption. The once feared John Canoer also appeared next to the sum of his or her prize money. The *Nassau Magazine* also started to feature photographs of John Canoe costumes.[40] In these tourist- and elite-oriented sources the once-feared and seldom-photographed John Canoe participants now smiled, holding the prize money amount next to them, for local residents and tourists alike. Through the board's photographic initiatives the formerly threatening and even cannibalistic John Canoer became tamed, well behaved, and picturesque

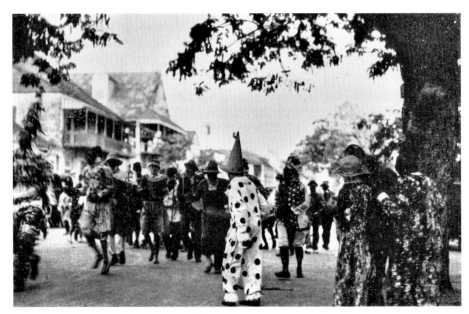

33 "A Christmas Masquerade," photograph, ca. 1929

negroes. Like the picture-perfect market woman and policeman, the masquerader became safe in the very process of being photographable. The masked identity of the performer was unmasked, literally and figuratively, through its mechanical reproduction.

Defries's later account about her experiences at the parade attests that the board rendered John Canoe safe, "picturesque," and orderly through the process of introducing prizes and photographing participants. Defries, whose early publication (1916) included no visual images of the event (after she was warned about the ear-biting episode), released another book, *The Fortunate Islands* (1929), which prominently pictured the parade (figure 33). Her earlier admonition—that she feared the incursion of blacks through her window (or having her ear bitten off)—also changed dramatically. The entire book was devoted to her "Adventures with the Negro in the Bahamas."[41] Her very ability to include a photograph of the John Canoes served as testimony to other potential travelers that it was safe to venture among the "negroes" in the Bahamas.

It would be wrong, however, to assume that the Development Board successfully transformed the event into a picturesque spectacle for tourist consumption, controlling space and the appearance of participants. On the contrary, masqueraders took full advantage of the suspension of the Street Nuisances Act on New Year's Day and began using both Boxing Day *and* the newly sanctioned day to perform John Canoe (dual parades on both Christmas Day and New Year's mornings persist to this day). By 1939 observers complained that participants took new liberties with the parade, appearing sporadically days before and after the officially sanctioned time of the event: "One of the somewhat objectionable features of the New Year celebration is that miniature John Canoe parades, sans constume [*sic*] or organization, appear sporadically on busy streets for several days before and after New Year's Day" (*NG*, 29 December 1939). Notably, the "miniature parade" participants appeared outside of the board's designated time period, displaying no organization and disregarding their "fancy" or "original" costumes. In short, they exhibited none of the features that the organizers had attempted to impose on the parade.

When John Canoes did dress up, their choice of costume suggests that the parade offered much more than a prizewinning and photo opportunity. In 1929, for instance, a masquerader appeared as a policeman. In 1935 a masquerader, who was awarded 2nd prize, paraded as Haile Selassie (*NG*, 31 December 1935), at a time when blacks throughout the African diaspora protested the Italian invasion of Selassie's Ethiopia. One prizewinner, who wore the costume that reproduced in miniature the Fort Montagu Beach hotel in 1949, also points to the complexity of the parade in the visual economy of tourism (Thompson 2002, figure 94). The black performer adorned the idealized and exclusionary space of the hotel within the context of Bay Street, the main tourist haunt. Through the costume the black John Canoe participant literally transformed himself into the ordered representation of tropical nature and epitome of modern luxuriance on the island. These embodiments of law and order, African diasporic consciousness, and tropicality in the John Canoe parade, provide a rare glimpse at how black Bahamians negotiated and negated tourism supporters' taming and ordering vision of the island.

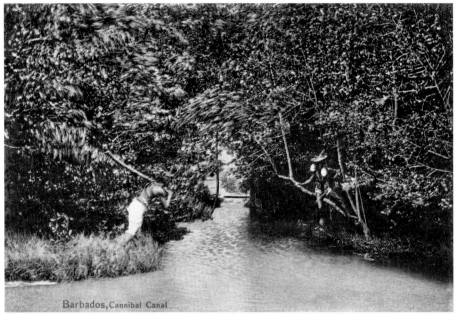

Barbados, Cannibal Canal

34 J. R. H. Seifert and Co., "Barbados, Cannibal Canal," postcard, 1901–7

REALIZING A PICTURE IN THE IMAGINATION: THE INSCRIPTION OF TROPICAL DREAMS ONTO THE CARIBBEAN LANDSCAPE

The Bahama Islands were not alone in their inscription into the representational structures of the tropical and the picturesque. Another coral island in the West Indies, Barbados, suffered a similar fate. On Barbados, for example, the hotel landscape of the American-owned Marine Hotel was created precisely to simulate a jungle environment. A part of that hotel became known on postcards as "Cannibal Canal" (figure 34). The hotel's staff were employed to enact the part of cannibals in this re-created jungle landscape. Cannibal Canal offered travelers a controlled tropical environment, with both nature and human behavior ordered, on an island that was devoid of jungles. As with Nassau, the lack of geographical conformity to "jungle ideals" ultimately did not matter; within the British West Indies they could be re-created to provide travelers with a

tamed ideal of the tropics. Travelers' dreams (and what tourism promoters assumed to be travelers' expectations) of the tropicality and the picturesque, the tamed and orderly tropics, developed for almost half a century on Nassau's landscape and society, and other coral islands.

The islands were beholden not only to travelers' visions of the tropics but to elite ideals of modernity. For the ruling elite in the Bahamas the island's tropical and premodern image provided an entrée into the wider modern world. The elites' desire to maintain Nassau's tropical and picturesque image on the island's stage set, in particular, led to the social control of space, including rules regarding who should occupy the tourist-oriented landscape and what types of behavior they could exhibit. Only black inhabitants deemed safe, cordial, and "photographable" were allowed to occupy the ordered picturesque landscape of the streets, both in images and on the physical landscape. The island's majority black population was constantly swept into or out of the representational regimes of tourism and on and off the tourist stage (both the main streets of the islands and the literal performance stage of the hotel), dependent on these tastes. Whether black Bahamians were touristically "in fashion" or not, their presence was constantly being mitigated and controlled in the name of the tourist industry. In this process Nassau's picturesque qualities went from being a pictorial ideal to a social policy. In the political application of picturesqueness travelers (and touristic visions of the islands) were naturalized as parts of the landscape, while members of the island's black population (groups that did not conform to this vision) were denaturalized as anathema to the island's civilized yet tropical image.

THROUGH THE LOOKING GLASS
Visualizing the Sea as Icon of the Bahamas

Natural, asocial, tropical islands float outside history—on blue semantic oceans signifying eternity.

Peter Osborne, *Travelling Light*, 2000

In most souvenirs of the exotic, however, the metaphor in operation is again of taming.

Susan Stewart, *On Longing*, 1993

In 1940 *Ripley's Believe It or Not* featured a record-setting event in the history of photography that took place in Nassau, Bahamas (*NG*, 9 March 1940). A British-born photographer, John Ernest Williamson (1881–1966), had created an underwater photosphere, which allowed its visitors to venture to the bottom of the sea to view, paint, or photograph the ocean from its depths. Through a glass lens, five feet in diameter, photosphere entrants could see firsthand what the inventive photographer had previously visualized in his groundbreaking work in underwater photography.[1] The photosphere immediately became a popular tourist attraction on the island, drawing many famous visitors to Nassau, including Princess Margaret and Alexander Graham Bell, to the underwater site (and sight). The creation of an underwater viewing cocoon, however, was not Williamson's only claim to fame worthy of Ripley's admiration. The photosphere also served as the world's first underwater post office. Postcards of the "marine fairyland," as reports hailed the underwater world (*TR*, 16 August 1939), could be obtained and posted to any part of the world from the submerged oceanic depths of Williamson's photochamber.

In this chapter I use Williamson's rather unusual photographic invention as a case study through which to explore the depths (literally) of the sea as a photographic icon of the Bahamas, and the Caribbean more broadly, and its emergence and significance as

a site of touristic pilgrimage in the islands in the early decades of the twentieth century. Why did viewing and picturing underneath the sea become an almost lifelong pursuit for this photographer in the geographic space of the Bahamas? Why did Williamson transform the photosphere, a viewing machine, into a popular tourist site and distributor of sights? Why did the photosphere assume the unique form and function that it did in the islands? Moreover, how did Williamson's photographic inventions impact local and global conceptions of the sea?

I argue that the photographic obsession with viewing and visualizing even into the depths of the ocean, epitomized by Williamson's photosphere, can be interpreted in part as another way of taming aspects of nature in the Bahamas through photographic representation. In a process comparable to the taming of the wildness of tropical nature into picturesque and orderly displays of the flora in tourism-oriented photographs, through Williamson's still and moving underwater photographs the mysteries of the ocean and its supporting marine life were domesticated and rendered safe.

I conclude by examining a contemporary hotel complex designed, in a comparable fashion to Williamson's photosphere, to give viewers access into the watery underworld of the islands: Atlantis. The resort, built by Sun International in the Bahamas in 1994, provides another instance of how ways of seeing the islands inspired by tourism can become developed on the physical landscape. Atlantis's owners attempted to reproduce an imaginary underwater world on land. Atlantis, I maintain, is a contemporary manifestation of a much older and historic interest in viewing, representing, and creating an inhabitable submarine environment, previously evident in Williamson's photosphere. The process of representing the underwater world in the hotel's landscape again rendered the islands' sea space safe for tourist occupation.

J. E. WILLIAMSON: VIEWING LOST WORLDS IN THE PHOTOSPHERE

John Ernest Williamson (often referred to as J. E.) was a photographer and then cartoonist for the *Virginia Pilot* and *Philadelphia Record*, respectively, before he moved to the Bahamas in 1914. Williamson's acumen as a newspaperman eventually spurred him to seek out new and uncharted photographic territories. One day, while wandering the old seaports of Virginia, Williamson was, in his words, "seized with a sudden inspiration to make photographs of the world beneath the sea" (Williamson 1936, 27). His child-

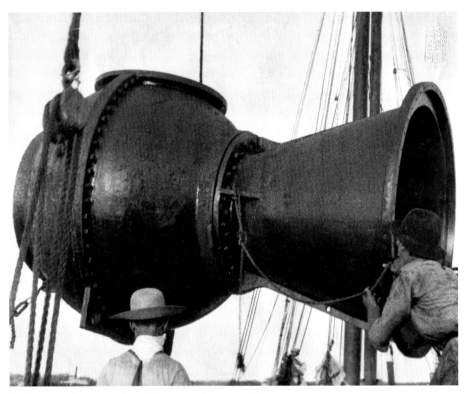

35 The photosphere, designed by Williamson, photograph, ca. 1914

hood fascination with the legends of the "lost Atlantis" and tales of the sunken cities of Port Royal in Jamaica and in the Yucatan partly inspired this new direction in his photographic work. Williamson began experimenting with underwater photography off the coast of Virginia and was successful in making the "first real undersea photographs in history" (36). However, Williamson realized that "only in the crystal clear waters of the tropics would it be possible to attain the [photographic] results at which I aimed" (39). With this objective in mind, Williamson and his brother, George, organized an expedition to the Bahamas.

In the islands Williamson assembled and perfected a new underwater device that allowed him to extend his field of vision beneath the sea. He combined a deep-sea tube,

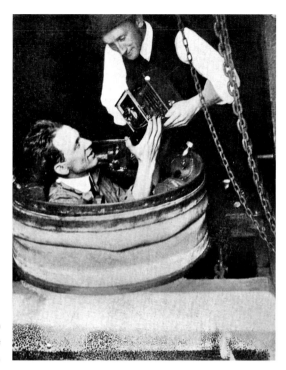

composed of a column of interlocking and unfolding concentric iron rings, which his father had invented,[2] with a steel photographic chamber or what he called a "photosphere" (figure 35). The body of the device was big enough to seat three to four persons behind a two-inch-thick funnel-shaped glass lens. The photosphere, which measured approximately 6 feet by 10 feet, was attached via the tube to a barge, dubbed the "mother ship." Williamson could communicate with the adjoining surface craft from the photosphere via telephone (Munro 2002). On his instruction the mobile flexible tube and attached chamber could be maneuvered and directed through the ocean.

Williamson took a camera down into the photosphere and by affixing it in close proximity to the glass, the photographer could record the world that wandered by his underwater studio (figure 36). Through the photosphere the photographer obtained photographs in depths of water up to 100 feet, because the clear waters were still illuminated

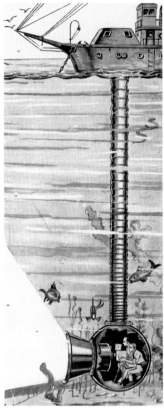

by natural light at this point (*NG*, 1 February 1936). Beyond this depth Williamson used artificial lighting to enhance the visibility and clarity of his photographic representations. As an early diagram of the viewing device reveals, he lit underneath the water in a fashion similar to which a studio photographer might artificially light her or his photographic subject (figure 37).[3]

When Williamson descended into the chamber on its maiden voyage, he marveled at the spectacle that unfolded before his eyes: "Reaching the photosphere I stood spellbound at the sight which greeted me. Could this be real, or was I dreaming? Nothing I had ever imagined had equalled this. It was more than I had ever dared hope for" (Williamson 1936, 47). Echoing earlier travelers' narratives, the photographer employed the descriptive language of a dream to characterize his initial encounter with the seascape. From the photosphere he obtained unhindered visual access to a seemingly imaginary world, the corals, reefs, fish, and other forms of marine life that inhabited the ocean. Williamson immediately began to document the "dreamlike" marine life that ventured by his photographic eye on film.

Williamson and his brother edited the footage of their initial underwater exploits and created the first moving pictures shot underneath the sea. They entitled the one-hour-long feature *Thirty Leagues under the Sea*, a take on the popular science fiction writer Jules Verne's novel *20,000 Leagues under the Sea* (1870). The documentary was precisely about the photosphere and its early expeditions. It also detailed how the islands depended on the marine life pictured so clearly in the footage.

The Williamsons immediately premiered the film at the Smithsonian Institution in Washington, D.C., sharing their vision of the "kingdom beneath the sea" with North Ameri-

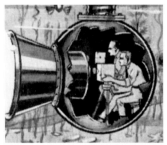

37 Diagram of two photographers inside the photosphere, n.d.

can and later British audiences (57). The footage caused quite a sensation by Williamson's own account, drawing sell-out audiences in theaters on Broadway, as well as in Washington, Chicago, and London. "Critics exploded with superlatives of praise. Amazing! Thrilling! Something entirely new! Something never viewed by mankind. . . . If there was nothing new under the sun, the 'Williamson Submarine Expedition' had proved that there was something new to be seen under the sea" (Williamson 1936, 78). Although the novelty of such a film may be hard to conceive of from the perspective of the twenty-first century, at the time of Williamson's underwater photographic invention a number of factors (including dark lighting conditions, water-permeable cameras, and films' sensitivity to water) had all variously prohibited photographers from visually recording beneath the sea. Additionally, in the first decades of the twentieth century, scuba suits and diving gear, through which the layperson could descend into the water for any substantial length of time, were also in their initial stages of development. It was not until the 1920s that single-lens masks came into being and the late 1930s before they were widely manufactured. The first underwater oxygen breathing device, patented in Italy, was not popularly available until the Second World War. Hence persons interested in the ocean's floor had few visual or experiential resources outside of Williamson's seminal footage through which to become visually acquainted with the underwater realm.

After the Williamson brothers' filmic debut they returned to Nassau, where they started to produce feature films or "photoplays," as they were called. In the spring of 1916 they partnered with Universal Pictures to create a film based on Verne's 20,000 *Leagues under the Sea*. The movie would become the first motion picture filmed underwater (*NG*, 10 December 1933). Williamson's 20,000 *Leagues* was but one in a series of motion pictures he created over the next two decades (he and his brother eventually dissolved their partnership).[4] While both the filmmaker and scholars have examined the content of the films in some detail elsewhere (Williamson 1936; Taves 1996), I am primarily interested in how the photographer's underwater invention, photographs, and documentary and feature films transformed, indeed ushered in a literal sea change in, the visual economy of tourism on the islands.

Before exploring how and why the photosphere intersected with tourism on the islands, it is necessary to situate Williamson's still and moving photographic work within the geography and visual cultural history of the Bahamas. One geological factor in particular attracted Williamson to the islands: the clarity of the islands' waters. The seas surrounding the Bahamas possess qualities that differentiate them from other parts of the sea in the Caribbean.[5] While the Caribbean Sea is known for its deep waters (averaging approximately 2,200 meters and reaching depths up to 7,000 meters), the shallow waters of many parts of the Bahamas (continuing to the north coast of Jamaica and south of Cuba) are somewhat of an anomaly. The shallowness of the water in this part of the Caribbean endows the seas surrounding the islands with a distinct clarity and color. The close proximity of the islands' sands to the surface of the water reflects the brilliancy of the underlying white sandy coral seafloor. Additionally, the shallow waters of the Bahamas contain less microscopic organisms, known as phytoplankton, which can greatly affect the color and transparency of the ocean.[6] Phytoplankton, essential sources of energy for marine life in deep waters, can in high concentrations contribute to what is known as red tides. In the Bahamas the plankton population is low because the waters are shallow and lack the nitrates and phosphates on which the organisms thrive. The waters surrounding the Bahama Islands are also especially clear because the coral isles do not contain rivers (the limestone absorbs the water before it can form rivers), which can cloud surrounding ocean waters with their sediments. The clarity of Bahamian waters afforded Williamson a level of visibility he was unable to achieve elsewhere in the world (*NG*, 1 February 1936; Munro 2002).

While the landscape of the coral islands of the Bahamas was deemed nonproductive when measured in terms of its agricultural output, the marine life in the surrounding coral reefs, according to marine biologists Alick Jones and Nancy Sefton, were some of the most productive, active, and biologically diverse in the region (1978). Jones and Sefton characterize many other parts of the Caribbean Sea as "barren," but they describe the vast coral reefs in the Bahamas as rich and productive in contrast to the "poverty of the open sea" (1978, 68). The islands are home to 900 square miles of coral reefs, including what is now recognized as the world's third-largest barrier reef. It is currently

estimated that the coral reefs support more than one million species, being more bio-logically diverse than some rain forests (Feeny 2001, 170). Hence, Williamson's under-water photographic invention was particularly effective in the Bahamas' unique geo-logical environment.

A VISUAL CULTURAL HISTORY SUBMARINE VIEWING:
THE SEA AND EARLY OPTICAL DEVICES

The photosphere and seafloor post office were in part the culmination of a much longer and complex history of the "visibility" of the Bahamian waters and their "unrepresent-ability." The brief analysis of travelers' narratives and guides that follows reveals that since the nineteenth century many travelers had been mesmerized by the ability to view far into the Bahamas' translucent waters, but what lay beneath them remained represen-tationally elusive. Through Williamson's photosphere travelers and tourist promoters could finally obtain photographic representations of that vision of the sea that had long escaped them.

In the late nineteenth century and first decades of the twentieth century, before Wil-liamson's underwater visual technologies, the beach and ocean occupied a relatively small representational share of the images used in touristic campaigns in the Bahamas (and elsewhere in the Anglophone Caribbean). Nineteenth-century travel writers like Charles Ives commented on the conspicuous absence of any mention of the "great clear-ness and brilliant hues of the water" in early and contemporaneous accounts of the islands (Ives 1880, 223). Guides produced on the Bahamas typically featured no more than one or two representations of the surrounding waters.[7] These images seldom pic-tured the beach but rather showed travelers buoyed in the safety of their boats gazing into the sea.

In the 1880s and 1890s the process of physically viewing the sea and looking into the depths of the Bahamas' transparent waters would become popular activities for trav-elers to the islands, more so in the archipelago than in many parts of the Caribbean (S. Brown 1995, 233). As Northcroft put it, drawing on the words of English poet John Keats, the seas in the island provided a "sight unique — 'a thing of beauty' and 'a joy for-ever,' a cause of ceaseless wonder and delight to those who, hitherto, have only known the ocean under its more somber aspects" (Northcroft 1912, 4). Edgar Howe, another

THE SEA GARDENS.

38 *The Sea Gardens*, engraving, ca. 1900

travel writer, was similarly astonished by the sea: "So clear is the water that unaided vision penetrates to astonishing depths, disclosing wonderful forms, graceful shapes and exquisite coloring" (Howe 1910, 312).

Several touristic rituals developed around this fascination with the translucency of the water. Travelers embarked on boating trips aided with special nautical glasses, which allowed them an even greater visual access to the world beneath the sea than the naked eye enabled. The popular activity is commemorated in several images from the small archive of early twentieth-century representations that picture the sea. In *Stark's History and Guide to the Bahamas* (1900), for example, an engraving entitled *Sea Gardens* shows a group of white women and men attired in long skirts and suits, respectively, peering into the ocean through "water glasses" (figure 38). Stark describes the water glass as a square structure buttressed by a glass that was attached to the side of boats, through which "all

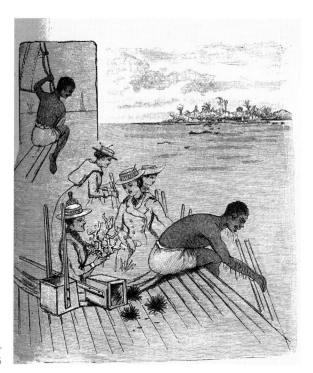

39 *Sponge-Glasses,*
engraving, ca. 1885

the wonders of the deep can be seen plainly as if no water intervened" (Stark 1891, 229).
The water glass may be viewed as a precursor to Williamson's viewing machine.

The water glass also came in other viewing varieties. According to other travelers,
like Amelia Defries and Lady Annie Brassey, who embarked on similar underwater
viewing expeditions, their boats were equipped with another kind of water glass: "simple
wooden buckets with glass bottoms, strong, double iron hooks, such as spongers use,
attached to poles ten feet long" (Defries 1917, 252). An engraving in Brassey's book,
titled *Sponge-Glasses*, pictures four white women in boats, accompanied by two black
male divers, looking through this latter variety of water glass (figure 39). All but one
figure in the engraving cast their eyes toward the ocean floor or to pieces of marine life
already pulled from the sea. Brassey's recollections aptly narrate the image: "A droll
little group we must have looked, sitting all in a row along the side of the boat, and

peering through the glasses which alone gave us admittance to the marvels of the magic world below. Without these aids to vision we could see comparatively little, on account of the slight motion on the top of the water, which rendered everything indistinct and hazy; whereas, with the help of our *tropical lorgnons*, all was clear and vivid" (Brassey 315; emphasis added). These accounts testify to travelers' efforts and interests in seeing farther and farther into the "magical world" beneath the surface of the sea, extending their gazes into the depths of the islands' transparent waters.

It appears that by the beginning of the twentieth century, the viewing apparatuses on boats became even more sophisticated as the old viewing boxes, which were mere appendages to sailing vessels, were replaced by actual boats outfitted with glass on their underside. By 1901, ads appeared in the local papers luring visitors to glass-bottom boats. "Its 22 square foot glass gives a wonderful view of the Flora and Fauna of the Ocean Bed," one advertiser assured (*NG*, 16 January 1901). The mechanisms for viewing beneath the sea seem to have been continually reinvented providing travelers with even greater visual admittance, a larger window, into the sea.

A photograph by the American photographer William Henry Jackson, taken in 1901, provides another glimpse at this popular tourist activity (figure 40). The image pictures five people on a glass-bottom boat all uniformly transfixed by the "flora and fauna of the ocean bed" below. The figures, whose bowed heads and steadfastly directed gazes form a human arch, reinforce the extent to which the seafloor became a fastidious object of study. The photograph is doubly an image about viewing. The photographer views and pictures five other people engaged in the process of viewing. Significantly, Jackson did not direct his camera's lens to the site that so engaged the boat's occupants, the seafloor. It is possible, indeed likely, that the photographer could not capture the constantly moving subterranean realm on his glass plate. Whether Jackson's focus on viewers of the seafloor (rather than on the seafloor itself) was by choice or necessity, the photograph illustrates a wider trend: at the threshold of the twentieth century, although the ocean was the object of keen visual study, it was seldom the subject of photographic representations (or any form of representation for that matter).

The popular tourist pastime of tossing coins into the sea, after which young black boys dove, may also be related to this touristic fascination with the transparency of Bahamian waters. Numerous travelers described the typical exchange between themselves and the diving boys, wherein "they [the divers] ranged themselves in an expec-

40 William Henry Jackson, Untitled
[Viewing the Marine Gardens through Bottom of Boat, Nassau], photograph, 1900

tant line along the edge of the wharf, and when I threw a penny they all went off like a lot of frogs" (Drysdale 1885, 12). The spectacle of the boys diving into the ocean after coins provided (cheap) native entertainment, while appearing to be an act of touristic generosity. The visibility of a coin even at the bottom of the ocean was central to this performance of black agility and white beneficence.

Photographs showing the diving boys were some of the most popular touristic representations in the first decades of the twentieth century in the Bahamas. While tourism-oriented images of black men on land (besides policemen) were fairly uncommon, they

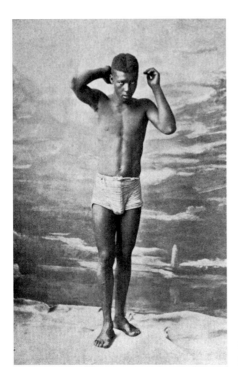

41 Jacob Frank Coonley, "A Native Diver," photograph, ca. 1890–1904

were frequent inhabitants of the sea in photographic representations. A rare studio image of a local man, "A Native Diver," seems to bear witness to the canonization of the diver in photographs of the Bahamas (figure 41). The image, by Coonley, pictures a young black man, in swimming trunks, posed awkwardly against a background of sea and sky (likely taken in the same studio as Coonley's "On the Way to Market," mentioned in chapter 2). Standing barefoot on the studio's floor, the model indeed seems like a fish out of water. He appears unsure of the posture he should assume in front of the photographer or to be caught off-guard by the camera's shutter. The resultant image casts a spotlight on someone seemingly unfamiliar or uncomfortable with his photographic inscription. The awkward if not vulnerable pose, the black man's semi-nude state, and the bare backdrop all recall an ethnographic framing of colonial subjects. Regardless of the photograph's circumstances of creation, like the images of trav-

elers gazing into the sea from their glass-bottom boats, the image of the diving boy became a visual substitute in part for describing and representing the clarity of the waters.

A TROPICAL LANDSCAPE UNDER THE SEA? WHAT TRAVELERS SAW THROUGH THEIR TROPICAL LORGNONS

So what did some travelers see when they peered through the water glasses or, as Brassey described them, "the magic glasses" (311) or "tropical lorgnons" (315)? From writers' descriptions of the islands' seascape, it appears that they visually processed the ocean floor not as a vision of some imaginary world beneath the sea but rather as a picturesque, even primordial, tropical landscape. A few extended passages from several travelers provide some indication of how visitors interpreted this underwater world. According to William Hutchinson in *A Winter Holiday*, for example,

> When the glass end is plunged below the rippling surface, and the other is filled with one's face, there is revealed *a scene which has no equal outside of dreams, or fantastic pictures from Arabian Nights. Great trees of coral*, with trunks a foot in diameter, spring from the white floor in *stately forests*, whose foliage is crimson dulse and yellow fan-shaped leaves. Beneath their roots are caves, wherein the entering seabeams from above play such tricks with light and shade as Rembrandt never dreamed of. (Hutchinson 1886, 105; emphasis added)

He continued:

> Plumes of coral, fans of coral and coral sponges swayed to and fro with the deep pulsations of the sea, as if moved by the same breezes that made the palms ashore wave a welcome to us pilgrims as we drew near. Fishes that had stolen their hues from some errant rainbow darted to and fro, flashing in the sunlit depths below as humming birds or orioles do in upper air, and every foot of distance passed revealed some novel and beautiful view. (83)

Lady Brassey also described the various "wonders" of the "marine exhibition" that she observed:

> If you can picture to yourself the most beautiful of corals, madrepores, echini, seaweeds, sea-anemones, sea-lilies, and other fascinating marine objects, growing and flourishing

under the sea, with fish darting about among them, like the most gorgeous birds and butterflies conceivable, all in the clearest water, which does not impede the vision in the least, and resting on a bottom of the smoothest white coral sand; if you still further imagine a magnificent blue sky overhead, and bright sun shining out of it; even then you will have but a very faint idea of the marvelous beauty of the wonders of the sea on a coral-bank in the Bahamas. (Brassey 1885, 314)

She concluded her synopsis of the islands' marine life: "You cannot imagine the world of utterly unexpected wonders that were at once revealed to us. What a fairy scene it was! . . . I had longed for years to behold such a sight, and I found now that the spectacle not only equaled but far surpassed my most sanguine anticipations" (314). Like Hutchinson, who used the metaphor of a dream to characterize the seascape, Brassey proclaimed that the submarine spectacle exceeded her fairy-tale expectations.[8] As we have seen, this dream terminology was not uncommon in touristic appraisals of the landscape, but what did it signify when applied to the islands' underwater environments? If travelers typically declared landscapes "like a dream" when the vegetation confirmed or conformed to a vision of the tropics they imagined, what did such pronouncements mean when redirected at the seascape? The use of this terminology in regard to the ocean is particularly hard to quantify since there were few preexisting representational models for the underwater environment. Keeping in mind that etchings and photographs seldom pictured the world beneath the ocean (before the invention of underwater photography by Williamson in 1915), what kind of representational ideals (real or imagined) did travelers draw on to organize their descriptions of the islands' seascape? If the underwater realms appeared to Brassey as a sight she "had longed for years to behold," what had structured or informed her expectations?

TROPICAL JUNGLES BENEATH THE SEA: TROPICAL *LORGNONS* AND REREADING THE SEASCAPE AS TROPICAL LANDSCAPE

These travelers' descriptions reveal that many tourists interpreted the underwater world as if it were a tropical landscape. Hutchinson, for instance, re-envisioned coral sponges as "welcoming palms," fish as "hummingbirds," and coral as "great trees" and "stately forests" (Hutchinson 1886, 83, 105). Charles Ives also contended that the sea-

scape bore similarity to "the vast and magnificent tropical forests, clothed in perennial green, adorned with graceful vines, teeming with flowers of every hue, and vocal with countless birds of the most varied and of the richest plumage, bear to a lady's little but luxurious boudoir, with its evergreen branches, climbing vines and captive birds in their small but gilded cages" (Ives 1880, 220). He described forms beneath the sea as tropical forests and colorful birds and flowers (216). In other words, a part of the fascination with gazing into the sea, the ritual of staring through the water glasses, lay in some travelers' interests in viewing a kind of tropical flora (a sexualized tropical nature in Ives's case, "like a lady's boudoir") as it could be found underneath the surface of the sea. This is confirmed in Brassey's own description of the water glasses as "tropical lorgnons" (Brassey 1885, 315). Her terminology inadvertently suggests that as she gazed into the waters, she put on "tropical glasses" seeing the seascape through her own expectations of landscapes in the tropics. Tropical lorgnons were then a kind of Claude Glasses, a set of preconceptions or way of seeing the tropics, through which some travelers filtered their visual experiences of the seascape.

For many visitors not only was the seascape like a tropical forest, but it was an even more primordial locus of nature in the New World than the physical landscape above sea level. Amelia Defries, for instance, lamented that nature on the land seemed greatly transformed from the world that greeted some of the first European explorers to the New World. She rested assured that forms of marine life beneath the sea remained unchanged. For her, while the landscape had been wiped of its original inhabitants and many aspects of nature "wantonly destroyed," the sea remained a last visage of a world untouched by modernization: "Scant care has been taken with Nature all over the New World. But the inhabitants of the sea have not been altered. The sea-gardens around these coral cays are among the wonders of the world still" (Defries 1929, 6). While the New World historically had been a blank slate into which numerous forms of vegetation and peoples throughout the globe had been emptied, the sea, according to Defries, had escaped these processes of transformation. Accordingly, not only were sea gazers privy to a tropical landscape underneath the water but, in Defries's estimation, the view through the water glasses allowed them to access an untouched and original tropical space.

The wonders of the seafloor also likely drew the eyes of many travelers because the seascape, unlike Nassau's landscape, fulfilled tourists' penchants for the sublime. Ives,

who lamented the disorderly appearance of parts of Nassau's landscape, was awestruck by the sea gardens. He devoted an entire chapter of his account to his underwater observations and concluded that even Egypt's pyramids failed to rival the gardens in "beauty and sublimity" (Ives 1880, 213).

To recap, many travelers approached the sea with the same "tropical glasses" that they used to organize their experience of tropical landscapes. However, one significant factor differentiated the tropical landscape from its seascape counterpart. While travelers' and tourism promoters' visual representations (especially photographs) were central in the perpetuation and reification of an idea of the tropical landscape,[9] neither party could easily represent this underwater landscape.

THE PROBLEM OF REPRESENTATION
AND THE UNDERWATER WORLD

Paralleling the developments in visual devices that facilitated greater visual accessibility into the sea in the Bahamas is another related history of travelers' failed attempts to represent both the transparent crystalline quality of the sea and the marine life that dwelled underneath its surface. Writers repeatedly lamented their inability to capture their experience of the ocean either in words or visual images, through "language" and "pigments."[10] Hutchinson, for instance, concluded a rather poetic description of the marine gardens with the regret that "words quite fail to convey the singular beauty of the submarine world so clearly exposed to view" (Hutchinson 1886, 105).[11] Charles Ives echoed these sentiments: "When we [he and fellow travelers] would propose the task of attempting some description of them [the marine gardens], we felt an indescribable reluctance to commence, and were awed into silence, knowing that we could make but a faint picture of the corals as they appear to the eye" (Ives 1880, 211). Such views about the inability to represent the islands are perhaps ironic given that numerous accounts boasted precisely that the sea gardens were "clearly exposed to view."

Some travelers, such as Northcroft, held out the hope that painters would be more successful or could "come nearest to nature" in their attempts to represent the sea (Northcroft 4). Indeed, it appears that aspiring artists did commit themselves to this task and attempted en masse to translate their visual experience of the crystalline seas

onto canvas. A locally published article, "The Island's Mystery," describes an entire beach where "artists by the score sit about patiently watching sea and sky and verdure. Many pictures they paint and the amiable guests at the great hotel buy them in vain hope that later they may recall the colour of the scene and catch a suggestion of its present charm" (NG, 24 March 1909). Defries, in *The Fortunate Isles* (1929), similarly describes artists who "camped out" on the beaches of Hog Island (a cay, later called Paradise Island, just a short boat ride from Nassau) watching, studying, and attempting to record visually the marine life beneath the sea from the shore (9).[12] These painters' attempts to represent the sea, as the author of "The Island's Mystery" suspected, were in vain, "for, when, under alien skies, they look again upon that which they bought they find themselves no richer than he with a handful of shells" (NG, 24 March 1909). Local connoisseurs in Nassau similarly dismissed many travelers' artistic efforts to capture the ocean, especially "the exact color of the sea," as futile.[13]

Some tourists attempted to procure other kinds of visual mementos from the underwater gardens. Like the process of travelers taking back actual specimens of tropical nature in their photographic albums, tourists in the Bahamas also sought physical pieces of coral and other forms of marine life from Nassau's underwater environs. Many travelers, after gazing through the water glasses, would direct black male divers to retrieve objects of fascination from their watery dwellings: "when a growth of coral was discovered by any one of the passengers, peculiarly beautiful and coveted, the diver immediately plunged overboard and soon detached and brought it to the surface. . . . They seemed like imps of destruction, marring a beauty they could not make . . . appreciate or enjoy" (Ives 1880, 222). Ironically, by encouraging divers (whom Ives assumed could not appreciate the aesthetic appeal of the seascape) to obtain submarine mementos, tourists routinely destroyed the natural habitat they so admired.

These practices did draw some public protest. A letter to a local newspaper, signed Conch, warned that tourists would eventually destroy the sea gardens "by encouraging divers to violate the law merely for the momentary gratification of a selfish whim to obtain a memento of their visit" (NG, 18 March 1899). The writer advocated that an act of government should be passed that would protect the gardens.

Despite the acquisition of marine curiosities, as with painted representations of the sea, some travelers expressed a somber dissatisfaction with their seafloor mementos. It

appears that the lonesome specimen once plucked from the seabed failed to fulfill its mnemonic function for some travelers; it ceased to recall the color and splendor of the whole. Nowhere is this failure more evident than in Ives's tale of his attempt to take home a beautiful hummingbird fish, which displayed a rainbow of colors while in the sea gardens. (In the name "hummingbird fish" we have another example of marine life being reread as popular birds found in tropical nature.) Ives was so enamored by the fish that he had one caught and placed in a jar of alcohol. While he sought to capture its colors permanently, the fish completely lost its brilliancy: in the very process of preservation "its beautiful colors soon faded away" (Ives 1880, 218). In sum, the sea gardens and their colorful marine life became objects of touristic fascination from which travelers could not obtain an adequate representation or memento.

So while the marine gardens and the island waters became popular sites of tourists' pilgrimages, they resisted many of the accompanying processes of sightseeing—the obtaining of a visual souvenir of the experience. While the procurement of visual mementos has been central to many travelers' quests, perhaps since religious pilgrims sought sacred relics as physical reminders of their journeys (Cohen 1989), the sea gardens were somewhat unique in that they denied what tourism theorist Dean MacCannell describes as sacralization. In sightseeing the process of making mechanical reproductions of the designated tourist site is central to its enshrinement as a site/sight of tourist visitation: "The next stage of sacralization is *mechanical reproduction* of the sacred object: the creation of prints, photographs, models or effigies of the object which are themselves valued and displayed. It is the mechanical reproduction phase of sacralization that is most responsible for setting the tourist in motion on his journey to find the true object" (45). The sea gardens enabled visibility yet resisted sacralization and commodification through visual representation, processes central in tourism.

REPRESENTING THE SEA IN EARLY TOURISM PROMOTION: THE SEASCAPE OF DISBELIEF

The seeming inability to represent the sea created representational challenges not only for travelers but also for tourism promoters, who often capitalized on the commodification of parts of the island in the tourist industry and actively used visual representations in many promotional campaigns to set tourists in motion. How could they attract visi-

tors to the marine gardens if they could not adequately represent the world underwater in words or images?

This dilemma was evident even in the earliest stages of the tourism-oriented campaigns of the 1880s. In 1886, in the West India Art Gallery of the Colonial and Indian Exhibition in London, the government of the Bahamas attempted to use the international forum to promote the islands as the Isles of June. As part of their promotional efforts they exhibited two paintings of the sea by the American artist Albert Bierstadt: *The Wave* and *Azure Blue Sea*. Bierstadt's *The Wave* became, as one reviewer described it, "one of the popular attractions of the exhibition" (Cundall 1886, 78). The piece pictured an immense wave breaking on a Bahamian coastline.

Despite the accolades, however, the work elicited two strands of criticism from exhibition audiences. Among viewers who had never ventured to the Bahamas, the colors seemed unrealistic and unbelievable. Northcroft reported on the responses in detail:

> All attempts to describe the beauty of the sea about the Bahamas, either by pen or picture, are unsatisfactory at best. Mr. Bierstadt, the distinguished American artist, has been remarkably successful in his picturesque attempt entitled "Azure Sea," and other painters of lesser note have emulated his efforts. But Mr. Bierstadt's picture has been scouted as a splendid exaggeration. Incredulous groups might have been seen before it as it hung in the Bahamas Court at the Indian and Colonial Exhibition (London) of 1886. In fact, those who have not been to the Bahamas, and who either see or hear or read some attempt to describe the waters of these parts, find it difficult to accept such representations as accurate; yet, after all, they are only approximations towards exactness. (Northcroft 1912, 4)

Bierstadt's "picturesque attempts" to represent the sea elicited incredulity among persons who had never ventured to the Bahamas.

On the other hand, viewers who had gazed on the islands' seas with their own eyes complained that Bierstadt's paintings were not realistic enough. According to Hutchinson, even the colors that "the master's brain [Bierstadt]" had combined fell "quite short" of adequately representing the appearance of the sea (Hutchinson 1886, 80). So, interestingly, at the very moment that the sea would have made its entrance into the pantheon of touristic icons of the islands, its believability was challenged. How could the unrepresentable quality of the waters be visualized? How would Williamson's photographs and photosphere intercede into this allusive representational history of the sea?

THE FULFILLMENT OF VISUAL DESIRE: WILLIAMSON'S PHOTOSPHERE
AND THE VISUAL ECONOMY OF TOURISM

Travelers' and tourism promoters' much-lamented inability to represent the sea or secure a memento of the islands' seascape seemed to have "launched a desire" for an apparatus like Williamson's photosphere. In Roland Barthes's study of photography he observes that the most powerful or evocative aspects of some photographs, what he calls *punctum*, can "launch desire beyond what it permits us to see" (Barthes 1981, 59). In the case of the Bahamas the transparency of the sea launched another kind of visual desire, beyond which the sea allowed travelers to see fully, represent, and capture as an image or souvenir. Williamson's photosphere would become instrumental in fulfilling these representational desires.

After decades of travelers' and promoters' failed efforts to represent the sea, in the late 1930s the islands' Development Board, as a local newspaper report put it, "made a good business deal with Mr. Williamson," enlisting his underwater photographic technology in the service of the tourism industry (*TR*, 16 August 1939). From correspondence between Williamson and the Development Board, it appears that the photographer first approached the government agency about establishing a mutually beneficial relationship in 1938 (Williamson to Development Board, 26 August 1938). He proposed a five-year exclusive contract with the board to fund what he called the Williamson Undersea Expedition. The expedition would allow the photographer to embark, as he described it, on "a new cycle of exploration and picture making especially in color photography, both still and motion pictures." The photographer also offered to open the photosphere to "a limited number of visitors," namely tourists, for the first time and to establish an underwater post office. Almost exactly a year to the date of Williamson's letter proposing a business venture with the board (which the promotional agency did financially support),[14] the underwater post office opened on 16 August 1939. The "good business deal" struck between Williamson and the Development Board had the potential to solve several of the representational riddles that had long befuddled both travelers and tourism promoters.

First and foremost, whereas formerly travelers only peered into the sea from its surface, the photosphere allowed them to inhabit the space of their curiosity. As William-

son detailed in his proposal, visitors would first board his "new and attractive barge," which was "yacht-like and somewhat of a showboat" (Williamson to DB, 26 August 1938). After being properly attired, they would descend the tube into the steel-walled photochamber. "There comfortably seated the visitor can get a rare view of the wonders of the Bahamas world of the underseas, through the five foot diameter photographic window of the Photosphere" (Williamson to DB, 26 August 1938). The photosphere thus fulfilled tourists' expressed desires to venture physically where the magic glasses had only allowed their eyes to wander. "How we longed to do what appeared to be so perfectly easy—to step down into the crystal depths and walk about at our leisure in the realms of Aphrodite" (Brassey 1885, 311), recounted Lady Brassey almost 50 years before Williamson's Undersea Expedition. The photosphere offered a sanctuary where travelers could feel secure even as they inhabited this underwater world. Williamson guaranteed that the journey to the bottom of the sea was safe and comfortable, "as if they were riding in an automobile along a country road" (NG, 16 August 1939). Like "carriage rides or quiet walks," to recall Walcott's description of travelers' passages through tropical landscapes (Walcott 1995, 33), occupants of the photosphere could safely inhabit the marine gardens.

From their underwater enclave travelers could accomplish another feat; they could create photographs or the equivalent of plein air paintings from beneath the sea. Newspaper woman Mary Moseley immediately identified the representational potential of the photosphere: "Motion picture and still cameras, especially in colour photography, will reveal the peculiar fascination of life in the depths of the sea. Famous artists will be invited to take palette and brush down into this new sphere of inspiration. Noted scientists, writers, news commentators and others will be able to view and record the wonders of the deep for hours at a time in comfort within the Williamson Photosphere" (NG, 10 December 1938). In short, the underwater sphere provided a place where photographers, artists, scientists, writers, journalists, and tourists generally could, as Defries elaborated, spend "weeks waiting and watching, learning Nature's ways and her secrets" (Defries 1929, 8). Whereas in the past, few artists and photographers had represented life beneath the sea, the photosphere precisely facilitated the representation of this realm in both paintings and photographs. Not only could the photochamber's inhabitants take photographic images from the enclosed space of the sphere, but by don-

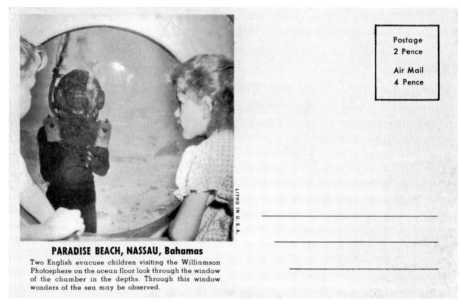

PARADISE BEACH, NASSAU, Bahamas
Two English evacuee children visiting the Williamson
Photosphere on the ocean floor look through the window
of the chamber in the depths. Through this window
wonders of the sea may be observed.

Postage
2 Pence

Air Mail
4 Pence

LITHO IN U.S.A.

42 J. E. Williamson, "Paradise Beach, Nassau, Bahamas," postcard, ca. 1945

ning a diving helmet they could "descend into the open sea and be photographed from the photosphere" (Williamson to DB, 26 August 1938). In this way they could be photographed as part of the seascape, temporary inhabitants of the underwater realms.

The Undersea Expedition also allowed tourists to secure souvenirs from the marine gardens. In addition to their own photographs or paintings, Williamson created a series of postcards that photosphere inhabitants could purchase. Some of the cards pictured persons staring into the photosphere, entranced by the "wonders of the sea" (as one postcard caption submits) (figure 42), making the activity of viewing from the photosphere and the underwater world revealed through its windows equal components of the images. While previously travelers had lamented their inability to garner mementos of their underwater experiences, through the postcards a variety of such views could be easily acquired. Additionally, stamps of the marine gardens (based on Williamson's photographs) could also be attached to the postcard, combining two miniature representations of the sea on the souvenir.

That the photosphere was also a post office meant that the postcards or travelers' impressions could immediately be issued precisely from the location they pictured. Williamson explained: "In perfect comfort and safety one can recline in the Photosphere and cruise through the marine gardens and coral forests on the floor of the ocean, appreciating the amazing beauty and colourful scenery of the ocean floor. Impressions so recorded may be transmitted to one's friends through the facilities provided by the Photosphere Post Office" (*NG*, 16 August 1939). This built-in function of the photosphere allowed tourists to reify their experience of the marine gardens by transmitting visual evidence of their underwater submersion to the outside world. If, as the literary critic Susan Stewart contends, "the other's [recipient's] reception of the postcard is the receipt, the ticket stub, that validates the experience of the site" (Stewart 1993, 135), the photosphere's post office (the first of its kind in the world) ensured the continued validation and visual confirmation of Nassau's submarine terrains. After decades of travelers' much-lamented inability to represent the marine gardens by pen or brush or to secure a souvenir, this immediate validation and authentication was especially desirable. The photosphere and post office thus provided a unique and timely invention. It served at least a fourfold role in tourism promotion, enabling the production, consumption, and dissemination of views of the dreamlike world beneath the sea, while allowing tourists to inhabit the sea in "perfect comfort and safety."

THE SACRALIZATION OF THE SEA:
THE SEA IN TOURISM PROMOTION

Williamson's Undersea Expedition facilitated not only tourists' descent into the submarine world but also the ascent of the islands' underwater image throughout the world. Williamson provided the Development Board with a long-awaited visual archive of still photographs from beneath the sea and motion pictures that the board could use in the international promotion of the island. The photographer, in selling the idea of the expedition to the board, deemed it "primarily a photographic one," which would supply a great number of "striking still and motion pictures" of the sea on a daily basis. Williamson further assured the board that his contacts with international media companies (including the *New York Times*, Wide World Pictures Syndicate and Fox Movietone, Paramount, and Metro-Goldwyn-Mayer) would guarantee wide visibility of his photo-

graphs. Indeed, from the moment the seafloor post office opened, Williamson seems to have delivered on his publicity promise. The post office drew unprecedented attention from international publications like *Life Magazine* and news media including Movietone Newsreel, with a weekly viewership of 100,000,000 people (Movietone News to Williamson, 31 December 1938). Even a writer for the *Miami Herald* (Miami being a tourism competitor) begrudgingly lauded the photosphere as "one of the sweetest publicity stunts ever thought up" (quoted in Williamson to DB, 4 November 1939).

Tourism promoters were particularly interested in the advertising potential of Williamson's color photographs (which he started to produce in the early 1930s), especially given earlier futile attempts to create believable images of the color of the sea. Before Williamson's use of the new developments in color photography, tourism proponents had lamented that the photographer's early black-and-white still and moving pictures failed to convey the colors of the ocean. In the 1920s one local commentator wished that "they [Williamson's films] could show not only the forms but also the natural colours of submarine life" (*NG*, 8 December 1923). The writer stressed the significance of color in representing the sea in particular. When landscapes were shown in black and white on screen, viewers could generally fill in the colors of foliage from their previous experiences of these environments. "But in the case of undersea pictures very few people know what the colours should be and the mind fails to complete the picture. It is for this reason that the desire for colour in undersea pictures is very great" (*NG*, 8 December 1923). In other words, viewers of Williamson's films had no representational reference pool through which to imagine the color of the islands' seascapes. Hence, almost a decade before Williamson's color photographic work, the correspondent wrote that "the beautiful colours of the water and sky at Nassau . . . simply demand color photography." Williamson's color photographs fulfilled a visual desire expressed by industry promoters, even those who lauded Williamson's earlier black-and-white filmic work, to have color images ignite and excite potential travelers' imaginations of the sea.

Tourism industry supporters had long recognized the promotional potentialities of Williamson's work (even before his formalized relationship with the Development Board). Newspaper editor, and member of the board, Mary Moseley, predicted in 1920 that Nassau's tourist trade would benefit both directly and indirectly from Williamson's work (*NG*, 21 April 1920). She noted how his films had already inspired tourist travel. (The editor herself helped to organize showings of the Williamson brothers' 20,000

Leagues under the Sea toward these ends internationally.) The editor of the *Tribune* similarly recognized that "Mr. Williamson has been the best and more active advertiser of the natural charms of these islands than any other individual, group of individuals, or the Board for that matter" (*TR*, 29 September 1928). Recognizing the advertising potential of his work, government officials made plans to use Williamson's films in the Bahamas Court of the British Empire Exhibition. Williamson, of his own volition, displayed his films at the Hall of Science at the Chicago World's Fair in 1933. His films put the waters of the Bahamas before exhibition audiences, apparently without suffering (as far as I have been able to ascertain) from the type of public critiques about their believability that had immediately surrounded Bierstadt's earlier painted representations.[15]

Throughout the 1920s Williamson brought the islands further into the international spotlight through a series of lectures entitled "Into the New World under the Sea" and "Beauty and Tragedy under the Sea," which he delivered in Great Britain, Ireland, and the United States (*NG*, 1 February 1936). The lectures centered "exclusively on Nassau and its adjacent waters, illustrated by actual pictures in their natural colours" (*TR*, 28 September 1928). A lecture pamphlet stressed that the submarine slides were "non-flam." The tour was organized by Lee Keedrick, a manager renowned at the time for presenting "the most celebrated lecturers" (*TR*, 28 September 1928). Again the local press viewed these lectures as "excellent boosters" for the Bahamas (*NG*, 21 November 1928): "In recent years Mr. Williamson has taken the name of Nassau clear across the American continent in lecture tours in which he talked to all kinds and conditions of audiences and a few years ago he did some splendid spade work for Nassau in England when he gave a series of lectures there" (*TR*, 16 August 1939). Although the above-cited article specifically mentions the different "kinds and conditions of audiences" to which Williamson lectured, the exact demographic makeup of these lecture attendees cannot easily be ascertained. It is likely that Williamson lectured to a host of different groups variously interested in exploration, marine biology, and tourist travel.[16] Regardless of the constitution of lecture audiences, several local commentators conceived of the viewers of Williamson's films and photographs in their entirety as potential travelers to the islands (*NG*, 8 December 1923; *NG*, 5 September 1934).

Significantly, Williamson's underwater photographic work did not just have the side effect of promoting travel to the Bahamas, but his images were also instrumental in cre-

ating a visual vocabulary through which to represent the sea. Few representations pictured the submarine world before 1915. Williamson's films and photographs, however, had the immediate effect of bringing forth the marine gardens as visual representations, both in his work and in a host of other artists' representations.

WILLIAMSON'S PHOTOGRAPHS AND REPRESENTING
THE SEA IN PAINTINGS AND HOTEL SEASCAPES

As early as 1915, for example, it is likely that Williamson's work influenced representations of a British-born artist, Stephen Haweis (1878–1969), who worked on occasion for the Development Board. In 1914 Haweis first traveled to the Bahamas, inspired by French artist Paul Gauguin's late nineteenth-century tropical travels to the Caribbean (Martinique) and South Pacific (C. H. B.1920, 5). Almost immediately after Williamson created his underwater photographs, Haweis created a series of paintings of the marine gardens. Whereas early representations of the marine gardens seldom pictured what lay beneath the surface of the sea, Haweis's images attempted precisely to visualize this underwater realm. His *The Sea Gardens through a Waterglass*, for instance, shows a black man peering through a water glass into the sea, but most of the image is actually devoted to picturing the sea gardens (plate 22). Haweis represents the sea through a series of postimpressionist swirls of color, structured like the panes of stained glass. The process of viewing is marginalized in the work, confined to the top of the painting, while the colors and forms that inhabit the marine gardens occupy center stage. Haweis's focus on representing elements underneath the sea's surface recalls Williamson's contemporaneous photographs.

Haweis's painting *The Divers* bears the imprint of Williamson's photographic images (figure 43). The work appears to be inspired, in subject matter and in composition, by one of Williamson's photographs of the same title (figure 44). Both images portray two silhouetted native divers with their arms and legs poised in hot pursuit of a coin on the ocean's floor. Revealingly, travel writer Amelia Defries placed the two images side by side in her book, recognizing the undeniable resemblance between Haweis's and Williamson's representations (Defries 1917, 186). Even though Haweis provided a wider perspective on the scene, including a glimpse of a boat above the water and the coral and marine life below, the main figures in both works appear the same. Beyond William-

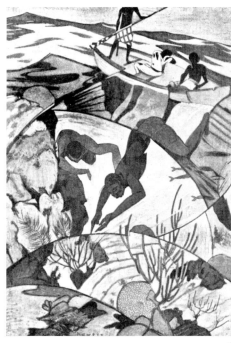

43 Stephen Haweis,
The Divers, ca. 1917

44 Williamson Submarine
Film Corp., "The Divers," ca. 1917

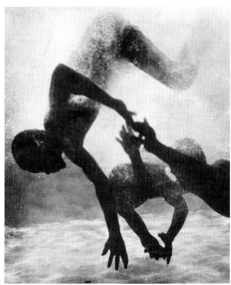

son's influence on Haweis's *Divers*, it appears that the photographer's work more broadly opened up the representational possibilities of visualizing beneath the sea, influencing representations and ways of seeing the ocean beyond the realm of photography.

The moment artists like Haweis visualized the sea gardens, the Development Board capitalized on these images in its promotional efforts. This is evident in a number of contemporaneous exhibitions and promotional schemes. In 1915 the board sponsored an international art exhibition of Haweis's paintings, which focused precisely on Nassau's submarine environments (DB 1915). Two years later the board supported and distributed a book by Haweis, *Sea Gardens of Nassau* (DB 1917–18). In 1924 the board used Haweis's paintings in the Bahamas Court at the British Empire Exhibition in Wembley (NG, 12 July 1924). Haweis's paintings accompanied a display of marine curios and fish gathered from Bahamian seas (NG, 6 October 1924). In short, the marine gardens and seascape quickly became central icons in Development Board campaigns after 1915, especially by the 1920s and 1930s. Williamson's work provided a visual precursor to these campaigns, a means through which the marine gardens could be visualized, used in tourism promotion, and iconicized as representative of the Bahamas.

Williamson's visual inventions also inspired physical representations of the marine gardens in hotel landscapes. As soon as seascapes became sacralized in visual representations, they informed the built environment of hotels in several ways. In 1935 the exhibition of Williamson's work that had been at the Chicago World's Fair returned to Nassau and formed a display at the Hotel Colonial (NG, 8 January 1935). In this instance the exhibit, which had projected an image of the islands to international audiences, literally became a part of the hotel space for travelers when they visited Nassau. Additionally, in 1938 enlargements of Williamson's photographs (54 × 68 inches) also formed murals in a small hotel, The Rozelda, owned by Development Board chairman, Roland Symonette (Williamson to Symonette, 10 November 1938). Hotel owners also made the marine gardens a more permanent part of their decor. In 1922 the Hotel Colonial's managers hired Haweis to create underwater murals "portraying the many varieties of bright-coloured and interesting native fish" for the hotel's lobby, which would surround a giant aquarium in the main entranceway (NG, 3 February 1923). In this project no longer were tourists confined to gazing at photographs or films of the sea gardens, but the aquarium reproduced the submarine environment in miniature. In a short period of just seven years between the creation of Williamson's films and the popularity of his submarine

representations, hotel owners aimed to re-create physically this environment within hotels. Much like the creation of tropical gardens on the Royal Victoria Hotel or Hotel Colonial's grounds, hotel designers aimed to reproduce the newest photographic icon of the tropical seascape within their properties. These hotel projects demonstrate that soon after tourism promoters and travelers committed aspects of the environment to photography and reified them as iconic, industry proprietors refashioned parts of the landscape in their image.

AN OCEAN IN THE GARDEN OF EDEN? DOMESTICATING THE SEA THROUGH ITS VISUALIZATION

Williamson's undersea photography did more than solve the riddle of submarine and aquamarine (the color of the sea) representation. The process of visualizing the seascape had a profound influence on conceptions of the sea both locally and globally. In the early part of the twentieth century the ocean was still largely an uncharted and unknown territory. Scientific research into the ocean and its inhabitants was at its infancy and did not begin in earnest until the 1940s. While colonists and imperialists in the first decades of the twentieth century could claim to have traversed and "civilized" even in the farthest recesses of the earth, they could not make similar claims about their exploration of its oceans. For this reason Lena Lenček and Gideon Bosker point out in their history of European and North American perceptions of the ocean and beaches that the expanse of the sea remained seemingly free from and immune to domesticating and civilizing forces at the start of the twentieth century. The ocean appeared "completely inhospitable to domesticating and civilizing forces" (Lenček and Bosker 1998, 27).

Because the ocean's depths remained veiled in mystery, many frightful myths and legends of the deep still inhabited imaginations of the sea in North American and western European cultures. Fears of the ocean's mysterious depths stemmed from long-held "ancient lore which painted the turbulent depths as miasmic stews of bellicose, limb-chomping creatures that guarded their domain with jealous ferocity" (Lenček and Bosker 1998, 27). The famed Loch Ness monster of Scotland, for instance, was not just the grist of fables but was widely believed to be a living and fearful underwater monster. Hence, before Williamson's photographic inventions, as one local report on Williamson attests, the ocean seemed to many "eerie," inhabited by "strange weird monsters"

and lost worlds like Atlantis: "Beneath its great expanse of 148,000,000 square miles, the ocean is literally one vast teeming foment [*sic*] of life, and in its eerie depths are strewn the wrecks of treasure laden ships . . . jealously guarded by strange weird monsters; we read of sunken cities, a continent engulfed—the lost Atlantis. But, again and again has the grip of the deep refused to surrender to the puny efforts of man the secrets of this undersea world of mystery" (*TR*, 29 September 1928). It appears that many of these fearful conceptions of the ocean derived precisely from the idea, reiterated in a local newspaper article, that the ocean refused to surrender its mysteries. As Haweis similarly described, "Down in the deep sea the imagination of man has always created palaces of mystery" (Haweis 1917, 5). In short, in the first decades of the twentieth century the ocean still seemed a vast, unknown, and unknowable entity.

"DANGER AND BEAUTY LIE TOGETHER":
SEA MONSTERS IN BAHAMIAN WATERS?

Even the shallow waters of the Bahamas were not immune to such imaginings and fears of the inhabitants of the deep. This is evident in Amelia Defries's caution to readers of her guide that the seemingly beautiful waters of the Bahamas could be deceptive: "The whole sea is infested with sharks and barracudas—for as there are poisons and antidotes in the bush, so in the sea beauty and danger lie together" (Defries 1929, 12). This echoes Williamson's "Tragedy and Beauty" lecture. Other travelers, especially in the late nineteenth century, expressed their consternation about sea creatures that lingered in the Bahamas' waters. Sharks were the most dreaded inhabitants of Bahamian waters. Fear of sharks hindered many tourists from even venturing into the waters for the purposes of sea bathing. One traveler, Milton Mackie, bluntly explained why he would never venture into Bahamian waters: "And all these marine divinities could testify that most gladly would I swim in the tepid waves from one Bahama Island to another—but for the sharks! These monsters give me pause" (Mackie 1864, 331).

Several travelers, including Mackie, recounted stories about blacks being swallowed whole by these monsters of the sea: "For, during my stay at Nassau, one of them swallowed his Jonah—a black man—[and] was found, after capture, to have digested the whole of him, excepting one hand, and his rum bottle. Dreadful!" (Mackie 1864, 331). William Church, the author of "A Midwinter Resort" (an article that included illus-

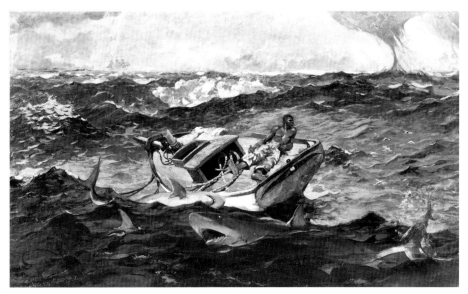

45 Winslow Homer, *The Gulf Stream*, oil on canvas, 1899

trations by Winslow Homer), retold an even more fantastic account of five men whose skeletons were found "neatly arranged in a row" in a shark (Church 1887, 506). These cautionary tales accompanied an early engraved version of Winslow Homer's well-known painting *The Gulf Stream* (1899) (figure 45). The painting, depicting a black boatman surrounded by sharks, seems a visual counterpart to contemporaneous travelers' professed fears of sea monsters and the sea generally in the Bahamas. In the painting the black male figure appears precariously poised, literally and figuratively, between two uncertain and unfortunate fates. His gaze assesses an approaching storm, while sharks seem to eye his teetering boat. In the painting, as in many of the earliest travel accounts, the sea in the Bahamas, despite its beauty, was a fearful space inhabited by human-devouring sharks.

While these cautionary tales of the sea existed in several accounts of the Bahamas, the "gentlest, most caressing mood" of the islands' shallow waters did seem to provide some tourists with a more sedate view of the ocean than could be encountered else-where (*Guide to Nassau* 1876, 18).[17] The transparent quality of the islands' waters made

them seem less intimidating. Travelers' ability to see some depth into the water provided an environment where some of the mysteries of the sea could be demystified and its "secrets uncovered" (Haweis 1917, 6). In fact, tourists typically only deemed parts of the ocean's floor that they could not see as fearful. Ives, for instance, generally admired the marine gardens but feared what lurked "in the edges of the lowest shadows" of the ocean, the areas of the ocean that remained "an impenetrable mystery" hidden from his "inquiring gaze" (Ives 1880, 218). Quite simply, only recesses of the ocean just outside of visual reach sparked travelers' imaginations and consternations about what lurked in the sea's depths.

With the constant improvement of visual technologies (culminating in the photosphere), which increasingly expanded and extended travelers' visual window into the ocean, the sea became increasingly less frightful. Williamson's photosphere allowed travelers to traverse the formerly uncharted territory of the submarine environment. Through his mobile photosphere, his flexible photographic eye, even the darkest recesses where Ives could not formerly penetrate visually could now be seen. Shadowy underwater realms could be flooded with lights from the mother ship and then photographed. Williamson's photosphere, photographs, and films presented the seemingly unknowable and mysterious entity of the sea as knowable. In the process the marine gardens went from being shrouded in mystery to being visualized ad infinitum and distributed throughout the world.

Even sharks and other sea monsters seemed less frightful through Williamson's visual technologies. The very first documentary that Williamson shot included a scene in which a young local diver killed one of the sea-devils, sharks, before the lens of the photosphere. The diver traveled to where the sea monsters lurked and challenged their ferocity in their habitat. A cover of the publication *Science and Invention* from July 1928 portrays Williamson in an underwater encounter with an octopus, another feared creature of the deep. The drawing depicts Williamson, in the fashion of a comic book superhero, brandishing a spear before the "sea monster" and saving a damsel in distress (plate 23). Despite the weapon portrayed in his hand, one could make the case that Williamson's preferred method of combat was his camera — through his photographic technologies he successfully battled long-held fears of the Bahamas' seas. Williamson himself described his Undersea Expedition as an initiative that would "conquer the mysteries of submarine life" (NG, 16 August 1939).

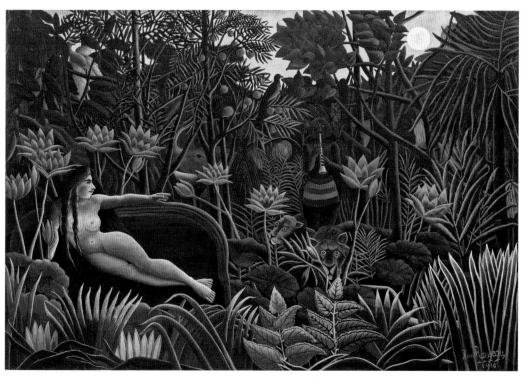

PLATE 1 Henri Rousseau, *The Dream*, oil on canvas, 1910

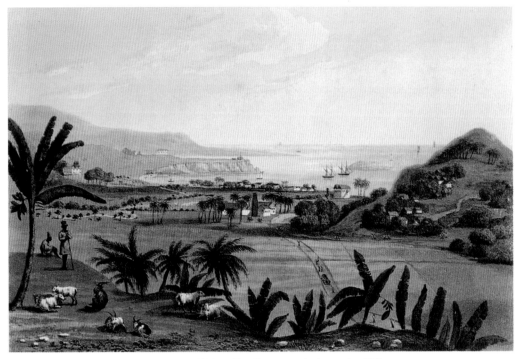

PLATE 2 Thomas Sutherland after James Hakewill, *View of Port Maria*, engraving in aquatint, 1820

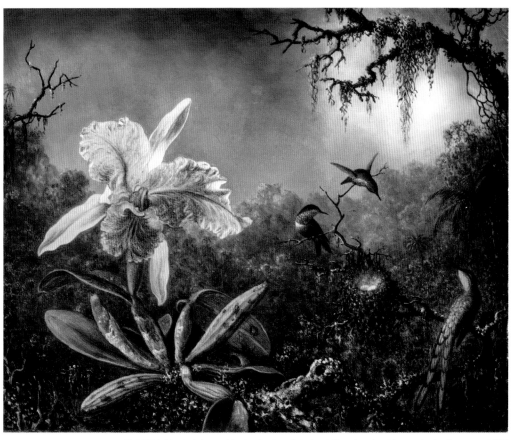

PLATE 3 Martin Johnson Heade, *Cattleya Orchid and Three Brazilian Hummingbirds*, oil on wood, 1871

Jamaica

"GREETINGS FROM JAMAICA"

PAW-PAW TREE, JAMAICA

Paw Paw is like our melons

"GREETINGS FROM JAMAICA"

COCOANUT TREE AND FRUIT, PORT ANTONIO

A cocoanut tree in Jamaica

Greetings from Jamaica, Taking off the Crop Sugar Estate

Harvesting sugar cane

PLATES 4 and 5 Scrapbook of Elizabeth and Helen Riley, including postcards of Jamaica, 1934

Kingston, the Capitol of Jamaica

Greetings from Jamaica,
King Street. Kingston

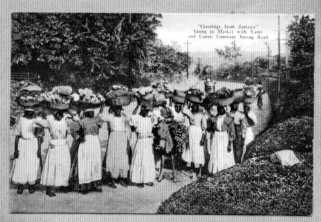

"Greetings from Jamaica"
Going to Market with Yams
and Canes, Constant Spring Road

The natives all speak the English language as this island is owned by England.

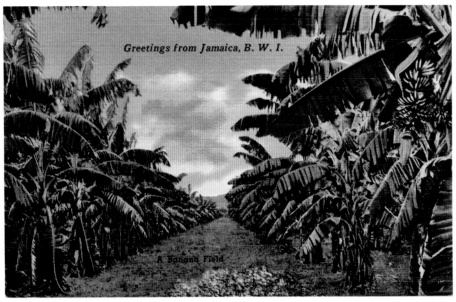

Greetings from Jamaica, B. W. I.

A Banana Field

No 207
A well laid out field of Jamaica Robusta bananas.

APR 27 1953

*Richard J.
Charette*

POST CARD

PLACE
STAMP
HERE
MADE IN U. S. A.

COPYRIGHT PICTURE BY CLEARY & ELLIOTT, JAMAICA, B. W. I.

65631

PLATES 6 and 6a Cleary and Elliott, "A Banana Field," postcard, ca. 1953

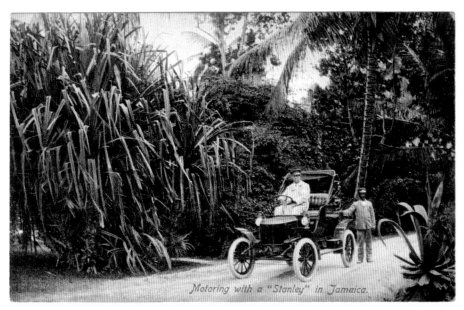

Motoring with a "Stanley" in Jamaica.

PLATE 7 James Johnston, "Motoring with a 'Stanley' in Jamaica," postcard, 1907–14

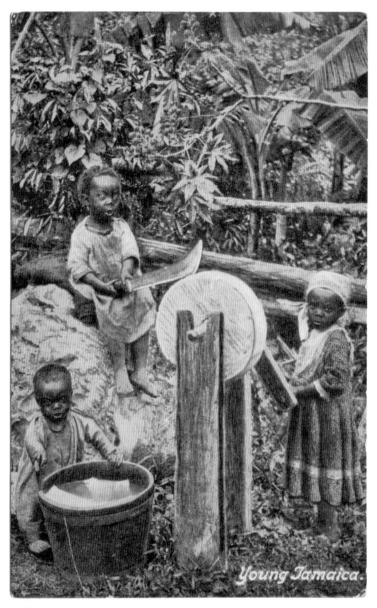

PLATE 8 H. G. Johnston [James Johnston], "Young Jamaica," postcard, 1907–14

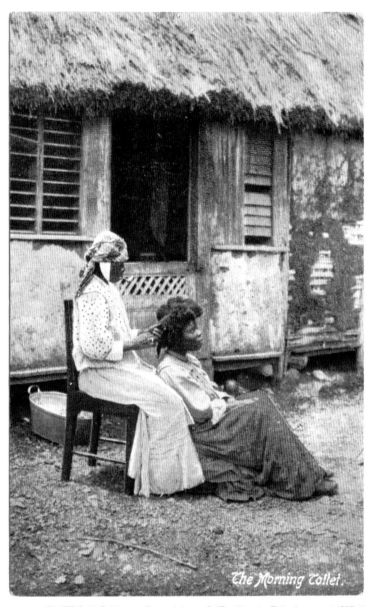

The Morning Toilet.

PLATE 9 H. G. Johnston [James Johnston], "The Morning Toilet," postcard, 1907–14

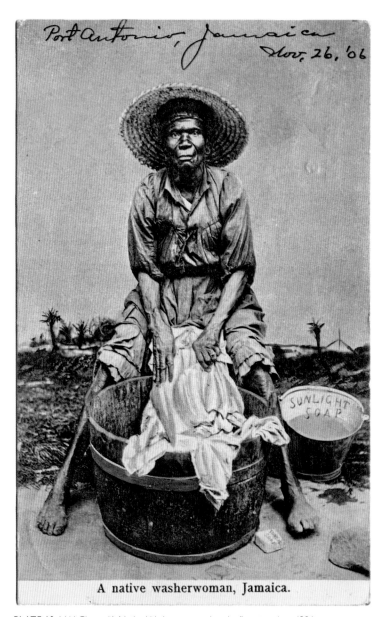

A native washerwoman, Jamaica.

PLATE 10 J. W. Cleary, "A Native Washerwoman, Jamaica," postcard, ca. 1906

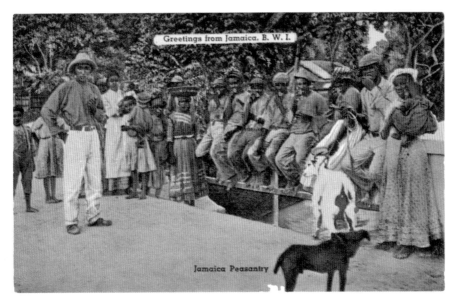

PLATE 11 E. Wells Elliott, "Types of Jamaica Peasantry," postcard, 1907–14

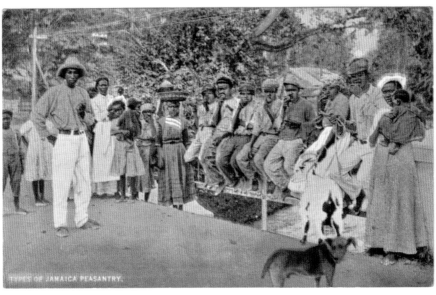

PLATE 12 Cleary and Elliott, "Jamaica Peasantry," postcard, 1907–14

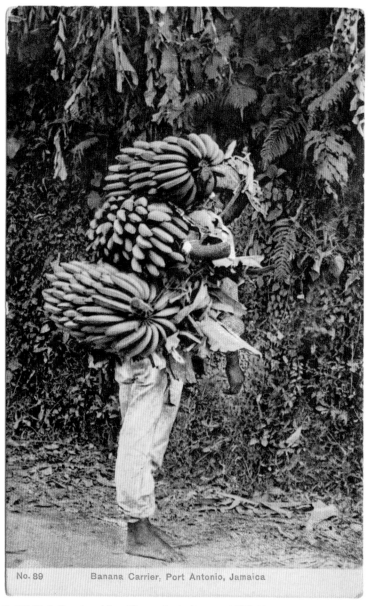

No. 89 Banana Carrier, Port Antonio, Jamaica

PLATE 13 A. Duperly and Sons, "Banana Carrier," postcard, 1907–14

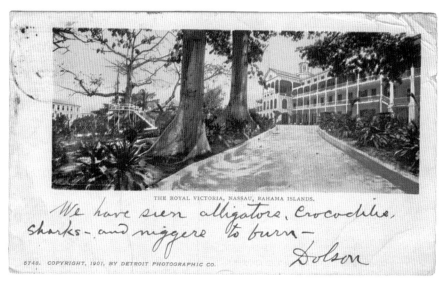

THE ROYAL VICTORIA, NASSAU, BAHAMA ISLANDS.

We have seen alligators, crocodiles, sharks — and niggers to burn —

Dolson

5748. COPYRIGHT, 1901, BY DETROIT PHOTOGRAPHIC CO.

PLATE 14 Detroit Photographic Company, "The Royal Victoria, Nassau, . . ." postcard, 1900

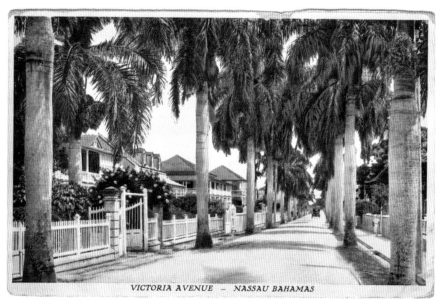

VICTORIA AVENUE — NASSAU BAHAMAS

PLATE 15 Sand's Studio, "Victoria Avenue—Nassau, Bahamas," postcard, 1915–30

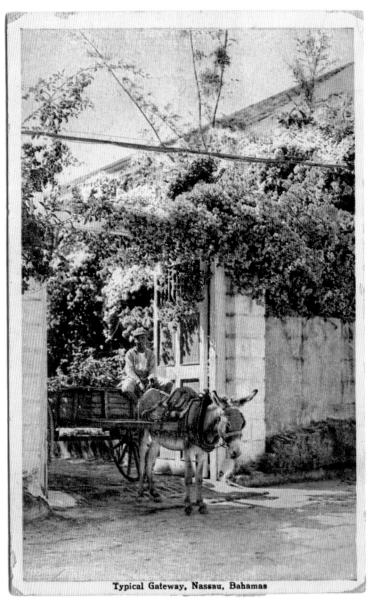

Typical Gateway, Nassau, Bahamas

PLATE 16 W. R. Saunders and I. O. Sands, "Typical Gateway, Nassau, Bahamas," postcard, 1915–30

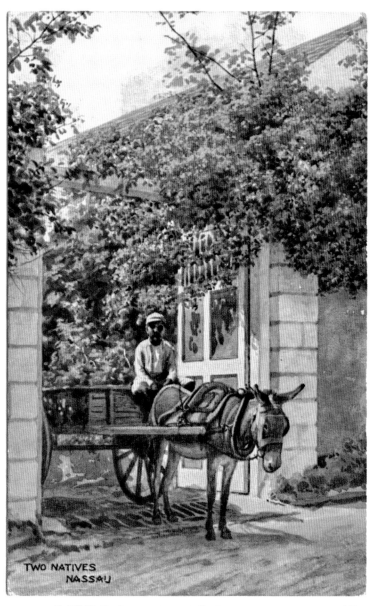

PLATE 17 City Pharmacy, Nassau, N.P., "Two Natives, Nassau," postcard, 1907–14

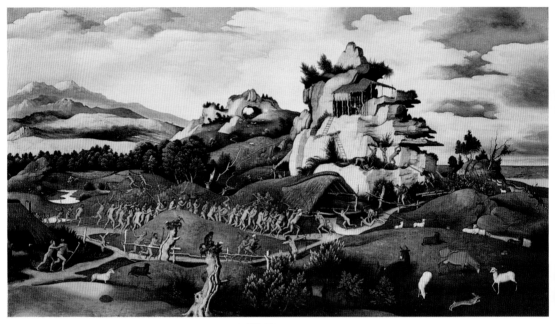

PLATE 18 Jan Mostaert, *West Indian Landscape*, oil on panel, 1520–30

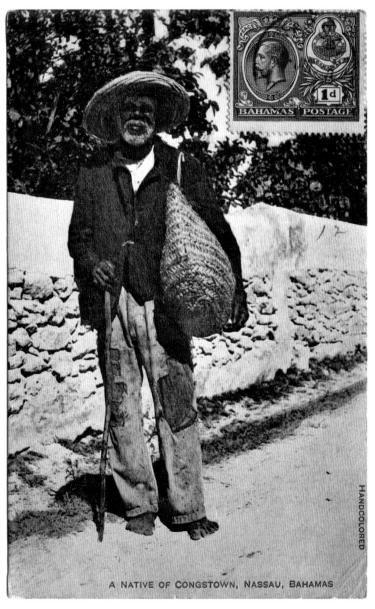

A NATIVE OF CONGSTOWN, NASSAU, BAHAMAS

PLATE 19 Photographer unknown, "A Native of Congstown, Nassau, Bahamas," postcard, ca. 1920

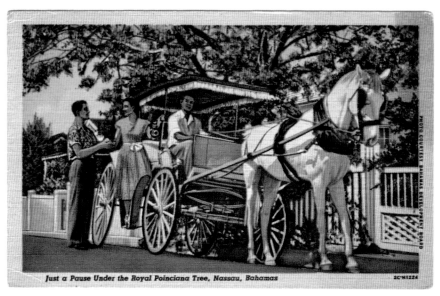

PLATE 20 P. M. Lightbourn for the Bahamas Development Board, "Just a Pause under the Royal Poinciana Tree, Nassau, Bahamas," postcard, 1930–44

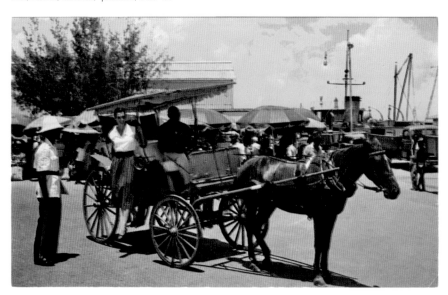

PLATE 21 The American News Co., "Nassau in the Bahamas," postcard, ca. 1950

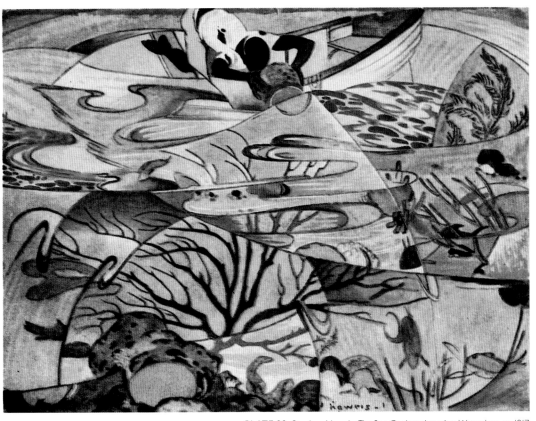

PLATE 22 Stephen Haweis, *The Sea Gardens through a Waterglass*, ca. 1917

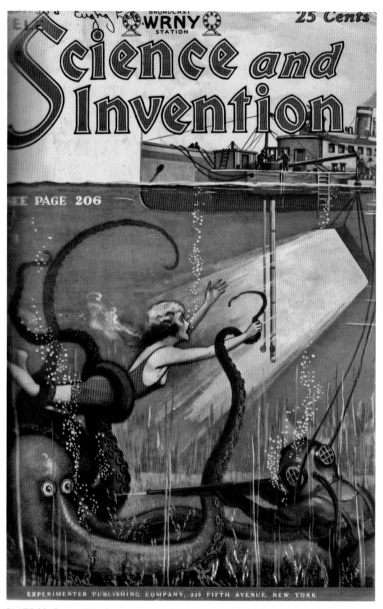

PLATE 23 Cover of the *Science and Invention* issue devoted to Williamson, July 1928.

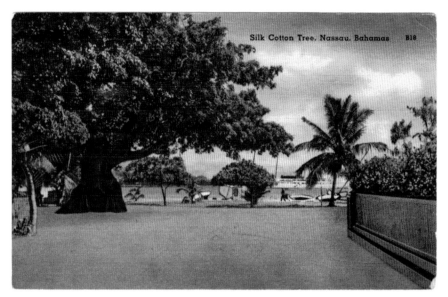

Silk Cotton Tree, Nassau, Bahamas B18

PLATE 24 P. M. Lightbourn, "Silk Cotton Tree, Nassau, Bahamas," postcard, 1930–44

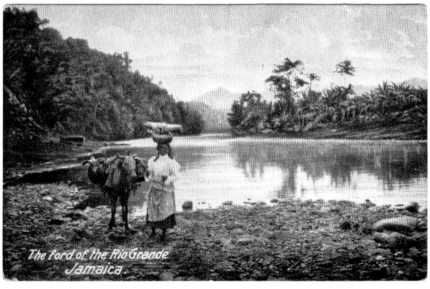

The Ford of the Rio Grande Jamaica.

PLATE 25 United Fruit Company Steamship Lines, "The Ford of the Rio Grande, Jamaica," postcard, ca. 1900

Directly behind our young coachman, and his friend with the long ears, is Balcony House. This is not just a quaint dwelling, it is an historic monument, built in 1790. Unique wooden knee braces buttress the balcony from which the house takes its name. In the winter of 1991, it was in a disgraceful state, crying out in shame. How can a community allow this? What should be the focus and show piece of historic Nassau is falling apart.

MARKET STREET, SHOWING CITY MARKET, NASSAU, BAHAMAS.

PLATE 26 Cropped "Two Natives" postcard in *Nostalgic Nassau*, 1991

PLATE 27 Detroit Publishing Company, "Nassau, Bahamas," postcard, n.d.

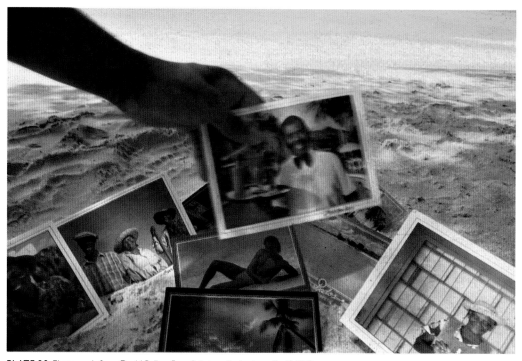

PLATE 28 Photograph from David Bailey, *From Britain or Barbados or Both?* 1990

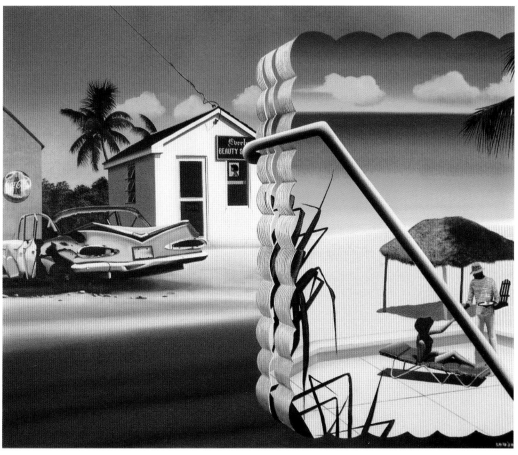

PLATE 29 David Smith, *Excerpts from the American Dream*, acrylic on canvas, 1984

PLATE 30 Irénée Shaw, *Neighbourhood*, from the *Gilded Cages* series, oil on canvas, 1992

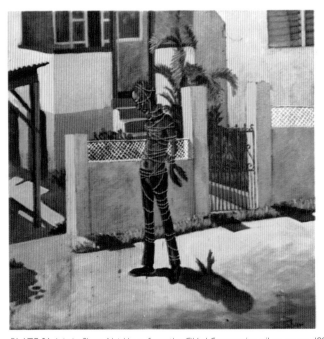

PLATE 31 Irénée Shaw, *Neighbour*, from the *Gilded Cages* series, oil on canvas, 1992

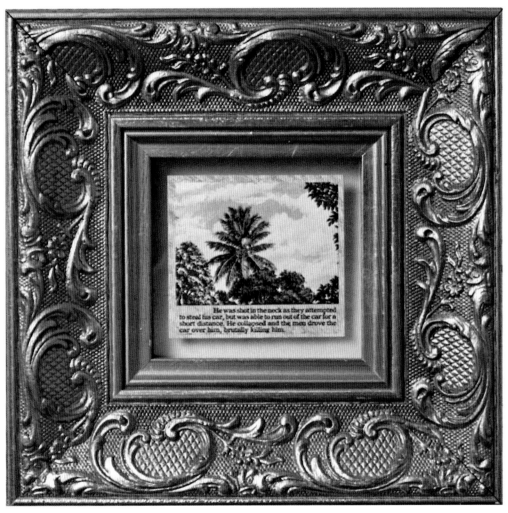

He was shot in the neck as they attempted to steal his car, but was able to run out of the car for a short distance. He collapsed and the men drove the car over him, brutally killing him.

PLATE 32 Christopher Cozier, *Wait Dorothy Wait*, mixed media, 1991

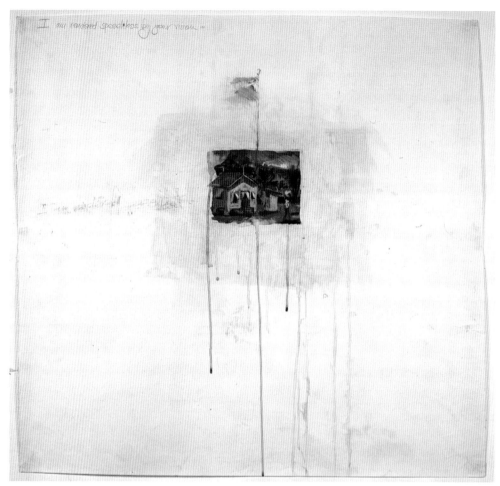

PLATE 33 Christopher Cozier, *I am rendered speechless by your vision, Three Stains on Paper, Cultural Autopsy* series, mixed media on paper, 1995

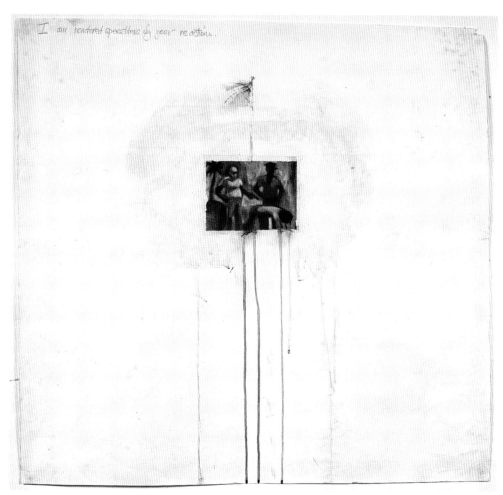

I am rendered speechless by your reactions.

PLATE 34 Christopher Cozier, *I am rendered speechless by your reactions*, *Three Stains on Paper, Cultural Autopsy* series, mixed media on paper, 1995

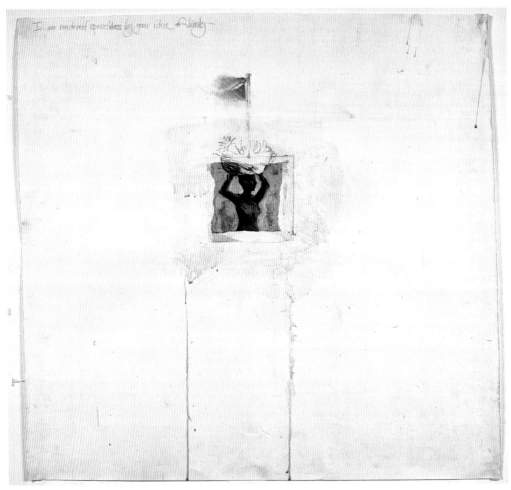

PLATE 35 Christopher Cozier, *I am rendered speechless by your your idea of beauty*, *Three Stains on Paper*, *Cultural Autopsy* series, mixed media on paper, 1995

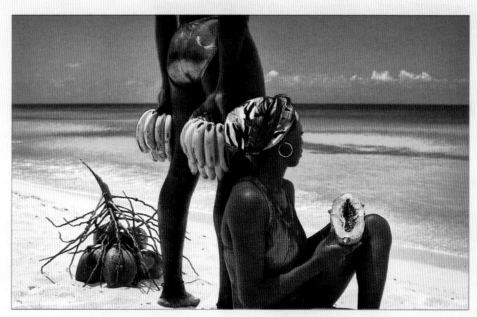

Colours of Jamaica

PLATE 36 Dick Scoones, "Colours of Jamaica," postcard, ca. 2000

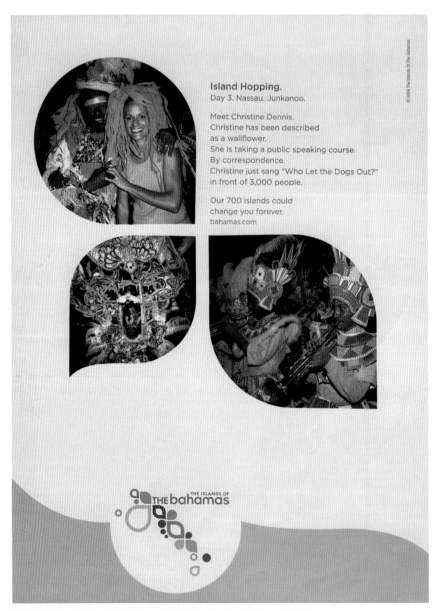

Island Hopping.
Day 3. Nassau. Junkanoo.

Meet Christine Dennis.
Christine has been described
as a wallflower.
She is taking a public speaking course.
By correspondence.
Christine just sang "Who Let the Dogs Out?"
in front of 3,000 people.

Our 700 islands could
change you forever.
bahamas.com

THE ISLANDS OF
THE bahamas

PLATE 37 The Islands of the Bahamas, "Island Hopping," advertisement, 2004

In this process Williamson's photographs from the depths of the sea continued the processes of photographic visualization that had brought "lesser known" regions of the world to light for European and North American audiences since the nineteenth century. James Ryan argues that from the 1830s until World War I, photographs were instrumental in familiarizing Victorians with foreign lands and peoples, allowing them to "symbolically travel through, explore and even possess those spaces" (Ryan 1997, 214). In addition to the creation of photographic images, Ryan sees a correlation between the visualization of these spaces through photographs and the imperial mission. The practice of photography, by illuminating the secrets of the "dark and dangerous surroundings of tropical Africa," paved the way for imperial expansion, the bringing of "civilization to these spaces" (Ryan 1997, 30). Although Ryan's remarks are directed primarily at photographic representations of foreign landscapes and their inhabitants, his insights into the connections between photography, the visualization of little-known territories, and the "civilization" of these spaces may also be applicable to Williamson's underwater expeditions.

Williamson also domesticated and "civilized" the islands' seascape by making the ocean floor seem like a tropical landscape, indeed, like a garden. The photographer, like so many travelers before him, envisioned the ocean through "tropical lorgnons"; he also used key descriptors of the tropical landscape to characterize the coral reefs and marine life encountered through the photosphere. To him the seascape seemed like a tropical landscape inhabited variously by "masses of coral jungles," "coral forests," and "sea devils" (sharks) (Williamson 1936, 267, 260, 101). Interestingly, Williamson himself pondered this relationship that he detected between the seascape and landscapes in the tropics: "Does Nature in the sea below imitate Nature above it, or is it the reverse?" (273). This reconceptualization of the coral reefs as tropical forests or fish as tropical birds may be interpreted as another way to conquer the mysteries of the sea and its inhabitants. Through this vocabulary the seascape was rendered familiar, already known, and comparable to a geographic space, the tropical landscape, that had been previously charted, classified, and studied by numerous naturalists, scientists, and explorers. If the sea seemed like a "tropical forest" with waving palms, travelers could slot the unfamiliar submarine environment into these preexisting representational ideals of tropical nature. Through this type of pictorial assimilation the sea seemed like a tropical landscape, like the dream of the tropics realized underwater.

Significantly, the rereading of the seascape as a tropical landscape did not assume the form of just any type of tropical environment but was frequently described specifically as "marine gardens." Of course, the concept of a garden refers to a specific kind of domesticated, manicured, and controlled version of the natural landscape. By looking at the seascape through tropical lorgnons, the civilized and orderly ideal of tropical nature as a garden was redirected at the environment underneath the sea. Additionally, Williamson and other writers went so far as to describe the world beneath the sea in the Bahamas as the "Marine Garden of Eden" (complete with "sea devils"), making the assimilation of the marine gardens to preexisting descriptions of the paradisiacal tropical landscape complete (Ives 1880, 219; Williamson 1936, 263).

This even more embellished inscription of the islands' seascape as a Garden of Eden deserves further consideration. It dramatically underscores how both the visualization of the islands and their various characterizations may have been attempts to fix the seemingly chaotic entity of the ocean into a knowable and tamed environment. As Lenček and Bosker point out in assessing characterizations of the sea in the Bible, "Tellingly, there is no sea in the Garden of Eden" (42). In the Creation story, as recounted in Genesis, the sea was conceived as a "great abyss," "a site of great mysteries, an uncharted and undifferentiated liquid chaos that is as unknowable as the spirit of God" (42). The concept of the Garden of Eden could not sustain the presence of this vast unknowable abyss of the sea. As they explain: "the Landscape of paradise is enclosed, reassuringly bounded, and within it everything has its knowable fixed place" (42). In short, Lenček and Bosker maintain that the boundlessness of the sea was in many ways antithetical to the idea of the Garden of Eden.

Lenček's and Bosker's observations about the sea and its seemingly untenable relationship to the Garden of Eden seem particularly pertinent given that the two were paired in unholy matrimony in descriptions of Bahamian waters. The application of the Garden of Eden to the vast entity of the sea in the context of the Bahamas may point to the fact that the reconceptualization of the sea as a submarine Eden was likely aimed at fitting the underwater environs into this bounded, contained, and knowable concept of Eden. The ability to see and classify the marine gardens, facilitated by the photosphere, indeed made the unbounded abyss of the ocean seem like a tropical garden. Many writers described the gardens as "an aquarium"—precisely placing an invisible verbal boundary around parts of the sea (Brassey 1885, 329; Defries 1917, 174). Con-

ceptions of the sea as a "garden," "Garden of Eden," or "aquarium" all point to some travelers', Williamson's, and tourism promoters' efforts to circumscribe the boundless sea, to re-present it as an ideal domesticated space.

WILLIAMSON AND GLOBAL NOTIONS OF THE SEA: BETWEEN NATURAL HISTORY MUSEUMS AND HOLLYWOOD

Williamson's photographic technologies developed in the Bahamas paved the way for him to render other seascapes as nonthreatening internationally. Through his photographic work he was able to rid other geographic locales of their mythical sea (or lake) monsters. In the 1930s Williamson was asked to investigate the mysteries of the Loch Ness monster (*TR*, 16 August 1939). (His underwater visual apparatus found no visual evidence of the creature.) In 1933 Williamson was enlisted to put to rest rumors, rampant in British Columbia, of another sea monster, the "Victoria Sea Serpent" (*NG*, 16 December 1933). (Williamson concluded that "the serpent" was likely the tentacle of an octopus.) A postcard, which Williamson collected during his travels to Scotland, comically illustrates the relationship between photography and the debunking of myths and fears of monsters of the deep (figure 46). In the card the Loch Ness monster appears and offers a smile to awaiting photographers. The caption on the postcard reads: "The Loch Ness Obliges the Photographers, Invermoriston." Williamson's collection of this image seems to poke fun at his very constitutive role as photographer and slayer of prevailing myths of monsters in bodies of water, both lakes and oceans. Through the process of being photographed the Loch Ness monster was but a smiling friendly creature. By extension, Williamson's own creation, reproduction, and distribution of postcards of the marine gardens or battles with sharks call attention to his role in using photographs to change such prevailing conceptions and fears of the sea internationally.

Williamson's collaborations with natural history museums within the United States further demystified the sea through its visualization. In the 1920s the American Museum for Natural History in New York and the Field Museum in Chicago worked with Williamson to create dioramas and exhibitions of the world beneath the sea. In 1929 taxidermists from the Field Museum took advantage of Williamson's underwater viewing machine to "observe" and "sketch" beneath the sea in the Bahamas for their Hall of Fishes. In keeping with the practice of expeditions to "uncharted territories," the mu-

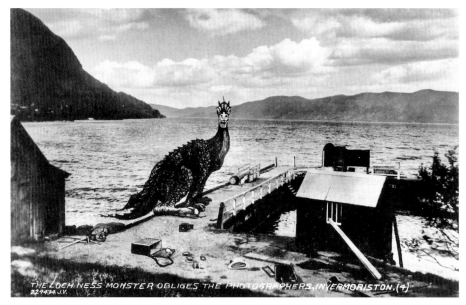

46 James Valentine, "The Loch Ness Monster Obliges the Photographers, Invermoriston," postcard, n.d.

seum embarked on an ambitious collection mission, netting over 190 types of fish and sharks and massive pieces of coral (one weighing over two tons) for its subterranean installation (*Annual Report of the Director* VIII [1930]: 89–90). The natural history museum in New York, following a 10-year partnership with Williamson, also constructed an elaborate two-story diorama of coral reefs in 1934, which is on view today in that museum's Milstein Hall of Ocean Life. The top tier shows a small, flat, sandy cay, while the bottom reveals a colorful and bountiful underwater environment. Through these displays of "ocean life" or "halls of fishes" the Bahamas' marine environment, which had a unique underwater ecology compared to other parts of the Caribbean, became a window through which countless museum-goers came to know the oceanic world more generally. By gazing into these dioramas, viewers experienced the simulated seascape through the glass of the photosphere. This curating of the realm beneath the sea would mark another important moment in the demystification of the ocean. The previously unseen seascape was now the object of constant visual inspection. Placed behind glass

and tagged with museum labels, the previously unknown and dangerous underwater domain was mysterious and fearful no more.

Williamson's photographs, his sea-monster investigations, and the dioramas he made possible were instrumental in making the sea a desirable and safer space of occupation internationally. Lenček and Bosker point out that "before Europeans could be persuaded to go down to the beach and luxuriate in its physical and spiritual bounty, they had to learn to see it. The eye that had been trained by scripture, harsh nature, and tradition to view the beach with fear or disgust had to be taught to gaze upon it with approval" (50). Williamson's underwater photographic inventions seem to have been successful precisely in inspiring this new way of looking at and venturing into the sea. Not coincidently, tourists entered and lingered in the sea after Williamson's photography and museum representations assured them of the ocean's safety. Sea bathing among tourists became popular in the Bahamas and in other parts of the Caribbean in the late 1920s and 1930s.[18] While many social and cultural factors contributed to this new found touristic ritual,[19] Williamson's multifaceted part in teaching audiences to gaze upon the sea with approval and without fear undoubtedly played a part in transforming the sea from a space travelers dared not venture to a place they dreaded to leave.

During the 1930s and 1940s the Bahamas' touristic image shifted increasingly to a new touristic site, the beach, superseding the former popularity of representations of the islands' tropical flora. A postcard by P. M. Lightbourn from the 1930s, which pictures a silk cotton tree in close proximity to the beach (a scene likely created in a photographer's darkroom rather than photographed on the islands), seems reflective of the transitions in the destination image of the islands in this period (plate 24). The silk cotton, which appears to thrive without any soil beneath it, frames the left side of the image, while the rest of photograph gives way to an open beach vista. In the card the former icon of the island's tropical nature, the silk cotton, is coupled with the islands' blue waters—then the emergent sign of the Bahamas. The coconut palm on the right side of the photograph counterbalances the silk cotton but would later replace it as the tropical botanical signifier most frequently pictured with the beach in representations of the Bahamas (and many other Caribbean islands). This image endures as the most popular icon of the Caribbean. The sea (and its tropical flora accompaniment) made its representational debut on a stage prepared in part by Williamson's visual technologies and reinforced by the demands of the tourist trade. In other words, the icon frequently

taken for granted as a natural signifier of the islands only became canonized through technological innovations of photography.

The pairing of the coconut tree and clear blue sea deserves further consideration. This visual partnership combines two signifiers of the tamed or domesticated tropical environment. The coconut palm's presence on the islands often served as visual testament to a civilized and orderly tropical landscape. The transparent blue seas also frequently offered a tamed and domesticated seascape. Both, when pictured together, provided dual assurances that both the land and sea in the tropical environment of the Bahamas were safe for tourist occupation.

While Williamson's visual technologies "conquered" many mysteries of the sea, as a feature filmmaker and Hollywood collaborator he simultaneously revived many of the myths of the great abyss. The Hollywood productions on which he worked, including *20,000 Leagues under the Sea, Bahamas Passage* (1941), and a Disney version of *20,000 Leagues under the Sea* (1954), and the television series *I Search for Adventure*, presented the sea as a stage of mystery, adventure, and danger, many of the qualities his documentary films and museum dioramas debunked. In these Hollywood productions and in Williamson's own feature films, including *Submarine Eye* (1917), *Girl of the Sea* (1920), *Wet Gold* (1921), and *Wonders of the Sea* (1922), filmmakers pulled their characters and plots from the pages of folklore, oral legend, and science fiction.[20] Many of the photoplays cast the sea as a setting of fabled sea monsters, mermaids, shipwrecks, and lost treasure. A photograph from *Girl of the Sea* conveys a sense of the mysterious underwater world Williamson projected in his films. Shot through the circular window of the photosphere, a female inhabitant of the deep—recalling legends of mermaids—searches through a ship's wreckage (figure 47). This interest in the long-held lore of the sea is perhaps not surprising given that Williamson himself was inspired to explore underwater by the legend of the lost world of Atlantis. In the cinema, in contrast to the embalmed displays of marine life in natural history museums, viewers inhabited an unpredictable underworld, one of danger, mystery, and exoticism.

Williamson's feature films would have implications on the cinematic imaging of the wider Caribbean. As a columnist in the Bahamas begrudgingly acknowledged, Williamson's sea dramas frequently unfolded on unidentified Caribbean islands. "It's regrettable that the identity of the islands [is] not disclosed" (*NG*, 1 September 1920), a commentator wrote in response to a recently released Williamson photoplay that made no

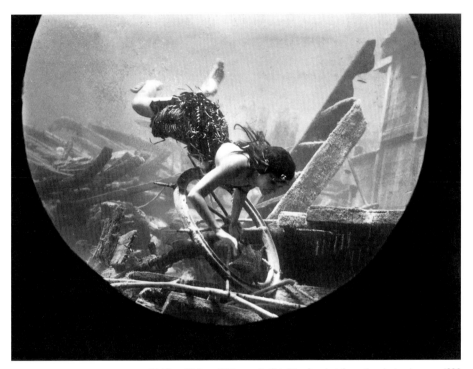

47 Film still from Williamson's *Girl of the Sea* shot from the photosphere, ca. 1920

explicit reference to the Bahamas in the film or in its credits. In short, Williamson's films promoted the Caribbean generally rather than the Bahamas specifically. The Caribbean as a whole starred in these moving pictures. In other words, Williamson projected the wider region primarily through its seascape, as islands of submarine adventure and excitement.

This filmic vision of the islands should not be seen as wholly separate from its dioramic counterpart (indeed the natural history museum of New York featured 20,000 *Leagues under the Sea*); rather, the cinematic and museum presentations worked in concert to create a complex and even ambivalent image of the ocean, both in the Bahama islands and throughout the rest of the Caribbean. The simultaneous Hollywoodization and museumification of the submarine territories visualized the ocean at once as a do-

main of adventure into the unknown and as a realm explored. It was dangerous and safe. The ocean was a space of mystery ready for exploration and a place already charted to reveal its secrets.

In 1954 Williamson made another proposal to the government of the Bahamas to present the ocean to audiences in a new form, "a floating aquarium" (Williamson to Colonial Secretary, 27 November 1954). The aquarium, he projected, "embodies all the advantages of previous experience and gives the public just what it wants, I Believe [*sic*], a close intimate view of life in the sea with an invitation to bring their cameras, etc. to record the wonders of the deep." Williamson envisioned that the aquarium would be divided into five parts and would include twin submarine galleries with "large circular windows for observation," which would display various forms of marine life. The proposed expansive observation window seems a further enlargement of the photographer's field of vision into the sea, but in a proposed built environment. If Williamson's photographic work and museum displays had led to the domestication of the seascape, the planned project would literally encase a living display of the submarine world in a giant aquarium. Through the windows of the aquarium a great number of viewers would be able to see a fixed and curated selection of marine life. For reasons that are unclear the government was not receptive to Williamson's latest underwater venture. Unlike his Undersea Expedition proposal of 20 years earlier, Williamson's specific vision of a floating aquarium on land was never realized. A recently built hotel complex in the Bahamas, Atlantis, however, may be viewed as the materialization of Williamson's dream of a submarine environment on land.

ATLANTIS: THE SHAPING OF LANDSCAPE INTO SEASCAPE

In 1994 Sol Krezner, chairman of Sun International, opened a hotel complex designed precisely to simulate the experience of being beneath the sea. He named the hotel Atlantis. Echoing Williamson's reasons for choosing the Bahamas as a site of underwater photographic exploration, the hotelier selected the Bahamas, Paradise Island specifically, because of the islands' clear waters. Krezner recalls, "The first time I came to Paradise Island I was impressed by the color and clarity of the water and the wonderful beach. When I took over the resort the whole complex was concrete. I knew that to turn Paradise Island into paradise, we had to transform the concrete into ocean and cre-

48 Making landscape into seascape, Paradise Island, Bahamas, photograph, 1994

ate a proper water environment" (*UT*, 22 December 1994). Krezner ambitiously aimed to transform the landscape "into paradise" by physically re-creating the seascape (the so-called submarine Eden) in the island's environment. By turning the island into this underwater paradise, Krezner set out to make the island a "must-see" vacation destination (*NG*, 4 November 1996).

Krezner spared no expense. His company spent an estimated $450 million changing Paradise Island into the world's largest outdoor open-water aquarium—a 3.2 million-gallon saltwater habitat (figure 48) (*ED*, May 1994, 12). According to a local report, "some 250,000 cubic yards of earth were removed to create the waterscape" and "virtually all the trees on site were removed" (*PIN*, December 1994). By carving out the landscape, Sun International created a blank slate on which Krezner's vision of an underwater world could be realized.

While much of the landscape was transformed to look like a "tropical sea," parts

of the surrounding landscape remained faithful to ideals of a tropical landscape. Sun International, controversially, imported palm trees from Jamaica into Atlantis's complex (*PIN*, December 1994). (Members of the opposition political party deemed it a travesty that Jamaican trees, rather than local ones, had to be procured.) In this instance the botanical signifier in Jamaica of the civilized tropical island landscape was transplanted to decorate the new domesticated seascape of the Bahamas.

Atlantis's ambitious transformation of land into seascape may be viewed as the end result of a much longer visual cultural history of the sea in the Bahamas. Although Atlantis's otherworldly and fantastic theme may be interpreted as but another Las Vegas- or Disney-style complex, the hotel's underwater premise firmly locates it within the islands' local geography and visual economy, the history of touristic efforts to view, represent, and even inhabit the islands' seascape.[21] Atlantis was the culmination of previous attempts to make the abyss of the ocean "picturesque," to present it as photographable, marketable, containable, and controllable; processes previously evident in tourism-oriented photographs, the photosphere, museum dioramas, and films.

Continuing in the century-long ritual of submarine viewing as a tourist activity, Krezner not only created Atlantis to look like the world beneath the sea but also organized the resort to facilitate the almost constant viewing of the underwater world. In partnership with landscape architecture firm Edward D. Stone Jr. and Associates and design firm Olio, Sun International organized the hotel as a "labyrinth with different viewing areas into the environment," as *Design Entertainment* describes it. They divided the 12,000-foot maze into several parts, including six exhibit lagoons for ocean life (including a "predator lagoon") and three underground grottos for wildlife observation. Most spectacularly, the aquariums included an underwater pedestrian tube from which visitors could view the sea from its depths. The resort's casinos, restaurants, and entertainment center were built on top of these lagoons because, as Krezner stated, "We wanted people to be inside the building, but be overlooking a tropical paradise" (*UT*, 22 December 1994). Atlantis's giant aquariums and mazes of underwater passageways allowed visitors "a close intimate view of life in the sea." In a sense Krezner built the structure of Atlantis to facilitate the long-held tourist pastime of gazing at and into the sea.

Atlantis accommodated another favored tourist activity, one that Williamson's photosphere first made possible: it provided an environment in which its visitors could

experience and inhabit the underwater environment in perfect safety. One of the ads for Atlantis assured visitors that "they may also have *an underwater experience without getting wet* by observing them [sharks] through large windows located throughout Atlantis. One of the best spots is a special clear bubble window that *enables visitors to put their heads directly into the underwater environment in complete safety*" (*UT*, 22 December 1994; emphasis added). Atlantis guaranteed a tropical seascape without fear, sharks without danger, fully seen from its depths. It provided a domesticated underwater environment where viewers could observe sharks, eels, and stingrays in close proximity but in absolute safety. A tidal pool also supplied the rhythm of the ocean without the pesky inconveniences of the sea, such as jellyfish, or an unexpected wave or change in current. In this way Atlantis physically re-presented the watery environments of the islands but a domesticated version of the island's seascape. Sun International constructed a submarine world that was entirely inhabitable. Through Atlantis the sea was "arranged for quiet walks and carriage rides."

Atlantis precisely created a controlled and aestheticized sense of the seascape by drawing on the techniques of visual display found in the museum (both a natural history museum and art museum) and in aquariums, providing a curated version of marine life behind glass (figure 49). Hotel management hired a "fish curator" to oversee the selection and importation of more than 100 species of "tropical fish" for the tanks. Unlike the embalmed exhibitions of a natural history museum, the curator would organize a living display of more than 40,000 fish and crustaceans. One of the center pieces of the resort is an area deemed "The Digs," which displays marine life in small individual tanks. Each compartment features a single species or a small number of fish and marine life chosen in all likelihood for their colorful visual effect. Designers bathed each tank in a museum-like florescent light, transforming the marine forms into glowing visual spectacles. Iridescent pink sea anemones populate one tank, electric green jellyfish float across another, while shockingly yellow eels peer out from behind an adjacent window (*ED*, May 1994, 13). Through museum lighting the much-vaunted colors of submarine life are emphasized. The hotel's marine environment is not only similar to a museum or aquarium but is like an art museum. Curators framed each specimen as a work of art, rendered from nature's colorful palette. The absence of any text throughout The Digs also highlighted the aesthetic qualities of marine life. Through the displays the once seemingly boundless sea was presented as a curated art exhibition.

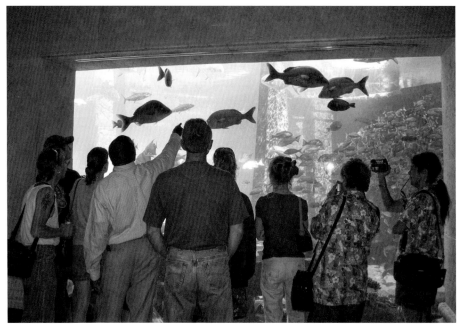

49 Underwater aquariums of Atlantis hotel, Paradise Island, Bahamas, 2004

While much of Atlantis can be viewed as the end result of a century of taming the sea through its visualization and museumification, like Williamson's sustained interest in Hollywood and science fiction–inspired tales from beneath the sea, Krezner's hotel rekindled long-held myths of the ocean as a space of adventure, excitement, and the unknown. In the "experience economy" of themed-resorts Atlantis provided a stage where visitors could relive cinematic or childhood tales or fantasies of underwater worlds. The "ethereal" background music, which played on seven-minute loops like a movie soundtrack in parts of the resort, heightened the sense that hotel occupants had entered a cinematic world of underwater adventure.[22]

The hotel's designers "pulled out the fun bits" from a number of textual sources from Plato and Edgar Cayce, from the philosophical to the metaphysical, to sculpt Atlantis's architecture of subterranean adventure and discovery (*ED*, May 1994, 13). They used Cayce's mystical "readings" (his psychic insights into past civilizations), which pur-

ported that the lost continent of Atlantis lay in the Bahamas' waters, as a sourcebook to re-create the ruins of Atlantis within the seascape. The landscape designers, for instance, constructed a "records chamber" purportedly sealed by the Atlanteans before the fall of their civilization, in keeping with Cayce's writings. By giving these textual accounts architectural form, Atlantis invited guests to wonder through a mythical landscape—like children allowed to venture into their dog-eared story books. Within the re-created ruins designers also placed an archaeological site, the so-called Digs,[23] where they invited guests to trade in their tourist beads for archaeologists' specs or, to use a more Hollywood-inspired analogy, Indiana Jones's adventure-worn hat. In The Digs each hotel guest could become actors in the script of subterranean discovery, participants in age-old narratives of the lost underwater city. Tourists became finders of lost civilizations.

Atlantis's archaeological theme provided not only adventure but the fulfillment of a long-elusive exploratory quest. In a similar fashion to Sun's contemporaneous Lost City resort in South Africa's Northern Transvaal (1992), which archaeologist Martin Hall has so insightfully examined, Krezner chose the lost city theme in the Bahamas not simply to have guests embark on their own archaeological adventures but to discover the "holy grail." Tourists could physically relive and retrace the steps of former explorers, psychic travelers, and armchair adventurers, as Hall details, but actually find a "lost civilization" within the resort. "The most magical places," the hotel's Web site reiterates, "have never been found on any map . . . until today." After centuries of writings and imaginings about these lost worlds, tourists could occupy the long-elusive landscapes of their desire, be they the "lost city" ruins of "Great Zimbabwe" in South Africa or Atlantis in Paradise Island. In the case of the Bahamas specifically, Atlantis gave concrete form to the legendary lost Atlantis and also realized the dream of the sea as representable, inhabitable, domesticable, knowable, and conquerable.

A NIGHTMARE FOR LOCALS:
KEEPING ATLANTIS SAFE FROM NATIVES

Sun International's investment in presenting a seascape and dreamscape of adventure and safety for tourists extended beyond the creation of the hotel's landscape to the control of who could embark on its labyrinth of submarine discovery. More specifically, in

December 1998, approximately two weeks after Sun International opened the second phase of Atlantis, the company closed the resort to the Bahamian public. Executives cited complaints from guests, who felt a "lack of privacy" due presumably to the number of "local visitors," as justification for the policy (*TR*, 24 December 1998). Sun International perhaps did not calculate that the creation of their "must-see" destination would draw local as well as international sightseers and adventurers. These unintended and unwelcomed hotel occupants drew the ire of the hotel's security. According to a statement issued by the prime minister's office, Bahamians attempting to enter the premises were greeted by "security officers poised at the Royal Towers . . . telling Bahamians they weren't permitted into the garden and lagoon area" (*TR*, 23 December 1998). Hotel staff also did not allow Bahamians to, as the report continued, "dine at Atlantis' Fathoms Restaurant and Café which offers its patrons a direct view of the remarkable sea aquarium." In essence, the hotel's management denied Bahamians access to parts of the resort that afforded "direct views" of the seascape. Quickly retracting what first appeared to be an outright ban on access to the hotel for Bahamians, Sun decided to institute an admission charge of $12 for residents, making the "privilege" of viewing the re-created seascape a commodity residents would have to purchase.

The policy immediately drew cries of public protest. Members of the opposition political party, the Progressive Liberal Party (PLP), deemed the act "economic apartheid" (*NG*, 24 December 1998), strategically employing a word associated with racial (not economic) segregation in the practices of a South African company (one infamous for its support and capitalization on apartheid in South Africa). Chairman of the PLP charged in a local paper, "We will not hesitate to use people power to crush any attempt by his [Krezner's] organization to institute the deadly virus of economic apartheid on Paradise Island keeping Bahamians away through the guise of astronomical fees and private security." Another politician, Obie Wilchcombe, characterized Atlantis's new entrance policies as a "nightmare": "The Bahamian people instead wake up to the nightmare that they will have to pay to enter" (*NG*, 24 December 1998). In an interesting twist on touristic appraisals of the tropical landscape (and seascape) as realizing a dream, in Wilchcombe's estimation residents attempting to enter the hotel landscape found themselves awake in a nightmare.

The public outcries reached such a pitch that Prime Minister Hubert Ingraham's office promptly published a letter to Krezner in all the local newspapers. Ingraham in-

formed Krezner that according to the terms of agreement under which his hotel was granted government concessions, the resort by law could not be closed to the Bahamian public. Krezner was advised, "All hotels that enjoy concessions under the [Hotels Encouragement] Act must make facilities available to the general public. It is, therefore, not acceptable or permissible that certain of the facilities at Atlantis be closed to the general public" (*TR*, 23 December 1998). Within days Sun International revised its policies but has remained a contentious presence on the islands.

Sun International's decision to deem its underwater-themed resort as solely the preserve of tourists, however, is not without precedent. The company's attempt to shroud the lost city in a local resident-resistant force field can also be situated within a longer history of tourism, site sacralization, and spatial segregation in the Bahamas. Historically, the moment tourism industry benefactors designated parts of the landscape as icons of the islands or as photographic sites, they protected and policed these areas as spaces of tourist occupation (sometimes exclusively so). This was particularly the case when hoteliers created the ideal tropical landscape in material form. The fashioning of the picturesque landscape was always an effort to make the landscape desirable and inhabitable for tourists (and some local elites). Such tourist-oriented landscapes (or waterscapes) were the realization of travelers' tropical dreams, fairylands that only tourists inhabited.

DIVING INTO THE RACIAL WATERS
OF BEACH SPACE IN JAMAICA

Tropical Modernity and the Myrtle Bank Hotel's Pool

The Jamaica of the tourist brochures, the Paradise Island with blue mountains and white sands, and a climate which must be as near to perfection as it is possible to get, is true enough as far as it goes, but it only goes as far as its upper classes or its visitors.

Morris Cargill, *Jamaica Farewell*, 1978

Racially, Jamaica has no greater living champion of the black man than Blake.

Spotlight, December 1956

One summer day in 1948, as tourists and elites casually colonized the poolside deck chairs of Jamaica's premier hotel, the Myrtle Bank, a black Jamaican journalist, Evon Blake, suddenly burst onto the brochure-promised scene. He hastily disrobed and plunged into the waters of the hotel's unofficially racially segregated pool. The staff quickly congregated at its edges, hurling threats at the intruder. Taking advantage of the protection of the water, which prohibited security from entering the pool, Blake defiantly challenged, "Call the police. Call the army. Call the owner. Call God. And let's have one helluva big story" (Blake 1967, 24). In this chapter I examine why Blake chose to occupy the Myrtle Bank's pool and what this event reveals about touristic representations, spaces of tourist occupation, and local inhabitants' reactions to them. More generally, I use the incident to explore how local people of different races and classes viewed, contested, or even envied the spaces of tourism and the life promised in tourism promotional representations.

I argue that Blake's plunge into one of the cornerstones of Jamaica's tourism industry, the Myrtle Bank's famed saltwater pool, can be interpreted as a subaltern act of

resistance to racial discrimination, one of the constitutive components, I contend, of tropicalization. The incident highlights the unspoken racial and class politics that governed the use of space in the hotel and other tourist-oriented and elite-frequented areas on the island. Moreover, the event illustrates the ambiguity and complexity of local responses to touristic representations, the bitter mix of resentment and desire that tourism and industry-promotional images generated for some inhabitants. For Blake's act also spoke of his desire to partake in the *local* benefits of tourism. He longed to submerge himself literally and figuratively in the modernity that the hotel and its pool represented for white elites, the local dream of tourism that was typically denied to black Jamaicans of all classes.

To understand the social and iconic significance of the Myrtle Bank and its pool, it is necessary to provide a history of the complex. The story of the hotel demonstrates that it was intrinsically bound to local elite expectations that tourism would bring modernity to the island, and the hotel would be a physical manifestation of all that was modern in Jamaica. However, modernity, as local elites defined it, was refracted through the lens of tropicalization: they could only make Jamaica modern by imaging parts of the island as tropical reposes for British and American leisure classes. An examination of photographic representations, advertisements, and newspaper accounts of the complex will reveal some of the changing social and iconic investments in the hotel and tourism generally in colonial Jamaica.

AN EARLY HISTORY OF THE MYRTLE BANK (1870–89): JAMES GALL'S "AMERICAN HOTEL"

The history of the Myrtle Bank begins with another outspoken newspaper man, James Gall. In 1870, long before Kingston had a tourism industry, Gall, a Scotsman, purchased a waterfront property on Harbour Street facing the sea in downtown Kingston. He decided to utilize the clear springs on the site to construct a sanitarium for invalids and tourists. He called the property Myrtle Bank, recalling the name of his grandfather's property in Edinburgh (*PP* no. 5, 1936–37) and lined the property with myrtle hedges in an effort to transplant the property in the image of his Scottish homeland.[1]

Gall billed the sanitarium in early promotional materials as "the headquarters of Americans, literary men and scientific travelers" (from 1875 article reprinted in *DG*,

5 July 1969, 9). In an effort to attract this clientele, Gall also referred to his board-ing house in the British colony as "The American Hotel." It is possible that the Scots-man chose to designate his hotel as American to attract this geographically neighboring tourist clientele (*PP* no. 5, 1936–37, 14). Or, perhaps, he used the term in part to bask in the aura of modernization that was associated with American enterprise in the Carib-bean region at the time (Pérez 1999; Neptune 2001). Despite Gall's claims and interna-tional aspirations, however, the majority of his advertisements never circulated outside of his locally distributed newspaper, *Gall's Newsletter* (*PP* no. 5, 1936–37, 14).

In the 1870s and 1880s Gall's Myrtle Bank started to attract local Kingstonians. The hotel's grounds played host to a range of secular and sacred activities, from a local lot-tery and an annual Christmas Bazaar to Salvation Army services attended by residents (*DG*, 23 October 1948). He also opened a sea bath that local people and tourists fre-quented, indulging in the relatively new activity of sea bathing, a pastime associated with health at the time. Some doctors prescribed both the salt air and the immersion of the body in seawater in short spurts as cure-alls for numerous physical ailments. Gall fenced in an area of the ocean to carve out a protected space for bathers. Gall's ads re-veal that sea bathing, open to men from between 5:00 A.M. to 7:00 A.M., was not the hedonistic sun-worshipping affair it would become later. Rather, for early bathers, who engaged in the activity fully clothed, "physical contact with the sea, tactile and coenes-thetic, was perceived for the most part as serious or dangerous" (Urbain 2003, 70). As the first place to offer these new activities in Kingston, the Myrtle Bank further appealed to the town's upper-class white residents.

A "MAGNIFICENT STRUCTURE" FOR THE GREAT EXHIBITION:
THE KINGSTON HOTELS COMPANY, THE MYRTLE BANK HOTEL,
AND TROPICAL MODERNIZATION (1889–92)

Given the increasing popularity of the Myrtle Bank among the upper echelons of so-ciety in Kingston throughout the 1870s and 1880s, it is no wonder that a local syndicate, the Kingston Hotels Company, cast its eyes on the Myrtle Bank's site as the center of accommodations for the Great Exhibition of 1891. The ruling elite firmly believed that the exhibition would put Jamaica on the map as an emergent modern colony and saw

the Myrtle Bank Hotel as the initial staging ground of Jamaica's entrée into the modern world. For this reason local residents called for the creation of a "magnificent structure that will be a pride to the citizens and an ornament to the city—the Myrtle Bank Hotel" (*DG*, 25 November 1890, 2). The mission was paramount to the future development of the colony. As a letter writer to the *Colonial Standard* put it: "Without proper Hotel accommodation a country, however progressive it may be, must remain isolated from the outside world. . . . A country can in no true sense be in touch with the progress of civilization if communication[s] with it are restricted to the actual necessities of business" (1892, quoted in Taylor 92). In a spirit similar to Gall's pronouncement that the Myrtle Bank was the headquarters of an international literati, the letter writer prophesied that the hotel, devoted to the leisure classes, would provide a crucial link between Jamaica and the "progressive" and "civilized" outside world.

Buoyed by a government loan, the Kingston Hotels Company, a corporation composed of local residents, constructed an entirely new edifice on the grounds of Gall's Myrtle Bank.[2] The hotel opened on 20 January 1891. Postcards show that the "pride of Kingston" was a three-story structure composed of brick (figure 50). The hotel comprised three separate buildings, joined by verandas, which collectively formed an open-ended rectangle facing Kingston's Harbour Street. A gateway framed the facade of the hotel and a circular garden, replete with manicured palms, occupied its center. Contemporaneous newspaper accounts enumerated the impressive number of one million bricks and two thousand barrels of cement that went into its construction. They also detailed the notable features and fixtures of its interior, the 10-foot-wide verandahs, the "broad staircase," the "handsome pink" restaurant entirely covered in mirrors, with "everything being in the latest style" (*DG*, 20 January 1891; repr. in *DG*, 11 October 1996). This public accounting aimed to assure investors and concerned citizens generally that Jamaica's entrée into the modern world was secure.

To attract travelers to the new hotel early advertisements all emphasized the modern features of the hotel. An advertisement from 1902, for example, boasted, "The hotel, which is lighted throughout with electricity, is replete with every Modern Improvement" and guaranteed potential visitors that "particular attention has been paid to the sanitation which is perfect" (Smith 1902, n.p.). Not only was the building clean and outfitted with modern conveniences, but ads stressed that the services provided therein

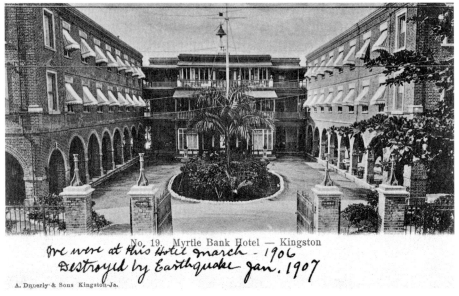

We were at this Hotel march - 1906
Destroyed by Earthquake Jan. 1907

A. Duperly & Sons Kingston-Ja.

No. 19. Myrtle Bank Hotel — Kingston

50 A. Duperly and Sons, "Myrtle Bank Hotel—Kingston," postcard, 1891–1902

were "conducted on the American plan." The Kingston Hotels Company hired American managers and advertised this fact. It appears that the local owners of the hotel believed Jamaican creoles incapable of governance of such a modern building (Taylor 1993, 82).

While managers stressed the modern features of the main building of the hotel complex, they also emphasized that the surrounding landscape was thoroughly tropical. In contrast to Gall's Scotland-inspired hotel grounds, advertisements and photographs assured travelers that within the hotel's property they would feel like they were in a tropical country landscape, although the hotel was squarely situated in the island's capital city: "yet, when within the premises themselves, the scenery surrounding induces the belief that visitors are in the country, for they see nothing but beautiful grounds, an avenue of Palms and a splendid array of tropical plants, flowers and fruits" (Wilcox 1909, 20). The hotel's owners were keenly aware that travelers longed to experience a tropical landscape during their sojourns to the island, and they made the grounds a microcosm of these ideals (see chapter 1).

In these early ads, the hotel's ocean-side location and its saltwater and freshwater pools barely factored in the Myrtle Bank's emergent touristic image, occupying the equivalent of a visual footnote at the bottom of advertisements. If the sea figured at all, it did so mainly for the "picturesque view of the Harbour and the Palisadoes" the ocean offered visitors (Smith 1902). In photographs from the early twentieth century, the hotel's tropicality and touristic appeal was firmly associated with its flora, the hotel's gardens, and not the sea. The early ads marketed a brand of tropical modernization, a hotel building that was modern in every convenience but tropical in every other regard.[3]

In spite of the hotel's multifaceted campaign and its indebtedness to numerous investors and Jamaican taxpayers, the Myrtle Bank failed to live up to expectations for many tourists and locals alike. Travelers to the hotel complained that despite the lure of American management, service in the hotel was deplorable. When a session of the legislature convened to ponder what was gravely described as "The Hotel Question" (*DG*, 28 March 1893, 7), legislators were forced to concede that the much-vaunted "American staff" had reputations for drunkenness and not much else. For this and other reasons related to the growing pains of a tourist trade, within three years of opening, the Myrtle Bank was a financial failure. Unable to pay even the interest on its loan, the Kingston Hotels Company folded, and the government assumed ownership of the hotel in 1893.

Following the government takeover, debates raged in the press and legislature about the fate of the hotel and tourism generally in Jamaica. Some critics saw the empty colossal structure as an omen that the tourism track to modernization should be abandoned and the hotel closed (*DG*, 16 December 1892). They attacked the government for raiding the public purse at a time of economic recession, "squander[ing] large sums of money to raise huge edifices to accommodate strangers," to the neglect of the rest of the island (Taylor 1993, 75). Other supporters of tourism pleaded the case that the Myrtle Bank should remain open. One letter writer warned that if the hotel ceased operation, "the fame she [Jamaica] is already acquiring as a health resort will be nullified . . . and she will sink into a comatose, forgotten existence that must affect her commercial and industrial relations and petrify the spirit of enterprise and progress" (*DG*, 15 December 1892). This impassioned and pessimistic view of Jamaica's fate if the Myrtle Bank closed demonstrates that "the hotel question" was much bigger than the future of a hotel. Debates about the structure were more largely about the island's status in the modern world,

for the hotel not only brought guests to the colony but transported Jamaica into the progressive world.

A temporary answer to the hotel quandary came in the name of Sir Alfred Jones and Elder, Dempster and Company, who purchased and refurbished the property in 1901. The hotel was featured in the company's extensive British-oriented advertising campaigns. Johnston, in his lantern lectures on behalf of the company, for instance, featured a photograph of the Myrtle Bank and stressed that the hotel was "being run according to the most improved and up-to-date methods." Unlike earlier promotions of the "American plan," he stressed that "English managers and clerks, French and Swiss chefs" had been brought over to ensure the highest quality service and cuisine (Johnston 1903b, 11). The company stimulated significant British interest in traveling to Jamaica and reinvigorated American patronage in the hotel, leading to the highest occupancy rates since the exhibition (Taylor 1993, 85). The growing reputation and success of the hotel under Elder, Dempster and Company, however, was short-lived. In 1907 the great earthquake shook the structure, and much of Kingston, to its foundation.

THE RESURRECTION OF THE NEW PICTURESQUE MYRTLE BANK HOTEL: AN AMERICAN ENTREPRENEUR AND LOCAL DREAMS OF MODERNITY (1907–18)

Ironically, in the earthquake's aftermath photographs of the Myrtle Bank in ruins became a part of the visual economy of tourism on the island (figure 51). While industry advocates, including Johnston,[4] promoted a utopian society devoid of natural disasters and civic disturbances, after the earthquake they quickly capitalized on the human fascination with viewing a dystopian society, particularly a society turned upside down by the forces of nature.[5] More specifically, photographs of the Myrtle Bank—a structure once celebrated for its modern construction techniques and good management—provided a particularly sobering testament to the power of nature over human endeavor.

While tourism promoters, writers, and lecturers frequently attributed the order of Jamaican society to British colonial rule, the dystopia that resulted from the earthquake reflected unfavorably on British colonial governance. The governor's inability to respond in a timely fashion to the crisis brought about by the earthquake called into question the colonial authorities' ability to meet the needs of a modern Jamaica.[6] Conversely,

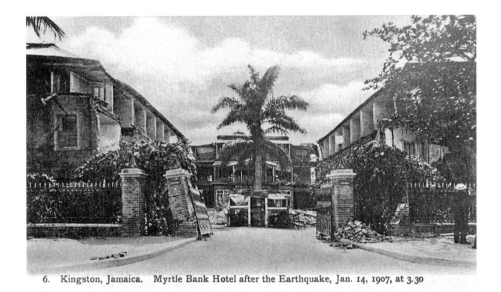

6. Kingston, Jamaica. Myrtle Bank Hotel after the Earthquake, Jan. 14, 1907, at 3.30

51 N. Richards, "Kingston, Jamaica. Myrtle Bank Hotel after the Earthquake, . . ." postcard, 1907

the fact that American sailors ably spearheaded the relief efforts in Kingston, much to the chagrin of the British governor, increased the presence and prestige of Americans in the colony. Both processes would impact the fate of the Myrtle Bank, as the incident seemed to indicate to some of Jamaica's elite that they should turn to American interests to help them realize their utopian dream of a modern Jamaica.

In the postearthquake reconstruction of Kingston, American interests would play an increasingly influential role in the British colony, particularly through the tourism industry. It was an American proprietor, E. R. Grabow, who bought the Myrtle Bank after the earthquake and inspired Kingstonians with his vision of a new modern hotel (*PP* no. 3, 1927, 4). If the dystopia of the earthquake shook the foundation of British colonial rule, the resurrection of the Myrtle Bank ushered in an era of renewed faith in Americans' ability to modernize Jamaica.

A new Myrtle Bank opened in 1910. Its grand structure and pink color far surpassed what one local writer characterized as the "gloomy" appearance of its predecessor (*PP*

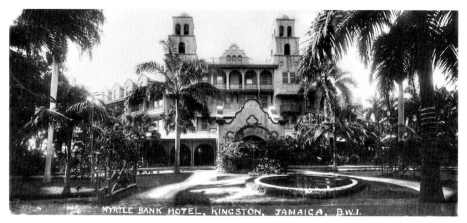

52 Photographer unknown, "Myrtle Bank Hotel, Kingston, Jamaica. B.W.I.," postcard, ca. 1910

no. 5, 1936–37, 15) (figure 52). It was a colossal California missionary–style building, four stories high and capable of housing 160 guests. Structurally, it was a mirror image of the earlier building. While formerly the structure sat bracketing Harbour Street, the new structure turned its back on the city, forming a *U* shape in the opposite direction, facing toward the sea. Its ornamental entry porch, bell-shaped arcade, twin towers, and rounded parapet at its apex gave the appearance in photographs (especially those typically taken from the ground) of a crown, its archways the structure's jewels. Befitting the modern crowning achievement, the facade appeared to be concrete even though it was wood at its core.

American architect Thomas Sargent designed the new structure, and a Boston firm, Nicholson and Son, built it. They succeeded in creating a modern building that matched or even exceeded elite expectations of the hotel since the Great Exhibition. Contemporary reports celebrated the hotel as it neared completion: "The hotel is a picturesque and substantial building and a distinct ornament to the new Kingston which is being built. The architect . . . has certainly given the metropolis a building it can be proud of, one which will stand out prominently as a great testimony to his skill and ability" (*DG*, 17 January 1910). In local lore some residents quickly viewed the earlier hotel's destruction as predestined (*PP* no. 5, 1936–37, 15). Subsequent advertisements, appearing

throughout 1942, celebrated the reconstruction of the hotel after the earthquake as almost a biblical resurrection: "the disastrous earthquake of 1907 brought it tottering to the ground—quickly from the ruins of bricks and plaster a new and modern MYRTLE BANK arose" (*PP* no. 4, 1941–42). With the hotel's restoration, tourism advocates hoped the tourist trade would be saved and the modern era inaugurated in the island.

While the facade of the building seemed a testament to American modern architecture, its portico and surrounding grounds offered a more tropical architectural grammar. In contrast to the austere front of the building, the architecture of the back of the structure paid homage to a Mediterranean style, with its open verandas, curves, balconies, pitched roofs, and window awnings (Pigou-Dennis 1998, 3). From their balconies guests could view a landscape swept with coconut palms and newly transplanted with a "splendid specimen of trees, palms, orchids, and in fact, all tropic growth, not only of the West Indies, but also of the East Indies" (Grabow n.d.). Both architecturally and in its grounds, the hotel continued to pay homage to the twin touristic gods of modernization and tropicality.

Two photographs of the hotel featured in the Duperly and Sons' photography book *Picturesque Jamaica*—one of the hotel's coconut grove and the other of its facade—further underscore these twin characteristics of tourism promotion on the island (figures 53 and 54). The inclusion of photographs of the Myrtle Bank in a book carrying the title *Picturesque Jamaica* also speaks to the new hotel's increased iconic value in Jamaica's visual economy in the postearthquake era. When Johnston earlier showed a photograph of the old Myrtle Bank in his lectures, he did so with the caveat, "But it is not intended, nor is it advisable that the visitor should spend most of his time at the Myrtle Bank" (Johnston 1903b, 11). He advised travelers to devote most of their time to touring the outlying countryside and other hotels. The new Myrtle Bank, however, was itself picturesque, a physical personification of all that was worth seeing in "tropical" Jamaica and a picture-worthy locale. Reflective of the hotel's new picturesque status, numerous images of the hotel flooded the photographic market in Jamaica. The Myrtle Bank quickly became one of the most popular images of the island in photographs, postcards, and tourism-promotional literature. Notably, the beach failed to be a lure in the new "picturesque" image of the hotel. The lack of iconic significance of the sea or water was reflected in the landscape of the new structure, which contained no pool.

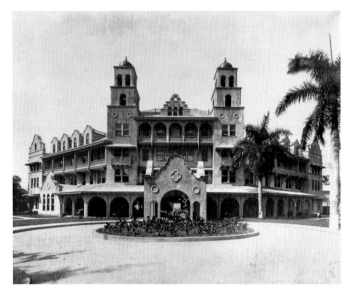

53 A. Duperly and Sons, "Myrtle Bank Hotel, Kingston," photograph, ca. 1908

54 A. Duperly and Sons, "Cocoanut Grove, Myrtle Bank Hotel, Kingston," photograph, ca. 1908

Through these photographs and advertising campaigns the Myrtle Bank started to make strides in American and British patronage. The outbreak of World War I in August 1914, however, presented another obstacle on the Myrtle Bank's ill-fated rise to preeminence, as both the unsafe wartime seas and the depressed economic climate made travel to the island difficult or undesirable. Again the hotel fell on hard economic times and the possibility of closure lingered. In 1918 the owner persuaded the United Fruit Company to take over the hotel in hopes that financial support from the American corporation would help the hotel ride out the wartime storm.

ON THE IMPORTANCE OF BEING AT THE MYRTLE BANK: THE WHITE FAMILY ELITE AND THE MEANING OF THE HOTEL AFTER WORLD WAR I

Effectively cut off from outside patronage during the war, the hotel entered into another phase; a new clientele began to frequent the fledgling hotel—the local white elite. Since the time of Gall's sanitarium, the Myrtle Bank had provided a space for local functions, but the wartime drought in tourists made white residents the primary clientele of the celebrated hotel. During this period Jamaica's white upper classes hosted balls, dinners, and dances in the hotel, making it the center of their festivities (PP, 1940–41, 7). As historian Elizabeth Pigou-Dennis points out, an examination of the calendar of elite activities at the Myrtle Bank during the war period does not betray that a world war raged and global economic recession weighed heavily on the island at this time (Pigou-Dennis 1998, 4–5). The Myrtle Bank was the scene of extravagant Thanksgiving feasts and fancy waltzes. At this juncture the hotel, long promoted as a unique country getaway within Kingston for tourists, provided a getaway and gateway for white elites, a utopian enclave removed from the economic and social woes of surrounding Kingston.

What, then, do we make of this period when local elites became the primary occupants of the hotel? What does this shift in patronage reveal about the local meanings of the hotel and tourism generally during and before wartime in Jamaica? Who in particular, which residents, were allowed to inhabit this space originally fashioned for tourists? By exploring this new era in the Myrtle Bank's history, we can begin to understand the local importance of *being* at the Myrtle Bank (both physically *being* there and *being*, as in subject formation; how being at the Myrtle Bank was intrinsic to elite racial and

class formation). This exploration will provide a context for understanding Blake's own desire to enter into the inner sanctum of the Myrtle Bank and the course of personal and social transformation he hoped to achieve through his occupation of the Myrtle Bank's pool.

The stage was likely set for the shift in actors at the Myrtle Bank since Gall's locally published advertisements billed the hotel as "the center of literati," enticing residents to rub shoulders with international travelers at the property. Since that time many of the advertisements for the hotel had, intentionally or not, dual audiences: the same "modern features" hotel owners used to attract international audiences also garnered attention at home. The hotel quickly became "a synonym for . . . all that is best and brightest in the innumerable phases of attraction so indispensable to modern ideals for the needs of the day and the pleasures of the night" (Macmillan 1939, 87).

The entertainments held in the hotel, in particular, appealed to local whites. Before the Myrtle Bank and the establishment of other hotels, the retiring hour in Kingston was 9:00 P.M. In this lackluster social environment the hotel's events provided, as one local writer put it, "brilliant illumination." The balls, banquets, billiards contests and orchestras thrown to entertain guests inevitably made " 'society' . . . sit up and take notice" (*PP*, no. 3, 1926–27, 5). A part of the local attraction was precisely the international and modern constitution of these entertainments and their audiences. It is not surprising, then, that during wartime the elite—who had formerly vicariously basked in the aura of modernity brought by associating with "Americans and literati"—would become the primary consumers of the modern comforts and entertainments of the Myrtle Bank.

While tropical modernization formed the cornerstone of the Myrtle Bank's touristic pictorial image as promoted by American, British, and local proprietors, it was the modern features of the hotel that attracted the attention of many residents. In the account of the opening of the new hotel, for example, the *Daily Gleaner* writer provided splendid details about the interior and facade of the hotel and its modern features, but its "tropical gardens" never entered into one line of the report. Revealingly, the familiar term *picturesque* appears in the opening sentences of the account, but in the written picture and sketch of the hotel that accompanied the report none of the telltale signs of tropicality enter the description. Instead, the author only saw and presented the hotel for its modern characteristics. If, as I have argued, the picturesque was a vision of the island that conformed to travelers' expectations of a tropical landscape, the opposite

can be said of the picturesque in this account. The picturesque here confirmed an elite vision or dream of Jamaica as modern in every respect.

By being at the Myrtle Bank, the elite symbol of their modernity to the outside world and to themselves, white elites could finally feel perfectly in step with the modern world. The splendor and extravagance of their wartime balls testified that the fairy godmother of tourism had finally waved her magic wand, making Jamaica no longer a stepchild of the modern world. If before the war many British and American travelers confirmed their modernity through the act of travel to the tropics (albeit residing in a modern hotel), during wartime local whites affirmed their modernity by enjoying modern comforts and entertainments at home.

Although many segments of white society could undergo this modern metamorphosis by being at the Myrtle Bank, the hotel was especially central to and transformative for a set of white Jamaicans described by one scholar as the "family elite," a group of approximately 21 families who were becoming increasingly powerful at the threshold of the twentieth century in Jamaica (Douglass 1992). This group comprised recent immigrants to Jamaica and their descendents, who came from England, France, Scotland, Ireland, and Palestine in the mid- to late nineteenth century (many of whom came to have black kin in their family trees).[7] Originally small businessmen, teachers, ministers, and traders, they were at first snubbed by and rivals of the white planter classes in Jamaica, descendants of the sugar plantocracy in pre-Emancipation Jamaica. While perceived class and occupational differences may have distinguished the family elite from the landed gentry, the "aristocracy of skin" (Douglass 1992, 90), the social hierarchy determined by skin color in Jamaica, frequently made them allies against nonwhite Jamaicans. Despite the privileges of skin color in the Crown Colony, which deferred governmental decisions to Britain and its representatives, this group of white Jamaicans was politically disenfranchised. At the beginning of the twentieth century, however, with the decline of the sugar industry, the family elite rose to economic prominence. It is at this time that the Myrtle Bank became a particularly important social space for the first generation of Jamaica's mercantile white elite (Douglass 1992, 156).

For the newly affluent white elite the Myrtle Bank not only provided the opportunity to star on a modern world stage, but it also spoke to their increased importance and visibility in the domestic landscape of Jamaica. The Myrtle Bank provided a public space where they could show off their recently acquired financial wealth and, in doing

so, purchase social standing. The balls held at the Myrtle Bank provided opportunities for elites to flaunt their wealth, particularly through women's dress (Pigou-Dennis 1998, 5). Contemporaneous newspapers provided detailed accounts of the type of garments and jewelry women wore.[8] Such social displays and the local reporting of these incidents are perhaps indicative of the increased social capital of consumerism in colonial Jamaica and its (potentially destabilizing) influence on the white social hierarchy as it existed in Jamaica. The family elite, in particular, who had once been castigated by other whites, could through their fashionable appearance at the Myrtle Bank appear on equal footing with the plantocracy and British colonials.

The Myrtle Bank, with its lights, balls, and galas, quickly rivaled the former center of white elite society in Jamaica, King's House, the Colonial governor's residence (Cargill 1978, 88–89). King's House had long been the nucleus of the British ruling elite, senior civil servants, the legal establishment, Church of England authorities, and local people who were considered "socially acceptable" (Cargill 1978, 89).[9] An invitation to the governor's mansion signaled one's arrival in "society." During the war period the Myrtle Bank provided a parallel social universe where entrants, with notable exceptions, just needed wealth and white complexions to gain admission. Suddenly, "[to] be a *Myrtle Banker* was the acme of many a Jamaican" (Issa and Ranston 1994, 64). That an American-owned hotel could provide the new enviable space of white society speaks further to the changing poles of influence between British colonial rule and American enterprise in Jamaican society at the time, as American imperialists made competing claims to their instrumentality in a modern Jamaica.

While the Myrtle Bank provided an alternative space that marked social ascension for white family elite, it remained closed to many other Jamaicans. "Under the UFCo's American policy *non-whites* were not allowed past the sacrosanct portals—only the well-heeled and well-accepted could walk into the world famous lobby" (Issa and Ranston 1994, 64). As Douglass attests in regard to black inclusion at the Myrtle Bank, "There was no question of 'crossing the boundary.' One informant said to me about this period that 'there was only one society and it was white society.' Although he said he remembers a friend who once helped sneak a 'dark' Jewish friend into the hotel, there was an unspoken but unequivocal rule that blacks were not welcome at the Myrtle Bank" (Douglass 157). Similarly, white Jamaican newspaper columnist Morris Cargill recalls

in his memoirs that season passes were implemented solely for the purpose of keeping blacks out. Because Cargill was one of the few white Jamaicans to speak openly about the issue of racial discrimination at the Myrtle Bank, it is useful to quote him at length:

> [The hotel] . . . was the public center of Jamaica's high society. Public is perhaps not quite the right word, for the season ticket was more or less the equivalent of membership in a club; and while the hotel was in theory open to all, the staff and the management made it painfully plain that those who did not have season tickets were not welcome.
>
> When the management first gave me my season ticket, which was within a week of my returning home, I was naïve enough to ask him why one was necessary.
>
> "To keep the niggers out," he bluntly replied.
>
> I had not been home for long before I realized that in Outposts of Empire such as Jamaica, 'keeping the niggers out' was a task to which the vast majority of Whites addressed themselves constantly and with considerable enthusiasm. (Cargill 1978, 90)

These recollections provide a glimpse into the complex racial and class landscape of the Myrtle Bank, a hotel whose social boundaries were fluid enough to include the new mercantile elite and (light-skinned) Jews but rigid enough to exclude black Jamaicans. Even Syrians, who within Jamaica were considered white, were not allowed into the family of the Myrtle Bank: "though they had money, they were not considered the status equals of other Jamaica whites" (Douglass 157).

Cargill's remarks also attest to the simultaneous invisible yet impenetrable nature of these boundaries. He, for instance, points out that "in theory" the hotel was "open to all," yet he qualifies this statement with the admonition that whites were staunchly devoted to "keeping the niggers out." Douglass's informant also drew attention to the "unspoken" but "unequivocal" boundaries at the hotel. Although no signs pronouncing racial exclusivity hung ominously over the Myrtle Bank's doors, a social barrier as imperceptible yet insurmountable as a glass wall surrounded the hotel. Because of this barricade, the booming social world that Jamaica's family elite enjoyed at the Myrtle Bank during the wartime period, where locals fashioned themselves as modern subjects, remained closed to black Jamaicans of all classes.

THE UNITED FRUIT COMPANY AND THE SALTWATER POOL AS
SYMBOL OF TROPICALITY AND SOCIAL DISTINCTION (1918–43)

After World War I another change in patronage took place at the Myrtle Bank. American travelers, long the intended but elusive clientele of the hotel, started flocking to the Myrtle Bank in large numbers. In the postwar period North Americans increasingly traveled in the pursuit of pleasure and leisure. They were encouraged to travel to Jamaica and the Myrtle Bank specifically through the United Fruit Company's extensive advertising campaigns and through promotions by the newly formed governmental Tourism Development Board (established in 1910). The passage of the Volstead Act in the United States in 1919, which prohibited the consumption of alcohol, served as an additional catalyst for American travel to neighboring Caribbean locales. Again, the Myrtle Bank's grounds were transformed to meet expectations of holiday makers: the United Fruit Company enlarged the hotel's bar in 1922. All these factors contributed to a record season for the Myrtle Bank after the war: "In the winter of 1918–19 thousands of people arrived from England and the United States, seeking the genial climate of a tropical country. The hotels of the island, such as they were, became crowded, overcrowded, and the Myrtle Bank Hotel came at once into its own" (*PP* no. 4, 1940–41, 7).

In the postwar period the crowds of travelers, especially Americans, intersected with the social circles of the white Jamaican elite who congregated at the hotel. For many elites the Americans were the final missing ingredient in their long-held vision of the hotel, an accoutrement to their modernity and social standing in the wider world. In the postwar period, the hotel became an important hub where Jamaican men could form international business alliances with Americans and where white women could seek alliances of another kind, American husbands (Douglass 157).

At this time the United Fruit Company's advertisements for the hotel started to reflect its status as an international hub. They boasted that the Myrtle Bank was "The Crossroads of the Caribbean." "Here, at Myrtle Bank, businessmen or pleasure-bent vacationists from every corner of the globe meet to enjoy the congenial atmosphere and hospitality of the hotel, for Myrtle Bank is the Island's social center." A map of the Americas, with navigational lines skirting all over the world, accompanied the ad: they came to their nexus at the edges of Kingston, at the Myrtle Bank (*WIR* 1, no. 1, 1944).

The United Fruit Company owned the Myrtle Bank for 25 years, 1918–43, and under

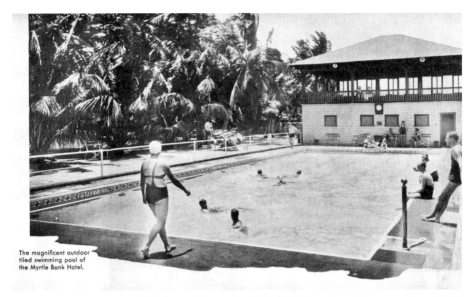

The magnificent outdoor tiled swimming pool of the Myrtle Bank Hotel.

55 Unknown photographer, Myrtle Bank's "magnificent" saltwater pool, ca. 1933–43

its management the hotel's touristic image underwent several changes. The most notable difference in the photographs and postcards of the hotel produced in the United Fruit Company era was the rise in pictorial prominence of a saltwater pool. The hotel had not possessed a pool since 1907, when the new Myrtle Bank was reconstructed without one. Two decades later, the United Fruit Company reinvested in a pool for the grounds, digging out a natural stream for the creation of their watery oasis in 1933 (*PP*, no. 3, 1927, 4).

One of the most recurrent photographs circulated by the United Fruit Company pictured a white middle-aged woman in a bathing suit and swimming cap on approach to the pool (figure 55). Several swimmers wade in the pool, while casual spectators stand or sit at its edges. From the deck above, a couple peers down at the proceedings. Unlike earlier images of the hotel, which were devoid of people, this photograph has a very snapshotlike quality, capturing a scene alive with human activity: swimmers in midstroke, bathers in midstride, like it could have been taken with any holiday-maker's Kodak. The photograph also contrasts with contemporaneous images of blacks,

in which they wear stiff poses, like cardboard cutouts propped up on the landscape. Perhaps the Myrtle Bank's advertisers used the visual language of the tourist snapshot to attract visitors to the hotel. The image is but one of hundreds of photographs which featured the pool after the 1930s.

The popularity of the Myrtle Bank's pool in the context of Jamaica cannot be explained outside of changing global perspectives regarding the beach that took place in the 1930s and 1940s (a change that was in part also responsible for the rise in tourist arrivals to Jamaica). Although the Myrtle Bank's pool was not a beach, that the pool was filled with salt water, even as it sat on the ocean's edge, reveals that it served as a beach surrogate. Articles on the hotel easily slid from references to the sea to the pool, as if they were one and the same. A statement in *Planters' Punch* epitomizes this view: "All have heard of Jamaica's sea bathing. Almost at once many will hurry down to the Pool, where the sea water shimmers green within its tiled walls" (*PP* no. 4, 1940–41, 8).

In the postwar period, sunbathing and swimming, behaviors once deemed deviant, became commonplace pastimes on the beach.[10] In medical orthodoxy the sun shed the harmful health stigmas associated with it in the nineteenth century, and sunbathing developed as an intrinsic part of the seaside ritual. Suddenly, having tanned skin, once associated with manual labor, became a mark of leisure and social status. More seaside visitors also turned to swimming as a physical activity at this time. Travelers from the United States and Britain increasingly sought a particular type of beach that would facilitate these new activities. Many beaches in the Caribbean and South Pacific—where the sea was crystalline and turquoise, the surf was gentle and tame, and the sand was white and powdery soft—fit into this postwar ideal of the beach. The archetype of the tropical beach fringed with white sand, one that continues to dominate the representational vocabulary of the islands, was defined in this era.[11]

Consumer culture also played a role in making beachgoing and swimming fashionable, as swimwear was first designed and marketed as such in 1928 (Löfgren 227). Before this innovation sea bathers indulged in the activity fully clothed and typically with their own sex. In the postwar period men and women, half clad in newly fashionable bathing wear, mingled together on the beach. As one of the only socially condoned places where where seminude bodies were unabashedly on display, the idea of the beach as a space of hedonistic escape became reified.

The United Fruit Company, as tourism promoters and fulfillers of travelers' desires,

had to be responsive to ever-changing vacationers' tastes. Their construction of the pool paid heed to the newly popular icon of touristic leisure, in an era when pools were still uncommon entities globally. The pool allowed the Myrtle Bank's owners to update the "tropical" side of the hotel's "tropical modern" image. In advertisements the hotel's pool was inserted, like the interchangeable cards of a stereoscope, where tropical gardens once stood. In ads for the hotel in *Planters' Punch* from the 1930s, for instance, the familiar photograph of the Myrtle Bank's imposing facade occupies the top of the image, but the coconut grove has been replaced by the "tiled salt-water pool" (figure 56).

In a process contiguous with the addition of tropical trees into the hotel's grounds, efforts to create a saltwater pool stemmed from the Myrtle Bank's (and much of Kingston's) tropical geographic deficiency. The hotel did not possess a sand-brimmed beach. The Myrtle Bank sat on a rocky periphery of the ocean, overlooking a deep harbor, a fact frequently elided in photographs of the hotel through the careful cropping of images.[12]

While in the late nineteenth century and early twentieth century Port Antonio, the center of the fruit industry, provided the inspiration for touristic images of Jamaica, by the 1930s parts of northern Jamaica that possessed the island's most desirable beaches started to steal the representational spotlight from other parts of the island. Montego Bay, in particular, located on the north coast of the island, boasted a small secluded beach known as Doctor's Cave, which became the center of that town's burgeoning leisure industry (figure 57). Tourism interests billed Doctor's Cave as "the most beautiful spot in Jamaica." In the 1940s industry supporters increased their beachfront assets when they hired an American engineer to increase the size of Doctor's Cave to over a mile (Martin 1986, 10). With the help of modern ingenuity—the placement of cement ducts and the calculation of current flows—the beach would become the foremost icon of Jamaica's natural beauty. Doctor's Cave became one of the most photographed spots in tourism promotional photographs in the postwar period, and Montego Bay steadily became a tourist magnet, pulling travelers who previously sojourned to Port Antonio and Kingston. The United Fruit Company would have to respond to this new tourism competitor and this shift toward the beach in the constitution of the island's destination image.

Not to be outdone, the United Fruit Company reproduced the sea in miniature within the Myrtle Bank Hotel and in some respects created an environment more envi-

Myrtle Bank Hotel

KINGSTON, JAMAICA, B.W.I.

T. G. S. HOORE,
RESIDENT MANAGER.

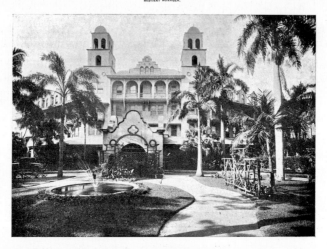

THE PREMIER HOTEL OF THE WEST INDIES
AND
THE CENTRE OF DISTINGUISHED SOCIAL LIFE IN JAMAICA

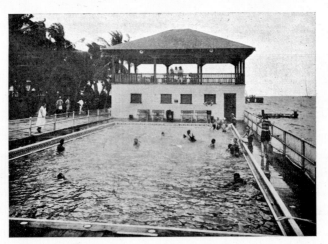

MYRTLE BANK HOTEL TILED SALT-WATER SWIMMING POOL

56 Advertisement for the Myrtle Bank, Jamaica, 1932–33

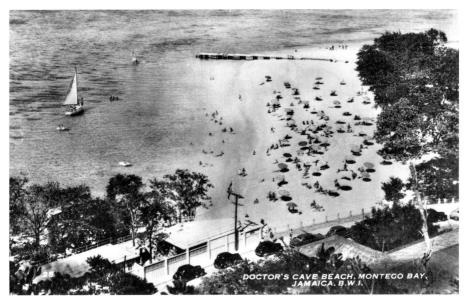

57 Unknown photographer, "Doctor's Cave Beach, Montego Bay, . . ." postcard, ca. 1950

able than the beach. While the United Fruit Company's saltwater pool may have held little of the allure of an expanse of sand and sea, the pool offered the promise of touristic safety that many other beaches could not. The enclosed saltwater pool was not subject to the whims of mother nature: seaweed, sea creatures, sand, or strong currents. No undertow threatened to pull bathers into the sea's expanse. Swimmers could emerge from the Myrtle Bank's pool covered in the light residue of salt water, without any of the potential hazards of the seaside experience. In addition to being safe, articles on the pool assured bathers of its cleanliness: "the pool . . . is drained at nights so that a little army of cleaners may scrub it with hand-brushes to ensure its perfect cleanliness" (*PP* no.4, 1940–41, 8).

The pool was also free of another potential threat to touristic habitation: it was free of "natives." At approximately the same time that the United Fruit Company carved out its pool in the 1930s, Doctor's Cave was at the center of public debates over local inhabitants' rights to the beach. Precisely because the beach was becoming such a central icon in Montego Bay's emergent touristic image, industry supporters submitted that ac-

cess to the beach should be controlled. Members of a white elite bathing club, Doctor's Cave Bathing Club, in particular, pointed to incidents in which black residents would bathe nude in the sea as proof that the beach needed to be properly policed, managed, and regulated (Taylor 1993, 151). Such indecent and disorderly behavior, they reasoned, threatened the town's fledgling tourism industry (Taylor 1993, 150). As such, the club proposed to the parish board that it should be allowed to lease and oversee the property in order to develop fully the touristic potential of the beach.

Despite protests that "the rights of the general public were neither for rent nor for sale . . . [and that] the board had no moral authority to lease the public rights to any select group of people" (Taylor 1993, 150), the parochial board leased the beach to the club in 1929. The club was given the authority to impose any charge it saw fit on beachgoers and to demand that users be "decently dressed [and], decently behaved" (Taylor 1993, 152). The entrance fee also ensured that Jamaicans had to be of a certain class to enjoy the pleasures of the beach.

While tourism interests spawned a web of social controls around the emergent icon of touristic leisure, Doctor's Cave, the Myrtle Bank's owners were not similarly entangled in public debates about beach access. Secreted away in the fortress of the Myrtle Bank, few residents threatened to streak from the surrounding bushes into the hotel's saltwater pool. The United Fruit Company succeeded in creating an alternative beach universe over which it had exclusive control, as creator and master. Free of natural and human dangers of the beach, the Myrtle Bank's pool was like the beach but even better.

As local elites also frequently communed at the Myrtle Bank's poolside for lunch or indulged in dips in its waters, it is also useful to consider more specifically what the pool and the beach meant for this local community. Although the global meanings of the beach also had resonance for local whites, as a familiar part of Jamaica's landscape, did it have the same allure of the foreign and exotic as it did for many tourists? Especially in light of the sometimes alternative definitions of and investments in modern, picturesque, and the tropical, what did the pool mean for elites?

Morris Cargill's recollections about the beach provide one perspective on the meaning of the pool for this white social group. He contends that beachgoing was not popular locally until "the tourists came along and told us we ought to value them [beaches] more highly." He adds acerbically, referring to ensuing debates about local access to beaches, "Then we turned around and complained that we were being robbed of a Na-

tional Heritage" (Cargill and Roberts 1987, 127).[13] It is worth noting that in Cargill's glib appraisal, the elites' desire to occupy the beach stemmed not from changing medical and popular opinion but from a touristic valuation of the beach. Although evidence from Doctor's Cave and Gall's Myrtle Bank reveals that elites had visited the beaches since the late nineteenth century, Cargill maintains that elites learned to see and to bestow value on the beach following the gaze of travelers. Cargill's observation leads us to wonder whether widespread beachgoing among elites and, by extension, Myrtle Bank dipping was in part about their relationship to American tourist cohorts in the late 1920s and 1930s.

By engaging in the pleasures and rituals of the seaside in the Myrtle Bank, it is possible that elites aimed to forge or cement a sense of a community, of oneness, with the American and British guests at the hotel. According to Urbain the beach historically had provided a central stage for the performance and consolidation of class identities. Precisely because the beach provided a rare social space for the physical intermingling of classes in the United States and Britain, it became important for beachgoers from the upper classes to distinguish and divide themselves from the hordes of people who gathered at the beach. As a place where most people were stripped of their typical outward signs of social distinction, the performance of identity at the seaside became all the more important to the upper classes. As Urbain explains, "Once this sign [of social distinction] is lost, it has to be won back. . . . Here, with the help of rites, games, and protocols, one has to produce signs and meanings in order to reinstall oneself as an individual, in one's unity and difference" (200–201). In the context of Jamaica, outside of the space of balls, stripped of the material markers of social distinction, the pool provided an everyday space where elites could establish and perform their social oneness with guests through the shared choreography of practices and protocols regarding the beach and the business of leisure, where they could reinstall themselves as participants in the practices and pleasures of the modern world.

This establishment of social distinction was reflected in advertisements for the hotel in the 1930s and early 1940s, which unabashedly advertised the Myrtle Bank as "The Center of Distinguished Social Life" (*WIR* 6, no. 3, 1940, 43). Unsurprisingly, these ads all featured photographs or mentioned the hotel's pool, enthroning it as the space that marked one's participation or even initiation into a life of social distinction. As the center of the performance of rituals of social standing, it is not surprising that elites placed

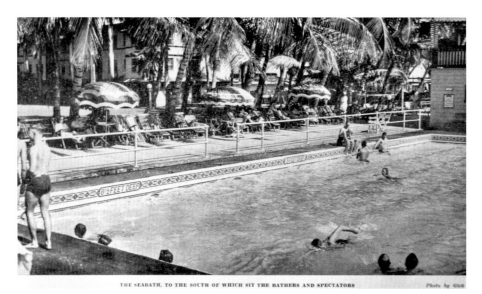

THE SEABATH, TO THE SOUTH OF WHICH SIT THE BATHERS AND SPECTATORS Photo by Gick

58 Denis Gick, "The Seabath, to the South of Which Sit Bathers and Spectators," photograph, ca. 1940–41

a premium on being in or being on the many architectural structures that surrounded the pool. An article on the hotel in *Planter's Punch* describes the pool area: "At times there are hundreds of people on this pier, in the sea-front bar on the other side looking down upon the pool, on the terrace facing the Pool and in the Pool itself" (*PP* no. 4, 1940–41, 8). The accompanying photograph, captioned "The Seabath, to the South of Which Sit Bathers and Spectators," further calls attention to the importance of seeing and being seen at the hotel's pool (figure 58). The photograph, of course, extended the spectatorship of the pool, adding to its social distinction in this very process.

THE MYRTLE BANK UNDER ABE ISSA (1943–65): LIFE AS THE TOURISTS LIVE IT

In 1943 the Myrtle Bank underwent another (and final) change in ownership when a local company, E. A. Issa and Bros., purchased the hotel from the United Fruit Company. Given the centrality of the hotel for family elite in particular, it is not surprising

that the hotel's new owner, Abe Issa, was part of the second generation of this group. His father had migrated to Jamaica from Palestine in 1893, after hearing about the island from persons who visited Jamaica's Great Exhibition. Issa's ability to acquire the hotel, which had oscillated between British and American ownership and management since 1902, speaks to the social and economic empowerment of this group in Jamaica in the mid-twentieth century. Under Issa's management, after World War II the Myrtle Bank experienced a sort of Golden Age, attracting not only "literary men and Americans" but some of Hollywood's reigning pantheon and British political figures. Guests included Joan Crawford, Ann Miller, Walt Disney, Winston Churchill, and Duke Ellington. (It seems that celebrity trumped race in the case of African American musician Ellington's appearance at the hotel.)

The hotel's new owner ran a series of campaigns that claimed quite simply and immodestly: "Life Begins at the Myrtle Bank Hotel." One ad laid out the details of the life the hotel promised in greater detail. Under the heading BACKGROUND FOR GRACIOUS LIVING the following words appeared: "The charm of the Myrtle Bank lies in the perfect blending of old-time ideas of hospitality with modern conveniences. It is more than a luxurious hotel. 'The Myrtle Bank' is key to a way of life. Set in a tropical garden, right on the blue Caribbean, with its own palm-sheltered swimming pool, garden and sun patio . . . here is the way of life you've always longed for!" (*WIR* 1, no. 1, 1944). Whereas former campaigns extolled the hotel as an important place in the social life of the island, these ads made the hotel the agent, "the key," to creating the life "you've always longed for." Of course, in keeping with earlier ads, it is unclear whether such remarks are directed toward international or local audiences.

Significantly, the main icons used in such advertisements shifted once again, as promotional materials from the era typically placed representational priority on the exterior of the building. More specifically, most advertisements pictured the hotel's facade, imaging the Myrtle Bank as a modern space and, in fact, downplaying its tropicality. This may simply reflect long-held elite visions of the hotel as a symbol of modernity, an aspect they "longed for."

In at least one advertisement for the hotel, a representation of the saltwater pool was paired with the exterior of the building, albeit partly concealed by coconut palms (figure 59). In the former the very informal and snapshot quality of previous photographs of the pool and its inhabitants of all sizes and sexes has disappeared, replaced by female models

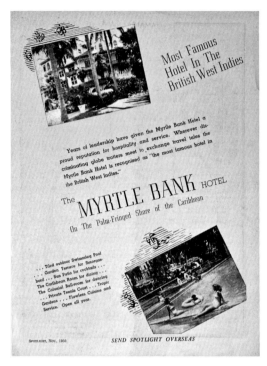

displayed in poses of relaxation. The pool's occupants are uniformly young, white, suspiciously dry, and quite aware that they are being photographed. Indeed, the women look like they could have been contestants in the many beauty pageants that were held at the Myrtle Bank's poolside. The ads may reflect new efforts to sexualize and eroticize the experience at the hotel through the representation of scantily clad female bodies, the first time such representations appear explicitly in the visual economy of the island. Or they may simply have been invested in picturing a type of lifestyle at the hotel, one of glamour, picture-perfect beauty, and gracious living. Even poolside, where guests might typically be stripped of social markers, the life of glamour was manifest.

The importance of the Myrtle Bank and its pool as "a way of life" was reified when Issa actually transported his office to the pool. Every day, donning swimming trunks, he would dictate to secretaries, direct messengers, field phone calls, and meet clients,

all from his "gaily coloured" poolside chairs (Issa and Ranston xii). Issa's daughter reasons that after years of selling the sun to tourists, he decided that he too would partake in poolside pleasures. Crucially, the local owner's poolside office speaks to his desire and ability to live the life promised to guests in the hotel's advertisements; he made the dream of touristic leisure a part of his business routine. In addition to partaking in touristic pleasures, Issa's poolside routines were the culmination of local expectations that the hotel would bring enterprise, modernity, and American tourists to the island and would refashion and transform the life of local elites in this process. Issa not only owned this valued symbol of modernity; he also lived the longed-for modern life.

SACRALIZATION AND DECONTEXTUALIZATION:
THE ENCLOSED DOMAIN OF THE MYRTLE BANK HOTEL

So far I have sketched some of the changes in and complexities of the Myrtle Bank's image world, examining how local, British, and American business interests variously imagined and physically fashioned the hotel at different historical moments to respond to the changing expectations or touristic dreams of tropicality and picturesqueness: first through its tropical gardens and coconut groves and then its tiled saltwater pool. The hotel frequently not only conformed to these ideals but redefined them, becoming itself the representational epitome of Jamaica as it came to dominate pictorial campaigns of the island.

Additionally I outlined how another process ran concurrently with the hotel's rise to pictorial prominence in international tourism campaigns and its popularity with elites: its relationship to the surrounding landscape and nonwhite inhabitants became increasingly tenuous. The physical space of the hotel itself withdrew into its own domain. Indeed, the hotel's most celebrated features, its modern American architecture, its tropical gardens and saltwater pool, did not resemble the rest of Kingston.[14] In the 1930s and 1940s the Myrtle Bank's pool was most emblematic of how processes of sacralization paralleled (and even contributed to) the exclusivity of the pictured location. The much photographed Myrtle Bank pool was in some respects doubly removed from urban Kingston, geographically and socially. It was mimetic of beach spaces at a time when seasides on the island were increasingly under siege and out of the occupational rights of black Jamaicans, precisely because these locations were iconic in the tourist

trade. Furthermore, the pool resided in a racially exclusive hotel. In other words, like a world enclosed in a glass-bubbled souvenir, the Myrtle Bank's sacralization, which centered on the pool, occurred at the same moment that the hotel and its saltwater oasis became out of reach to the majority of the island's black inhabitants.

The processes of social detachment or withdrawal described above, however, are not unique to Jamaica (Judd 1999). Jean-Didier Urbain recounts that decontextualization creeps into tourist-oriented spaces and seaside tourism respectively in many parts of the world: "Decontextualization (the absence of reference to the local context) is a characteristic feature of the seaside universe" (Urbain 115). Given the racial landscape of Jamaica and the local importance of the poolside universe — as simultaneously a symbol of modernity, picturesqueness, social standing, and whiteness — the processes of decontextualization would generate specific meanings and unusual responses in the context of colonial Jamaica, particularly among those who had to observe this closed social universe from the outside.

VIEW FROM THE OUTSIDE: EVON BLAKE, BLACK JAMAICANS, AND THE LIMITS OF SOCIAL TRANSFORMATION AT THE MYRTLE BANK

It is against this historical backdrop that Blake's "historic" plunge into the Myrtle Bank's pool should be reconsidered. By situating his actions in light of the complex and even conflicting meanings of the hotel for American and British tourists and local elites, we can also begin to grapple with what the hotel came to signify for black Jamaicans, or for one black Jamaican in particular: Evon Blake.

A few biographical details about Blake will help us to understand something of his character and his relationship to the Myrtle Bank (figure 60). Blake was born in the countryside in Jamaica, Clarendon, in 1906. At the age of 18 he abandoned his educational pursuits in agriculture, and, like many black Jamaican men in the first decades of the twentieth century, he headed to Panama to take advantage of economic opportunities there. Paradoxically, given the centrality of the United Fruit Company in the Myrtle Bank, Blake worked as a cargo handler for the United Fruit Company for more than 11 years (when the Company had spread its banana enterprises throughout South America). During his time in Panama he studied stenography and worked for a daily

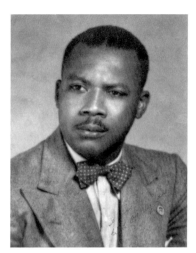

60 The journalist
Evon Blake, photograph, n.d.

newspaper. On occasion he used his column to advocate for better pay and conditions for West Indian workers. When he returned to Jamaica in 1933, after a brief stint as a policeman, he started writing for the *Daily Gleaner*, producing a column on the Petty Sessions Court, *The Poor Man's Theatre*. In 1939 he established his own monthly news magazine, called *Spotlight*, which he would edit until 1956.

Blake was a flamboyant character who described himself as a "bumptious pipe-puffing Negro." That Blake featured himself as "man of the year" in his own magazine in 1956 begins to convey an idea of his own sense of self-worth (*SP*, December 1956, 35). Blake's role as *Spotlight* editor is particularly noteworthy to this investigation of the Myrtle Bank, since his news magazine featured advertisements for the hotel. Ads in his own publication boasted that the hotel was "famous throughout the world as an address of distinction" and assured potential visitors that "your pursuit of happiness reaches a sun-kissed climax such as you've never dreamt of" (*SP*, December 1944–January 1945; *SP*, February–March 1945). Yet in the early 1940s, as a black Jamaican, Blake's self-lauded accomplishments would not have garnered the newsman enough distinction to allow him entrée into the privileged social world of the Myrtle Bank. Given Blake's familiarity with the dream of the Myrtle Bank and his unprecedented attempts to insert himself

into the locus of the hotel's glamorous tropical image, Blake's writings as a journalist and the published responses to his editorials provide an invaluable glimpse at the politics of race and class that surrounded tourism generally and the hotel specifically.

THE MYRTLE BANK HOTEL, TOURISM, AND
BREAKING THE CONSPIRACY OF SILENCE SURROUNDING
RACE DISCRIMINATION IN JAMAICA

Blake's actions at the Myrtle Bank were unorthodox in many respects, especially given the rigid racial and class hierarchies in colonial Jamaica. As Douglass argues, Blake's open challenge of racial exclusivity was especially significant and unusual in the British colony "given the more subtle way in which class and [racial] hierarchies structure[d] social space" (Douglass 66). Building on and extending her remarks, it is useful to consider more fully what the state of race relations was in Jamaica or, more precisely, how Blake interpreted them.

Until the popularity and visibility of spaces like the Myrtle Bank and the coming of American tourists, many Jamaicans of different classes remained mute on the issue of race prejudice and discrimination in the island. Many residents viewed racism as a social malady of the United States since Jamaica was exempt from forms of racial violence like lynching and legally sanctioned racial segregation. In the late 1930s a few dissident residents cautioned that Jamaicans needed to examine the local permutations of racial discord. In 1938, in an article poignantly entitled "Discrimination," published in the newspaper *Public Opinion*, black social critic Amy Bailey rallied against those who comfortably asserted that "race prejudice and color prejudice do not exist" in the island. Bailey insisted that "[*exist*] is too mild and inactive a term. Thay [*sic*] *live* and *move* and *have their being* in this blessed isle" (*PO*, 16 July 1938).[15] She called attention to the particular and peculiar form of race discrimination in colonial Jamaica: that it "lived and moved" but "all classes" refused to talk about it and even denied its existence.[16]

Similarly, in 1941 the British writer Esther Chapman lamented what she described as the "conspiracy of silence" surrounding race in Jamaica: "The color question in the West Indies, and particularly in Jamaica . . . is swathed in yard upon yard of pretence; there is a conspiracy of silence on a topic which is the unremitting secret preoccupation of a large proportion of the population" (*WIR* 1, no. 1, 1944, 16–18). Although Chapman

concluded that Jamaica suffered from "social snobbishness" and not racial discrimination, she (and Bailey) point to the particular challenges faced by would-be fighters of race discrimination in Jamaica: how does one fight or even target a social enemy few Jamaicans acknowledged was there?

In this environment, in which Jamaicans cast a blind eye on the racial hierarchy in the island, tourism (particularly the onslaught of white American tourists and hoteliers) would play a central role: it threw the "unspoken" local inequalities of race into sharp relief. The transposition of white Americans and some of their perspectives on race in the seemingly "harmonious racial landscape" of Jamaica provided a lens through which local race prejudices could be refracted and, more simply, articulated and acknowledged.

As early as 1910, members of the governing colonial elite in Jamaica whispered concerns that the presence of American tourists could threaten the racial democracy in the island, that these tourists would carry with them and resurrect their racial prejudices (Bryan 1987, 46). Local newspapers reported ominously on how American-centered tourism affected local race relations in the rest of the Caribbean.[17] They feared that the influential gaze of American tourists would influence local ways of seeing racial difference and that this would institutionalize racial discrimination against black Jamaicans. Historian Patrick Bryan suspects that British colonial elites were concerned about the importation of American racism simply because it would force them to contend with the local permutations of racial prejudice. "The course of Jamaican social history since 1866 had been dedicated to denying differences between her Majesty's subjects on the basis of colour. A formal colour bar would have exposed the racial contradictions in Jamaican society" (Bryan 46).

Despite this awareness of tourism's possible influence on race relations, historian Patrick Taylor concludes that under the weight of tourism racial discrimination worsened in the British colony. "The color question had always hung over Jamaica, but with the growth of tourism it festered further, for the industry revitalized distinctions of color that had faded with the widespread planter destitution since Emancipation" (Taylor 1993, 112). While the presence of American hoteliers and tourists did exacerbate racial distinctions, it had another effect: the blatant forms of race prejudice associated with Americans started to make "the ostrich issue" of racial discrimination part of public discourse.

It is not surprising that Bailey and Chapman would summon tourism or the specter of the Myrtle Bank in their articles on discrimination. Bailey pointed out that store merchants in the downtown areas of King Street in Kingston rationalized discrimination on the grounds that "tourists want the kind of clerks they are accustomed to find in the stores 'at home,' or as near a shade a possible" (*PO*, 16 July 1938). Chapman, in support of her argument that social snobbishness was changing in Jamaica, cited that on a recent occasion blacks had appeared at the Myrtle Bank. Black socialist and journalist (and former editor of Garvey's *Negro World*), W. A. Domingo retorted in response to Chapman's article that her sighting of black guests on a "special occasion" at the Myrtle Bank "proves nothing more than that there must be an unwritten ban against them in the past. . . . The test lies in whether or not distinctly dark-skinned guests are welcomed [at] the Myrtle Bank and other first-class hotels in Jamaica at all times" (*WIR* 1, no. 2, 1944, 24). In other words, spaces of tourist occupation, the very visible centers of social distinction for tourists and white elites, and especially the Myrtle Bank Hotel provided places where the issues of race, skin color, and class discrimination could be articulated and, ultimately, as I will show, contested.

These comments on the prevalence of racial discrimination must be contextualized within the changing contemporary political landscape in Jamaica in the late 1930s and 1940s, wherein black and brown Jamaicans accrued unprecedented political rights. On the heel of worker riots in 1938 Jamaica saw the emergence of black and brown leadership, political parties, unions, and the attainment of universal suffrage in 1944. Despite these new political gains, however, racial discrimination still pervaded other social spheres, placing limits on black social mobility. W. A. Domingo best summarized the paradoxes of the modern state for blacks when he attested that it was easier for a black man to become a judge than a store clerk in Kingston's white-owned businesses (*WIR* 1, no. 2, 1944, 24). While laws existed to facilitate black participation in the political realm, none mandated black inclusion in the white-dominated business or social worlds. Arguably, gains for blacks in the political realm may have made other forms of discrimination in Jamaican society harder to address and combat.

In the early 1940s Blake added his voice to the few who decried the pervasive forms of racial discrimination in the island. More specifically, he used his editorial column, *Straight from the Editor*, to insert the issue of race prejudice, both its American and its local manifestations, into the public sphere. He challenged his readers to acknowledge

and redress the issue of racial discrimination in the island: "I think that every honest and sincere person who has been in Jamaica even for the shortest time will admit that colour prejudice and colour discrimination exists in the island. . . . Colour prejudice and discrimination based on colour are deplorable anywhere and any time. In this country where the population is so heterogeneous, it is not only deplorable; it is positively dangerous" (*SP*, March 1947, 7). Jamaicans, he claimed, had to stop "burying our heads in sand. . . . We must face the issue squarely and cooperate wholeheartedly to make the future different from the cancerous past." He attempted to defuse reprisals for raising the taboo race question, anticipating that a "host of complacent persons is sure to rise and accuse him [a journalist who raises the question of race discrimination] of STARTING a class-&-colour war and committing an unpardonable crime." Blake's defensive stance reveals that addressing the issue of race was "dangerous" business, both for the "instigator" and, in the minds of the journalist's detractors, for the racial tranquilly of society as a whole.

"SOUTH OF THE SOUTH": AMERICAN TOURISTS AND SEEING RACE IN JAMAICA

One strategy Blake used to broach the delicate subject of race discrimination in Jamaica was to tackle the importation of "American" forms of race bias in the island, types of race prejudice long identified with racism in the island. In a *Spotlight* article provocatively titled "South of the South," Blake exposed how an American proprietor in the island, one whom Blake suspected of being "half-negro," transposed the "crudeness and color prejudice" of the southern United States into Jamaica. Blake reported on a "well known" black Jamaican and his black American female guest's failed attempts to gain entry into the "members only" Colony Club, adding that this incident was but one of many reports of "respectable blacks" being turned away from the racially exclusive establishment. The shunned woman retorted that she was shocked to encounter such practices in Jamaica: "I thought Jamaicans were emancipated and civilized." Recounting the incident allowed Blake to expose some of the contradictions about race in a British colony where people liked to believe they were "civilized and liberated." He forced his readers to acknowledge that even the "crudest" practices of racial discrimination were rampant in Jamaican society. Significantly, and perhaps an indication of how sensitive

an issue the practice of race discrimination was in colonial Jamaica, Blake reported that three nights after this occurrence took place, "fire flattened out the Colony [Club]. Expressions of sympathy, even from whites, were few and formal" (*SP*, March 1947, 24).

Through *Spotlight* Blake also made his readers aware of how the presence of American business interests and American tourists was influencing and transforming the racial landscape in other parts of the Caribbean. By focusing on race relations elsewhere, he encouraged his readers to reflect on the local implications of tourism in Jamaica. Two places that he consistently spotlighted in his magazine as examples of the detrimental influence of Americans on the racial affairs of the islands were Bermuda and the Bahamas. Blake singled out "snobbish, dollar-hustling" Nassau, in particular, as the "lousiest place on earth" for the practices of racial segregation carried out in the name of tourism (*SP*, December 1955, 12–13). He decried Nassau's "almost unparalleled record in the Caribbean for slighting important persons of colour," claiming "its general attitudes towards Negroes are equaled only in the most sociologically retarded of Dixie backwaters." He encouraged his readers to pay heed to the challenges tourism wrought on the racial democracies of these islands: "The challenge is particularly sharp because of our nearness (in miles) to Bermuda and the Bahamas."

Racial discrimination in Nassau struck a chord with Blake because many "important Jamaicans of colour," including Sir Alexander Bustamante, then the chief minister; Hugh Springer, registrar of the West Indies University; and Rudolph Burke, president of the Jamaica Agricultural Society, had experienced racial segregation firsthand during layovers on the island in the 1940s and 1950s (*SP*, December 1955, 13).[18] They all suffered the humiliation of not being allowed to stay in the island's American-owned racially segregated Colonial Hotel. These incidents of race discrimination were not limited to the Bahamas and Bermuda. In 1943 *Spotlight* reported that Learie Constantine, the famous first black captain of the West Indies cricket team, was asked by the Imperial Hotel in London to "seek comfort elsewhere" because white guests, "presumably Americans," objected to his presence (*SP*, December 1943–January 1944, 32). Like the incident at the Colony Club, these occurrences testified to the encroachment of American Jim Crow practices under the British flag (coincidently, each of these establishments paid homage to the British Empire in name: The Colonial Hotel, The Colony Club, and Imperial Hotel). By highlighting a litany of offenses against black West Indians in multiple locations, Blake attempted to triangulate the issue of race discrimination

back home. In regard to Burke's experience of segregation in Nassau, Blake concluded his report by stating, "Some Jamaicans didn't bother to raise their voices. They know of local hotels no better than Nassau's British Colonial" (*sp*, January 1948, 5). In particular, he called attention to the conspicuous silence of the British governor on these matters.

More broadly, Blake believed that definitive steps needed to be taken to redress Jim Crowism in British colonies in the British legislature in London and specifically by the British colonial secretary of state, Oliver Lyttelton, who was charged with "protect[ing] the colonies from the enemies who would destroy them from within." In the House of Commons, however, Lyttelton basically defended the practices of race segregation in Britain's colonies when he submitted that "I am advised that (the maintenance of the color bar in Bermuda) is essential to the tourist trade on which people of colony as a whole depend for their livelihood." In Blake's estimation Lyttelton was presented with a choice between "[U.S.] dollars and democracy," and the colonial secretary, by excusing racial discrimination as a modus operandi of tourism, had unapologetically chosen the latter. In Blake's grave appraisal the choice "threatens the undoing of the British Empire" (*sp*, December 1953, 8). It is ironic, given the long-standing power struggles between U.S. imperialists and British colonial authorities, that American-based tourism ultimately threatened to "undo" the British Empire. The encroachment of Jim Crow policies highlighted the limits of a racial democracy in the British Empire and colonial authorities' inability, complacency, or unwillingness to protect the rights of black British subjects.

Significantly, Blake blamed what he described as "picturesque" images of the island in tourism for fostering American racist perceptions of the black population in Jamaica. In 1944, at a tourist convention at the Myrtle Bank held to assess the state of the industry after World War II, "Mr. Blake deplored the fact that advertising showed the 'picturesque' aspects of Jamaican life (little barefooted black boys climbing coconut palms, for instance) and never showed the self-respecting coloured man, of high social caste, enjoying the ordinary pastimes of civilized persons in his land" (*wir*, June 1944, 14–16). Such representations, he argued, framed travelers' expectations and responses to the black population: "The American who comes here for the first time is surprised when he walks out of a hotel and sees black people and white people and brown people all dressed up and associating on terms of equality, . . . when he sees that we are civi-

lized people and not savages, . . . because our advertising is on the wrong psychological note" (*PO*, 11 May 1944). In essence, Blake argued that Americans did not treat blacks as equals and with respect because picturesque images of the island did not represent them as such. Specifically, they did not picture blacks as of "high social caste" and "as civilized persons."[19] Blake blamed American "advertising agents in New York skyscrapers . . . who knew nothing about the island" for constructing this narrow view of the islands, and he submitted to an audience of colonial officials, pressman, and Americans that "Jamaica's advertising . . . should be prepared by Jamaicans who know about themselves and their history" (*PO*, 11 May 1944). Blake pointedly accused advertisers in metropolitan skyscrapers, architectural testaments of modernity, of perpetuating an image of Jamaica's black population as premodern, ahistorical, and barely civilized.

Blake's impassioned remarks at the convention led to the passage of a resolution "urging that future advertising should convey to visitors that they will be expected to associate with Jamaicans of all colours and shades" (*PO*, 11 May 1944). Many conference participants agreed with Blake. As Esther Chapman observed, "While it is absurd to make tourist posters into sociological documents, there is something to be said for those who maintain that visitors to countries with mixed populations should be told in advance that coloured people are part of the life of the community, and expect to be treated with ordinary deference and consideration. If it does not assume the proportions of a Crusade, and if the tourist is not accosted as though he were a scallywag being hooked by a missionary, I am in agreement with this view." (*WIR* 1, no. 2, 1944, 14-16). In contrast to long-standing industry or colonial campaigns to change or control the behavior of "natives," the proposed tourist posters would instruct tourists on how to behave toward locals.

A contemporary writer, Orford St. John, adopted Blake's preemptive advertising strategies when he primed tourists on how to see and respond to local inhabitants. In an essay entitled "How to Behave in the Tropics," St. John encouraged visitors to envision themselves as fish staring at a new world from their bowls:

> You will be looking through the glass at a strange new world. But there will be others outside the glass, looking in.
>
> So do not view the figures that people the landscape as though they were clowns and acrobats in a circus. They are not in the least picturesque. They are human beings like you.

When you are tempted to regard them as quaint, remember that they too are watching you. Their way of life is different from yours and yours is also "different." The behaviour of tourists also, may sometimes recall the circus. And when it comes to staring, the Jamaican will probably win. (*WIR*, 3 December 1949, 13)

St. John's instructional comments extend Blake's efforts to transform the content of tourism advertisements by challenging the very dialectics of touristic viewing and the typically uneven power relations of this exchange. Flipping the script, he encouraged tourists to see themselves through the eyes of the island's inhabitants, as "different," as entertainers in a circus. Moreover, by calling attention to Jamaicans as viewing subjects, St. John tipped the balance of viewing power. Indeed, in a staring contest, he predicted, "the Jamaican will probably win." He flatly rejected the existence of "picturesque" inhabitants, the very cornerstone of the island's touristic campaigns. St. John encouraged tourists to discard their "field-glasses," their picturesque visual filters, and "get to know people in the country places, not with the patronising comment and the eagerly expected tip, but with intelligent interest and plain talk." This process could only happen if tourists left their "tanks" (a reference to the Myrtle Bank Hotel, which was also known as the "Turtle Tank") and traveled into the country, "the true Jamaica."

Blake's faith in the potential of new forms of touristic representations to change tourists' views and their treatment of blacks was likely influenced by his appreciation of Haiti's tourism campaigns (for which he ran ads in his news magazine) and tourists' willingness to fraternize with "Negroes" in the Black Republic. In Haiti tourists fully expected to encounter a "Negro Country. . . . The unwritten message in Haiti's tourist publicity is something like this: 'If you object to associating with Negroes go somewhere else'" (*SP*, March 1954, 16). Blake credited such advertising with making "Americans, even crackers from the 'Deep South', go to Haiti and forget their color. They chin and chum with Negroes, and they appear to love it. They sit next to Negroes in swank hotels and clubs, bathe in swimming pools with Negroes, dance with Negro men & women, & consider themselves privileged when offered the opportunity to pay their respects to officials of the 'Black Republic.'" Haiti, marketed as the first Black Republic and land of voodoo, was a popular vacation spot among persons looking for black culture in its unadulterated forms. Blake expressed bewilderment that "these same whites landing in Jamaica 1 hr. 30 min. later, are believed to object to socializing with

Jamaicans." Blake was careful to point out that despite this "belief" (presumably held by tourism industry proponents in Jamaica), Americans' views on race were undergoing transformation. On the heels of World War II, with the catastrophic results of racial supremacist philosophies laid bare, and with U.S. Supreme Court decisions signaling a legal end to practices of race segregation, Blake recognized that many Americans (particularly the classes that traveled) opposed practices of Jim Crow. "These Americans are not likely to enforce indiscriminate segregation abroad—unless encouraged."

Although many of Blake's comments were directed at Americans and their influence on race in Jamaica and other British colonies, he ultimately concluded that American racial prejudice could only take root in an environment where it was "encouraged." In an article, "Colour and the Tourist Trade," he quoted a foreign hotelier in support of his point. "In certain matters," the hotel owner confided to Blake, "I follow the practice or policy of people who belong to the island and who should know the score. . . . It is Jamaicans themselves who set the pattern. Foreigners, such as I, only follow." Blake argued that racial discrimination should not be laid solely at the feet of Americans: "If truth were told in Jamaica, it would be that the people most guilty of racial discrimination are Jamaicans themselves—and not white at that; for Jamaica has less than one-half per cent of real, full-bodied whites." In other words, Jim Crowism in Jamaican society reflected a uniquely local brand of racism practiced by many racially mixed inhabitants. Practices of racial segregation in the island, which some hoteliers justified as the desire of American tourists, thinly veiled the racial prejudices of local "would-be" whites.

While a number of Blake's editorials targeted the issue of race discrimination and segregation generally, at times his commentaries and actions aimed directly at the Myrtle Bank's unequivocal racial boundaries. It is likely that the visibility and exclusivity of the "American" hotel made it a pertinent local example of the contradictions and challenges of tourism to racial democracy in the British colony. In 1947 Blake reported on the racial constitution of the audience at a concert at the Myrtle Bank Hotel. "There was not a colored person among them save Concert Promoter, Stephen Hill and his photogenic, exquisitely gowned wife." Blake's singling out of the hotel seems especially bold, considering that the hotel's owners advertised in the pages of his magazine (*SP*, February 1947, 1). If only out of goodwill, Blake contended, blacks should have been invited: "People notice such little things, especially in Jamaica, where eyes are so keen

and feelings are so sensitive." Blake's attention to the promoter's "photogenic" companion and the journalist's use of "keen eyes" draw attention to the continued importance of being seen and dressing to be seen at the Myrtle Bank. In this instance, through Blake's aptly titled *Spotlight* magazine, the affairs at the Myrtle Bank were now thrown into a more critical light, one that cast the hotel proceedings of social distinction in an unfavorable spotlight.

Blake's article must be contextualized within the purported changes in the policies of racial discrimination after Issa's purchase of the Myrtle Bank. By 1947, by some accounts, the hotel's "doors were thrown open to Jamaicans—something the United Fruit Company never wanted" (Issa and Ranston 65). A pictorial biography on Issa, produced by the hotelier's daughter, Suzanne Issa, for instance, maintains that Issa brought an end to practices of racial segregation. " '*The barriers*,' said Abe, '*were terrible*' " (Issa and Ranston 65). The book presents Abe Issa as a protector of the black rights in the face of tourists' racial prejudice. In support of this view, Suzanne Issa recounts a story of her father's reaction to one woman who expressed displeasure at the presence of blacks in the hotel. In response to the appearance of the president of the Jamaica Labour Party, Alexander Bustamante and his entourage in the hotel's restaurant, the tourist protested, "Just listen to them. Most of them black and behaving as if the place belonged to them." According to Issa's daughter, the owner swiftly rebuked the woman, informing her, loud enough for all to hear: "*And so indeed it does*." The author also posits that when a black female employee of the hotel decided to go for a swim in the pool, Issa sent over a drink to her poolside chair. These accounts, published some 50 years after the events, seem very invested in projecting an image of the Issa-owned Myrtle Bank as racially inclusive and reflective of the new changes in political empowerment taking place in Jamaica; the hotel "belonged to them."

While officially Issa's Myrtle Bank may have welcomed all races, as Blake pointed out in his audience inventory, black faces were still scarce at the hotel in 1947. It is possible that many blacks simply steered clear of the hotel because of its long-standing racial exclusivity. As an informant explained to Pigou-Dennis, "A little apartheid ruled at Myrtle Bank in those days, I'll tell you the truth. It wasn't that they stopped you coming in but they'd treat you in such a way, you'd never come back" (6).

Blake, however, suspected that racial inclusiveness only extended to players in the new political landscape of Jamaica. While political or labor leaders like Bustamante

could dine in the hotel, few other nonwhite Jamaicans made the hotel's social roll call. (Perhaps this is what Chapman meant when she described Jamaica's primary social ill as social snobbishness.) Blake did not view the presence of some blacks in the hotel as a testament to the hotel's racial openness. Rather he perceived the admission of some blacks into the hotel's portals as a sign of the racial transcendence of a select few. In other words, only blacks who achieved a certain social and political status were admitted into "the Club," becoming in essence "socially white," as Barbara Blake-Hannah, Blake's daughter, puts it.

An incident Blake reported on at the Myrtle Bank, for example, exposed the selective forms of racial discrimination that continued to take place at the hotel in the late 1940s. At a meeting between a local women's group, the Jamaica Women's Club (a group that had "no obviously Negro members") and a visiting women's group from Florida at the hotel, only one black woman was invited to attend the event: Lady Edris Allan, wife of the finance minister of the government. Blake questioned why JWC members had admitted this black woman in particular. One observer Blake quoted suspected that they did so to "capitaliz[e] on her title under the guise of democracy." In essence, her title bought her access to the event at the hotel, despite her race, and brought the women's group the appearance of racial inclusion. Her ladyship was an accessory, not unlike the garments donned at Myrtle Bank balls, to the group's social status as a whole.

But the tale of race and racial transcendence at this meeting between women's groups gets even more involved. To the Miami women's association many "white" women in the JWC were questionably so: "In Jamaica many persons who in the U.S. would be classified as coloured and given Jim Crow treatment, pass for white. The Miamians probably did not know this." Blake described the visiting women's group's reaction to their "white" Jamaican counterparts: "When they sat down to an International Relationship Luncheon at the Myrtle Bank Hotel, March 24, their eyes rested uneasily on many faces of doubtful 'white.' When they beheld Lady Edris Allan their eyes expressed consternation. 'What, a coloured woman!' one of them exclaimed audibly. . . . When Miss Dorothy Fong, Chinese resident, came under their gaze, only good breeding and brave hearts kept the Miamians from fainting outright" (SP, March 1949, 29).

Through his enthusiastic recounting of the incident Blake could call attention to several of the paradoxes of contemporary views on race in Jamaica and question the purported racial openness of the hotel. First, although the hotel operated under the

guise of democracy, only certain blacks were permitted through its portals. Arguably the appearance of democracy made the race problem even harder to articulate, speak out against, and combat. Again, Blake used the presence of American tourists, who rejected the newly defined (selectively inclusive) categories of whiteness as they existed in Jamaica, to expose local contradictions in the racial landscape. The Miamians also called attention to the fickle and constructed character of race in different geographical locations and at different historical moments; for the very Jamaican women who clung to the exclusive label of whiteness, according to the American women, were not white at all. Certainly, Lady Allan, who had accrued a social whiteness and was newly welcomed into functions at the Myrtle Bank, was in their eyes simply "a coloured woman!" Blake took delight in reporting on the clashes of these racially exclusive social worlds, because the encounter exposed the assumptions and prejudices in both groups' constructions of race.

In a social landscape where many people tread lightly around the issue of race, Blake's sometimes humorous, matter-of-fact, and pointed commentaries on race set off a firestorm of controversy throughout the 1940s and 1950s. Some readers and even a visiting British M.P., Geoffrey Copper, accused him of being an inciter of racial violence by unduly stressing "black and white hostility" (*SP*, January 1951, 5). One letter writer, responding to Blake's public accounting of blacks at social events, protested, "Your section 'Straight from the Editor' last month, would have been better titled 'Straight from the Devil,' for never in [my] life have I seen such dangerous writings" (*SP*, March 1947, 2). The writer objected that Norman W. Manley, leader of the PNP, had attended an event that Blake had singled out in a previous article. "Surely . . . you wouldn't call him white, or brown. Throughout the world he is classified as a Negro." This remark still affirms that only political notables could be found at these events. Besides caustic letters, Blake was also "soundly cussed to my face and I suppose, behind my back" (*SP*, August 1948, 1).

Other letters to the editor congratulated Blake for his candor in addressing the question of race discrimination. Amy Bailey applauded Blake for adding his voice to a cause for which she had seemed the sole voice crying in the wilderness (*SP*, November 1948, 2). One appreciative reader extolled Blake's "courage to express such views in print in Jamaica where people are so quick to victimize and bring pressure to bear. There are so many social evils in the island, mostly affecting people of darker skins, that it is good to

know that at least one writer has the courage enough not to call them by pretty names" (*SP*, March 1947, 3).

Blake seemed to revel in being at the center of controversy, a state that translated into increased sales (*SP*, April 1947, 1). Beyond market value, scandal also had social utility. Regardless of whether readers appreciated or disapproved of his comments, the columns provoked public debates about race: "But whether they praise the reader or abuse him is not the important point. What is important and satisfying is that an attitude of 'smug complacency' towards unsavory features of social patterns has been disturbed" (*SP*, April 1947, 1). Periodically, however, Blake would silence the storm of controversy surrounding race in his magazine, like a conductor quieting his orchestra, and vow not to broach the subject again: "And having made this observation, I am writing no more on the subject,—at least for the time being" (*SP*, April 1947, 1).

Ultimately, Blake recognized, in a 1947 editorial, the limited effectiveness of "the stroke of a pen" to redress the "underlying causes of prejudice and discrimination." Soon thereafter, following decades of documenting racial prejudice and challenging his readers to acknowledge the "dangerous" silence shrouding race in the island, Blake put down his pen. Trading in his characteristic pipe and suit and tie for the unlikely attire of a black activist, swim trunks and a robe, Blake breached the portals of the Myrtle Bank, headed steadfastly toward the symbolic center of the island's touristic and racial landscape and dove in.

Blake's plunge into the pool provided an active challenge to the racial status quo, a culmination of his 10-year-long crusade. The act left no room for debate about whether race prejudice existed. Blake went into a space where discrimination "lived and breathed," to recall Bailey's words, forcing his most vocal and smug critics to confront the very practices they denied. Like the little boy who dared to whisper, "The emperor has no clothes," in Blake's plunge into the pool and, by some accounts, his subsequent triumphant parade around it, the naked truth of racial discrimination was laid bare (Blake-Hannah 2000). The occupants of the pool, as Blake's daughter recounts, immediately stopped their saltwater frolicking—their living of the dream of the Myrtle Bank—and scrambled from the pool as Blake entered. Perhaps, his daughter reasons, "they thought they would be touching across the water's expanse." Regardless, the guests' panicked exodus from the pool at the sight of this black man left no doubt about whether racial prejudice existed, whether blacks were welcomed, or whether racial

prejudice was Blake's devilish invention. No head counts of socially acceptable blacks could excuse the form of racial prejudice evident in the mass departure from the pool. The emperor had no clothes, and everyone who had formerly cast a blind eye to racial prejudice could see. Blake took advantage of the visibility of the pool, seen as it was by hundreds of guests, and used this visibility to call attention to the usual invisibility of blacks within this space.

To an editor who thrived on controversy, the event and the "helluva story" about it promised to propel the discussion of race beyond the readership of his magazine. While Blake's actions were not commemorated in photographs or even reported in newspapers like so many other Myrtle Bank affairs, the story about the event and indeed the vivid mental image of Blake's escapades provided another form of representation and site of remembrance.[20] His contemporaries and local historians recall that although no newspapers dared to acknowledge the incident, the island buzzed for years with news of Blake's transgression (Lumsden 2001; Maxwell 2003; Neita 2003; Wilmot 2004).[21] Oral accounts of the occurrence, in various embellished versions, Blake-Hannah recognizes, made Blake's pool escapades the stuff of legend (Blake 1967, 24).[22]

In addition to highlighting, transgressing, or shattering the racial boundaries of the hotel, Blake's occupation of the pool should also be located within other symbolic investments in the Myrtle Bank in the context of Jamaica: that it realized the dream of modernity, social status, and whiteness. His stubborn possession of the pool may also have been a defiant response to the marginal status afforded blacks in the fashioning of a modern Jamaica through the harbinger of modernity, tourism. Blake recognized that in the tourist trade promoters continually portrayed blacks in Jamaica as outside of the project of modernity. Recall that the newspaperman called attention to the fact that touristic representations typically pictured blacks as "bare-footed black boys with holes in their trousers and climbing coconut trees; or higglers with large baskets on their heads," depicting them in costumes of poverty. These photographs strongly contrasted with the image of elites, who wore fine garments and displayed flashy jewelry at the balls of the Myrtle Bank Hotel, who lived the glamorous and modern life tourism afforded. However, the island's touristic image, its allure to modern travelers, was precisely staked on these representations of blacks as premodern and not quite civilized.

Blake, the "pipe sniffing negro," would not have seen himself and other blacks of his profession and class reflected in the touristic image world of Jamaica. He was not a par-

ticipant in the life of the Myrtle Bank and strongly resented the flipside of the island's modern image, the semicivilized black. His plunge into the pool must, then, also be contextualized in light of this representational erasure. By jumping into the pool, the place where elites went to be seen and fashioned as modern subjects, Blake inserted himself, his black body, into the representational center of modernity on the island and created another form of representation (the story and enduring mental image of this moment) at which he was at the center. Earlier Blake had complained that picturesque representations never portrayed blacks "enjoying the ordinary pastimes of civilized persons in his land." Blake's temporary occupation of the pool challenged that. Not unlike Issa's own poolside installation, Blake aimed to participate in the civilized ritual of swimming in the pictorial center of the island. He also sought to make the activity his ordinary pastime and subsequently made weekly pilgrimages to Myrtle Bank's pool part of his family's routine.

Blake also likely identified the Myrtle Bank Hotel as a place that both marked and facilitated one's social standing in Jamaica, as it had served this role for the family elite and "socially white" black or coloured Jamaicans in previous eras. Professionally, by the late 1940s, Blake was an accomplished man, an editor of a monthly magazine with a 30-year career in the field. He certainly saw himself as "socially distinct." Blake also clothed himself in signs of distinction. His daughter notes, for example, that he insisted on driving the latest model American car, which he would change on a yearly basis. He would also dress in a style reminiscent of Clark Gable: "White sharkskin suits, polka-dot ties, crisp shirts and two-toned shoes" (*JR*, 20 November 1988, 9A). It is useful, perhaps, to compare Blake's American car and Hollywood-style dress with the newspaper reports on events at the Myrtle Bank, where conspicuous consumption was an important part of displaying class and social standing for newly emergent elites. Blake's pipe may be seen as another important marker of status. The newspaperman also had the distinction of being one of the first blacks invited to King's House, a point that Blake considered a badge of honor. Even this sign of acceptance from the British governor was not enough to grant Blake entrée into the inner sanctum of the Myrtle Bank, however. In colonial Jamaica "wearing" black skin frequently cancelled out all other signs of social distinction.

In light of Blake's own conscious performance of social distinction, his plunge into the pool of the hotel in particular may be viewed as an act aimed at accruing social stand-

ing. In a broader sense, in the context of Britain and the United States, the beach had historically facilitated the dream of class ascension for working classes. It was one of the first places where different classes mingled, stripped of class markers.[23] In the context of Jamaica, however, the beach and the Myrtle Bank pool held no such transformative qualities for blacks. "Unlike the seaside excursions . . . for England, and their links to the railway industry which put seaside travel within the reach of workers (though not the extremely poor) Jamaican seaside excursions became an organised package for overseas visitors" (Bryan 1987, 42). In other words, seaside excursions in Jamaica never offered persons of all classes in Jamaica a landscape of escape, a place to forget and temporarily transcend their social stations. Indeed, the rise in popularity of overseas seaside excursions actually led to the erosion of blacks' rights to travel to the sea, and in the case of the Doctor's Cave only a certain class able to pay fees had access to one of the most treasured beaches. The arrival of American tourists on Jamaican beaches did not lead to class elevation and social distinction for black Jamaicans but frequently contributed to the placement of a glass ceiling in terms of social ascension for many of them. Blake may have chosen to jump in the pool to partake in the process of social transformation long associated with the sea among Jamaica's elites and the working classes in other locations, to stubbornly try to get it to yield its socially transformative powers for blacks.

A DECLARATION OF SOCIAL WHITENESS?

Blake's plunge may also have been a declaration of his "social whiteness," Blake-Hannah suggests, an announcement of his rightful citizenship in the inner circles of white Jamaica. As a central space of renewing, performing, and consolidating white identity, Blake's actions may have been an attempt to join in the choreography of poolside rituals that cemented white social sameness. Blake-Hannah recalls that her father's decision to jump into the pool was precipitated by his hiring of a white British-borne accountant for his magazine. The accountant, a newcomer to Jamaica and Blake's underling, was immediately welcomed at the Myrtle Bank, where during his lunch breaks from the news magazine he would occasionally go for a dip in the hotel's swimming pool. The social acceptance of Blake's white employee and his own exclusion aggravated him, throwing into stark relief how skin color in Jamaica was the ultimate marker of social distinc-

tion. Blake-Hannah's conclusions about her father's actions are supported by Blake's own lambasting of the social currency of race in Jamaica. In 1950, in *Spotlight*, he went on a diatribe against these practices: "What angers me is the brass of people who would place an ignorant, unwashed white person on par with or above the cultured Negro and accord to the former treatment which is denied to the latter. I am even more angry when I find this attitude pervading and being put into practice right under my nose in my own country" (*SP*, May 1950, 2). It is interesting that Blake uses "unwashed" to describe "uncultured" white people, co-opting and redirecting the colonial and touristic obsession with cleanliness onto "ignorant" whites and claiming for himself the label of "cultured."

While the motivations for Blake's jumping into the pool were multifaceted, the plunge had the direct effect of shattering the racial boundaries and wall of silence that surrounded the racial exclusivity of the hotel and its pool. Ultimately, he understood the representational and symbolic stakes of the pool, and his actions aimed simultaneously to claim everything the pool stood for—to be modern, socially distinct, worldly, and, perhaps, white—while shattering and exposing the very constructions of these notions at the same time. Through his words and actions he cast a spotlight on local permutations of racial exclusivity and racial prejudice and in doing so provided a stage on which these practices could be exposed, contested, and attacked. In recalling the event, Blake would submit that after an hour the pool was permanently desegregated for all blacks. He felt his actions ultimately influenced the desegregation of other spaces in Jamaica, like the stores and banks in downtown Kingston. Blake went on to chair a Beach Control Commission that protected local inhabitants' rights to use beaches. One of the primary targets of the commission was Doctor's Cave and its policies of racial discrimination. In short, Blake's foci moved from the space of the pool to its north coast referent, Doctor's Cave beach.

CONCLUSION

Given Blake's complex relationship to tourism and his early criticisms of the construction of Jamaica in picturesque photographs, it may seem surprising that the journalist produced a tourism-oriented photography book, *Beautiful Jamaica*, in 1970. Blake himself called attention to his unlikely role as editor of the "photographic volume" in the

introduction, given that he had "never shot a picture and, in fact, doesn't even own a camera." He underscored his status as a nonproducer of photographs, both in the book and more generally. While on its surface Blake's publication, which included such sections as "Beautiful Jamaica," "Faces of Jamaica," and "Law and Order," may reproduce some of the narratives and photographs long used to image the island, the volume presents a more complex vision of the recently independent Caribbean nation (which gained independence in 1962). Indeed, Blake was careful to distinguish his photographic project from the representations produced by earlier "romanticists," who "with camera, pen, and brush" had "taken enthusiastic turns at describing the Jamaican scene" (9). Such efforts had, in Blake's estimation, "told the story [of Jamaica] and captured the picture only sketchily." Needed, the journalist opined, was "a cohesive, intimate, penetrating and knowledgeable work . . . an attractive pictorial package containing both the panorama and the depth, linking the natural story with the human story, presenting the Time-made and the Nature-made together with the modern and manmade" (9). Blake's photographic formulation revealingly attempted to tell a polyvisual story of Jamaica, one that encompassed surface and depth, nature and culture, the historical and the modern. In attempting to visualize this more complex picture of the island, the book also included sections titled "Historical Flashbacks," "Industry," "Nation at Play," "Wings for a New Nation," and "Men, Women, and Machines." The newspaperman added another dimension to the island's long-standing tropical image: "Beautiful Jamaica is not only the story of the most pulsating playground of the tropics. . . . Here also, and of equal importance, is the exciting continuing story of the young country popularly referred to as 'the Cradle of Social Democracy.'" While Blake's efforts to provide visual insights into Jamaica beyond the tropical facade may have also pandered to tourists who sought island life off the beaten path, the editor's reluctant role as the producer of a picture book can also be viewed as a final chapter in his career as a deconstructor of touristic representations and champion of social democracy on the island. Realizing his own early prescription that tourism-oriented photographs should be produced by "Jamaicans who know about themselves and their history" (*PO*, 11 May 1944), Blake billed his pictorial volume as "Jamaica as Jamaicans wish the world to see their island" and emphasized the nation's status not as a "tropical playground" but as a social democracy, a political status that Blake played no small role in creating.

"I AM RENDERED SPEECHLESS BY YOUR IDEA OF BEAUTY"

The Picturesque in History and Art in the Postcolony

We shall see that these two images are not without importance. That of the colonized as seen by the colonialist; widely circulated in the colony and often throughout the world (which, thanks to his newspapers and literature, ends up by being echoed to a certain extent in the conduct and, thus, in the true appearance of the colonized).

Albert Memmi, *The Colonizer and the Colonized*, 1965

I admit the right of a man to write books or publish pictures which he knows are unfavourable and sometimes unfair advertisements of a people, but it is undoubtedly also the right as well [as] the duty of those of us who are unfavourably and unfairly advertised to protest.

E. Ethelred Brown, *Daily Gleaner*, 18 January 1915

In the summer of 2000 in Jamaica, as the nation celebrated its thirty-eighth anniversary of independence from British rule, a series of incidents illustrated that colonial and touristic ways of visually imagining the island continued to pervade postcolonial Jamaican society. During that period a popular music video, starring Father Reese, the winner of the local National Festival Song Competition, played repeatedly on a local television station.[1] The musical composition, entitled "Miss Jamaica," praised the island's beauty. To lend visual accompaniment to the lyrics, the musician took photographs of the island, often posing dramatically like a hunter before his pictorial prey — a mountaintop and flowers being chief among these elements. Periodically, the focus of his lens would fill the entire television screen, ushered in by the loud click of a camera's shutter, presenting viewers with a still shot of his photographic image. This reenactment of the process of creating snapshots of the island, using images that would be at

home on any postcard of Jamaica, demonstrated that the island continued to be presented through its ability to be like a representation—a picturesque locale—although now in the context of a national celebration.

Concurrently, the proceedings of a local Commission of Inquiry frequently occupied the local radio waves and animated the talk-show circuit. The public inquiry investigated the events of the previous summer, when authorities forcibly removed "street people" from Montego Bay (one of the main tourism centers on the island) and dumped them into the swamplands of another parish in the middle of the night. The cleansing of the landscape of "unsightly" persons again seemed in keeping with early twentieth-century colonial and elite interests in preserving a safe and picturesque environment for tourists.

In more literal ways colonial and touristic representations of the past inhabited the landscape of contemporary Jamaica. At the time, indeed since the early 1990s, several local collectors have actively acquired photographs and postcards of Jamaica dating from the late nineteenth century and early twentieth from throughout the globe, reversing the representational tides that long flowed from the island. These late nineteenth-century photographs gained new visibility in the fin-de-siècle of the twentieth century through picture books and exhibitions. This visual repatriation was perhaps prefigured by the gift of a collection of more than 200 postcards to the University of the West Indies Library, Mona, Jamaica—the Cousins-Hereward Collection—from the relatives of a deceased private collector in London in 1985. Since that time several Jamaican collectors have published books and catalogues on old postcards and photographs of the island—*Jamaica: The Way We Were* (1991), *Photographs, 1850–1940* (1997), and *Duperly* (2001)—with more books scheduled for publication. Additionally, in 1996 the Royal Geographic Society in London sponsored an exhibition, entitled *Photos and Phantasms*, of photographs of the Caribbean from the start of the twentieth century (some of which had also circulated as postcards in the early 1900s) taken by the British geographer and photographer Harry Johnston. The exhibit, which first opened in London, returned the images to Jamaica (and other places they pictured—Barbados, Haiti, Cuba, and Trinidad), marking another large-scale migration of old photographic materials to the island in the 1990s. Photography enthusiasts also announced plans to create a photography museum in Kingston, which would give these images a permanent home ("Photo

Jamaica" 1998, 26–27). Through all these initiatives the photographs acquired an unprecedented widespread local visibility, likely their greatest viewership since they first circulated a century ago.

Such photographic repatriations are not unique to Jamaica but can be found throughout the Anglophone Caribbean, particularly in locations with mature tourism industries. Publications of old photographs, particularly in the form of picture view-cards, appeared across the region in the 1990s: *Nostalgic Nassau* (1991), *Glimpses at Our Past: A Social History of the Caribbean through Postcards* (1995), *Bygone Barbados* (1998), *Reminiscing: Memories of Old Nassau* (1999), *The Bahamas in White and Black: Images from the Golden Age of Tourism* (2000), *A Journey of Memories* [Trinidad] (2000), and *Reminiscing II: A History in Photographs of Old Nassau 1860–1960* (2006). Publishers have also reissued old picture view-cards from the early twentieth century. *Back Then: Bahamian Style* (1996) is one such series. Postcards also populated the pages of scholarly historical publications across the region. Like messages in a bottle washing up on their shores of origin a century later, after traveling long and untraceable routes, many photographic images have returned "home."

But what do originally tourism-oriented postcards and photographs of the Anglophone Caribbean signify, in their newest resting place, for local residents? Or, as a reviewer of *Photos and Phantasms*, Gabrielle Hezekiah, pondered, "Who were these 'natives' in Johnston's photographs, and how can we understand our present fascination with the other even when that other is ourselves?" (1999, 30). Her question can be directed at local uses of and interpretations of colonial and touristic postcards and photographs generally. If many of these images served formerly as quintessential souvenirs of the tropical, the picturesque, and "civilized savagery" for colonists and tourists, what do such objects mean for contemporary residents? How do these representations, used in the past primarily as mementos for travelers, inform popular memory in the present? The contemporary interest in postcards from yesteryear, I argue, relates to local needs and desires for a society like the one pictured on many of the tourism-oriented photographs—a safe, disciplined, and picturesque locale. In the face of a number of postcolonial discontents and challenges, these touristic images act as visual placebos, assuring many local residents of the redemptive possibilities of their own nations.

These postcard books and historical accounts attest to the little-explored afterlife

of colonial representations, their long and illustrious careers among (formerly) colonized populations. Whereas new scholarship on the "other histories of photography" has been attentive to how colonized peoples fashioned themselves as modern subjects in the photographic medium,[2] less work has analyzed how local inhabitants reinterpreted, reclaimed, or even republished the colonial photographic archive.[3] The recent reproduction and recirculation of late nineteenth- and early twentieth-century photographs in books throughout the Anglophone Caribbean reveal that postcolonial subjects, in addition to creating alternate image-worlds in contradistinction to colonial photographs, also reconstructed their identities and histories—for better or worse—precisely through these colonial representations. It is not surprising that the postcard—an object created to traverse geographic boundaries and to bear handwritten traces of its users' interpretations—would figure prominently in these local postcolonial reappraisals and reuses of the colonial archive. That many publications frame postcards as transparent "windows into the past," however, raises questions about the consequences, contradictions, and even pitfalls of the postcolonial use of colonial photographs, of looking for "our histories" in the image pool of picturesque representations.

Several Caribbean artists have been attentive to the potential hazards of using colonial and touristic archives as objects of historical reconstruction and artistic inspiration. Trinidadian artists Christopher Cozier, Che Lovelace, and Irénée Shaw; once Bahamas-based artist Dave Smith; and British artist of Barbadian descent David Bailey all employ and deconstruct the postcard or tropicalized representations in their work. Many of these artists use the postcard, a form postcolonial critic Malek Alloula aptly deemed the "fertilizer of colonial vision" (1986, 4), to denaturalize the islands' century-old tropicalized image, calling attention to the postcards' role in the production of this representational ideal of the islands. Their work evinces an ongoing and unresolved struggle to come to terms with the legacy of touristic representations on how local audiences imagine, represent, and define as representative their contemporary societies and their histories. The very different usages of the postcard in postcolonial Anglophone Caribbean society in the artists' works, local postcard publications, and history books attest to the longevity of and mutable meaning of colonial representations among an unintended audience—the (formerly) colonized.

The Golden Era of the Picture Postcard A biography of the social life of the postcard in the Anglophone Caribbean must begin by retracing its origins, its producers, and its (intended) consumers. Postcards, while part of a wider colonial and imperial image pool, have a distinct form and history. "Postal cards" of the West Indies reached their height of production during the "golden era" of postcard collection, 1895–1915 (Woody 1998, 13).[4] In 1904 the Colonial Office in London specifically encouraged local officials in the islands to produce postcard series to stimulate the region's burgeoning tourist trade.[5] Colonial governmental bodies, passenger steamship companies, hoteliers, and local mercantile elites all seem to have heeded this call and created postcards for many islands in the West Indies, particularly in the first years of the twentieth century.[6] The postcards would often be printed and sometimes retouched in Europe (Germany was a central postcard manufacturing center) or in the United States and then returned to the islands where they were offered for sale.

The intended consumers of Jamaica postcards included tourists, colonial officials, and the all-important potential tourist clientele. Postcard sellers frequently baited visitors specifically in their ads. They boasted "Picture Postcards: A big choice of views for visitors—Hope [Gardens], Castleton, Montego Bay, &c and many of the inhabitants and their pickaninnies" and deemed their shops the "Headquarters for Tourists [with] the Largest and Finest Assortment of Illustrated Jamaica Postcards" (*DG*, 27 January 1905; *DG*, 2 January 1904). Colonial officials stationed in the islands also purchased and collected postcards, as the Cousins-Hereward collection testifies. H. H. Cousins worked as the director of agriculture for the colonial government in Jamaica before returning to Britain with his substantial collection of postcards (Robertson 1985, 13). In addition, American and British companies and colonial governments targeted potential travelers as postcard viewers, distributing cards at colonial exhibitions and at ports of call to attract visitors, especially in places with direct steamship services to the islands.[7]

The postcards, like many tourism-oriented photographs, often depicted representations of ordered, cultivated, and nonthreatening tropical nature and presented images of an orderly, disciplined, and modernizing society generally. As curator of the Barbados Museum and Historical Society, Kevin Farmer concluded, after perusing his insti-

tution's collection of postcards of Barbados, many postcards represented the island as "an exotic location without danger" (Farmer 2001). The postcard, by making tropical nature into miniature views, further domesticated the islands' landscapes by literally rendering them picturesque—into thousands of possessable picture postcards.

Postcard producers also promoted the islands as premodern to travelers. The figure of the black island native and donkey—along with his barefooted, tree-climbing, sugarcane-eating representational counterparts—frequently performed this role of tropical backwardness on postcards. One postcard of Jamaica produced by the United Fruit Company, for instance, referred to a black market woman and her beast of burden as the "Ford of the Rio Grande," casting the island as lagging far behind the modernity, enterprise, and technology of the United States on the scale of industrial evolution (plate 25). Both place and people were imaged as aspiring to, yet lagging behind, the time and history of the "civilized world." The postcards presented the islands not just as geographically different, another foreign and tropical world, but as a place temporally apart, a universe trapped in the past.

In addition to postcard producers' choice of photographic subject and caption, they further embellished the islands' premodern and tropical image through hand painting and the sustained reprinting of certain postcards over decades. The removal of electrical lines in one version of the "Two Natives" card and the enhancement of tropical vegetation in the image evinces a familiar visual formula in Anglophone Caribbean postcard aesthetics, the subtraction of elements of modernity (electrical wires) and addition of signifiers of tropicality (tropical fruits and tropical nature) (see plates 16 and 17). That postcard producers circulated images of a premodern Caribbean, including the "Two Natives" representation, for decades further contributed to this ideal of unchanging and eternally primitive Caribbean societies, arresting the region in temporal representational stasis. The various stages of production and reproduction—selecting subjects, captioning, and overpainting—betray postcard makers' continual struggle to assert the tropical picturesque narrative through postcards and their attempts to control, stabilize, and contain the meaning of the cards and the image of the islands generally for potential travelers.

While some postcard producers aimed to cultivate the islands' tropical image and to steer the meaning of the postcards, travelers to the West Indies often used the miniature views to construct their own visual narratives on the island. At a time when few (but an

increasing number of) travelers possessed the technological means to create their own photographs, tourists in the islands selectively culled the postcards in different Caribbean ports for mementos of their trips, choosing from the wider public archive for their personal remembrances. At the beginning of the twentieth century, postcards of exotic places occupied a coveted position in many travelers' albums, many of which would be publicly displayed in their sitting rooms.[8] As souvenirs (from the Latin verb *subvenire*, meaning *to come to mind*) postcards would serve as travelers' objects of recollection, tools to remember their past tropical sojourns. West Indies postcards doubly paid homage to the past, being souvenirs of past travels to the lands time had left behind.

Whether postcards resided in travelers' albums or traversed the oceans to designated recipients, they often literally bore their purchasers' handprint—their signature, date and place of use, and, on occasion, their interpretation of the image. Indeed, overlaid on producers' captions, postcard collectors frequently inscribed the image with their own meaning. Before 1902, when senders could not write messages on the back of the postcard, they literally scrawled their comments across the entire face of the pictorial image on the postcard, obstructing or becoming a part of the photographic representation. The postcard form thus recorded what Susan Stewart describes as the private experience of the public mass-produced image. The message marked the sender's personalization or interiorization of the image, his or her literal appropriation of the exotic and foreign into narratives of the self (Stewart 1993, 138). As a result, the postcard form, while enlisted in the service of various touristic or colonial agendas, inherently and literally left a space open on the bottom or back of the image for alternative interpretations.

These handwritten remarks on Caribbean postcards frequently reveal the inevitable instability of the islands' civilized savagery and premodern image. Whereas some purchasers confirmed the naturalness and reality of this tropical ideal, others (even while using an image of a quintessential icon of tropical orderliness) viewed the islands as places of tropical danger. Handwritten testimonies to the presence of "Barbarians" (a spoof on Barbadians), "crocodiles," and "niggers" on the islands' picturesque postcards, for instance, highlighted the danger of the tropics and the savagery of "the natives."[9] From early on postcards became sites where competing ideas and ideals of the islands and their inhabitants were prescribed, inscribed, and destabilized.

Although many postcard producers imagined travelers as their primary consumers, postcards also gained a steady viewership among an unintended audience—the islands'

local inhabitants. Local white elites, for one, purchased and collected postcards. They did so to such an extent that when a local black woman, Lizzie Anderson, featured on a popular postcard of the Bahamas, died, the *Nassau Guardian*, an organ of the white local elite, reported to a readership obviously familiar with tourism-oriented photographs that "the deceased was well known as a hawker of poultry and was the original of the well known photograph (taken several years ago) of a woman with a basket of turkeys and chickens on her head" (*NG*, 16 September 1908) (figure 22). That the woman could be called to mind by reference to her photographic celebrity attests to the visibility and popularity of the form among the islands' elites. In addition to purchasing local cards, the upper classes also collected "postcards of London and Suburbs" (*DG*, 31 January 1905) and postcards of local celebrations of Empire (*NG*, 29 June 1911). Thus, while postcard producers marketed the images as souvenirs for travelers to remember their journeys to tropical peripheries, local white elites appropriated the picture view-cards to consolidate their attachment to the metropole. Postcards of England, local commemorations of Britishness, and images of the island's civilized black British subjects served as visual mementos of mother England.

The islands' black inhabitants, the people most frequently pictured in postcards, also formed an unintended audience for these representations. At the cost of 1 pence each, however, few black workers could afford to purchase and send postcards, much less collect them.[10] Hence, generally the class transcendence often attributed to the mass-produced postcard, the so-called poor man's art form, in Europe and the United States was not a feature in the region. Yet despite the seemingly prohibitive costs, there is evidence that some black inhabitants did acquire postcards. In 1908, for instance, a traveler to Nevis documented that local masqueraders wore costumes made out of postcards (Williams 1908–9). In this artistic reuse, masquerade participants appropriated and personalized the postcard for their own purposes. The "poor man's art form" literally became the poor black man's art form in Nevis, a Christmas masquerade costume. The islands' black population, although not frequent patrons of postcards, inevitably had access to these images, particularly in their places of employment. As store clerks, although racial and skin-color discrimination hampered black stewardship in areas tourists frequented, some blacks eyed the publicly displayed postcards at length. Black Bahamian Daisy Forbes, for instance, minded a Red Cross shop in Nassau in the 1940s, where she viewed some postcards with disgust and embarrassment. On her watch Forbes would

hide what she considered the most offensive image, a version of the "Two Natives" postcard, ensuring that when travelers selected their remembrances of the island, the postcard would not form a part of their visual image bank (Forbes 2000). In a limited way she steered the narrative of postcard representations, tipping the delicate scale of civilized savagery toward the former. Although she, like many other blacks, could not control the means of production, she exerted some control over the site of consumption.

Sustained critiques of postcards, and touristic images generally, throughout the first half of the twentieth century also reveal that local black audiences, across class, constantly surveilled the presentation of the island in the miniature universe of postcards, being particularly vigilant of the construction of the black race in these representations. A black activist and member of the grassroots association Jamaica League, E. Ethelred Brown, for instance, critiqued the singular focus in postcards on the most economically disadvantaged and uneducated segments of the black population. He advocated a boycott of the offending producers of postcards purporting to be "native scenes"— and declared it "the duty of those of us who are unfavourably and unfairly advertised to protest" (*DG*, 18 January 1915). Decades later advocates for black rights on the islands from the middle classes continued to enlist their voices in the ongoing protest over the touristic construction of blacks. In 1956, in the Bahamas, black suffragette Doris Johnson echoed this critique of the "revolting" portrayal of blacks in touristic representations—in particular she spoke out against a Development Board advertisement of an ape wearing a police uniform. While many postcards alluded to the similarity between blacks and animals, in the offending image they explicitly melded into one— the black policeman, the epitome of black discipline, was combined with the primordial image of savagery and prehumanity—the monkey (*TR*, 30 January 1956). Although postcard producers constructed the civilized savage image and naturalized this ideal through several devices, black critics of these representations constantly called attention to and protested the artifice of these pictures—the singular focus of their subject matter (black backwardness, poverty, tropicalness) and the constructed character of their form. These and other critiques reveal not only a long-standing local attack on the incessant focus on black "natives" in touristic representations but attest to the unyielding production of these images despite these outcries.

Thus contemporary postcard books utilize postcards borne out of the specific imag-

ing needs of the islands' tourism industries at the beginning of the twentieth century and consumed primarily by travelers, colonials, and elites on the islands. This tropicalized image world was, however, from early on inherently open to alternative and even opposing meanings, as the changing captions and handwritten commentaries testify. The cards, as publicly displayed images, were also viewed by local audiences. While black inhabitants "wrote back" protesting the visual narratives of these representations these critiques and contestations left no traces on the archives—archives that centrally pictured the islands' black population. The absence of these perspectives on the tropicalized image world, unlike the producer's captions on postcards or the purchaser's handwritten commentary, would dramatically affect how subsequent viewers would interpret the photographs, read the narratives of these representations, and represent the past, particularly in postcard books and in historical accounts in the region. Or, to use historian Rolph Trouillot's terms, because blacks did not leave "concrete traces" on either the "making of *sources*" (postcards) or "the making of *archives*" (collections of postcards), it would dramatically affect "the making of *narratives*" and "the making of *history* in the final instance" (Trouillot 1995, 26).

THE MAKING OF NARRATIVES: THE POSTCARD IN CONTEMPORARY PICTURE BOOKS AND HISTORICAL ACCOUNTS

Narrating the Past through the Postcard Books' Form In more recent times in publications throughout the postcolonial world unintended consumers of postcards have become primary ones. In many former colonies postcards have become central tools in the reconstruction of postcolonial histories of the subaltern and the deconstruction of the imperious imperatives of postcard makers. Algerian scholar Malek Alloula, most notably through his study of colonial postcards of Algerian women, aimed "to return this immense postcard to its sender," to use the images to explore, explode, indeed, to "exorcize" French colonial myths about Algeria (Alloula 1986, 5). Authors in the Anglophone Caribbean have also used postcards to reflect on the colonial past; their picture books, however, have done different work. Many contemporary authors of publications on Caribbean postcards have framed the old images as historically accurate representations of the past and proffer the picturesque society featured on postcards as visual evidence of the "better days" of colonial rule or the "golden age" of tourism. They not

only privilege and reiterate the narrative of picturesque tropicality, originally created to appeal to tourists, but present key features of the islands' carefully crafted touristic image as historical fact to local audiences. This is evident even in the subtitle of one publication that framed the postcards as transparent windows onto "the way we were," to cite the title of a book on Jamaica (Sherlock 1990).

The typically brief texts that accompany the visual images in these publications further frame the postcards and photographs as documentary and objective representations of a former era. *Nostalgic Nassau*, for example, promises a "nostalgic peep into the past" (Malone and Roberts 1991, 1). And Ann Yates, the author of *Bygone Barbados*, offers "Barbadians and visitors . . . a piece of our past" (Yates 1998, ix). On two occasions she describes her picture book as a "history" of Barbados (ix). The author of *The Bahamas in Black and White*, Basil Smith, also bills his book as "a valuable record of the way things were" and "a celebration of the work of this elite cadre of photographers who created the images that made The Bahamas famous" (Smith 2000, 9–10). The producers of these publications reintroduce these images as a visual history of the islands to local audiences (as is suggested in their use of the collective "we" and "us") and visitors.

These books base much of their claims of historical accuracy or transparency on the simple fact that they use photographic postcard images, subscribing to the belief that the camera never lies. They work under the assumption that because they feature photographs, these images picture or document "the way we were." *The Bahamas in Black and White*, in the very title, invokes both its use of photographic images and a more colloquial understanding of "black and white," as something that is clear, documentary, and conclusive. Many of the titles point to the inclusion of photographic materials by way of description, but they also index, by extension, the images' historical accuracy.

Unsurprisingly, given these documentary claims, several authors interpret the picturesque society featured on postcards as visual evidence of the "better days" of colonial rule. Yates, for example, lauds the images in *Bygone Barbados* as visual documents of the orderliness of Barbadian society in the colonial era: "These photographs give us a wealth of information, *they show a well ordered, law abiding, church going and diligent island* . . . with robust commerce, many gracious buildings, schools and churches" (1998, ix; emphasis added). The "well-ordered" image of the island she detects in the photographs is precisely the picturesque ideal makers of touristic representations had

to project of predominantly black societies to assure travelers of their safety in the tropics. Indeed, authorities wielded the importance of maintaining the islands' picturesque image as an upraised baton, as a tool in imposing discipline. The appearance of an orderly society Yates detects is precisely the image that tourism promoters aimed to transmit and enforce.

Some authors designate and celebrate the sites pictured in the cards, particularly the places that epitomized the ordered tropical landscape, as historically important. In *Nostalgic Nassau*, for example, Shelley Malone and Richard Roberts lament the disappearance of the Royal Victoria Hotel's gardens. They express sorrow that "the once splendid exotic gardens are gone and sadly she awaits her demise. Ah . . . but, thanks for the memories dear lady" (Malone and Roberts 1991, 46). In regard to a postcard of Victoria Avenue, another crowning example of an ordered tropical landscape and ode in appellation to the British Empire, they comment, "Today unfortunately [Victoria Avenue's] charm is gone, and it more closely resembles a parking lot" (27). They view their project as a way to preserve the past: "Before the best of old Nassau is completely forgotten, the authors hope to create an affection for the good (or bad, depending on your point of view) old days" (1). Many of the sites they cite as historically valuable are those that were designated as sights in early touristic campaigns. Generally, the books position both the societal order and the physical locations long treasured in the visual economies of tourism and reinscribe these myths and spaces of touristic importance as the state of the past and historical treasures respectively. They also position this era, which coincides with British colonial rule, as "the good old days," even though Malone and Roberts concede that some people may differ with their point of view.

Another trait of early postcards resurrected as historical fact in some of these accounts is the idea that the islands remained unchanged, that time, in essence, stood still during the colonial period. The authors of *Nostalgic Nassau* pick up on the "representational sameness" inherent in the postcard image world, but they interpret this as indicative of Nassau's unchanging character during the colonial era. They claim, "The Bahamas has altered more in the last thirty years [the Bahamas gained independence in 1973] than in the previous one hundred and thirty. Most of the early Victorian domestic architecture has disappeared, due to public apathy and the greedy demands of property developers with little appreciation of history" (Malone and Roberts 1991, 1). They suggest that in the colonial era the island remained unchanged but that in the

postindependence period "Old Nassau" had disappeared because of people who lack an appreciation of history. The authors base their historical claims on old postcard representations, which precisely imaged the islands as places outside of history, time, and modernity.

While postcards historically left a space open for competing interpretations, these publications present the materials in a more closed form, siphoning off possibilities for alternative interpretations. Even though at least one publication did acknowledge the viability of differing interpretations, the books share several organizational and design features that construct the interpretative frame for these representations and narrate the images as objective documents of the islands' former picturesque past. Although all books, of course, structure their narratives, the re-presentation of the multisided and multiply narrated postcards in the contemporary picture books would explicitly shape how the postcards could be read by their newest recipients—contemporary local viewers.

First, the writers seldom contextualize or describe the historical circumstances under which many of the representations they proffer were created; they do not allude to the touristic impetus behind many of these photographic creations. The books also do not address the issue of the original consumers toward whom these images were directed. Without describing the touristic impetus of these postcards, these books recirculate the images in a contextual vacuum, or in a new context, as objective images of the region.

Second, few of the publications identify the particular creators or publishers of the image. Even when the authors mention the names of photographers in their introductory remarks, they seldom attribute particular representations to specific image makers. As a result of this authorial erasure, multiple images from numerous creators and publishers are recomposed into an anonymous visual pastiche. The paucity of research into photography in the Anglophone Caribbean in general may account in part for this lack of contextual information.[11] Many public photography archives in the region, including the National Library of Jamaica or Department of Archives and Public Records in the Bahamas, do not identify photographs or postcards by their makers. Rather, if their collections are systemically organized at all, they are classed by subject matter. The nonattribution of these images in the archives and in publications conceals the identity of photographers, revealing a seemingly collective, impartial, and transparent visual record of the islands.

Third, the mailing addresses and postal markings, which indelibly document many cards' previously traveled international routes (which often appeared on the verso of cards), are seldom reprinted in the publication. Interestingly, the postcard's authenticity, according to Stewart, was generally based on their being purchased in or sent from their place of origin—they had to be materially connected in some way to this originating locale (Stewart 1993, 138). The absence of postal marks in contemporary publications suggests that the currently perceived authenticity of the cards resides not in their places of origin (that is, the collections of persons in Europe and the United States). Rather, by downplaying the former transnational origins of many cards, the books' creators imply that the images never left home. Perhaps these earlier routes would disrupt the "rootedness" of the postcards—their ability to speak as objective documents about the origins and history of the islands. The publications reinstate the postcard as "native" to the islands and as "national" documents, when actually both the production and consumption of the postcards was a multilayered transnational process.

Fourth, the printed captions that originally appeared on many of the postcards and the senders' handwritten messages have often been eclipsed in the republication of these materials, as books generally do not reprint the back of the cards. By concealing the earlier personalized reading of the cards, the postcards recirculate without traces of their previous use, their former interpretations. This erases the history of the cards as sites where competing interpretations sometimes coexisted, where tropicalization was still in process and protested, where visual representations were explicitly open to subjective rather than objective interpretation.

The contemporary picture book authors' own printed comments, however, may be viewed as a new form of handwriting, the assertion of another private inscription on the postcard archive. The authors' own "handwriting," in this instance the more indelible and authoritative form of the printed word, claims possession of the postcards as evidence of their past. Unlike the singular personal inscription of the cards by early travelers, however, the authors strive toward a more collective reclamation of the images, as is evident in the constant referral to "our past" in the publications. To authenticate the postcards as objective documents of a collective past, however, the representations could not bear traces of their previous privatization by travelers.

That the earlier caption or handwriting could disrupt the easy appropriation of these postcards into contemporary narratives of the picturesque past is evident in what ap-

pears to be the deliberate erasure of a caption on a postcard republished in *Nostalgic Nassau* (plate 26). The authors reprinted a version of Sands's "Two Natives" postcard, but hid its caption, overlapping it with another card. If the old caption had remained, the majority black population in the Bahamas might find it difficult to interpret such an image as evidence of the "good ole days." It might even (re)provoke local black contestation of the representation of race in postcards and resentment of the racist practices so commonplace during the era in which they were produced. Preempting this possibility, the authors erased the old caption. Not unlike early postcard producers, who retouched or changed their captions in an attempt to make the image work for its touristic cause, this action marked an attempt to control the meaning of the cards, although now by removing a caption rather than adding one. The erasure also calls attention to the authors' self-conscious and active role in selecting and recollecting the past. Like tourists picking postcards of the Anglophone Caribbean to remember their travels, the books' producers choose particular representations to reconstruct the islands' history.

These authors not only selectively tell the history of the islands through their choice of postcards, but they attempt to steer the meaning of the postcards for other viewers by not allowing viewers the opportunity to view postcards in their historically layered complexity. Some of these organizational and contextual erasures may be attributed to the particular publication genre of the coffee-table picture book. Few picture books encumber their glossy pages with in-depth explanatory texts or feature the admittedly unexciting back of postcards. Indeed, Alloula's book is rare in that it is simultaneously a picture book and scholarly text—dedicated to the memory of Roland Barthes no less. (Its miscegenational form has in fact drawn the wrath of many academics.)[12] In short, any analysis of the books must take into consideration the expectations and limits of the publication form and its intended popular audience. This having been said, within a broader history of West Indian postcards, the picture books tend to ventriloquize the earlier intended meaning of the cards, precisely as they silence the contested interpretations of these representations, which were sometimes inscribed on the postcards. In other words, while postcards of the islands have historically been sites over which, and on which, competing, ambivalent, and opposing images and interpretations of the islands battled for significatory supremacy, the content and form of these contemporary publications highlight the imperatives and narratives of early postcard producers. The

questions remain: whose stories do these new narratives of the past tell? Who precisely frames the publications for public consumption, and to what end?

Revealingly, the creators of all these books and the most avid collectors of postcards and photographs in the Bahamas and Jamaica are (with few exceptions) all from the white elite classes of these societies. The newly published series of old postcards of the Bahamas, *Back Then . . . Bahamian Style*, were also reprinted from "the private albums of old Bahamian families," according to the jacket of the images. ("Old Bahamian" commonly denotes white moneyed Bahamian families in the context of the Bahamas.) Tellingly, postcards, even in more contemporary times, continue to remain out of the hands of the black population.

The racial and class backgrounds of the collectors, although not determining factors, do provide some perspective on their possible interest in and use of these colonial and touristic representations. Significantly, under colonial rule generally, and the race and class hierarchies institutionalized under this system, white elites garnered economic and political privileges on the islands, occupying one of the highest rungs on the social ladder (under British colonial elites). Members of the social group were also often the economic and social benefactors of, and supporters of, tourism and used the industry (and postcards) to cement their ties to Empire and the modern world. With the transition to independence in some British colonies, during the 1960s and early 1970s (Jamaica became a nation in 1962, Barbados in 1966, and the Bahamas in 1973), the white elite still remained disproportionately influential politically and economically on many of the islands (Johnson and Watson 1998, x).

However, in the anticolonial and nationalist movements that powered the march toward independence and in the first decades of self-governance in these Anglophone Caribbean nations, typically the long-devalued history and cultural contributions of African-Caribbean populations came to the fore both in searches for national culture and in new social histories on the region.[13] This shifting emphasis on black cultural practices and historical research often left the "white minority" on the margins of national culture and "peripheralised in historical discourse" in these societies (Johnson and Watson 1998, 1). The more recent republication of postcards may be viewed as a subtle recentering of the history of white minorities, a shift of the historical spotlight back on the era of colonial and white political rule.

Given this social, cultural, and historical background, perhaps it is not surprising that white collectors would be attracted to images of the colonial era and the heyday of tourism and would nostalgically position these representations as "the good days." Of course, not all collectors and compilers of these books aim consciously to venerate the colonial past. Indeed, they may simply organize the books, their recollections, based on their own experiences and understandings of the past (their "private albums"), revisiting, visualizing, and even celebrating their recently neglected histories from their own perspectives. Through their published postcard collections they can re-create the social world that they, or their families before them, once inhabited. The publications may be viewed very literally as private albums, personal visual records, of the past. Joseph Abdo Sabga, the author of a postcard book on Trinidad, concedes as much when he prefaces his publication with the words: "I hope that you will find this selection to be an interesting one, bringing back fond memories, and acting as a personal album on a Journey of Memories" (2000, xii).

Typically, this private commemoration of the good old colonial days, however, is seldom presented as a select view of the history of the islands but rather as a journey of memories on which all viewers can personally embark. As such the books often posit that socially and economically society as a whole was better off during colonialism. Regardless of the various authors' motivations, when most of the publications seem to re-present history from similar (white elite) perspectives, this version of history has become reified. In this way, as Farmer points out, many of these publications engage in and authorize a kind of "romantic amnesia, for in fact 'the good ole days' weren't that good for many members of these societies" (2001).

The picturesque ideal, which many postcards of the islands conjure, was created as part of and against the backdrop of the social and political repression of the majority of the population. The images presented on postcards obviously gloss over the conditions of segregation and discrimination under which much of the islands' inhabitants suffered during colonialism. The same hotel that Malone and Roberts picture, for example, and recall nostalgically with the words "thanks for the memories, dear lady," was described by black Bahamian suffragette (and Development Board critic) Doris Johnson as "the symbol of white superiority" in her recollections, *The Quiet Revolution in the Bahamas* (1972, 10). The hotel was one of the last establishments desegregated in Nassau. Thus the colonial nostalgia in which many of these books engage proffers a very select version

of history that can naturalize and neutralize the violence of colonialism and tourism, presenting it to contemporary audiences as an ideal period in their past. In this process, the same images used to sell the islands to a tourist clientele a century ago have more recently been reemployed to sell this colonial past to the islands' inhabitants.

These books, which celebrate the colonial era, must be further contextualized within a wider sentiment of British colonial nostalgia that has pervaded much of the Anglophone Caribbean region (and other areas) in recent times, across race and class. As historian Barry Higman contends in his historiography of the Anglophone Caribbean, "In the English-speaking Caribbean, the not-too-distant past for which some feel a nostalgic hankering is generally represented by a world in which crime and violence were less common, food cheaper, manners more polite, and the family unit stronger. Those were the good old days" (Higman 1999, 150). Higman found that many local contributors to a *Nostalgia* column in the *Daily Gleaner* in the 1990s in Jamaica recalled the colonial era fondly, and associated the "good old days" with British colonial rule particularly. Such structures of longing exist among many classes of Jamaican society, from white Jamaicans to the island's black working-class population, including a former UNIA member. *Nostalgia* commentators described the colonial era invariably as a time when "things were plentiful," "food and everything was cheap," "everything was better run," and when "no Jamaican ever lost a single penny due to bank failure" (115). (Higman goes on to point out that as early as 1848 the Planters' Bank on the colony, failed.) Higman concludes that disillusionment with contemporary socioeconomic and political predicaments in Jamaica is likely a major contributing factor in this general nostalgia for a colonial past.

Although Higman does not go into great detail about the sources of this postcolonial discontent, multiple local economic and social crises may have inspired this widespread nostalgia in Jamaica and in other Anglophone Caribbean countries. The 1990s saw the collapse of the financial sector in Jamaica with many of the island's leading banks closing their doors and the Jamaican dollar falling to all-time lows. The prospect of higher gasoline prices led to rioting in 1999. Escalating murder rates and violent crimes remain dramatic indicators of wider social discontent, disfranchisement, and desperate poverty. These high murder rates and incidents of social unrest have, in turn, threatened Jamaica's number-one earner of foreign revenue, tourism, adding another economic blow to an already faltering economy. Any local social disturbance on the island

registers high on the Richter scale of the international press, further shaking Jamaica's venerable and vulnerable tourist trade. The emphasis on societal order and touristic safety remains as high in the maintenance of the island's tourism image now as it did some hundred years ago, if not more so.

The story of Jamaica in the 1990s—increased crime, poverty, and economic uncertainty—echoes to some extent that of many other islands in the region. Although the financial and social forecast is not quite as dismal elsewhere in the Anglophone Caribbean, approximately 30 to 40 years after independence, many people express disenchantment with current economic and social conditions. The increased influence of multinational corporations, international monetary boards, and developmental agencies in the region has also ushered in a new and uncertain economic future for the postcolonies. In the face of this social instability, perhaps unsurprisingly, residents from many walks of life cast a rose-colored glance at a past when (they perceive) these current social conditions did not exist.

These early twentieth-century images, which picture the touristic ideal of an ordered and orderly Caribbean society that was safe for travelers, are likely so popular in recent times because they offer a vision of a disciplined society on the islands at a moment when crime and violence (manifested even in riots on some islands) seem to reflect anything but social order. Indeed, postcards enable and encourage the perpetual consumption of the past, especially when contemporary circumstances are too "looming" or "alienating" (Stewart 1993, 139). The souvenir's "function is to envelop the present within the past. Souvenirs are magical objects because of this transformation" (ibid., 151). Philip Sherlock's introductory remarks to the postcard book, *Jamaica: The Way We Were*, suggest that the postcards serve this function of temporal escape in the contemporary Anglophone Caribbean: "Each postcard flies us back into years we never knew. . . . We experience the nostalgia of generations and Jamaica—The Way We Were becomes Aladdin's Cave" (Sherlock 1990, 6). In this way the image world of the Caribbean created on postcards does not function so differently from how it did for tourists decades ago, in that the postcards provide a visual escape to a seemingly ideal premodern location and past time removed from the current pressures or predicaments of contemporary society.

Even more than functioning as objects of the past, contemporary reappraisals of the postcards are about refashioning futures. The postcards recirculate to inspire "magi-

cally" the transformation of postcolonial society into this ideal. These publications narrate these postcards of an orderly Caribbean society as "our history" in order to make them parts of the inhabitable dream of the future for these Caribbean societies. This suggestion seems substantiated in Sherlock's closing remarks: "Imagination takes wing and we set off into a future, hoping that some day what we imagine will become actuality" (Sherlock 1990, 6). By positioning the disciplinary societal ideal as the history of the islands, as the once real state and condition of the islands in the past, the authors suggest that such an orderly society is an obtainable reality or possibility for contemporary society in the near future.

A letter to the *Daily Gleaner* from a Jamaican resident, Dawn McDowell, cited in Higman's analysis of nostalgia, makes this hypothesis about the connections between the touristic images of Jamaica in the past and hopes for a contemporary return to this ideal in the future more intelligible. Higman paraphrases McDowell's recollection at length:

> *"Not so long ago Jamaica was a beautiful place, and Jamaicans were a compassionate people."* The island's future, she said, "looked extremely promising on Independence Day in 1962. Even though I was not around, by hearsay and fact, I can state categorically that this was true. Books on Jamaican history tell of that era." When talking to her grandmother about "the good ole days," the growth of crime was a constant topic, linked to materialism and global changes in technology. *If only people would do good, she believed, Jamaicans could "regain our reputation as being the little island paradise that we once were. . . . knowing that we have a history to be proud of."* (Higman 1999, 151; emphasis added)

McDowell defers to the recent past, "not so long go," in what turns out to be an indictment of the present and a prayer for the future. She also refers to Jamaica's former status as an island paradise, citing this as a historical fact. Even though McDowell first uses the words "our reputation" as being the little island paradise (suggesting how Jamaica was known, as opposed to how it was), she quickly asserted that the reputation as paradise was indeed real. The statement emphasizes the complex ways that touristic images of "beautiful Jamaica" as an orderly paradise at this moment in time are reinstated as historical fact and not connected to the construction of the island's tourism image.

McDowell's reflections on the island's paradisiacal past, however, ultimately end in a commentary and prescription for contemporary Jamaican society. She expresses faith

that if people could "do good" this "beautiful place" would once again return. Her view of "not so long ago" bears direct relation to contemporary society and her belief that the paradisiacal ideal of the island is an obtainable reality and goal for contemporary Jamaica.

In light of the history of the image world of tourism and its effects on the creation of an orderly and safe space for tourists, it is significant that McDowell asserts that if only local residents "could do good," that if only they behaved in certain ways, paradise would return to the island. In other words, while on some Anglophone Caribbean islands inhabitants have long been encouraged to behave in certain ways for tourists or were removed if they disrupted the desired picturesque order of the tourist landscape, here the writer uses the touristic ideal of the past to reissue a call for good and orderly behavior on behalf of the island's population in the present. Her comment may also be constructively related to Yates's commentary about an "orderly and diligent Barbadian society." These contemporary recuperations of an orderly Caribbean past confirm that the postcards that once were used to project a disciplined and safe image of the islands for tourists are more recently related to a contemporary desire for an orderly and safe society for the islands' residents.[14]

The picturesque and orderly ideal of the Anglophone Caribbean past represented in these books may be compared to what Mike Wallace refers to as "Mickey Mouse history" (1996), the re-creation of the past as clean, wholesome, and a world without conflict, as typified in Disneyland's utopian re-creation of Main Street.[15] Presentations of the Anglophone Caribbean through postcards create a similar deferment to the past as an ideal period. However, instead of physically creating an improved version of the past in the present, they rely on the use of past representations (images that were ideal representations of the islands at the threshold of the twentieth century) in the present to reconfigure historical memory about the islands. Unlike Mickey Mouse history, which, Wallace argues, inspires a certain passivity, "invites acquiescence to what is," and promotes "a way of not seeing and—perhaps—a way of not acting"(Wallace 1996, 149),[16] the picturesque representations of the past in the context of the Anglophone Caribbean encourage viewers to envision the past and inspire action, a certain type of behavior needed to transform the islands into their orderly representational counterpart.

This use of a paradisiacal past to inspire a sense of a shared history, "a history to be proud of," according to McDowell, and to urge fellow citizens to "do good," recalls

Homi Bhabha's descriptions of the pedagogic and performative function of narratives of nation (Bhabha 1990, 297). Although McDowell's remarks and the contemporary postcard books are not produced by the state per se (even though they use images originally sanctioned by the colonial state), they all aim to foster a sense of a collective nation partly based on the notion of a shared paradisiacal past, "our history," or "the way we were." Bhabha points out that often the idea of nation is performed or mobilized through these appeals to a shared origin, past, or through representations of the landscape "as the inscape of national identity" (Bhabha 1990, 295). Such narratives serve a pedagogic function, inspiring national affiliation and civic forms of behavior, that is, "doing good." In other words, contemporary recollections (visual and otherwise) of a picturesque past aim to narrate an idea of the postcolonial nation as a place that was once (and can be once again) an orderly society, to spur public sentiment and (re)create the well-ordered and disciplined society visualized in early touristic representations.

Narrating the Black Past: Postcards and "the Making of History in the Final Instance" While such socioeconomic considerations may shed light on the contemporary currency of these representations, of even greater interest here are the deeper epistemological consequences of this postcard nostalgia on history and popular memory, repercussions even more pronounced in the use of postcards in "history in the final instance": scholarly historical accounts. Continuing the tradition of co-opting the postcard into multiple and even opposing narratives, in addition to their enlistment in the script of colonial nostalgia and the recovery of the history of "white minorities," the postcards have also become central sites in the project of postcolonial reconstructions of subaltern histories. More specifically, historians interested in retelling, rewriting, and reconstituting the social history of the islands' black (and to a lesser extent Indian) populations have also turned to photographs and tourism-oriented postcards in their publications. Faced with the difficult task of excavating the black past in the absence of many material artifacts or local written narratives, scholars have placed a heavy burden on photographs, using the images as proof of the historical significance of black subjects, indeed, of their history as historical subjects. In order to fill in the gaps, the silences, and erasures in written archives on the region, Caribbean scholars drew from the same representational pool of colonial representations as the postcard book creators.

While many Caribbean scholars interested in narrating a history "from below" care-

fully and critically sifted through textual colonial archives, some of the same scholars employed visual sources as transparent reflections of the past of the islands' black histories, perhaps strategically so. This practice is widespread across the pages and even on the covers of many history books. It is evident, for example, in an invaluable social history of the Bahamas (one that has been central to my own research on the black population in the archipelago): Michael Craton's and Gail Saunders's two-part history *Islanders in the Stream* (1992, 1998). Although Craton and Saunders call their readers' attention to the biases of colonial and travelers' descriptions of the islands' black population, when discussing the "pictures, adopted and augmented by postcard makers such as the Detroit Publishing Company," they praise "the unbiased eye of the camera" for its ability to "add to—and sometimes correct—written descriptions" (1998, 213). They cite Jacob Coonley, one of the photographers who created many of his photographs and postcards to promote the islands as winter tourism resorts since the 1880s, as an example of unbiased reportage. Craton and Saunders interpret Coonley's and other photographers' images of "dusty, ragged, barefoot and always smiling ordinary people" as rare records of the harsh conditions in which blacks lived on the islands. They suggest that such representations of poverty provide a truthful account of black life, precisely in contrast to touristic representations. They do not take into consideration that images of black destitution—of barefooted, barely civilized natives—were central spokes in the revolving and recurring visual mechanics of tropicalization.[17] In their efforts to readdress the racial imbalances in historical narratives, they counted on photographs to provide a countervailing window into black life at the start of the twentieth century.

In addition, Craton and Saunders employ the visual language so prevalent in tourism, particularly ways of seeing the landscape through the lens of the picturesque, in their historical reconstruction of the black past in the Bahamas. In a section subtitled "The Life and Culture of Bahamian Blacks after Slavery" they refer to "the daily passage of market women up and down Market Street" as "one of the picturesque Nassau sights," reintroducing in the context of a historical account the descriptive language often found in travel literature and touristic images (Craton and Saunders 1998, 106). Picturesqueness is thus framed not as part of the process of tropicalization—the making of the island like a tropical picture or the presentation of the market woman as picturesque—but as a quality the landscape and its people possessed in the past. In this reuse the history of photography in the production of place and disciplining of people is

erased. The contrived touristic image reappears, wearing the invisible mask of history, as the past as it was, not the past as it was produced.

Recent social histories have not only framed colonial and touristic images as transparent reflections of the past but have positioned them as archetypical representations of black Caribbean society. In *Cultural Power, Resistance, and Pluralism* (1995), an effort to construct the cultural history of colonial Guyana, for instance, Brian Moore uses postcards and photographs (some of which are from Jamaica) to illustrate what he frequently describes in his captions as the "typical" customs of different racial and ethnic groups.[18] Continuing the history of captioning, recaptioning, and decaptioning (hiding captions), Moore replaces earlier captions with new ones. A photograph by James Johnston, which circulated widely on postcards with the caption "The Morning Toilet" (plate 9), for instance, reappears in the chapter on Afro-Creole Folk Culture next to the label "Creole Woman plaiting hair in yard" (Moore 1995, 96). The new caption transforms Johnston's photograph from a spectacle of black cleanliness for tourists to an objective illustration of blacks engaged in their daily routines. The reproduced image appears cropped into an odd-sized *L* shape, which erases many traces of the figures' immediate humble surroundings and wider geographic environment (figure 61). Deemphasizing the particularities of location likely more easily facilitated its appropriation as a representation of another country, Guyana, and its evidentiary value as "Afro-Creole" types. Additionally, a photograph of Johnston, the Scottish-born photographer of "The Morning Toilet," appears in the text on colonial Guyana next to the words "typical dress of the white elite males" (Moore 1995, 25). Moore's book evinces another attempt to enlist postcards into new historical narratives. The cropping, relabeling, and geographic reattribution all re-present the once "touristic" postcards in a new guise: as representative representations of the past. This newest historical recuperation of postcards and touristic photographs dramatically transforms them from objects that many black critics denounced as precisely not representative and indicative of the black population into typical representations of the black race. Such attempts to recuperate the images, to wrangle the postcards into the service of social history narratives, point to the inherent difficulties, even conundrums, of using colonial photographs to narrate black histories. Can postcards, the very representations that denied historicity to the black population, ever unproblematically yield "black history"? Can black histories ever be built on fragile postcard infrastructures?

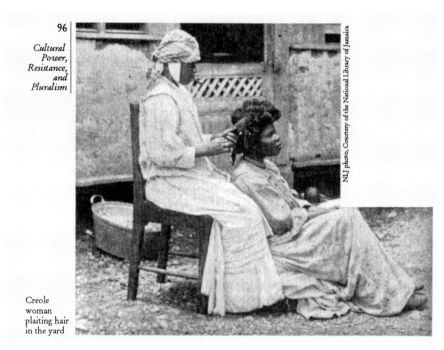

NLJ photo, Courtesy of the National Library of Jamaica

Creole
woman
plaiting hair
in the yard

61 Photograph, "Creole woman plaiting hair in the yard," n.d.

Another book, *Bain Town* (1976), by a local black Bahamian historian, Cleveland Eneas, also evinces an interesting attempt to appropriate the postcard for narratives of black history, in this case by physically transforming a turn-of-the-century postcard (figure 62). This is evident on the cover of his book, which utilizes an image based on a Detroit Publishing Company postcard published in 1903 (plate 27). *Bain Town* was an early postindependence attempt by a local scholar to write a history of black communities in the Bahamas. The book set out to, as presaged in the foreword, "educate our young people to understand that the black man in The Bahamas has a social history and the roots of a culture which is indigenously Bahamian and in which he may feel proud" (v). *Bain Town*, a mixed genre of nostalgia and history, highlighted the specific African ethnic identity of Eneas's Yoruba community.

By reusing, reconstituting, and relabeling the postcard, Eneas co-opted the old post-

62 Cover of Cleveland Eneas's *Bain Town* (1976), based on Horace Wright's painting, *Boy with Sugar Cane*, ca. 1948–51 (see plate 27)

card for use in his *Bain Town* narrative. When the painted postcard—an impressionist depiction of a black Bahamian boy eating sugarcane while a dog reclines at his feet—was first published, at the start of the twentieth century, it was one of numerous representations of black backwardness and tropical languor in the islands.[19] It circulated with the caption, "Nassau, Bahamas," casting the cane-eating boy as representative of a geographic type. The cover of *Bain Town* retained the general subject matter and impressionistic painterly style of the earlier postcard. In an interesting contrast to the nondescript background that the little boy and his canine companion occupy in the early card, on *Bain Town* the young male protagonist appears part of a wider social frame and landscape—in a picket-fenced yard and in a neighborhood. In the painting the boy also is depicted as part of a familial context, next to a woman, possibly a mother figure. Eneas used a painting by art educator and artist (and friend of the author) Horace Wright

for the cover. It is unclear whether Eneas knew of the origins of Wright's painting. Whether he did or not, however, does not alter the fact that his use of Wright's image dramatically transformed the viewing context and meaning of the early postcard. Even the very republication of the postcard with the book's title, *Bain Town*, in bold type across it, rescued the boy from his circulation as touristic type in "Nassau, Bahamas" and placed him on the front of a book celebrating the particular experiences of a boy, Eneas, growing up in the community of Bain Town. More broadly, the painted cover also transformed the object of the postcard, the anonymous boy, into the subject of "art." The reuse of the postcard on the cover of *Bain Town* some 80 years after it first circulated also epitomizes the long and frequently undocumented secret life of the postcard in the postcolonial context: its transformation from touristic propaganda to black history, its metamorphosis from an object of black shame to black pride, its oscillation between the spheres of mass culture and art, and its circulation without concrete traces of black perspectives on it to its republication as the cover of a book by and about a black Bahamian.

In sum, the postcard has served many purposes in publications in Anglophone Caribbean postcolonies, whether the reuses fall into the colonial nostalgia camp or the genre of black social histories or somewhere in between. In fact, many of the publications straddle these genres (Sherlock 1990). Indeed, replicating the history of postcards as documents that could appeal to different and even opposing narratives, a single publication could offer both historical sensibilities at the same time. Across and within these genres photographs and postcards have become ropes in representational tug-of-wars, battlegrounds on which the legitimacy of different racial groups are fought, "visual evidence" in different and sometimes competing narrations of nation. They have become archives through which various authors, as articulated in Eneas's book, construct histories they "can be proud of." The colonial photographs have become firmly embedded in present imaginings and contestations of the postcolonial Caribbean nation. Hezekiah put it best when she observed in regard to the presentation of race and nationhood in *Photo and Phantasms* that "the idea of Caribbeaness and of self is what is at stake in the presentation of these photographs" (1998, 35).

Despite authors' enlistment of the postcard into different agendas, these histories base their various claims on the narratives of early postcard producers. They reinvest

in the purported objectivity of the postcards. David Scott's observations about how the political demands of anticolonialism shaped postcolonial discourses in the Caribbean and elsewhere are relevant here: "The task of decolonization consisted in the demand of *self-representation*, a process of restoring an authentic relationship between representation and reality. . . . What was not theorized (or anyway, what remained undertheorized) in this space of anti coloniality . . . was the whole question of the decolonization of representation itself" (Scott 1999, 11–12). By using postcards to represent local histories, historians constructed a counternarrative to colonial representations yet left in tact and indeed strengthened the representational authority of the colonial postcard. They failed to decolonialize the colonial and touristic constructions of the postcard itself. Thus, precisely at the moment that some historians aimed to counter colonial discourses through the authorship of "new" or recent histories, they based their authority on the tropical and picturesque narratives of the early twentieth-century postcard. Instead of returning the images to their senders, postcards have become coveted and intimate parts of the historical construction of narratives of nation in the Anglophone Caribbean.

The Postcard in the Caribbean Art Worlds In addition to the postcard's new resting place in the annals of history books and the glossy pages of picture books, the postcard has been put to use by another set of producers, Caribbean artists. Some artists have assembled postcards or tropicalized images in their artworks to explore their own relationships to the Caribbean and representations of the islands and to reconstruct their own personal, familial, national, and regional histories. Others have utilized the postcard in efforts of deconstruction, interrogating how the postcard creates its seemingly innocuous tropicalized meaning. In this way they continue the line of critique sounded by the Jamaica League and Doris Johnson, who attacked the select slice of life featured in touristic representations and methods used to project these images as real or indicative of the islands. Recalling Trouillot's stages in the production of history, they call attention to the production of the postcard as a source of tropicalized imagery, as part of the narrative of the collection and as objects of history (or historical erasure). In other words, they use their work to narrate their own histories of the region, paying particular attention to how tropicalized representations interceded into this history and into the

production of history. Moreover, in addition to stressing how postcards inform ways of remembering, they explore how the aesthetics of the postcard influence ways of seeing, imagining, and representing the Anglophone Caribbean.

Many artists address the history of tropicalization in the islands, but they also engage the latest phase of postcard production, the more contemporary visual language of the postcard in the Anglophone Caribbean. After World War II, tourism in the English-speaking Caribbean and the marketing of the islands, in postcards and newer forms of advertising like billboards and posters, entered a new phase: mass tourism (again with Jamaica, the Bahamas, and Barbados as industry leaders). In the 1950s and 1960s, with the convenience and affordability of nonstop international jet air service and the dawn of the cruise ship industry, these islands became increasingly accessible and popular destinations, especially for holiday makers from the middle classes in the eastern United States.[20] In this period many tourism boards throughout the broader Caribbean region started to depend even more heavily on public-relations firms in New York to appeal to this broad-based clientele. As Jean Holder, secretary general of the Caribbean Tourism Organization, admonishes, "[Since the 1950s] Madison Avenue created for the Caribbean and sold images that appealed to the market" (quoted in Gayle and Goodrich 1993, 21).

Several central visual icons and trends in touristic representation arose in the era of mass tourism, distinguishing it from the earlier and more popular "golden age" of postcard production. Crafters of the islands' destination images drew on a more select pool of visual tropes. The sun, sand, and beach, in particular, became increasingly ubiquitous signs in the visual economies of tourism in the region. As Gilmore, in his social history of postcards, points out, "the rapid growth of tourism which came with comparatively cheap air travel seems to have encouraged a proliferation of the beach and palm trees type of card" (1995, vii). Typically, only captions identified these representations of the beach as representative of particular geographic islands.

At least two factors directly attributed to this imaging of the islands as undifferentiated spaces of palm-fringed white sandy beaches. First, very generally, by the 1950s the beach had moved squarely to the center of the touristic "tropical experience," becoming a primary signifier for "the tropics" from the Caribbean to the South Pacific (Löfgren 1999; Osborne 2000, 107–20). Second, and more specifically, in 1951, as more Caribbean governments developed the tourist trade, a panregional tourism organization was set

up, the Caribbean Tourism Association, to market the region as a whole. In their campaigns signifiers that united, rather than distinguished, individual islands, such as the beach, increasingly dominated representations of the "Caribbean." The combination of local and global factors influenced the widespread representational proliferation of the Caribbean as an undifferentiated space of white sandy beaches dotted by coconut trees. Many beach scenes were not populated by local people. If locals did appear in the beach card universe, they did so primarily as servants to tourists—as waiters, entertainers, or beachboys.

This later phase of postcard production was also subject to local contestation. Just as many critics had tackled the unjust representations of the islands' black inhabitants, Michael Manley's government in Jamaica also attempted to counter the prevailing touristic construction of that island's landscape. In the 1970s under Prime Minister Manley's social democratic government, the Jamaica Tourist Board commenced a "Jamaica: It's more than a beach. It's a country" campaign. The board aimed to assert a national (postcolonial) identity, "a country," and geographic specificity in the face of the representational tyranny of the newest tropical icon—the beach.

Although early twentieth-century postcards also repeated a limited (but not unchanging) formula of tropical signifiers and motifs, they still displayed a far greater degree of specific references to popular sites on individual islands than their contemporary beach-centered counterparts. Perhaps this is why the contemporary postcard books employ images from this earlier golden age of postcard production, with only one exception.[21] The geographically nondescript beach postcards resist historical reclamation in national narratives. If earlier postcards denied and erased social transformation, the later phase of postcards perfected this "process of historical deracination" (Walvin 1992, 208). As historian James Walvin laments in regard to contemporary touristic images of the Caribbean, "These images of a welcoming Caribbean, far removed from life's pressing anxieties, fly in the face not only of the region's own domestic problems but, more directly of concern to Caribbean historians, they seek to deny the historical forces which have shaped the region" (1992, 208). His sentiments are more generally echoed by Peter Osborne, who argues that touristic images on the whole "suck the historical matter out of things, the better to embalm them into myth" (Osborne 2000, 115). In the face of these combined effects of postcard production—"historical deracination" and the denial of societies' postcolonial anxieties—artists have attempted to "return the

cards to their senders," to echo Alloula, to interrogate the very history of the islands' tropical construction in postcards.

In 1990 David Bailey, an artist born in England of Barbadian descent, created a series of photographs entitled *From Britain or Barbados or Both?* about the touristic construction of Barbados through the contemporary postcard (plate 28). One part of the series consisted of 16 photographs of postcards of Barbados arranged on a beach. Bailey was drawn to postcards, in particular, because "they so dominated the islands." The postcard's propagandistic ability to present a very "stylized image" through the "documentary language of photographic realism" also sparked the artist's interest in the form. By using popular postcards already in circulation in his photographs, Bailey practiced what Stuart Hall describes as "transcoding." As Bailey paraphrases, transcoding characterizes a process: when "you can create something new working with the actual imagery you want to overturn itself, it becomes cited in the work itself" (Bailey 2001). Given this interest in transcoding, Bailey chose the postcard as his weapon of representational deconstruction.

By placing postcards of a beach on the beach, by bringing the sign and referent into close proximity, Bailey points to the multiple layers of construction within the visual language of the postcard. The photographer, who positioned and posed the cards on the beach, made the sand, in essence, his photographic studio. He thereby denaturalized the beach as an inherent representation of the islands, emphasizing the seaside as an image factory of sorts, as a space where representations are staged, constructed, manufactured infinitum. Each card added to the exterior beach studio called attention to the micro and macro processes—the wider system of signs and codes—that produce and reproduce these representations. Bailey's own series of photographs added another dimension to his hall of postcard mirrors, forcing viewers to consider the seemingly infinite fragments of the postcard's image world. The photographer also included his hand in some of the photographs, arranging and rearranging the images, which explicitly made the point, "if you don't understand that this is highly constructed, I'm actually positioning these as well" (Bailey 2001). Bailey further emphasizes the constructedness of postcard representations through "displacement and disjuncture," removing them from their more common viewing contexts.[22] In doing so he called attention to the ways that different settings can naturalize and structure the meaning of postcard representations.

Importantly, Bailey created different narratives by arranging and photographing the

postcards in various series. "With the postcards I was interested in how one can build up a narrative, a narration, within that" (Bailey 2001). Bailey composed a series of photographs starting with a single postcard of a "black male with just trunks on in a very exotic pose, staring at the camera. That postcard is centered in the frame of the beach, then there is a buildup of other postcards wherein it is almost hidden within that" (Bailey 2001). The ensuing buildup of postcard representations buried the original image. However, the series can also be read in the reverse direction, starting with the wider sequence and ending in the lone postcard of the male figure. Viewers coming on the series can, of course, enter and leave the narrative of the cards at different points, following their own visual paths through the images, recollecting what they will from the postcards of Barbados. Bailey recalls, "I was thinking about . . . the idea that images are a makeup of signs and codes that can be read and reread and that the way in which you position these signs and codes within the frame could change whatever meanings you could do." Individual viewers of the photographs can participate in or can reactivate this process, reinscribing the islands into their own narratives. The series thus prompts viewers to be aware of the various narrative possibilities of the postcards (at a time when other narrators of the postcard limit the range of interpretation) and to be active participants in their analysis of the images.

Bailey's position as a conductor of the visual arrangement of the images calls attention to his own relationship to these representations. Unlike many black Caribbeans before him, Bailey portrays himself as collector and narrator of a postcard archive. But what purposes do the postcards serve for the photographer? As the title of the series reveals, Bailey turned to the postcards as souvenirs to recollect and piece together his relationship to Barbados, a place he imagined as his "home away from home," as Paul Gilroy puts it in an article about the series (10). The photographer was interested in exploring his feelings of belonging and estrangement from his parents' country of origin (Barbados) versus his country of birth (Britain), his "inescapable feelings of cultural homesickness and homelessness" (Gilroy 10). As a first-generation immigrant, as a part of the Caribbean and African diaspora, he hoped his travels to Barbados would confirm his rootedness to the Caribbean: "you want to identify with Barbadians who are black and who were also in some cases . . . my relatives" (Bailey 2001). The photographer's desired diasporic and familial connection to the island, however, was shattered when he traveled to Barbados and discovered that many black Barbadians (including some family

members) viewed him as an outsider, as British. While metropolitan tourists typically used Caribbean postcards to remember the foreign and exotic, Bailey (who grew up in "the metropole") turned to postcards to contemplate his own "foreign" status within the country he imagined as familiar and familial.

Ironically, Bailey's appearance in Barbados as a photographer (he first had ambitions of creating a documentary series of photographs on the island) contributed to residents' appraisal of him as a foreigner. Many Barbadians, when they spotted him with his camera, viewed him with suspicion, challenging him, as he remembers, "Who I am? What are your intentions? We don't know you" (Bailey 2001). This cold reception (in the land often depicted with postcard smiles) directed at a visitor with a camera is not unique. Julie Pritchard Wright, a filmmaker who shot a documentary in Barbados in 1989, has also described her (sometimes violent) encounters with residents who strongly opposed having their picture taken (Wright 1989, 135–36).[23] Several persons eventually explained to her that many locals were sensitive to the presence of the camera among foreigners, as it was not uncommon for them to find their images suddenly for sale on postcard racks, without remuneration.[24] While Bailey aimed to use his camera to explore his connections to his home away from home, the very presence of the camera, precisely because of the long and contentious history of the postcard (and having pictures taken by tourists), complicated and hindered the process. In order to create a work about his relationship (or lack thereof) to Barbados, Bailey transcoded the very images that structured local people's interactions with others.

Crucially, in Bailey's photographs the occupants of this central icon of Barbados, the beach, are only white tourists. By including their presence, registered in the passing of feet or half bodies that trudge by the makeshift beach studio, Bailey also draws attention to who occupies the space of touristic representations, as well as the physical landscape of the island represented in the cards. While smiling black faces populate the world of postcards, they have no presence on the surrounding beachscape pictured in Bailey's photographs. Conversely, white tourists, not featured in the postcards, solely colonize the landscape of the beach, walking by his postcards. This dichotomy between the placement and configuration of blackness and whiteness in the visual economies of tourism and the subsequent ways that mostly white visitors occupy the physical spaces featured in these representations, points to a central and disturbing trend in tourism in the Caribbean: many of the central sites/sights "fetishized" (to use Bailey's term)

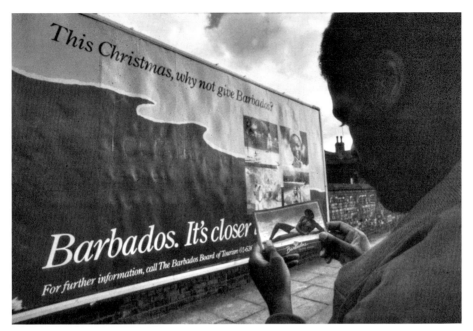

63 Photograph from David Bailey, *From Britain or Barbados or Both?* 1990

in postcards and touristic representations generally have become designated spaces of tourist occupation on the islands, sometimes exclusively so.[25]

Bailey built on the themes explored in the series of postcards on the beach when he encountered a larger-than-life billboard for Barbados in London, which featured, of course, a beach (figure 63). He consequently extended the *From Britain or Barbados or Both?* series, picturing himself holding the central card (of a black man in a bathing suit) from the postcard series in front of the enlarged Barbados seascape. The displacement of the miniature tropical beach postcard next to the gigantic billboard on the backdrop of the metropolitan cityscape underscores the overblown touristic construction of Barbados in the metropole. Bailey's body, only hinted at through a fragmentary hand in the rest of the postcard series, now stands squarely positioned within the picture frame. His full inclusion in the image, staring intently at the postcard version of Barbados, calls attention to the stereotyped and exoticized view of Bailey's own identity prevalent in

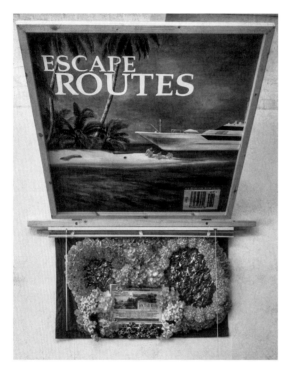

64 Che Lovelace, *Quantity of Pieces Found in a Packet of Cowboys and Indians* (detail), mixed media, 1998

Britain—the rendering of him, the black Barbadian male, as exotic and foreign. Thus in both Britain and Barbados the image of the island constructed in postcards cast Bailey as other. In a major usurpation of his perpetual state of "homelessness" through Caribbean postcard aesthetics, however, Bailey inserts his own presence as the producer of the postcard into the frame of the representation, becoming at once object and subject, viewed and viewer, consumer and producer, and victim and defiant challenger of postcard aesthetics.

Trinidadian artist Che Lovelace, in *Quantity of Pieces Found in a Packet of Cowboys and Indians* (1998), also tackled the larger-than-life touristic representation of the Caribbean—an image he became acutely aware of during an artistic residency in London (figure 64). As part of a series dealing with the history of cross-cultural encounters, Lovelace painted a tourism poster advertising the island—one that featured an obliga-

tory beach and tourists languishing on the landscape—to explore the clichés of the Caribbean that structure tourists' relationship to the islands. He was also interested in how these touristic representations informed local perspectives of the landscape, "how this message became part of the way even Caribbean people thought of their own countries" (Lovelace, quoted in *Newsday*, 22 May 1998, 55). Lovelace's aim was not to expose these tropicalized images as disingenuous but rather to explore the very social processes that transform representations into clichés. Indeed, "instead of avoiding the cliché," the artist sought "to find the truth behind it," precisely how it comes to be seen as truthful, and to "tackle it through ambiguity" (Lovelace 2003).

Several presentation devices used in *Quantity of Pieces Found in a Packet of Cowboys and Indians* involved viewers in the process of image production and, even more so, consumption. Lovelace mounted a painting of a beach on the back of a canvas, explicitly reversing the natural viewing order of art. The stretchers and the back of the canvas remain exposed to view. He also presented the painting in reverse—composing the painting from the poster's mirror image. This again required viewers to read the image backward, to view the deceptively familiar image from a new perspective.

Lovelace further removed the painting from one of the standard orders of viewing representations when he hung the work from the wall at a 45-degree angle by an adjustable chain. The image again refuses easy apprehension; it demands work on the part of the viewer—outside of passive consumption. Spectators could literally become active participants in the viewing process, by manipulating the angle of the poster. Through these devices "the viewer is given control of how you want to balance the elements of the story" (Lovelace 2003).

In addition to inviting viewers to be active participants in the consumption of the image, Lovelace's re-creation of the mass-produced tourism photograph through painting also made viewers aware of the processes of production, the artful workings of the poster's designers. Despite the photographic realism of the touristic poster, its creation was as imaginative as an artist's canvas. A large painted barcode appears on the lower right corner of the painting. The juxtaposition of the painted and the commercially produced, of art and commodity, again emphasized the manufactured image of the island and the wider commodification of the beach.

Lovelace hinged the tourist poster to a shelf, which held a mélange of objects—toy cowboys and Indians appear posed for battle amid a tropicalized garland of plastic

flowers. Advertisements for Trinidadian holiday homes, promising sanctuary for travelers, also appear on the shelf. It seems a vendor's stall of tropicalized commodities—of history rendered in colorful miniature toys, of tropicalized nature replicated in plastic, of the island's landscapes domesticated for tourist consumption. A vertical blind hung in front of the shelf, allows viewers to determine how or whether they visually consume the commodities. Lovelace stresses that he did not intend for the work to be didactic—to prescribe or critique any particular way of seeing the islands. Rather, as evident in the blinds that each viewer could adjust to her or his own unique position, *Quantity of Pieces Found in a Packet of Cowboys and Indians* made viewers aware of "where you are perceiving things from" (Lovelace 2003).

Like Lovelace's shelf of tropicalized commodities, David Smith, an artist originally from England who resided in the Bahamas, has also tackled the construction of the islands as facilitated through the ubiquitous postcard. Starting in the mid-1980s, Smith created a series of paintings that juxtaposed the image world of postcards with the social landscape of the islands. Smith's *Excerpts from the American Dream* (1984), for instance, portrays a partial view of a postcard rack, against a barren and decaying urban landscape (plate 29). Smith appropriates not just the icon of the postcard but its very stylized and glossy visual language to render the cards and the surrounding Bahamian landscape. Behind a postcard rack, which contains a card picturing a white tourist lounging by a beach being served by a black man, Smith provides viewers with a glimpse of the poor social and economic conditions that exist beyond the confines of the postcard's landscape. It visualizes aspects of the islands' environment that the postcard world often denies—a broken old car, a knot of electrical wires, and evidence of black enterprise. His use of a glossy, photorealist postcard style to depict aspects of the landscape that would seldom inhabit the world of postcards underscores the card's select content and its method of construction.

In particular, unlike the image world of Caribbean postcards, which portray the Caribbean as premodern and beyond the reach of Western industrialization, capitalism, and modernity, Smith foregrounds the physical traces of these processes on the islands' landscapes. In contrast to early commercial postcards, which contrasted the tropical islands with the modernity of the United States, Smith pays particular attention to the influence of American capitalism on the islands. In *Excerpts from the American Dream* Smith juxtaposes two American "dreams": the postcard rack offers the dream of pictur-

esque tropicality to (American) tourists, while the American consumer goods (the store advertising Coca-Cola and the American car) offer the dream of modernity, the promised riches of the tourism industry, to local residents. However, these signs of Western capitalism—the rusting Coke sign and the American car up on cinder blocks—all exhibit evidence of decay, suggesting a failed modernity, the unfulfilled dreams of tourism in the islands. The work attests to the intrinsically bound circuits of consumption that interlock modernity and tropicalization on the islands and to how these processes are inextricably related to the selling of the islands' touristic image.

Trinidadian artist Irénée Shaw has also drawn attention to the visual excision of aspects of modernity or any elements that image makers deem blemishes on Trinidad's idyllic image. In 1993 Shaw created the *Gilded Cages* series of paintings aimed at visually recovering aspects of the island frequently airbrushed out of tropicalized landscape representations of Trinidad. In one work, *Neighbourhood* (1992), Shaw presents a view of the island as it appeared from her home, a snapshot of the landscape as framed by her window. Struck by a sense that this accidental vista did not resemble any of the contemporaneous commercial or touristic landscape paintings of Trinidad, Shaw decided to represent this view and to pinpoint the precise elements that marred Trinidad's landscape aesthetics (plate 30). Like a schoolteacher armed with a red pen, Shaw demarcated in red all the elements that "defaced" the scene. She corrected landscape. Anything that violated the ideal of the tropical image appears not erased in the painting but rendered in red pigment. Red electrical lines scar the sky. Red outlines of a box-shaped house haunt the landscape. Similarly, in the painting *Neighbour* (1992) a vagrant appears entangled in a straitjacket of red lines embroidered into the canvas (plate 31). Comparable to chalk drawings surrounding a crime scene, the red lines allow viewers to trace the aspects of the landscape frequently painted over, cropped, or considered unworthy of artistic representation. Shaw reenvisions the tropicalized landscape, inserting aspects of modernity, history, and contemporary society into the visual frame of the island. The red outlines, however, simultaneously highlight these elements and make them transparent, render them present and absent, portray them in a state of representational ambiguity. The paintings, visually wrapped in red threads or lines, also speak to the packaging of the landscape, to its being bound, even imprisoned, in a commodifiable and preordained form. To counter this, Shaw painted in an "unwieldy" format, with canvases measuring as large as 7 feet by 5 feet. In both subject matter and form

Shaw's *Gilded Cages* series defies postcard renderings of the island, presenting a view of Trinidad that transgresses tropicalized representational molds in a size that resists domestication.

Trinidadian artist Christopher Cozier, in *Wait Dorothy Wait* (1991), similarly explores the relationship between representations of the "tropical landscape" and their connection, or lack thereof, to wider Trinidadian society (plate 32). The work comprised a series of small paintings, the size of postcards, which were each a collage of locally available postcards. Cozier used postcard reproductions of artwork by local artists, many of whom painted Trinidad's landscape in an impressionistic style. Although these artists created painted views rather than photographic ones, this newer genre remained faithful to the content of early twentieth-century touristic postcards. Cozier appropriated the postcards and repositioned them in his own composition. He recaptioned the postcards, pairing them with murder headlines from local newspapers; the more shocking the headline, the better. One postcard of an impressionistically rendered coconut tree against an azure blue sky, for example, appears above a journalist's account of a robbery victim's untimely death: "He was shot in the neck as they attempted to steal his car, but was able to outrun the car a short distance. He collapsed and men drove the car over him, brutally killing him." Cozier framed the postcard and the caption in "gaudy" ornate frames, explicitly presenting the mass-produced reproductions as art.

Cozier juxtaposed the headlines and tropical landscape to explore the coexistence of the "notion of the tropical" and "notion of the things that were happening in the society at that time" and how residents make sense of the constitutiveness of these "unrealities" (Cozier 2003). *Wait Dorothy Wait* derived its name from a popular calypso by Black Stalin, in which the calypsonian professes he must postpone the composition of a crowd-pleasing party song, resist the lure of a lime, to confront first the pressing political issues of the day. At the time, new International Monetary Fund policies and the economic recession likely topped the calypsonian's political agenda. In the series Cozier, too, refuses to create a crowd-pleasing visual composition, resisting the lure of the tropical. By interspersing headlines, he interjects the political, societies' urgent pressing issues, into a visual landscape that historically denied and actively suppressed societal discord and change. He implores audiences "to wait," to suspend their visual pleasure found in the familiar recesses of tropical postcard representations, to engage

society's other representational possibilities and political realities. Like Stalin's song, which uses a catchy hook even as he swears off more popular lyrics, Cozier used parts of postcards, many of which local viewers recognized, to critique the limited scope of the genre of tropicalized representations.

Wait Dorothy Wait was a response to images of the islands as they proliferated in North American and European metropoles and locally. The series was the first that Cozier completed when he returned to Trinidad in 1998 after studying in New Jersey. The work is in part about the enigma of arrival in the United States and the resultant hyperawareness of the touristic image of the Caribbean abroad. Cozier recalls that he continuously met people who had bought into the touristic construction of the region, who envied and awed his island home. He grew frustrated with these appraisals of the Caribbean, lamenting that "no sense of the history or the struggles of these locations were conveyed in those conversations" (Cozier 2003). His return to Trinidad furthered this disillusionment. "Touristic" representations also had local currency. "Then you come back here and say okay this is where I'm from. This is what I understand. It [the tropicalized idea of the island] is also articulated from here for various reasons— whether its class warfare or governmental or tourism objectives" (Cozier 2003). The replication of these experiences in the United States and Trinidad brought Cozier to the realization that the image of the island was "owned," parceled to the island's elites, tourist industry promoters, expatriates, and travel writers, and that local people had little currency in this visual economy. Residents were "the last people on the food chain in terms of articulating what this place is about." Cozier wanted to "violate" this convention and "own it." He explains, "It's not that it doesn't exist (it's out there) but you want to give it a meaning that in some way is related to how you experience and understand being from here" (Cozier 2003). He aimed to create work in which his own experiences and that of "ordinary" Trinidadians and their history could be reflected.

One major source of the perpetuation of tropicalized imagery in Trinidad was in paintings produced by artists locally. In 1998, when Cozier returned to Trinidad, the most commercially viable art on the island consisted of "tropical scenes" created in a French postimpressionist style. Cozier dubbed this style and form of painting "Francophony" (*Trinidad and Tobago Review*, July 1991, 22). In Cozier's estimation these paintings counterfeited colonial, touristic, and French Creole (many artists paid representational homage to nineteenth-century French mulatto painter and photographer Jean

Michel Cazabon) ways of seeing the island, newly fertilizing the tropicalized vision of the island. Their work could easily be subject to the same critique that Trinidadian Nobel Laureate V. S. Naipaul made of an earlier generation of Trinidadian artists: local artists had not learned "to see the West Indies for [themselves]." This was evident, Naipaul argued, even in the titles that artists in the Trinidad Art Society (established in 1943) chose to caption their paintings. " 'Tropical Fruit' is the title of one painting, a title which would have had some meaning in the Temperate Zone. Another, startlingly, is 'Native Hut.' There are the usual picturesque native characters and native customs, the vision that of a tourist, at whom most of these paintings seem to be aimed" (Naipaul 1962, 67–68). Naipaul detected that even as these artists purported to be Trinidad's art society, they represented the island through the perspective of the Temperate Zone, the eyes of the tourist. In the 1990s Cozier similarly perceived that many painters in Trinidad viewed the island through "tropical" lenses. While over the decades, from the nationalist movements in the 1940s to an antigovernment coup attempt in the 1990s, the meanings of these paintings changed, many artists represented the island through the visual vocabulary of tropicalization. In *Wait Dorothy Wait* Cozier underscored this recycling and repetition of tropicalized imagery, across the realms of the mass-produced tourist-oriented postcard to locally patronized art. Cozier qualifies that his series aimed not to single out individual artists who produced work in this style per se but to assert the validity, indeed the necessity, of other ways of representing the island. Given the confining strictures of tropicalized representations, Cozier was left to question, "What is my knowledge and experience of the place worth?" *Wait Dorothy Wait* was "an attempt to come to terms with that" (Cozier 2003).

Cozier interspersed headlines in the tropical collages to inject new experiences and narratives into the frame of visual representation on the island. The headlines, which may be thought of as new captions, narrate the postcards with events that "aren't supposed to happen in places like this" (Cozier 2003). The headlines spoke to the pain and suffering of ordinary people in Trinidadian society. Moreover, they encouraged viewers to consider whether the incidents were somehow particularly tragic because they were "an abuse to the image that we hold so dear." In addition, by sprinkling the tropical icons with contemporary news headlines Cozier compelled viewers to reevaluate Caribbean people's relationship to the landscape, historically and in the contemporary

context. Noting that people who inhabit the Caribbean are descendants of slaves or in-dentured laborers transplanted to the island as that very landscape was remade into a commodity through plantations, Cozier emphasized that through the auspices of tour-ism—the most recent commodification of the landscape—contemporary Caribbean people were "also caught up in that arrangement of displacement and reconstruction" (Cozier 2003). Given this historical and contemporary dispossession, how did locals imagine, define, and represent their relationship to the landscape?

Cozier also paired the headlines with the tropical icons because of the link he sus-pected between the rise in local consumption of tropical scenes and the escalation of so-cial and political unrest and violence. This connection seemed evident in the increased patronage of local galleries, which trafficked in tropical representations at moments of social instability. In other words, Cozier viewed the tropical paintings not simply as representations that ignored aspects of contemporary social and political life but as images local patrons actively consumed to ignore social and political strife. Com-parable to contemporary postcard books, which offered representational escape to a picturesque society unblemished by the problems of present-day society, the tropical paintings and their descendants, painted postcards, invited representational retreat to a tropical landscape suspended in the dream of the timeless and unchanging tropics.

In addition, Cozier was aware of how the state, particularly the agencies that en-gaged in tourism promotion, also partook in representational tropicalization following moments of political unrest. After the social unrest in Trinidad in the 1970s, for in-stance, the island's tourism promotion company implored a local photographer, Noel Norton, to create images of a racially harmonious Trinidad, after the social upheavals seemed evidence of racial discord (Norton 2003). In a fashion not dissimilar to early touristic images, such photographs aimed to defuse any notion of threatening racialized subjects. These photographs also provided another instance in which touristic images became representational battlegrounds where societal conflicts over race were manifest in postcolonial Anglophone Caribbean societies. Norton, following the violence of the 1970s, also staged a series of photographs of a white Trinidadian couple, enacting the role of tourists, meandering down a beach in Tobago on a donkey. The image placed the representational spotlight back on the beach, the space that historically washed away any notion of the islands as societies with social problems and political change; on the

island's inhabitants, to quote the photographer, as a "peaceful and happy people"; and on the other "tropical native," the donkey, long a signifier of the island's primordial and premodern innocence (Norton 2003). The photograph seems a willful assertion of the landscape and its inhabitants back into its tropically picturesque ideal when local events evinced anything but a peaceful and happy Trinidad. This persistence of the tropicalized image recalls Nancy Stepan's observations that often photographic representations of "the tropics" "require periodic reinvestment in times of change and challenge, moments of representational instability, when an accepted mode of seeing the tropics is contested and representation revealed for what it is (namely, a representation that is by definition only partial)" (Stepan 2001, 21). In the face of the political unrest the state reinvested in the island's unchanging tropical image, as if slotting familiar tropical images into tourists' and residents' purview would permanently blind them to the surrounding social environment. Cozier's *Wait Dorothy Wait* insisted on making the tropical landscape coexist with, to recall Walvin, "societies' pressing domestic problems." By requiring viewers to come to terms with the tropical image's partiality, it served precisely to trigger representational instability.

Cozier continued to dissect this theme of the local and political uses of tropical representations in postindependence Trinidad in his later Cultural Autopsy series. One piece in the larger body of work, *Three Stains on Paper*, consists, in part, of three postcard-sized watercolor paintings (plates 33, 34, and 35). Two of the paintings offer versions of the "Francophony" tropical genre—one of a clapboard house and another of a market woman. Flags, however, crown each painting, claiming the tropical images as national possessions. These representations buttress another watercolor depicting local authorities brutalizing a local man. Like the headlines in *Wait Dorothy Wait*, the representation of state-sanctioned violence not only compelled viewers to apprehend images of "idyllic pastoral landscapes" alongside those of an urban dystopia but pointed to the relationship between these seemingly oppositional sides of the island's representational coin. All three miniature paintings bleed into the surrounding white paper, simultaneously suggesting streams of pigment and drips of blood. As Cozier puts its, "By juxtaposing these perpetual assertions of our alleged 'true identity' with images that imply state violence against the 'ungrateful' who threatened the stability of our newly founded nations, I find myself wondering about the complicity of artistic repre-

sentation (as a form of nation building or cultural-production) with the maintenance of order" (Cozier 2003). Were the images long complicit in the ordering of the colonial regime now complicit with the maintenance of the postcolonial nation?

In keeping with the history of using captions as written appendages to tropical representations, each image in *Three Stains on Paper* is accompanied by a handwritten penciled title. They read respectively, "I am rendered speechless by your Vision," "I am rendered speechless by your reactions," "I am rendered speechless by your idea of beauty." In the work Cozier makes reference to what can be viewed as a history of subaltern "speechlessness" and astonishment in the face of colonial and postcolonial representations of the tropics.

As traced throughout this chapter, tropicalized West Indies postcards have contributed historically to what can be described as subaltern silences. While the postcard inherently provided a space for the contestation of the tropical image and provoked critical responses from blacks across classes, few blacks (or Indians) left their own captions, their personalization of the representations, on the visual archive. I use silences here to point not simply to absences of subaltern voices in postcard archives but, returning to Trouillot, to *the production of silences*. As the historian poignantly articulates: "By silences I mean an active and transitive process: one silences a fact or an individual as a silencer silences a gun" (Trouillot 1995, 48). Early postcards did not just evade subaltern narratives; they also produced silences. In more recent times the postcolonial uses of postcards have added to this history of the production of speechlessness but with a twist. Many picture books and historical accounts, by using the postcards as objective reflections of the past, attribute "speech" to the subaltern and narrate histories of the black past using sources blacks never authored. These accounts silence the voices that protested that postcards were not representative of the black race or "the country" behind the tropical landscape. Cozier points out that in addition to silencing speech, tropicalized representations impair vision. Even at the beginning of the twenty-first century newer visions of tropical beauty in the Caribbean and abroad continue to censure and censor the artistic expressions of Caribbean artists, making it difficult for them to leave the signature of their own unique experiences on the image world of the islands. In the face of these historical and visual silences Bailey, Lovelace, Smith, Shaw, and Cozier create work about the production of these silences. Indeed, Cozier attaches

captions about speechlessness to his paintings. Unlike predecessors who critiqued postcard representations of the island, however, the artists in different ways explicitly leave their handwriting, commentaries on the historic silences of the postcard on the postcard archive. They implore viewers to consider, approximately 100 years after the touristic tropicalization of the islands, "for whom are these images now made?"

TROPICAL FUTURES
Civilizing Citizens and Uncivilizing Tourists

These beaches are up for grabs. The tourists say they own them. They are the ultimate frontier, visible evidence of our past wanderings and our present distress.

Edouard Glissant, *Caribbean Discourse*, 1989

But on our tourist brochures the Caribbean is a blue pool into which the republic dangles the extended foot of Florida as inflated rubber islands bob and drinks with umbrellas float toward her on a raft. This is how the islands, from the shame of necessity, sell themselves; this is the seasonal erosion of their identity, that high pitched repetition of the same images of service that cannot distinguish one island from the other, with the future of polluted marinas, land deals negotiated by ministers, and all of this conducted to music at Happy Hour and the rictus of a smile.

Derek Walcott, *The Antilles*, 1995

The visual vocabulary of the Anglophone Caribbean first enunciated at the end of the nineteenth century continues to color representations of the islands. A contemporary postcard of Jamaica, captioned "Colours of Jamaica," reveals an assemblage of many of the prevailing tropes of tropicality examined throughout this book (plate 36). A black man and woman, whose headscarf recalls the figure of the market woman, appear in the postcard holding tropical fruit—the banana and papaya. The primary visual signifiers and export commodities of the New Jamaica—associated with American enterprise, British civilization, and local modernity—remain central to the postcard's commodity form. The black figures appear on the more recent photographic backdrop of the beach—a mid-twentieth-century addition to the cast of tropicality. Both models, whose faces we cannot see, look toward the sea. The woman's gaze recalls the very act of looking at the beach as a commodity. The black male's de-

capitated body (continuing a reluctance to photograph black men) becomes another object for visual and sexual consumption, as implied by the yellow bananas he tenders near his shimmering silver-trunked buttocks. The open papaya the black woman rests on her thighs provides another unsubtle signifier of available sexuality, another instance of representing black female sexuality through nature. The caption of the image aestheticizes all the elements in the photograph, framing them uniformly as the "Colours of Jamaica." The postcard may indeed be viewed as the colors on a century-old palette, a palette (with a limited visual spectrum) to which image makers have repeatedly returned to paint the Anglophone Caribbean since the late nineteenth century. While certainly the precise iconic combinations of tropicality have changed in contemporary times (the postcard makes overt sexuality much more blatant than in earlier representations, for instance), as have the producers and consumers of these representations, the underlying commodity status of the land and seascape, its products, and its people seem even more pronounced in the postcolonial era.

Although much of this book has been devoted specifically to examining the changing repertoire of visual tropes used to image Jamaica and the Bahamas in the colonial era, it provides a glossary of sorts for understanding the visual grammar of representations that continue to configure (or disfigure) practically the entire Anglophone Caribbean in the postcolonial period. The book's focus on the tropicalization of the islands in the first half of the twentieth century affords, in the words of anthropologist David Scott, "a form of description of the modern colonial past that enables us to appreciate more deeply the contours of the historical present we inhabit, and to appreciate it in such a way as to enlarge the possibility of reshaping it" (Scott 1999, 17). Indeed, as many island nations have come to invest in tourism more so than any other industry in the "historical present," these icons and attendant myths of the Anglophone Caribbean have gained even greater international currency and visibility. The tourism trade, which is still largely based on marketing stock tropes of tropicality, accounts for approximately 70 percent of the gross national product of many islands in the English-speaking Caribbean. How has tropicality been manifest, in familiar and new forms, in contemporary times? How have new visual technologies and multinational campaigns changed the landscape of tropicality? How have postcolonial governments' resuscitation of images of picturesque tropicality—tied as they were (and are) to colonial, imperial, touristic, and racist visions of the islands—been reconciled with the stated objectives of decolo-

nization and nation building in the postindependence era? Given the long-standing connection between the aesthetics of tourism and the politics of the colonial state, how have the continued stakes in maintaining the islands' tropical yet civilized image informed social discipline and physical space in the postcolony? Can contemporary independent governments strategically reemploy and reinvent tropical tropes in their efforts to attain political sovereignty and economic autonomy?

While these issues clearly merit another book-length consideration, I hope that I have provided a backdrop through which such urgent questions can be historically considered and reevaluated. By shedding light on the confining wall of these representations and their political reverberations, I aim to add my voice to the long-standing local critiques of these representations and their implications on race, social space, and visual imaginary, perspectives increasingly silenced in the pan-Caribbean siren calls to tourism promotion. Such a history will hopefully provide another countervailing perspective to much of the locally produced touristic discourse, which is invested in a willful forgetting, a repackaging of slavery and colonial rule as ideal periods in the islands' history (and a severing of the connections between tourism, colonialism, and racism). I will conclude with a few impressions on contemporary manifestations of tropicalization drawn from across the Anglophone Caribbean, impressions that point to the complexities and ambiguities of tourism in the present.

Flipping through a popular news magazine in 2004, I was surprised to see the underlying trope of early twentieth-century tourism in the Anglophone Caribbean and the Atlantic islands (as Bermuda and the Bahamas were sometimes called)—the idea that the island was civilized—as the unabashed byline of an advertisement for Bermuda. Underneath a collage, which included tropical flowers, lapping seascapes, and ancient ships, tourists were invited to "retrace 400 years of civilisation." The Bermuda Department of Tourism ad went on to cite the island's British credentials, its high teas and British manners, as part of its civilized inheritance. While such an advertisement is not surprising, coming from an island that is still a British colony (with a locally elected parliamentary government), the fact that the ruling black majority government would choose to employ language that seems in keeping with the assurances of missionary photographers, tourism promoters, and the colonial government from a century earlier deserves consideration. Was it ironic that a local government on a Caribbean island, long on the receiving end of British civilizing projects, now advertised this quality as the island's de-

fining feature, its touristic virtue? Were they simultaneously implying that a trip to the island would civilize visitors, claiming to perform the reformatory role the metropole once claimed?

Although the Bermuda advertisements stressed Britishness, they simultaneously dressed British civilization in tropical drag. Aimed at visitors with annual incomes exceeding $125,000, their campaigns marketed "high tea in a bikini" and "the charm and manners of the British, with a propensity to get down," combining icons of British civility with a tropical propensity to misbehave. In other words, the campaign mixed the long-standing representational cocktail of picturesque tropicality used to image the Anglophone Caribbean and the Atlantic islands with a new twist, emphasizing the island as a space of touristic behavioral transformation.

In a contemporaneous campaign the Bahamas' Ministry of Tourism also updated its century-old tropical picturesque image, advertising the islands of the Bahamas as sites that "could change you forever." One advertisement pictures the Junkanoo parade, the icon of the picturesque Bahamian black since the late 1930s (plate 37). While in the past the very process of photographing a masquerader served as visual testament to the Bahamian blacks' civilization, the advertisement, which pictures a Junkanoo participant embracing a tourist, also documents the visitors' behavioral change. As the text on the advertisement tells us, the young woman's experience in the islands had transformed her from a "wallflower," who was "taking a public speaking course . . . by correspondence," into a songbird, who "just sang 'Who Let the Dogs Out?' in front of 3,000 people." Indeed through the impromptu performance the tourist unleashed her own inhibitions, her primal and carnal (or canine) nature. The accompanying image, which pictures the tourist in a makeshift Junkanoo costume and wearing a frozen smile for the camera, adds visual confirmation to her physical and psychological transformation. Since the 1930s tourists have frequently inhabited photographs of the islands, but this image of cultural cross-dressing (donning "native costume") seems to testify to a shift in marketing the Bahamas, a transition from imaging blacks as civilized subjects to presenting tourists as "uncivilized" ones or as inculcated into the doctrines of "native" festive culture. The photograph records, evinces, and participates in the transformation of native and tourist in the contact zone of cross-cultural encounter. While this marketing of the exotic touristic experience within the islands is not new or unique, the advertisement does make a more ambitious claim than earlier forms of tourism pro-

motion. It purports, in a reversal of the logic of civilizing campaigns, that travelers to the island will be "changed forever," that their experiences in the Bahamas will forever transform and reform the tourist on their return. In sum, they position the islands as the nexus of behavioral virtue, of the (un)civilization of touristic subjects.

Through multinational corporations the tropical experience with its attendant transformatory qualities is not restricted to island travelers but is purchasable through a range of commodities. In 1991, for instance, an American company started producing a clothing and furnishing line, christened Tommy Bahama, based on a tropical theme. All the signifiers of Caribbean islands' commodification from the days of the sugar plantation to "tourist transplantation," to use Supriya Nair's term, form the motifs of the clothing line (Nair 1996, 72). While tropical signifiers—such as the royal palm—inform the visual lexicon of many products, Tommy Bahama is particularly interesting in its marketing not only of clothing but of a tropical lifestyle; the company advertises Tommy Bahama as "the purveyor of Island Lifestyles." The corporation's Web site provides an instruction manual for tropical living. "Live the island style everyday," the company beckons.[1] A drop-down menu provides links on everything from how to dress in a tropical fashion to how to make tropical drinks and decorate for a "paradise-inspired party." They recommend, unsurprisingly, placing "greenery, preferable [*sic*] palm fronds or banana leaves, beneath plates and bowls." Just the arrangement of these icons of tropicality, the Web site prompts, would transform any space in the (Internet-accessible) world into a conduit of tropical hedonism, into a "paradise nation." Tommy Bahama indeed seems a contemporary testament to the power of the earliest tourism promoters and their efforts to attach the island to the idea of tropicality in order to inspire travelers to seek out their tropical dreams by venturing to the island. Now by simply attaching "Bahama" to a brand, the company could persuade customers to go virtually native, to fulfill their tropical dreams without leaving home.

No tropical environment or tropical experience would be complete without photographs. The Tommy Bahama site includes an "Island Photo Album," where it invites virtual tropical sojourners to submit photographs of their paradise-themed parties. Although they do not include a camera, long the accoutrement of the tropical traveler, under the site's tropical accessories, they may well have. The process of taking a photograph allows Tommy Bahama acolytes to create souvenirs and evidence of their tropical living. Moreover, as photographs historically did in the Bahamas, they play an intrinsic

part in marking the photographed space and its inhabitants as transformed: as living the tropical dream.

While these government-sponsored and multinational campaigns testify to the resilience of tropes of tropicality and their associations with a tropical *art de vivre*, what are the effects of this continued investment in tropicality on Caribbean postcolonies? If in the colonial era the logic of maintaining picturesqueness informed the rhetoric and politics of governmentality (especially along the lines of race), as majority black postcolonial governments still tout the tropes of civilization and orderly behavior (or a combination of Anglophile hedonism), how do such images continue to inform "the conduct of conduct"? Revealingly, in most Anglophone Caribbean societies in addition to advertising tourism abroad, local authorities also invest in internal tourism campaigns. These initiatives do not aim to encourage domestic travel but to instill a civic sense of the importance of tourism in all sectors of society. While these campaigns vary across islands, their underlying message remains the same: they urge residents to govern themselves, to behave in ways that facilitate the tourism industry. One such campaign in Dominica in the 1980s called on citizens to "SMILE. You are a walking tourist attraction" (Pattullo 1996, 62). By smiling, residents could be camera-ready attractions. Their nonthreatening smiling faces embodied signs of welcome, offering constant assurance to tourists of the friendliness of the natives. In 1994 Barbados's Information Service similarly inculcated residents with "Tourism and You" television spots that stressed the mantra, "We need all the tourists we can get. . . . If they come and talk with you in the streets . . . make them feel at home" (Pattullo 1996, 71). These measures have also taken the form of educational programs in primary and high schools (Taylor 1993, 176), the establishment of "hotel training" schools (177), and less formal courses where, as one "graduate" of a Barbados program put it, "they told us how to behave to tourists and how to dress nice" (quoted in Pattullo 1996, 60). Many governments support such campaigns to bolster their respective tourism industries in a very competitive, "we need all the tourists we can get," market.

These schemes, however, which "educate" the public on how to dress and behave "nice," exact subtle forms of behavioral controls on the level of the individual. "Tourism matters to you," the campaigns reprimand, pointing a commanding finger at every citizen. Or more correctly, they direct these ads and training programs toward the working classes, as the bus drivers and market women who figure prominently in these cam-

paigns attest. Certainly it is not unique or unusual for governments to attempt to mold its citizenry or to encourage economic development. What does seem peculiar is how much governments use tourism to shape the idea of civic duty (even citizenry) and to rationalize the exertion of state control. Do these measures, refracted through the economic logic of tourism development, provide governments with a means to control the "fragments of nation," more specifically, classes that may not wholeheartedly subscribe to the national project as defined by the state (Chatterjee 1993)? The rhetoric "tourism matters to us all," for instance, attempts not just to illicit smiles but also to mask the grimaces of unionists fighting for higher wages (across industries), to silence voices of opposition to proposed land deals, and to commodify culture against the desires of culture bearers.

Perhaps one of the most explicit examples of the connection between tourism and state-authored social and spatial controls was the Jamaican government's decision in the early 1990s to employ soldiers in popular resort areas of the island to protect tourists and police natives. The use of soldiers may be viewed as a practical measure to shield tourists from crime and harassment, two threats to the island's travel industry. The militarization of the spaces of tourist occupation also made the disciplinary character of the island's tourism industry explicit: as obvious as armed soldiers walking among bikinied tourists. In contrast to the internal campaigns that encouraged self-regulation, the soldiers enforced, with the threat of deadly violence, how to behave toward tourists.

The controversial policy was caricatured in a cartoon published in the *Jamaica Gleaner*. "Come to Jamaica and feel secure" assures a billboard in the center of the image, as a heavily armed soldier looms out of its surface into the wider landscape (figure 65). The familiar tropes of the touristic landscape, a coconut palm and sun, occupy a position at the margins of the image; the island's primary touristic trope is security. The cartoon spoofs a contemporaneous advertising campaign that advertised Jamaica on television against the Bob Marley reggae sound track "One Love." "Come to Jamaica and feel alright," beckoned the song's melodious refrain. Marley's universal appeal to one love, his famed counterhegemonic antiestablishment critique (which precisely fueled his commodification by multinational companies), and celebration of Rastafari and African roots made the song a perfect chorus of touristic beckoning and welcoming (Alleyne 1999). It could appeal variously to seekers of the universal through local travel, the culture of countercultures, and the authenticity of black expressive

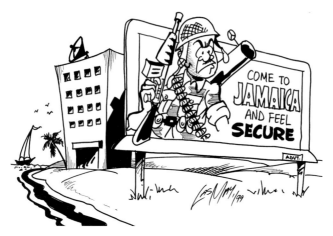

65 Las May, "Come to Jamaica and Feel Secure," editorial cartoon, January 1999

forms. Despite the ode to "feeling allllright," the cartoonist proposes a more apt voice-over for the island's tourism campaign: "Come to Jamaica and feel secure." The image also pokes fun at tourists who might have harbored Marley-inspired expectations of the island only to find themselves unexpectedly in a militarized zone when they arrive in Jamaica. The billboard's guarantees of touristic safety, however, have historical precedents in early twentieth-century photographs of police and prisoners; tourism was long based on images of and the presence of law enforcers. While contemporary governments face a very different set of social and political challenges and deploy soldiers to reach a different set of political and economic goals from their colonial predecessors, they similarly use tourism as a means to impose and justify the imposition of social controls.

Governments also increasingly direct state resources to the protection and pleasure of tourists frequently to the neglect and exclusion of communities outside the tropical tourist bubble (Judd 1999). The recent growth of all-inclusive hotels (a concept born in Jamaica), which locals and nonguests are not allowed to enter, also seems the culmination of another trend analyzed throughout this book, namely that the islands' landscapes have become increasingly created or controlled to make them safe, inhabitable, and desirable for tourists, not locals. The investment in the maintenance of "safe spaces" for tourist occupation to the exclusion of the local population has continued in the post-

colonial era. Taylor observes this trend in the resort town of Montego Bay: "It was the local person who felt like an alien rather than the holiday maker from abroad, for blacks were not welcome in the principal establishments in Montego Bay and its environs" (Taylor 1993, 175). These exclusionary practices are perhaps most evident on the islands' beaches. Signs reserving beaches for tourists are planted in many parts of the Caribbean. Calypsonian the Mighty Pep immortalized the social battles being waged over beach space in a calypso called "Alien." In the song he decries the all-inclusive hotels that were buying "up every strip of beach, every treasured spot they reach," ostensibly making local inhabitants "like an alien in we own land" (quoted in Pattullo 1996, 82). The struggles over beach space dramatically underscore the ways in which the tourist trade resulted in a landscape where some local inhabitants became foreigners, indeed, aliens "in we own land."

I should stress that despite the state's efforts to use tourism matters to impose social controls, as with any state attempt to wield power, the islands' inhabitants negotiate, and frequently negate, the authorities' initiatives in their everyday lives. The Jamaican government's decision to use soldiers to defend tourists demonstrates their own acknowledgment that their internal campaigns had failed to produce the desired behavior on the part of some citizens. Local people in efforts to fulfill their own personal, economic, and social needs routinely violate the prescribed codes of acceptable conduct, from aggressively peddling their goods to robbing tourists of their possessions. A series of holdups of tourists on tours of plantations in Jamaica in the late 1990s evince a local usurpation, a literal hijacking, of the state's marketing of tourism, based on nostalgia for the plantation era of black servitude and an assurance of security in a soldier-enforced environment.

Most everyday forms of negotiation do not take such dramatic forms but involve residents who view tourism practically as a job, as a means to a self-empowering end. Moreover, local residents have also capitalized on governments' obsession with tourism to garner state funds in support of their personal or communal causes. The Junkanoo groups in the Bahamas routinely command, and receive, financial support from the government by beating the tourism drum. As one Junkanooer designer astutely pointed out, tourists do not factor in the preparation for or even assume a noticeable presence at the celebrations (Beadle 2000). These social organizations, which also act as burial societies, however, can capitalize on the perception that Junkanoo simulates tourism.

The touristic and global interest in Rastafari, the group at the heart of the island's "feel all right" image, has given this historically marginalized group an increased cultural status within the island. This community moved from the role of "social outcasts," who in the past authorities routinely and even violently attempted to remove from "sanitized tourist zones," to the arbitrators of "national culture" in part because of the tourism trade (Edmonds 2003, 81). Indeed, the colors red, gold, and green, associated with Rastafari have become the cultural property of a global marketplace. In 2004 the multinational companies Roots, Gucci, Puma, and Christian Dior capitalized on the trademark Rastafarian colors for their brands. The global currency (or hegemonic appropriation of a counterhegemonic culture) of red, gold, and green, in turn fueled tourist travel to the island (Wong 2004). While most of this profiteering enriched the coffers of multinational corporations and the islands' tourism industry benefactors, Marley's estate (which runs a local museum), musicians, and various local merchants, from street vendors to rent-a-dreds, have undoubtedly benefited from this global exposure. In short, groups can use tourism as their own form of social and economic leverage within and beyond the nation-state.

In sum, it would be wrong to interpret the story of tourism told here as one of oppression. A perception that tourism colors all aspects of society would flatten the island nations of the Anglophone Caribbean through a new set of Claude Glasses, another vision (or blindness) that refuses to see the complexities of Caribbean society. Indeed, the sketch of contemporary tropicalization provided here evinces not a singular history of oppression or resistance but, more ambiguously and perhaps optimistically, a tale of practical survival. Walcott hints at this in his appraisal that the islands "out of the shame of necessity . . . sell themselves." The Nobel laureate places "necessity" at the heart of what he deemed the islands' "seasonal erosion." Is it possible and even useful, however, to also view the "high-pitched repetition" of tropical tropes not as shameful but tactful, as a strategic means to meet economic needs or necessities? In other words, in a world that "underdeveloped" the Anglophone Caribbean, tropicalization in the contemporary Caribbean may be viewed as a strategy employed by postcolonial governments to capitalize precisely on the "overdeveloped" world's dreams of tropicality to realize their own national dreams and global aspirations.

NOTES

1 I interviewed One Love in St. Thomas in May 2001. When I asked him where he got the idea
 to make his living in this way, he responded that "Jah" (the Creator) had inspired him through
 a dream (One Love 2001).

2 Generally, "kissing teeth" or "sucking teeth" refers to a sound made when air is drawn through
 the teeth in contempt (Holm 1982).

3 In the nineteenth century, potentially fatal diseases like malaria and yellow fever were not so
 much associated with mosquitoes or infections, as they were viewed as maladies of tropical
 landscapes (Redfield 2000, 193). On the association of the West Indies with death and disease,
 see Curtin 1989; Arnold 2000; Stepan 2001.

4 Cuba, along with Jamaica and the Bahamas, began to pursue a tourism industry in the 1890s.
 The War for Independence on the island, however, interrupted the development of the in-
 dustry in Cuba at the turn of the twentieth century. For more on the beginnings of tourism
 across the Caribbean consult Taylor 1993; Pérez 1999; Rosa 2001.

5 Aparicio and Chávez-Silverman (1997, 1) use the term *tropicalizations* in their edited volume
 of the same name to characterize "the system of ideological fictions with which the domi-
 nant (Anglo and European) cultures trope Latin American and U.S. Latino/a identities and
 cultures" and to refer to the transcultural exchange between Europe and the United States
 and Latin cultures and peoples. Although they focus on Latin American and Latino/a cul-
 tures in the United States, Aparicio and Chávez-Silverman recognize that the Caribbean
 was also "overdetermined" by tropicalization. The meaning I attribute to tropicalization also
 draws on Michael Dash's (1998, 21–42) discussion of "tropicality." Dash calls attention to the
 tropes—the basic units of discourse—used to invent the ideal of the tropics. Quoting Hay-
 den White, Dash explains, that "tropics is the process by which all discourse constitutes the
 objects which it pretends only to describe realistically and to analyze objectively" (26). This
 characterization is especially pertinent to this investigation of photographic tropes of tropi-
 cality, which tourism promoters purported to be realistic representations of the islands when
 ideals of the tropics had long transformed, indeed constituted, the environment featured in
 the photographs.

6 For further elaborations on the creation of the idea of "tropical nature" see Grove 1995;
 Stepan 2001; Casid 2005; Tobin 2004.

7 Most official agencies for tourism promotion assumed that would-be travelers were white. In
 the 1950s local blacks publicly appealed to tourism promoters to extend advertising to black
 clienteles. M. J. Thompson, a letter writer to the *Tribune* newspaper in the Bahamas, for ex-
 ample, complained in 1952: "Despite many humble requests the Development Board still re-

fuses to advertise in Negro periodicals abroad. The Board, it seems, does not want Negro tourists to come here. Others do however. A dollar is a dollar no matter from which quarter it comes" (*TR*, 14 May 1952).

8 Exhibitions occurred usually at one of four venues: the Colonial Studio (in the Hotel Colonial), the Nassau Art Centre, the Arts and Crafts Exhibition (an annual event sponsored by the governor), or at Fred Armbrister's Studio and Gallery. Below are the names of artists and photographers who held art exhibitions of their locally produced work, with the year(s) of their shows in parentheses: Miss L. K. Strombow (1893); Mr. Elmer J. Reade (1900–1930s); Mrs. Meeres (1908); Mr. Edward Trumball (1923); Mr. Karl Straub (1909); Mr. Prosper Senat (1911); Mr. Samuel F. O. Leary (1911); Mr. Howard F. Howard (1913–14); Miss Margaret Redmond (1921); Mr. George H. Clements (1922); Mr. Hart L. Woodcock (1922); Rev. Fr. and Mrs. Dequency (1924); Mr. Edward King (1927); Miss Jean M. Turtle (1924); Mr. Gordon Bazeley (1927–28); Mr. Theyne Lee-Elliott (1935); Mrs. Stratton (1935); Mr. Kenneth Thompson (1935); Mr. Ford Copper (1935); Mrs. Cruishank (1935); Mr. George Pearse Ennis (1935); Mr. Lee Elliott (1935); Mr. Louis Agassiz Fuertes (1937); Mr. Frederick Soldwedel (1930–40); Mrs. Vera White (1936); Mr. Colton of New York (1930); Mr. William Holmes (1940); Miss Betty Barclay (1940); Mr. John DeGroot (1940); Mrs. Albertson Wooley (1940); Mrs. Marshall Clarke (1941); Mr. William Henry (1940); Miss Helena Sturter[v]ant (1934); Miss Anne Harcourt (1939); Mr. Russell Iredell (1939); Mrs. W. Green (1940); Mr. E. A. Roure (1940); Mr. Frederic Wykes (1939).

9 This body of literature is vast. For work especially pertinent to the development of this project see the following: on the Orient (Said 1978, 1994; Lowe 1991; Mitchell 1988); Africa (Mudimbe 1994; Coombes 1994); India (Mitter 1977; Guha and Spivak 1988; Inden 1990); and the Caribbean and the Americas (Hulme 1986; Dash 1988, 1998; Greenblatt 1991; Sheller 2003). For materials on visual culture in particular, see Nochlin 1983; Smith 1969; Alloula 1986; Nederveen 1992; Lutz and Collins 1993; Mitchell 1994; MacKenzie 1995; McClintock 1995; Lewis 1996; Poole 1997; Ryan 1997; Codell and Macleod 1998; Geary and Webb 1998; Tobin 1999.

10 These observations are particularly insightful given the discourses that surround tourism in the Caribbean, which tend to rely on binaristic understandings of space. Many scholars argue that tourism created an illusory facade and touristic stage set when compared to the "reality" of life for the majority of the islands' inhabitants (Balink 1948; Floyd 1974; Strachan 2002). They subsequently set out to expose the "paradise myth" as unreal. Such dismissals, however, fail to explore how the socioeconomic machinery of tourism, lubricated by the "paradise myth," has become embedded in a local understanding of what Lefebvre (1991) describes as the "social space" of the landscape and society. For a critique of such perspectives see Levinson 1997.

11 For instance, photographer F. S. Armbrister's images for the Bahama Court at the British

Empire Exhibition at Wembley were first put on public exhibition at his studio (*NG*, 25 March 1924).

12 These "representative men" included British governor Sir Augustus Hemming, Mr. C. E. Demercado, Lt. Col. Ward, Mr. John Macdonald, Mr. Oscar Marescaux, Hon. Dr. Johnston, Mr. W. H. Johnson, His Grace the Archbishop of the West Indies, Hon. George Solohon, Hon. T. L. Roxburgh, J. W. Middleton, Mr. Robert Craig, and Mr. A. H. Rowley.

13 As Polly Pattullo explains in her well-researched analysis of tourism in the contemporary Caribbean, "by the 1990s, all Caribbean territories were in the tourism business, as the politicians proclaimed it 'the engine of growth.' An image of movement and acceleration, of power and prosperity had been touted to launch Caribbean peoples into 'development' and 'modernism' out of their poverty on the periphery of the world" (1996, 5). This widespread regional investment in the tourism industry has few parallels elsewhere. Head of the Caribbean Tourism Organization, Jean Holder, recognizes that "what is unique about the Caribbean is that it is more dependent on tourism than any other part of the world" (Holder, quoted in Pattullo, 12).

14 The white business oligarchy in the Bahamas, known locally as the "Bay Street Boys," had vehemently opposed the idea of racial desegregation, stating that such a social policy would negatively impact the tourism industry on which the colony was economically dependent. In 1953 the House of Commons in Britain censured the racial segregation that existed in the Bahamas (and Bermuda), accusing local authorities of "pandering to intolerance . . . by arguing that the colour bar was essential to the [American] dollar tourist trade" (*DE*, 17 December 1953).

15 A British anthropologist and photographer, Harry Johnston, complained that the Maroons of northeastern Jamaica were "insolent and disobliging, and inclined to levy blackmail on any one who passed through their villages or plantations and wished to photograph the scenery" (Johnston 1910, 279).

16 The literature on what can be described as the politics of the picturesque in painting is extensive and will be summarized in chapter 1. Some of the major scholarly contributions to the field include Berger 1972; Barrell 1980; Solkin 1982; Cosgrove 1984; Bermingham 1986; Cosgrove and Daniels 1988; Daniels 1993; Taylor 1994; Helsinger 1997; Rosenthal, Payne, and Wilcox 1997.

17 Claude Lorrain so profoundly influenced how Britons viewed the countryside that optical devices dubbed "Claude Glasses" became an important visual accoutrement to the British picturesque tour. Purportedly devised by Lorrain, the black convex glasses made landscapes appear in miniature, with details merged and color muted, and rendered any environment like a Claude landscape (Mayer 1969).

18 For another consideration of how British pictorial models changed in the colonial context see Bunn 1994.

19 Several scholars have started to do important new work in the field of Anglo Caribbean art history and visual culture, namely Poupeye 1998; Tobin 1999; Mohammed 2001; Casid 2002, 2005; and Dacres 2004. See also Cozier and Paul 1999 and Paul and Thompson 2004.

20 The popular use of travelers' or colonial representations as the cover illustrations of historical texts on the region, without any kind of contextualization, is an example of this unproblematized use of visual representations as "objective" documents in Caribbean studies (Cummins 1998).

21 Mittelholzer drew on his own experience as an aspiring artist to delineate the limited scope of the travelers' notions and representations of the region. Mittelholzer recalls presenting a Canadian traveler with his paintings of town scenes in New Amsterdam, Guiana, who flatly told him they were not tropical-looking enough. The unsatisfied patron explained, "You see, what I thought you were going to do was something with native huts—grass-roofed huts and palms and jungle trees. Something really *native*! That's what I want! *That's* what I'm after!" (1958, 9).

22 In 1958 journalist Eugene Dupuch tabled the first antisegregation paper in the House of Assembly, which called for an end to race discrimination in hotels.

23 A sampling of literature on the manipulation of colonial photographs and postcards includes Webb 1995; Ryan 1997; Prochaska 1991; Geary and Webb 1998.

CHAPTER ONE / FRAMING "THE NEW JAMAICA"

1 One album is in the David Boxer Collection of Jamaican Photography in Kingston, Jamaica, and another at the Institute of Commonwealth Studies in London, England.

2 These terms, "The New Jamaica" and "Awakened Jamaica," appear repeatedly in newspaper accounts, books, and articles from this period. According to the *Daily Gleaner*: "The 'New Jamaica' dates in popular estimation, from 27th January, 1891. It was the Exhibition which first brought the colony to the notice of the modern world, and since that date there has been a constant accession of interest in the island. There have been internal troubles, almost approaching chaos, but these have not hindered the general upward movement. Jamaica is a very different place now to what it was in 1891. Newcomers can scarcely appreciate the improvement, but 'old time' residents (who are not crooked in mind) can do so and are thankful for change" (*DG*, 27 January 1891).

3 For local articles on tourism and the anticipated increase in land acquisition and white settlement, see *DG*, 4 January 1899; and *DG*, 11 December 1903. See also Governor Blake's "The Awakening of Jamaica": "The object of this paper is to show that here, amid all the loveliness of which Nature is so lavish, is ample room for immigration of the proper kind . . . young men well born and well educated." Blake goes on to state, "I should not advise the advent of white agriculturists except in communities, on such a scale that the colonists would find themselves

a part of a homogeneous society, with a sufficient number of white neighbours to form their own social public opinion and standard of morals" (Blake 1890, 543). I. N. Ford (1893) reiterates this point: "Blake . . . had the right aim in view in making the resources of the island better known abroad, in order to attract a fresh supply of white blood" (249).

4 In 1870 sugar had contributed 44.5 percent to agricultural exports. By 1900 it had fallen to 10.8 percent. The number of estates declined from 316 in 1867 to 122 in 1900.

5 For more on how Scott's novels helped to make certain sites in Scotland popular tourist destinations see Reed 1980; Gold and Gold 1995.

6 While the precise inventor of the magic lantern is unknown, Athanasius Kircher, a Jesuit priest working in Germany in the mid-seventeenth century, provides the first written description of the optical device. Composed of an oil lamp, a lens, and glass paintings, the first magic lanterns projected images associated with the supernatural, hence the name "magic lantern." Over the next century and a half, entertainers who traveled from town to town used the magic lantern as the center of their shows. By the 1830s, with the invention of "limelight"—where oxygen and hydrogen ignited into a powerful light source—the lantern moved from sideshow entertainment to one of the most popular pastimes across classes in Victorian England. In the 1850s another innovation, the ability to produce photographic glass slides, greatly increased the quality of the lantern's projections. In its heyday, the 1880s and 1890s, the lectures served not only the purposes of entertainment but illustrated educational scientific lectures from the university to the museum (Humphries 1989, 12–26). The lantern's origins as an instrument of magic and its later "scientific" uses likely made the medium particularly attractive to tourism promoters, who were interested in presenting the "fairyland" of Jamaica as objective truth.

7 Industry promoters mounted displays of the island's picturesque scenery through photographic displays (sometimes of enlarged photographs) at colonial exhibitions in Chicago (1893), St. Louis (1904), and Liverpool (1905), "giv[ing] the passing visitor an instant idea of the beautiful scenes to be found on our sunny Caribbean island" (*DG*, 15 February 1893). They sponsored the production or distribution of photography books and magazines on the islands, including Johnston's *Jamaica, the New Riviera* (1903a) (based on his lectures), *Jamaica through a Kodak* (1907), *A Snapshot of Jamaica* (1907), and *The Golden Caribbean* (1903), taking prospective viewers on visual excursions through the island with each turn of the page. They also commissioned postcards of Jamaica, a means of advertising the island that echoed through its mass-produced and miniature form the promotion of Jamaica as a series of picturesque vignettes.

8 Gilpin doled this advice to artists on how to deal with such landscapes: "But if art *must* stray among them [cultivated landscapes]—if it *must* mark out the limits of property, and turn them to the uses of agriculture; he wishes, that these limits may, as much as possible, be concealed" (Gilpin 1782/1789, 44).

9 Picturesque ways of seeing enabled travelers and settlers to portray unfamiliar and even threat-

ening aspects of Britain's colonies in a recognizable and comprehensible aesthetic form. Although pictorial conventions evident in Britain provided the lens through which the colonies were filtered, the picturesque in each geographic context was filled with new meaning and content, responding to particular geographic, colonial, and local sociopolitical environments. On the uses of the picturesque in imaging the British Empire and its colonies see Cohn 1996; Suleri 1992; Ray 1998; Sampson 2002; and Auerbach 2004.

10 In 1820 Jamaica produced approximately 20 percent of the world's cane sugar (Holt 1992, 118).

11 For more detailed examinations of Beckford's and other "picturesque" representations of Jamaica and the Caribbean consult Bohls 1999; Sandiford 2000; Crowley 2003; Casid 2005.

12 He originally planned to publish Robertson's images in his publication, but financial and legal woes prevented him from doing so (Beckford 1790, x).

13 Hakewill's and Robertson's images likely graced the walls of absentee landholders' homes in Britain (approximately 30 percent of the island's plantation owners were absentee landholders) and those resident on the island (Higman 1988, 78). Their works also found more public visibility in England through prints and exhibitions. Robertson, for instance, exhibited his Jamaica works in England at the Incorporated Society of Artists in 1775. Robertson's works also circulated as six engravings entitled "Views in Jamaica" in 1778. Of the 26 Jamaica landscapes that Robertson exhibited, 6 were engraved by Danial Lerpiniere, Thomas Vivares, and James Mason and published by John Boydell.

14 Beckford also hoped that his *Descriptive Account* would intercede into contemporary "legislative discussions" surrounding slavery, a system he viewed as essential to the social stability and economic viability of the island (Beckford 1790, v). For an analysis of Beckford's text see Sandiford 2000; Crowley 2003; Casid 2005.

15 Beckford echoed similar sentiments. He argued that slaves enjoyed better conditions than England's working classes in part because of the beauty of their surroundings (see Beckford 1790, 202).

16 Beckford maintained that in Jamaica "the banks of the rivers are fringed with every growth that a painter would wish to introduce into this agreeable part of landscape: and those borders which Claude Lorrain, Poussin, and Salvator Rosa, took apparently so much pleasure and pains to enrich, are there excelled by the hand of Nature alone" (11).

17 Colonial transplanting was not unique to Jamaica, even though the island was an originary and long-standing fertile laboratory of these practices. Many plant species introduced by British colonists into the "New World" generally were first reared experimentally in Caribbean islands. After the British settled in Jamaica in 1655, they often flattened much of the indigenous environment, even burning remaining roots, carving out a space for new colonial botanical introductions. Additionally, according to Barry Higman, new estate owners would flatten the preexisting plantation to the ground. For a discussion of the history of colonial

transplantation see Mackay 1985, 14; Higman 1988, 291; Pulsipher 1994, 202; Frost 1996; Casid 1999, 14.

18 Between 1870 and 1871 Heade also publicly exhibited two large paintings stemming from his journey to Jamaica entitled, *Jamaica* (circa 1870–71) and *Mountains of Jamaica* (circa 1870–71). The latter was also shown in London in 1873, where critics hailed the work as "original and startling," and again in San Francisco in 1875. See North 1980; Stebbins 1975, 93. North's Jamaica paintings had the distinction of occupying a permanent exhibition space in Kew Gardens, London's botanical gardens (ironically, a center of British colonial transplantation from which many of the island's tropical plants were dispatched).

19 Johnston in a single sentence could characterize parts of the island as a painting, panorama, or picture. In *Jamaica, the New Riviera*, for instance, he wrote that "the harbour of Port Antonio unfolds itself like a *grand panorama*. 'Such riotous colouring as Nature indulges in here was *never seen out of a painting by an 'impressionist'*—the intense emerald, the marvelous amethyst, with the vivid yellow and dark greens of the tropical verdure on the hills beyond,' *present a picture* never to be forgotten, and might well be named the Venice of the West Indies" (Johnston 1903a, 19; emphasis added).

20 Pullen-Burry's limelight lecture similarly visualized parts of the island that displayed transplanted tropical nature as picturesque. An article describing one of her lectures, "Telling the Story of the Beauties of Jamaica," reported that she too concentrated on these aspects of the island: "Views bearing on the chief industries of the island were then shown, bananas, sugar, cocoa-nut, palms, coffee, and some curious cattle imported and crossed with British breeds" (*DG*, 10 March 1906). The reference to crossbred cattle in addition to agricultural crops is particularly significant because in a sense it focuses on another imported addition to the plantation landscape. Fruit companies like Elder, Dempster and Company brought new breeds of cattle to the island to work on their properties. Again, as with tropical plants, the cattle in the Jamaican landscape were also characterized by their strangeness.

Similarly, James Gall, in his lectures, presented the New Jamaica as a landscape abundant with tropical vegetation and dominated by picturesque plantations. One lecture by Gall rendered the landscape solely in terms of old and new agricultural products. A list of slides shown in succession animated a select view of the island's landscape. After showing some historical engravings and showing images about the development of a local newspaper (he was a journalist for 42 years), the limelight images pictured, in order:

A Sugar Estate, Ploughing the Cane Fields, Cutting the Canes, Carrying the Canes to the Mill, Sugar and Rum, Capt. L. D. Baker "The Banana King," A Banana Walk, Carrying Bananas, Bananas Coming into Town, Bananas Coming Coastwise, Loading the Boat with Bananas, Lightering Bananas, Loading the Steamer with Bananas (two images), Getting Ready for Sea, A Bearing Cocoanut Tree, Climbing for Cocoanuts, Husking for Cocoanuts,

A Pine Apple growing, A field of Pines, A Tobacco Plantation, A Mango Tree in Bearing, A Coffee Tree, A Nutmeg Tree, and several images of "The Floor Scrubber," Old Rose, the Fiddler, Big George—the Estates Manager, The Native Chimney Sweep, and The Old Woman Mounting a Bicycle, Ah, Boy! I'm old, but I'm strang!! [*sic*] (Gall 1899)

21 Gall, Johnston, and Hale all transported audiences "into the bush" of the banana plantation in their lectures. A plethora of other crops cultivated for export at this time also became primary subjects of photographs of the island, particularly mangoes, cocoa, and pineapples.

22 A promotional book published by Elder, Dempster and Company in its first year of operation explicitly laid out these twin initiatives: "The splendid fruit of Jamaica will be placed on the English markets at prices within the means of all, and its magnificent climate and scenery, with all the glamour of its wonderful romance, and the picturesque life everywhere abounding will be thrown open to the tourist of modest income and limited leisure" (Rhodes 1901, 6).

23 Johnston did show one slide of indigenous vegetation entitled "Largest Known Logwood Tree." Johnston also pictured a silk cotton tree, "Tom Cringle's Tree," some species of which were indigenous to Jamaica. It is probable that the "largest logwood" and silk cotton became acceptable candidates for the picturesque precisely because they conformed to ideals of the peculiar forms of tropical nature as a result of their commanding size and dramatic appearance.

24 Although by the beginning of the twentieth century no form of vegetation more legitimately represented Jamaica than another, Johnston's select choices would present only certain natural forms as representative of picturesque Jamaica.

25 In the case of Cuba, for example, the following postcards were included: Gallego's Club and Opera House, Students' Tomb, Habana, Centro Asturiano, and Parque Central.

26 In 1865 black Native Baptist leader Paul Boyle led an insurrection in Morant Bay in the parish of St. Thomas, Jamaica, precipitated by discontent with black working and social conditions. Protestors clashed at the local court house. The island's governor, Edward Eyre, repressed the rebellion through the harsh administration of marshal law, executing more than 400 people.

27 As historian Patrick Bryan puts it, "One of the major concerns of the Crown Colony was the maintenance of order . . . with the legal abolition of slavery in 1834, the law, the system of justice became more essential as a mechanism for controlling 'combustible blacks' " (Bryan 1991, 22).

28 Hale, in reference to an image of vendors selling jackass rope, for instance, commented during his lantern lecture: "And here too one will note with pleasure the cheerful dispositions and respectful manners of these sable subjects of King Edward VII" (9). In regard to an image of the Mandeville market, Johnston similarly stressed that the chatter of tongues one would hear in such a scene belied a "peaceful and contented people" (1903b, 22).

29 His photograph "Mending our Ways" suggested that the pictured subjects are prisoners working on the roadways as punishment and social rehabilitation for their crimes.

30 See Johnston 1903b, 12; Rhodes 1901, 25; Johnston 1903a, 26; Blake 1890, 538.

31 One traveler to the island, for example, admonished, "It's a strange world, is Banana land. You see bananas grow so easy down there they've nothing to do but lie down in the shade and let them grow. If it wasn't for that they'd never raise any, they are so lazy" (quoted in *DG*, 20 February 1903).

32 Johns wrote:

> To take a case in point as proof of the principles which guide these ephemeral scribes [travelers who wrote on the island] in libeling a people. When the Commission on Education of 1898 was sitting at Mandeville a witness, an Englishman, stated with regard to the people's habit of uncleanliness that if they had water they would not know how to use it. He was severely cross-examined by the Honourable Dr. Johnston, a member of the Commission, who asked the witness that comparing Jamaica people on a road to market on a Saturday with similar class in the South of England or West of Scotland which would he say was in his opinion more today and clean. And the witness, though reluctantly, was forced to confess when thus tackled by one who knew what he was talking about, that the people of Jamaica were in every respect superior. (*DG*, 2 February 1904)

33 Johnston maintained, "If any one is to organise the advertising of the island it must come from people who live in Jamaica" (*DG*, 30 January 1904).

34 Gall partly projected this vision through the following series of images: "A Banana Walk," "Carrying Bananas," "Bananas Coming into Town," "Bananas Coming Coastwise," "Loading the Boat with Bananas," "Lightering Bananas," and "Loading the Steamer with Bananas" (two images).

35 The *Daily Gleaner* reported: "The story goes that Captain L. D. Baker has been actively engaged in the importation of shackles in casks in large quantities for the purposes of entrapping the people when they got to the Exhibition and making them slaves again. . . . The Exhibition is a trap" (*DG*, 7 November 1890).

36 Jones brought the troupe to England originally to perform at the Colonial Products Exhibition at St. George's Hall in Liverpool in 1904. After this appearance they embarked on a 36-week tour of the United Kingdom (*DG*, 31 December 1906).

CHAPTER TWO / DEVELOPING THE TROPICS

1 Stark used almost an exact quote from L. D. Powles's *Land of the Pink Pearl* (1888, 13).

2 Most of this chapter will concentrate on images and campaigns that advertised the capital of the Bahamas, Nassau, on the island of New Providence. New Providence is one of the smallest inhabited islands in the archipelago of more than 700 islands and cays that make up the Bahamas. In the earliest phases of tourism Nassau became the central hub of the indus-

try. Through promotional campaigns Nassau became important in creating a wider idea of the Bahamas *as a whole*, when geographically it made up only a fraction of the islands' physical landscape. Consequently, throughout the chapter I will sometimes intentionally use the more general terms "the Bahamas" or "the islands," when in most instances touristic representations focused specifically on Nassau. When I describe particular events, policies, and practices that impacted the capital, I use the singular "island" to denote their specificity to Nassau.

3 A Cunard line mail and passenger ship began running monthly trips to the islands between New York, Havana, and Nassau in 1859 (Craton and Saunders 1992, 75).

4 Fifty years after Emancipation in the British territories, the colony's annual budget was balanced precariously on a triad of earnings from three main industries: the pineapple industry, the sponging trade, and sisal manufacture. As the century neared its end, however, profits from the pineapple and sisal industries fell off partly as a result of competition from Hawaii and the Philippines respectively. The sponge industry remained the single most profitable trade. The trade in sponges also eventually fell prey to a microscopic fungoid disease that attacked sponge beds in the 1930s. Given the uncertain fate and volatility of existent industries in the late nineteenth century, the governor and other members of Nassau's legislature turned to tourism as a possible source of economic salvation for the islands. See Thompson 1979; Craton and Saunders 1992.

5 Jacob Frank Coonley was an accomplished photographer in New York before he started working in the Bahamas during the 1870s. Since 1856 Coonley had worked as a landscape painter, Daguerreotypist, manager of a stereoscopic printing shop, manufacturer of albumenized paper, Civil War photographer, and studio portrait photographer (Johnson 1990, 150). Coonley first came to Nassau at the request of the governor of the Bahamas, Sir William Robinson, in 1877 (Coonley 1907, 107). It is likely that Governor Robinson invited Coonley to Nassau in order to create photographic images of the islands. Coonley's photographs from his 1877–78 trip to the Bahamas became commercially available in Nassau and provided the basis for illustrations in popular American periodicals such as *Frank Leslie's Illustrated News*. Coonley returned to New York in 1878, but some years later, in 1888, he returned to Nassau, where he set up a studio from which he worked (during the winter season) until 1904 (Thompson 2003). A substantial proportion of Coonley's business centered on the sale of "views in great variety of all points of interest around Nassau," to quote his advertisement to travelers and residents (*NG*, 26 January 1898).

6 James Osborne Sands, or "Doc" Sands, as he was popularly known, was born in Rock Sound, Eleuthera, in the Bahamas in 1885. Sands took over Coonley's photography business at the age of nineteen. Sands did a considerable business in portrait photography at "prices to suit everybody" (*NG*, 22 December 1909). Much of Sands's work revolved around the tourist trade. From the production of postcards to a photography book, which included "views of the city,

its most picturesque corners, the hotels and the beaches" (NG, 1 November 1924), many of Sands's photographic images catered to the tourism industry. Fittingly, in 1927 the Development Board used Sands's work as "valuable advertising material" in its international promotional campaigns (NG, 30 July 1927).

7 Jackson, originally from New York, was a well-known photographer of the American Midwest (his portraits of American Indians were particularly popular). Before he became a primary field photographer for the Detroit Publishing Company in 1897, Jackson worked for the United States Geological Survey of Territories, railroad companies, and various railway-side hotels (Hales 1988). Photojournalist and historian Michael L. Carlebach suggests that hoteliers and railway owners such as Henry Flagler also turned to Jackson to help them promote the state in the 1880s and 1890s. It is likely that Flagler's extension of his commercial empire to the Bahamas in 1898 inspired the photographer to add the Bahamas to his photographic repertoire of touristic views (Carlebach 1998).

8 Thanks to Becky Smith and Steve Stuempfle of the Historical Museum of Southern Florida for confirming the date of Jackson's journey to Nassau.

9 The very impetus of the picturesque in Britain, the Grand Tour to Italy, for example, was about the pursuit of intellectual enlightenment. The Grand Tour became a necessary ritual in the cultivation of picturesque taste and procurement of cultural refinement and social distinction among the British aristocracy. As part of an educational coming of age, in addition to seeing nature aesthetically, young male and female travelers to Italy were schooled in both history and art. For more on the Grand Tour consult Andrews 1989; Redford 1996; Hornsby 2000.

10 When black men did enter into representation, they almost invariably belonged to the sea, not the land (see chapter 3).

11 Traveler J. Milton Mackie most explicitly illustrates this in his pronouncement that "while the free African thrives in these tropics like a green bay tree . . . the Anglo-Saxon, and even the Spaniard, is a sickly exotic" (1864, 344). In his estimation Afro-Bahamians were naturally occurring parts of the tropical environment (growing, indeed, like trees), whereas whites seemed to wither in tropical climes and landscapes.

12 The same adjectives, which travelers and promoters used to describe the gliding movement of the market woman, were here reattributed or reread on the Bahamian landscape. Blake, for instance, characterized the market woman as tall and peculiarly graceful, similar to his descriptions of palm trees (Blake 1886, 177).

13 For an examination of the convergence between anthropology and photography see Banta and Hinsley 1986; and Edwards 1992, 2001. For an analysis of late nineteenth-century and early twentieth-century photographs of Africa see Alloula 1986; Geary 1991b; Prochaska 1991; Landau and Kaspin 2002; Geary and Webb 1998; Hight and Sampson 2002.

14 Hutchinson raved that "the most striking and singular effect produced upon my mind was the extraordinary similarity of the following scene with those so graphically described by Living-

stone in his African travels. . . . Outside, the hot air of a tropical mid-day fanned foliage found in Africa as in Andros, and the odors were as spicy as on the Nile" (Hutchinson and Woodward 1886, 114).

15 Edith Blake noted, "The people themselves ascribe the malady [consumption] to the influx of American invalids who of late years flock to Nassau during the winter" (1888, 689).

16 Stark's use of *palmy* likely referred to the combined ideals of a productive landscape and plantations visually defined by palm trees.

17 A few writers did offer another vision of labor on the island. Northcroft, for example, stated that "the comparatively poorer soil of these islands makes hard work a necessity for those who wish to live and prosper" (82).

18 Although not every traveler utilized this vocabulary, many tourists and promoters used these or similar terms and employed photographs to visualize these concepts.

19 At least 10 percent of Jackson's representations featured the hotel's grounds.

20 As Northcroft commented, "In front and on either side of the hotel lie spacious grounds planted with trees and flowering shrubs, affording the guests a pleasant and much frequented promenade" (Northcroft 1912, 9). See also Ives 1880, 70; Howe 1910, 352.

21 Ives describes a whip being used to remove the assembly of blacks whenever they got too loud in the hotel's courtyard (1880, 78).

22 Ironically, the Royal Victoria Hotel's gardens were later destroyed in 1973: "To decorate the newly-completed Independence Drive along which Prince Charles' motorcade was supposed to pass, the Royal Vic's spectacular tropical gardens were literally uprooted" (*TR*, 25 July 1978).

23 Almost every visitor remarked on the immediate visual bombardment of light they experienced in the city's main thoroughfares. "The roads through town are made by smoothing off the top of the coral rock, and they are nearly as dazzling in the sun as a white-washed wall" (Church 1887, 503). Some tourists complained about the blinding effect of the streets, while others felt that when punctuated and softened by tropical palms, they created nothing short of a perfect picture. Northcroft, for instance, described the visual impact of the streets: "the roads, so excellent, glistening in the bright sun, make walking, driving or cycling a pleasure, and both invite and assist in explorations. . . . Their white, wide-stretching surfaces [are] quite a feature of the city, and the frequent avenues of trees with which they are bordered increase their picturesqueness" (20).

24 The street leading up to a staircase carved into limestone, known as the Queen's Staircase, was also pictured in Stark's guide. It was viewed as another marvel of nature on the island. The scene provided one of the most popular "street scenes" on the island, as Northcroft described it (43–44). The Queen's Staircase became especially symbolic or iconic of the islands when it was featured on the first pictorial stamps of the colony, replacing the sovereign's silhouette no less (*NG*, 25 September 1901). The stone archway known as "Gregory's Arch" was another frequently represented street scene.

The appearance of the Queen's Staircase on the stamps drew criticism from local residents. A letter writer signing his name *Philatelist* protested, "Our stamps have always bore the Sovereign's head. And it is difficult to find a prettier series. The present departure from this style is most unhappy and comes as a complete surprise to the public. . . . Who decided that a new issue of a particular stamp was necessary; who selected the design; and who chose the water mark?" (*NG*, 25 September 1901).

25 The avenue was formerly known as Culmer Street.

26 The West Indies Regiment (whom the constabulary force from Barbados replaced), composed of black men from throughout Britain's Caribbean colonies, served as another force of colonial order, fighting for British territorial possessions on the African continent.

27 For more information on the liberated African communities see Johnson 1991, 30–54; Adderley 1996; Craton and Saunders 1998, 101–30.

28 In the 1922–23 season 10,295 tourists visited the island; 25,000 visited in the 1934–35 season; and 57, 394 came in 1938 (Saunders 1997, 26).

29 The Development Board used photographs and paintings at the Imperial Institute Exhibition (1908), the Toronto Exhibition (1913), the colonial exhibition at Wembley (1925), the British Empire Exhibition (1923), and the Centennial Exhibition in Adelaide, South Australia (1935).

30 They also composed photographic albums, which they deposited at the offices of the Munson and Ward SS lines "for the purpose of advertising" and also organized photography exhibitions on cruise ships (Development Board 1922–23).

31 The board also sponsored independent exhibitions of the island's images, which traveled internationally (Development Board 1915–16, Development Board 1919–20, *NG*, 4 March 1922, *NG*, 28 April 1928).

32 They placed photography albums at the West India Committee and the Royal Colonial and Imperial Institutes.

33 The Development Board had a photographic display at the Tropical Ball in New York (*NG*, 18 December 1935). The existence of an event called the Tropical Ball in New York and the willingness of business owners to have their store windows adorned with tropical island displays indicate a sense of metropolitan audiences' appetite for things and places deemed tropical in the 1920s and 1930s.

34 More unconventionally, the board dressed the windows of the Saks 5th Avenue store in New York (*NG*, 27 June 1935), Messrs. Albury and Company in Miami (*NG*, 5 March 1927), and Raymond and Whitcomb's offices on 5th Avenue, New York (*NG*, 25 August 1934).

35 The board identified "class periodicals" as publications with readership among the "monied classes." These included *National Geographic*, *Harper's Magazine*, *Town and Country*, *The Spur*, *American Golfer*, *The New Yorker*, and *Golfer's Magazine* (Development Board 1931–32; *NG*, 30 December 1924).

36 Through newspaper accounts and the Development Board's own reports, it is possible to

compose a checklist of the most frequently employed visual images in the board's campaigns. Three enlarged photographs decorated the Bahamas' booth at the Tropical Ball: "Paradise Beach, a street scene, and the gardens of the British Colonial" (NG, 18 December 1935). An exhibition of Hart Woodcock's Nassau paintings was composed of the "familiar" images of "pink walls and purple gateways, his typical street scenes and his entrancing seascapes" (NG, 25 December 1928). A report credited Woodcock with "painting picturesque Nassau for many years" and deemed him an artist to whom "the island is greatly indebted for attracting many visitors to its shores" (NG, 25 December 1928). A photographic album sent to the West Indies Committee by the Development Board comprised fifty photographs. At least ten of them pictured "recognizably" tropical trees (especially images of coconut trees); three presented market women; two forts; and nine street scenes (including the typical Queen's Staircase, Gregory Arch, and avenues with palms), while approximately half of the images picture the island's shoreline. The large percentage of beach scenes reflects the increased centrality of this location in touristic images of the island in and after the 1930s (as I discuss in chapter 3). These visual fragments of the multifaceted campaigns suggest that street scenes, hotel landscapes, market women, and flowering archways remained enduring images of the islands in this period.

37 Below is a list of some of the dates on which articles appeared in the *Nassau Guardian* about keeping Nassau's streets clean: 10 May 1902; 17 March 1909; 13 November 1909; 16 March 1910; 8 November 1911; 18 January 1913; 25 January 1913; 1 February 1913; 8 February 1913; 12 February 1913; 12 March 1913; 28 June 1918; 2 July 1913; 6 September 1913; 9 June 1920; 6 January 1921; 18 January 1921; 25 January 1921; 21 February 1921; 16 October 1921; 3 December 1921; 12 January 1922; 28 September 1922; 5 October 1922; 17 October 1922; 22 November 1922; 28 November 1922; 23 March 1923; 2 August 1930; 11 January 1936; 4 March 1939; 18 January 1940; 30 January 1940.

38 In the mid-1930s a local performer, Paul Meeres, who danced with Josephine Baker in Paris, also returned to Nassau and opened a nightclub with a spectacular native show. He also offered tourists a "Thrilling Dance Fantasy" (NG, 1 January 1940).

39 Pictured is an example from the *Tribune* of a junior division John Canoe masquerader from 1967. Unfortunately, the newspaper's photographic archives date from this later period. For examples of earlier photographs of parade participants that were published in the local newspapers, see TR, 24 December 1940; TR, 3 January 1950; TR, 2 January 1951; TR, 22 December 1951; TR, 29 December 1951.

40 See *Nassau Magazine*, January 1935, 12–13; spring 1950, 17; midseason 1952, 24–25; summer 1953, 29.

41 This changing perception was evident in the introductory images in both of Defries's books. In *A Forgotten Colony* (1916) she included a photograph entitled "Native Cottage." In her later book, *The Fortunate Islands* (1929), almost the same image was employed but carried the title,

"The Author's House." That the author had sufficiently "gone native" is suggested in her occupation of the "Native Cottage."

CHAPTER THREE / THROUGH THE LOOKING GLASS

1 For an account of Williamson's achievements in underwater photography see the National Geographic film *Cameramen Who Dare* (1988).
2 His father's invention had originally been designed for marine salvage work.
3 For a consideration of Williamson's work within the history of underwater exploration see Norton 2000.
4 Williamson's photoplays included *The Submarine Eye* (1917), *A Deep-Sea Tragedy* (1917), *Girl of the Sea* (1920), *Wet Gold* (1921), *Wonders of the Sea* (1922), *The Uninvited Guest* (1924), and *The Mysterious Island* (1929). His documentary work also continued with the five-reel *Field Museum-Williamson Undersea Expedition to the Bahamas* (1929) and *With Williamson beneath the Sea* (1932; Williamson edited and released this film in 1955).
5 The Caribbean Sea has been defined as a body of water, approximately 2.7 square kilometers, encompassing the Bahamas, the large islands of the Greater Antilles and the Lesser Antilles in the Southern Caribbean, bounded by the coasts of South and Central America (Jones and Sefton 1978, 8).
6 In deep waters, in order for forms of marine life to gain energy, they feed on microscopic floating plants known as phytoplankton. These organisms capture light and turn it into energy through photosynthesis. In this process they can change the color of the water. In shallow waters phytoplankton are not as necessary because marine life can draw energy directly from the sun (Jones and Sefton 1978, 68).
7 In *Stark's History and Guide to the Bahamas* (1891), for example, out of 47 images, two pictured the sea: "The Beach at Fort Montague" (121) and "The Sea Gardens" (231). A photography book, *Nassau* (1901), included one image of the sea, "Nassau Harbor," among 38 photographs. The book *In Sunny Lands* (1895) featured four images of the sea out of 37 representations: "Fort Charlotte from the Sea" (5), "Diving for Coppers" (12), "Home of the Sponge" (26), and "The Sea Gardens" (35).
8 Another travel writer, Amelia Defries, echoed these sentiments, stating that the natural wonders of the sea gardens "transcend[ed] the wildest dreams of 'Arabian Nights'" (Defries 1917, 176).
9 As Stepan points out in *Picturing Tropical Nature* (2001), "The identity of tropical nature in the European mind depends upon its visual representations" (8).
10 Governor Henry Blake put it succinctly, in regard to both visual and written representations of the sea: "No language can describe the exquisite brilliancy of the tints, and no known pigments can reproduce them" (Blake 1886, 176).

11 Similarly, Defries decried in regard to the gardens that "words cannot describe adequately its beauty, its charms of colour and form, the variety of its life" (Defries 1917, 253).

12 Additionally, Bliss Carman, the poet who wrote the popular "White Nassau," about the island's picturesque streets, also addressed this touristic fascination with representing the island's water in order to secure a memento of their travels. Carman inquired in the poem "In Bay Street":

> Look from your door, and tell me now
> The colour of the sea.
> Where can I buy that wondrous dye,
> and take it home with me?
> (NG, 24 March 1909)

13 See, for example, a review of the artist George Clements's work: "An exhibition of interesting paintings of Nassau is going on this week in Mr. Armbrister's Studio on George Street. The artist, Mr. George H. Clements, has been visiting Nassau at intervals for many years and while one or two have been privileged to see his work this is, we think, the first time he has exhibited. Mr. Clements specialises in scenes and types along the waterfront. His drawing is true in every detail and we have seen no better figures anywhere. *His paintings are rich in colour and full of life even if he has not caught the exact colour of the sea*" (NG, 28 February 1922; emphasis added).

14 The board accepted the terms of the agreement as outlined by Williamson and agreed to pay him the seed money he required (Development Board to Williamson, 26 August 1938).

15 In private correspondence, however, a member of staff at the British Museum wrote to Williamson to verify "purely for biological reasons" whether his photographs had been "touched up"(A. K. Totton to Williamson, 3 March 1936).

16 In 1928, for instance, Williamson lectured at the International Travel Show at the Hotel Sherman, Chicago (NG, 21 November 1928). In 1936 he lectured at the Maryland Academy of Sciences (NG, 1 February 1936).

17 As an early guide expressed, "the sea appears here in its gentlest, most caressing mood. No foaming billows, no sighing of the salt sea waves, no moaning nor groaning—in fact, none of the usual melancholy aspects of old ocean" (*Guide to Nassau* 1876, 18). See also Northcroft 1912, 4.

18 The popularity of sea bathing in the 1920s is reflected in the government's allocation of funds for the creation of a bathing beach for tourists on Crown land near the New Colonial Hotel (Saunders 1997, 24).

19 These factors will be discussed in greater detail in chapter 4.

20 Williamson, for instance, brought another Jules Verne novel to cinematic life, *Mysterious Island*, in the late 1920s.

21 This is especially evident in the first phase of Atlantis's creation. Its second phase, which drew on a cornucopia of "tropical," "ancient," and "exotic" motifs, including Mayan and Egyptian sources, will not be tackled within the scope of this chapter. I am more interested in Atlantis's initial resort and its partly Bahamas-inspired theme, which was based in part on molds from Nassau's natural environment.

22 To quote Krezner, "Guests have the adventure of moving through the totality of it, to discover some or all of the aspects of Atlantis. That's our secret, if you like" (*UT*, 10 December 1998, 8).

23 As Olio's creative producer describes, "We spun the tale that three British archeologists unearthed it in the late 1920s, just before the Great Depression set and halted their work. The hotel rediscovered it when it broke ground in 1997" (*ED*, May 1994, 13).

CHAPTER FOUR / THE RACIAL WATERS OF BEACH SPACE

1 See undated article, "More about Myrtle Bank," by F. L. C. in Myrtle Bank files at the National Library of the island

2 Recognizing the social import of the hotel, Governor Henry Blake passed the Jamaica Hotels Law (1891), guaranteeing a government loan for the construction of the hotel. The government pledged £150,000 to the establishment of tourist accommodations (the Myrtle Bank Hotel, the Queen's Hotel, Hotel Rio Cobre, the Moneague Hotel, and additions to the Constant Spring). Two-thirds of the monies allocated for hotel construction were expended on the Myrtle Bank and Constant Spring. The governor also deemed all construction materials duty-free (Taylor 1993, 75).

3 A United Fruit Company promotional booklet, *Cruises over the Golden Caribbean*, touted these dual dimensions of Jamaican tourism: "the twentieth century has touched the edge of this tropical Eden, called Jamaica, with its magic wand and reared these two modern hotels [the Myrtle Bank and Constant Spring] for your comfort" (United Fruit Company 1929, 12, 13). While these twin ideals of modern comfort and tropical repose are not unique to tourism promotion in Jamaica, they would both contribute to the hotels' local significance.

4 Johnston assured audiences in his lectures of the unlikelihood of an earthquake happening in Jamaica (*DG*, 31 January 1903).

5 Johnston himself had traveled to and photographed Mount Pelee in Martinique and Souffriere in St. Vincent after volcano eruptions in 1902 and advertised these photographs for sale in his photography book, *Jamaica, the New Riviera*.

6 In the aftermath of the earthquake the governor's impotence was exacerbated when American sailors, who were stationed near the island, spearheaded the relief effort in Kingston. The British governor interpreted the American presence as a direct challenge to British authority and ordered them to leave the earthquake ravaged island, which they did. This standoff would

be an omen of the impending struggles between the Americans and British colonial authorities in Jamaica, as both would make claims to their instrumentality in the future development of the island.

7 It was not uncommon for these families to have African relatives buried on the back walls literally of proud European-centered family genealogies (Douglass 1992, 91).

8 As one *Daily Gleaner* account detailed in 1921, Mrs. Lionel DeMercado wore an "extremely handsome wrap of black and gold brocade . . . and . . . one of the most striking gowns on the occasion. It might be described as a Paris metal brocade in black and silver [and] platinum . . . simple but elegant [with] . . . a small inlet of brilliant crystal work, at the front of the bodice. . . . Such distinctiveness in costume is refreshing to a degree, and one is glad of the opportunity to see and note it" (*DG*, 3 January 1921, quoted in Pigou-Dennis 1998, 4–5).

9 Cargill describes the social protocols of King's House in this way: "You were fully in society if you were regularly invited to King's House for tennis or other such private occasions. You were partly in society if you were invited on public occasions only, and you weren't anywhere if you were never invited at all, which was the situation with 99½% of the island's people" (Cargill 1978, 89).

10 For a history of conceptions and uses of the beach see Pimlott 1976; Corbin 1994; Lenček and Bosker 1998; Löfgren 1999; Urbain 2003.

11 Although many beach historians do not consider the Caribbean in their analyses of widespread popularization and sacralization of the tropical beach, the beaches (and saltwater pools) in Caribbean islands like Jamaica (which preceded the touristic popularity of the South Pacific) also played a constitutive role in the postwar imaginative formulation of the tropical beach.

12 See, for example, a reproduction of the same photograph published in *Planters' Punch* (1936–37, 16).

13 For an early example of local "complaints" that Jamaicans were being robbed of their beaches, see *PO*, 17 May 1944, 4: "Certain big operators in the hotel business, *Public Opinion* learns, have been moving to secure concessions on all the available bathing beaches and desirable hotel sites around the island."

14 That the hotel was becoming a kingdom unto itself was even reflected in the architectural design of the new hotel. Unlike the previous structures, which seemed in a dialogue with Harbour Street and its urban environments, the Myrtle Bank was some 75 feet removed from Harbour Street and oriented toward its tropical grounds and not its urban surroundings.

15 Bailey went on to attack the very silence that surrounded the issue of race discrimination in Jamaica and the martyrdom of those who sought to redress the issue: "those who dare to hold aloft the flag of truth and say that race, colour and shade prejudice do not exist, are pilloried and martyred not only by the classes, but by the very ones they are most out to help" (*PO*, July 16 1938).

16 For a description of the complexities of this form of racism in other Latin American and Caribbean contexts see Wade 1993; Hanchard 1994; Ferrer 1999.

17 In 1910, for instance, the *Gleaner* reported that an incident of racial discrimination in an American-owned Hotel Plaza in Cuba threatened to plunge the country into racial unrest. "For once the race question is definitively raised and race hatred inflamed into violent activity, there will be no peace in Cuba for years to come" (*DG*, 29 January 1910). The reporter questioned whether Jamaica's authorities could guard against the importation of American prejudices in its own tourism industry. The account illustrates how discussions of race in Jamaica more comfortably centered on race relations elsewhere, be it Cuba or America. It also reflects the reactionary belief that even raising the issue of race discrimination could spark racial violence.

18 Nassau served as an important stopover for transatlantic flights on the British carrier BOAC.

19 A contradiction seems at work in some of Blake's commentaries on the issue of race and race discrimination. On one hand, he argued that "American" racial segregation could only be resurrected in a racially divided society. Yet his remarks directed at tourism promoters argued the case that they should more accurately show the "terms of racial equality" that existed in Jamaica. Maybe this seemingly circular logic reflects Blake's own faith in the power of images to intercede in society. If blacks were shown as equal participants in Jamaican society in internationally circulated representations, perhaps this would result in racial harmony.

20 Curiously, despite Blake's candor in his reportage on the Myrtle Bank, he made no mention of the incident in his news magazine.

21 Thanks to Barbara Blake-Hannah, Joy Lumsden, John Maxwell, Hartley Neita, and Fred Wilmot for sharing their recollections of Blake with me.

22 During my research in Jamaica, many people readily and happily recounted versions of the story about Blake's actions the moment I raised any questions about tourism and race in Jamaica.

23 Starting in the mid-nineteenth century, both the upper classes and emergent middle classes (with a newfound deposable income and time to travel) sought refuge from the urban environment at the seaside. With the development of mass transportation in Britain the working classes also migrated toward the seaside resorts. The seaside and new seaside entertainments offered a temporary reprieve from the regimentation of the workweek, and the salt air provided a refreshing antidote to the pollution and pulmonary ailments of the urban landscape for all classes. Working classes were able to peer through stereoscopes and enter the world of the upper classes. For more on the intermingling, maintenance, and transcendence of class on the beach see Walvin 1978; Osborne 2000; and Urbain 2003.

1 The National Festival Song Competition is an annual contest coinciding with Independence celebrations.

2 The phrase "other histories of photography" comes from a book by Christopher Pinney and Nicolas Peterson, *Photography's Other Histories* (2003). See also Sprague 1978; Bell et al. 1996; Appadurai 1997; Pinney 1997; Behrend 2000; Brielmaier 2003.

3 See Mitchell 1988; Lippard and Benally 1992; Poole 1997.

4 The "golden era" denotes the height of the craze in postcard collecting in the United States and western Europe, particularly Britain.

5 In 1904 the office urged, "It is added that a great effort is being made nowadays to restore prosperity to the West Indies by making the islands better known as holiday resorts. Quite an attractive series of pictorial postcards would doubtless tend to the end in view" (*DG*, 15 April 1904). The "attractive" pictorial postcard was thus recruited to play a role in the restoration of prosperity to the West Indies.

6 Companies specializing in transportation, such as the United Fruit Company; Elder, Dempster and Company (owners of the Imperial Direct Line); the Hamburg American Line; the Royal Mail Steam Packet Company; and Cunard Steamship Line, to name just a few, created postcard lines on Jamaica. The Cunard Steamship Line, the Florida East Railway Line, and Munson Lines published cards of the Bahamas. Local photographers, pharmaceutical companies, and mercantile elites, who owned businesses in the ports, also produced and distributed their photographs as pictorial postcards. For example, the City Pharmacy in Nassau published postcards. In Barbados several postcard photographers, Mr. Gibson and W. L. Johnson, worked for pharmacies located on Broad Street (near where passenger ships docked). Thanks to Kevin Farmer for this information on photographers in Barbados (Farmer 2001).

American and British postcard companies, without direct local business interests in tourism, also sent representatives to the region. The American Detroit Publishing Company and the British postcard companies Raphael Tuck and Sons, Ltd., and Valentine and Sons, Ltd., also dispatched photographers to the British West Indies.

In the case of Jamaica, several photographers originally hailed from outside of the islands: James Johnston (from Scotland), the Duperly family (originally from France but with several generations of printers and photographers in Jamaica), H. H. Cousins (from England), and H. A. Richards (a publisher from Hungary). In the Bahamas Jacob Coonley, W. H. Illingworth, and William Henry Jackson were all photographers from the United States who created postcards of the islands.

7 Especially important ports included New York, Miami, Palm Beach, Boston, Philadelphia, Baltimore, Liverpool, Glasgow, Southampton, and London.

8　Maxwell notes that at the start of the twentieth century many sitting rooms in British households contained these photographic albums into which travelers would chronicle their journeys and then publicly display their collection of views. Victorian collectors did not simply amass photographic objects but, following the taxonomies and hierarchies of scientist and botanist, often arranged these postcards and photographs into series or sets (Maxwell 1999, 11). In this process a single card often formed a new dialogue with its immediate photographic neighbors.

9　The "Barbarian" postcard resides in the postcard collection at the Barbados Museum and Historical Society.

10　As John Gilmore calculates, "The usual cost of a picture postcard in the Caribbean was probably the same as it was in Britain in the early years of the twentieth century: 'Penny plain, or two pence coloured'—two cents or four cents. It might cost only [a] halfpenny to send a postcard locally, or a penny to send it anywhere else in the world (1 or 2 cents), but for a labourer who was lucky to get 24 cents for a day's work, the cost of a card and mailing it would have seemed a lot of money" (Gilmore viii). According to ads in Jamaica "12 Selected varieties" of postcards could be "sent postfree for tenpence" (*DG*, 13 January 1905).

11　David Boxer's groundbreaking research in *Duperly* (2001), for example, promises to transform the field of research into photography and the photographic archives.

12　For critiques of Alloula see Coombes and Edwards 1989; Chow 1993.

13　Historian John Aarons reiterates that "a central tenet of the cultural policy pursued by all governments since independence has been the necessity of redressing 'the historical imbalance' caused by this period of colonial rule. This involved bringing the 'African experience' to the forefront of contemporary life by a variety of measures" (1998, 38). See also Thomas 2004.

14　It may be possible to interpret the actual process of collection by some residents as a response to the perceived disorder of contemporary postcolonial societies. In organizing the "chaos" of their collections (using representations that were precisely about the ordered tourist landscape), the owners of these materials can create an ideal order. This process allows them to structure, shape, and control the past in ways that they cannot control the present, the seeming disorder of postcolonial society. For more on the act of collecting postcards see Schor 1992, 197.

15　Although the postcard books are very different forms of cultural representation from Disney's amusement parks, both seem invested in convincing contemporary audiences that the turn of the century was an ideal period in their respective countries' histories and create a nostalgia for this era. Wallace finds, for instance, that Disney's Main Street presents late nineteenth-century America as "one of the greatest optimistic periods of the world, where we thought progress was great and we all knew where we were going. [Main street] . . . reflect[s] this prosperity, that enthusiasm" (John Hench, Disney designer, quoted in Wallace 1996, 137). Main

Street not only represents an ideal period of economic prosperity, but as a physical space it signifies an environment that was clean, tidy, orderly, and without crime, in striking similarity to nostalgic reconceptions of the Anglophone Caribbean past.

16 Wallace argues that Disney, by presenting history as a pleasantly nostalgic memory "diminishes our capacity to make sense of our world through understanding how it came be. Without a sense of the matrix of constraints and possibilities they have inherited viewers also lose a sense of themselves as agents in the present" (1996, 149)

17 John Gilmore argues that poverty in the context of Caribbean postcards was likely seen as picturesque (see Gilmore 1995, ix).

18 See photographs, for example, on pages 25, 166, and 206 in Moore 1995.

19 Indeed, when William Henry Jackson, the photographer from the Detroit Publishing Company, came to Nassau in 1903, he created the photograph on which the later postcard was likely based. The company captioned the photograph, "A Native Sugar Mill," pointing to the "comic" casting of blacks as not quite modern or industrious.

20 Caribbean tourism at this time became largely dependent on U.S. markets, especially those in New York, New Jersey, Massachusetts, Pennsylvania, and Florida (see Gayle and Goodrich 1993, 15).

21 Only *The Bahamas in Black and White* uses photographs produced after World War II, the era of mass tourism.

22 Bailey explains, "By placing them in the sand the idea there is what filmmakers call displacement, something from its natural environment has been displaced, reappropriated and positioned back in another so-called natural environment i.e., the postcard which normally you see in shops and stores where they exist in the natural order of our lives, but I'm displacing disrupting that . . ." (2001).

23 Wright recalls one incident when she was warned "that if I ever took pictures of him again he would beat the shite out of me, and at that point he pushed me roughly on the shoulder" (Wright 1989, 136).

24 To cite the full account of the incident, Wright notes "the following was the third version of the story that I had heard, and in this case, I knew the person in question. 'See that old guy over there—the old man with the beard, yes, well, he [was] at Keith's one day, in the corner, drinking he rum, and these people came by taking pictures, never asking yes or no thing. Anyway, they see the postcards a few months later, they have a picture of the old man going into Keith's and he no Keith got no little thing'" (Wright 1989, 23).

25 Since the 1980s, in Barbados promoters of tourism have increasingly policed the space of the beach, restricting, prohibiting, or controlling the presence of residents, especially if their activities impinge on the perceived comfort and enjoyment of tourists. In the 1980s, for example, the chairman of the Tourist Board in Barbados, Jack Dear, banned "beach boys" (men who

authorities accused of selling drugs and sex on the beaches) and imposed restrictions on the selling activities of vendors (Pattullo 1996, 60).

EPILOGUE

1 The company's Web site may be found at www.tommybahama.com.

REFERENCES

Aarons, John. 1998. "The Cultural Policy of the Jamaica Government since Independence." *Jamaica Historical Review* 20:37–50.

Adams, Frederick Upham. 1914. *Conquest of the Tropics: The Story of the Creative Enterprises Conducted by the United Fruit Company*. Garden City, N.Y.: Doubleday.

Adderley, Augustus. 1886. *Colonial and Indian Exhibition: Handbook*. London: William Clowes and Sons.

Adderley, Rosanne. 1996. " 'New Negroes from Africa'. Culture and Community among Liberated Africans in the Bahamas and Trinidad, 1810 to 1900." PhD diss., University of Pennsylvania.

Aguilar, Nelson. 2000. *Negro de corpo e alma: Mostra do redescobrimento*. São Paulo, SP, Brasil: Fundação Bienal de São Paulo: Associação Brasil 500 Anos Artes Visuais.

Albers, P. C., and W. R. James. 1988. "Travel Photography: A Methodological Approach." *Annals of Tourism Research* 15, no. 1:134–58.

Alleyne, Mike. 1999. "Positive Vibration? Capitalist Textual Hegemony and Bob Marley." In *Caribbean Romances*, ed. Belinda Edmonson, 92–104. Charlottesville: University Press of Virginia.

Alloula, Malek. 1986. *The Colonial Harem*. Minneapolis: University of Minnesota Press.

Andrews, Malcolm. 1989. *The Search for the Picturesque: Landscape Aesthetics and Tourism in Britain, 1760–1800*. Aldershot: Scolar.

———. 1994. *The Picturesque: Literary Sources and Documents*. Robertsbridge: Helm Information.

Aparicio, Frances R., and Susana Chávez-Silverman, eds. 1997. *Tropicalizations: Transcultural Representations of Latinidad*. Hanover, N.H.: University Press of New England.

Appadurai, Arjun. 1997. "The Colonial Backdrop." *Afterimage* 24, no. 5:4–7.

Appiah, Anthony. 1992. *In My Father's House: Africa in the Philosophy of Culture*. New York: Oxford University Press.

Archer-Straw, Petrine. 1998. *Photos and Phantasms: Harry Johnston's Photographs of the Caribbean*. London: British Council and Royal Geographical Society.

Arnold, David. 2000. " 'Illusory Riches': Representations of the Tropical World." *Singapore Journal of Tropical Geography* 21, no. 1:6–18.

Auerbach, Jeffrey. 2004. "The Picturesque and the Homogenisation of Empire." *British Art Journal* 5, no. 1:47–54.

Bacon, Edgar Mayhew, and Eugene Murray-Aaron. 1890. *The New Jamaica; Describing the Island, Explaining Its Conditions of Life and Growth and Discussing Its Mercantile Relations and Potential Importance*. New York: Walbridge.

Bailey, David. 2001. Personal interview. 22 April. Durham, North Carolina.

Balink, Albert. 1948. *My Paradise Is Hell: The Story of the Caribbean*. New York: Vista Publishing.

Banta, Melissa, and Curtis Hinsley. 1986. *From Site to Sight: Anthropology, Photography, and the Power of Imagery*. Cambridge, Mass.: Peabody Museum Press.

Barrell, John. 1980. *The Dark Side of Landscape: The Rural Poor in English Painting, 1730–1840*. Cambridge: Cambridge University Press.

Barry, Tom, Beth Wood, and Deb Preusch. 1984. *The Other Side of Paradise: Foreign Control in the Caribbean*. New York: Grove Press.

Barthes, Roland. 1972. *Mythologies*. New York: Hill and Wang.

———. 1981. *Camera Lucida: Reflections on Photography*. Translated by Richard Howard. New York: Hill and Wang.

Beadle, John. 2000. Personal communication. December 15. Nassau, Bahamas.

Beckford, William. 1790. *A Descriptive Account of the Island of Jamaica, with Remarks upon the Cultivation of the Sugar-Cane, throughout the Different Seasons of the Year, and Chiefly Considered in a Picturesque Point of View; Also, Observations and Reflections upon What Would Probably Be the Consequences of an Abolition of the Slave-Trade, and of the Emancipation of the Slaves*. London: T. and J. Egerton.

Behrend, Heike. 2000 "'Feeling Global': The Likoni Ferry Photographers in Mombasa, Kenya." *African Arts* 33, no. 3:70–77.

Bell, Archie. 1909. "Summer Isles That Nobody Cared to Own." *Nassau Guardian*, 27 March, 1.

Bell, Clare, Okwui Enwezor, Olu Oguibe, and Octavio Zaya. 1996. *In/sight: African Photographers, 1940 to the Present*. New York: Guggenheim Museum.

Bell, Hugh MacLachlan. 1934. *Bahamas Isles of June*. New York: R. M. McBride.

Benjamin, S. G. W. 1878. *The Atlantic Islands as Resorts of Health and Pleasure*. New York: Harper.

Berger, John. 1972. *Ways of Seeing*. London: British Broadcasting Corporation and Penguin Books.

Bermingham, Ann. 1986. *Landscape and Ideology: The English Rustic Tradition, 1740–1850*. Berkeley: University of California Press.

Berthold, Dennis. 1984. "*Charles Brockden Brown, Edgar Huntly*, and the Origins of American Picturesque." *William and Mary Quarterly* 41:62–84.

Bethel, E. Clement. 1991. *Junkanoo: Festival of the Bahamas*. London: Macmillan Caribbean.

Bhabha, Homi K. 1990. *Nation and Narration*. London: Routledge.

Black, Jeremy. 1985. *The British and the Grand Tour*. London: Croom Helm.

———. 1992. *The British Abroad: The Grand Tour in the Eighteenth Century*. New York: St. Martin's.

Blake, Edith. 1888. "In the Bahamas." *Nineteenth Century*, 682–92.

Blake, Evon. 1967. *The Best of Evon Blake*. Kingston, Jamaica: B. E. Blake.

———. 1970. *Beautiful Jamaica*. Port Antonio, Jamaica: Vista Publications.

Blake, Henry. 1886. "Try the Bahamas." *Fortnightly Review*, 174–83.

———. 1890. "The Awakening of Jamaica." *Nineteenth Century*, 534–44.

Blake-Hannah, Barbara. 2000. Personal interview. 27 June. Kingston, Jamaica.

Bohls, Elizabeth A. 1994. "The Aesthetics of Colonialism: Janet Schaw in the West Indies, 1774–1775." *Eighteenth-Century Studies* 27, no. 3:363–89.

———. 1999. "The Gentleman Planter and the Metropole: Long's *History of Jamaica* (1774)." In *The Country and the City Revisited: England and the Politics of Culture, 1550–1850*, eds. Gerald Maclean, Donna Landry, Joseph Ward, 180–96. Cambridge: Cambridge University Press.

Boxer, David. 2000. Personal interview. 15 June. Kingston, Jamaica.

———. 2001. *Duperly*. Kingston: National Gallery of Jamaica.

Brassey, Lady Annie. 1885. *In the Trades, the Tropics, and the Roaring Forties*. New York: Henry Holt.

Brielmaier, Isolde. 2003. " 'Picture Taking' and the Production of Urban Identities on the Kenyan Coast, 1940–1980." PhD diss., Columbia University.

Brown, Beryl. 1974. "A History of Portland, 1723–1917." MA thesis, University of the West Indies.

Brown, Dona. 1995. *Inventing New England: Regional Tourism in the Nineteenth Century*. Washington: Smithsonian Institution Press.

Brown, Sarah. 1995. "American Tourists' Narratives of the Caribbean, 1839–1939: A Study of the Experience of Tourism and of Cultural Encounter." PhD diss., George Washington University.

Bryan, Patrick. 1987. "Leisure and Class in Late Nineteenth Century Jamaica." Unpublished paper on file at the University of the West Indies Library, Mona, Jamaica.

———. 1991. *The Jamaican People, 1880–1902: Race, Class, and Social Control*. London: Macmillan Caribbean.

Bunn, David. 1994. "Our Wattled Cot: Mercantile and Domestic Space in Thomas Pringle's African Landscapes." In *Landscape and Power*, ed. W. J. T. Mitchell, 127–73. Chicago: University of Chicago Press.

Byatt, Anthony. 1978. *Picture Postcards and Their Publishers*. Malvern: Golden Age Postcard Books.

Caffin, Mabel Blanche. 1900. *A Jamaica Outing*. Boston: Sherwood Publishing.

Cargill, Morris. 1978. *Jamaica Farewell*. Secaucus, N.J.: L. Stuart.

Cargill, Morris, and Deryck Roberts. 1987. *Morris Cargill: A Selection of His Writings in the "Gleaner," 1952–1985*. Kingston, Jamaica: Topical Publishers.

Carlebach, Michael. 1998. "William Henry Jackson in Florida." *Journal of Decorative and Propaganda Arts*, no. 23:86–95.

Casid, Jill. 1999. "Sowing Empire: Landscape and Colonization in the Eighteenth Century." PhD diss., Harvard University.

———. 2002. "His Master's Obi." In *The Visual Culture Reader*, ed. Nicholas Mirzoeff, 533–45. London: Routledge.

———. 2005. *Sowing Empire: Landscape and Colonization*. Minneapolis: University of Minnesota Press.

Chard, Chloe, and Helen Langdon. 1996. *Transports: Travel, Pleasure, and Imaginative Geography, 1600–1830*. New Haven: Yale University Press.

Chatterjee, Partha. 1993. *The Nation and Its Fragments: Colonial and Postcolonial Histories*. Princeton: Princeton University Press.

C. H. B. 1920. "Watercolors by Stephen Haweis." *Bulletin of the Detroit Institute of Arts* 2:4–8.

Checci and Company. 1969. *A Plan for Managing the Growth of Tourism in the Commonwealth of the Bahama Islands*. Washington: Ministry of Tourism (Bahamas).

Chomsky, Aviva. 1996. *West Indian Workers and the United Fruit Company in Costa Rica, 1870–1940*. Baton Rouge: Louisiana State University Press.

Chon, Kye-Sung. 1990. "The Role of Destination Image in Tourism." *Revue de tourisme*, no. 2:2–9.

Chow, Rey. 1993. *Writing Diaspora*. Bloomington: Indiana University Press.

Church, William. 1887. "A Midwinter Resort." *Century Magazine* 33:499–506.

Codell, Julie, and Dianne Sachko Macleod. 1998. *Orientalism Transposed: The Impact of the Colonies on British Culture*. Aldershot, Hants: Ashgate.

Cohen, Erik. 1989. " 'Primitive and Remote' Hill Tribe Trekking in Thailand." *Annals of Tourism Research* 15:371–86.

Cohn, Bernard. 1996. *Colonialism and its Forms of Knowledge: The British in India*. Princeton: Princeton University Press.

Coombes, Annie E. 1994. *Reinventing Africa: Museums, Material Culture, and Popular Imagination in Late Victorian and Edwardian England*. New Haven: Yale University Press.

Coombes, Annie, and Steve Edwards. 1989. Review of *From Site to Sight, Anthropology, Photography, and the Power of Imagery*. *Art History* 12:510–16.

Coonley, J. F. 1907. "Pages from a Veteran's Notebook." *Wilson's Photographic Magazine* 44:105–8.

Cooper, Helen. 1986. "Winslow Homer's Watercolors." PhD diss., Yale University.

Corbin, Alan. 1994. *The Lure of the Sea: The Discovery of the Seaside in the Western World, 1750–1840*. Berkeley: University of California Press.

Cosgrove, Denis E. 1984. *Social Formation and Symbolic Landscape*. Madison: University of Wisconsin Press.

Cosgrove, Denis E., and Stephen Daniels. 1988. *The Iconography of Landscape: Essays on the Symbolic Representation, Design, and Use of Past Environments*. Cambridge: Cambridge University Press.

Cozier, Christopher. 2003. Personal interview. 24 July. St. Anns, Trinidad.

Cozier, Christopher, and Annie Paul, eds. 1999. "Debating the Contemporary in Caribbean Art." *Small Axe* 6.

Crary, Jonathan. 1990. *Techniques of the Observer: On Vision and Modernity in the Nineteenth Century*. Cambridge, Mass.: MIT Press.

Craton, Michael. 1968. *A History of the Bahamas*. London: Collins.

Craton, Michael, and Gail Saunders. 1992. *Islanders in the Stream: A History of the Bahamian People*. Volume 1. Athens: University of Georgia Press.

———. 1998. *Islanders in the Stream: A History of the Bahamian People*. Volume 2. Athens: University of Georgia Press

Crawshaw, Carol, and John Urry. 1997. "Tourism and the Photographic Eye." In *Touring Cultures: Transformations of Travel and Theory*, eds. Chris Rojek and John Urry, 176–95. London: Routledge.

Crowley, J. E. 2003. "Picturing the Caribbean in the Global British Landscape." *Studies in Eighteenth-Century Culture* 32:323–46.

Cummins, Alissandra. 1999. "Imaging the West Indies: Visual Iconography as the Language of the Colonial Discourse." Unpublished paper. *Association of International Art Critics*. Barbados.

Cundall, Frank. 1886. *Reminiscences of the Colonial and Indian Exhibition*. London: W. Clowes and Sons.

———. 1928. *Jamaica in 1928*. London: West India Committee.

Curry, Robert Arthur. 1928. *Bahamian Lore*. Paris: Lecram Press.

Curtin, Philip D. 1989. *Death by Migration: Europe's Encounter with the Tropical World in the Nineteenth Century*. Cambridge: Cambridge University Press.

Dacres, Petrina. 2004. "Monument and Meaning." *Small Axe* 16: 137–53.

Dahl, Anthony George. 1995. *Literature of the Bahamas, 1724–1992: The March Towards National Identity*. Lanham, Md.: University Press of America.

Danforth, Susan. 2001. "Cultivating Empire: Sir Joseph Banks and the (Failed) Botanical Garden at Nassau." *Journal of the Bahamas Historical Society* 23:21–28.

Daniels, Stephen. 1993. *Fields of Vision: Landscape Imagery and National Identity in England and the United States*. Cambridge: Polity Press.

Dann, Graham. 1988. "Tourism Research on the Caribbean: An Evaluation." *Leisure Sciences* 10:261–80.

Dash, J. Michael. 1988. *Haiti and the United States: National Stereotypes and the Literary Imagination*. New York: Macmillan.

———. 1998. *The Other America: Caribbean Literature in a New World Context*. Charlottesville: University Press of Virginia.

Day, Susan de Forest. 1899. *The Cruise of the Scythian in the West Indies*. London: F. Tennyson Neely.

Defries, Amelia Dorothy. 1917. *In a Forgotten Colony; Being Some Studies in Nassau and at Grand Bahama during 1916*. Nassau: St. Martin's.

———. 1929. *The Fortunate Islands; Being Adventures with the Negro in the Bahamas*. London: C. Palmer.

Department of Archives. 1989. *Highlights in the History of Communication in the Bahamas*. Nassau: Department of Archives.

Development Board [DB]. 1913–40. *Annual Reports*. Department of Archives. Nassau, Bahamas.

Douglass, Lisa. 1992. *The Power of Sentiment: Love, Hierarchy, and the Jamaican Family Elite*. Boulder, Colo.: Westview Press.

Driver, Felix, and David Gilbert. 1999. *Imperial Cities: Landscape, Display and Identity*. Manchester: Manchester University Press.

Drysdale, William. 1885. *In Sunny Lands: Out-Door Life in Nassau and Cuba*. New York: Harper and Brothers.

Dunkel, Douglas. 1985. "Tourism as a Form of Demographic Imperialism: A Comparison of the Bahamas and Virgin Islands." PhD diss., Michigan State University.

Duperly, A., and Son. 1908. *Picturesque Jamaica*. Kingston: n.p.

Edmonds, Ennis. 2003. *Rastafari: From Outcasts to Culture Bearers*. Oxford: Oxford University Press.

Edmondson, Belinda. 1999. *Caribbean Romances: The Politics of Regional Representation*. Charlottesville: University Press of Virginia.

Edwards, Elizabeth. 1992. *Anthropology and Photography, 1860–1920*. New Haven: Yale University Press.

———. 2001. *Raw Histories: Photographs, Anthropology, and Museums*. Oxford: Berg.

Eneas, Cleveland. 1976. *Bain Town*. Nassau, Bahamas: C. and M. Eneas.

Enloe, Cynthia. 1989. *Bananas, Beaches, and Bases: Making Feminist Sense of International Politics*. Berkeley: University of California Press.

F.L.C. n.d. "More about Myrtle Bank." In Myrtle Bank file at the National Library of Jamaica, Kingston.

Farmer, Kevin. 2001. Personal interview. 15 May. Bridgetown, Barbados.

Feeny, Pamela. 2001. "Coral Reefs, a Blessed Burden." In *Bahamas Handbook*, ed. Dawn Lomer. Nassau: Etienne Dupuch Jr. Publications.

Ferrer, Ada. 1999. *Insurgent Cuba: Race, Nation, and Revolution, 1868–1898*. Chapel Hill: University of North Carolina Press.

Field Museum [Chicago]. 1930. *Annual Report of the Director*. VIII: 89–90.

Finley, Cheryl. 2002. "Committed to Memory: The Slave Ship Icon in the Black Atlantic Imagination." PhD diss., Yale University.

Floyd, Barry. 1974. "The Two Faces of Jamaica." *Geographical Magazine* 46:424–31.

Forbes, Daisy. 2000. Personal interview. December 15. Nassau, Bahamas.

Ford, I. N. 1893. *Tropical America*. London: Edward Stanford.

Foucault, Michel. 1995. *Discipline and Punish: The Birth of the Prison*. Translated by Alan Sheridan. New York: Vintage.

Frost, Alan. 1996. "The Antipodean Exchange: European Horticulture and Imperial Designs." In *Visions of Empire: Voyages, Botany, and Representations of Nature*, eds. David Philip Miller and Peter Hanns Reill, 58–79. Cambridge: Cambridge University Press.

Galassi, Peter. 1981. *Before Photography: Painting and the Invention of Photography*. New York: Museum of Modern Art.

Gall, James. 1899. Jamaica: Past and Present. Manuscript Collection. National Library of Jamaica. Kingston, Jamaica.

Gayle, Dennis, and Jonathan Goodrich, eds. 1993. *Tourism Marketing and Management in the Caribbean*. New York: Routledge.

Geary, Christraud M. 1991a. "Old Pictures, New Approaches: Researching Historical Photographs." *African Arts* 24, no. 4:36–39.

———. 1991b. "Missionary Photography: Private and Public Readings." *African Arts* 24, no. 4:48–59.

———. 2002. *In and Out of Focus: Images of Central Africa, 1885–1960*. Washington: Smithsonian National Museum for African Art.

Geary, Christraud M., and Virginia-Lee Webb, eds. 1998. *Delivering Views: Distant Cultures in Early Postcards*. Washington: Smithsonian Institution Press.

Gilmore, John. 1995. *Glimpses of Our Past: A Social History of the Caribbean in Postcards*. Kingston: Ian Randle Publishers.

Gilpin, William. 1782/1789. *Observations on the River Wye and Several Parts of South Wales, etc., Relative Chiefly to Picturesque Beauty*. London: R. Blamire.

———. 1792. *Three Essays: On Picturesque Beauty; on Picturesque Travel; and on Sketching Landscape: To Which Is Added a Poem, on Landscape Painting*. London: R. Blamire.

Gilroy, Paul. 1990. "David A. Bailey: From Britain, Barbados or Both?" *Creative Camera* 2: 10–13.

Glissant, Edouard. 1999. *Faulkner, Mississippi*. New York: Farrar, Straus and Giroux.

Glissant, Edouard, and J. Michael Dash. 1989. *Caribbean Discourse: Selected Essays*. Charlottesville: University Press of Virginia.

Gold, John, and Margaret Gold. 1995. *Imagining Scotland: Tradition, Representation, and Promotion in Scottish Tourism since 1750*. Aldershot, Hants: Scolar Press.

Goodrich, Lloyd. 1959. *Winslow Homer*. New York: George Braziller.

Gosse, Philip Henry, and Richard Hill. 1851. *A Naturalist's Sojourn in Jamaica*. London: Longmans.

Grabow, E. R. n.d. *Myrtle Bank Hotel*. Swampscott, Mass.: E. R. Grabow Press.

Graburn, Nelson. 1977. "Tourism: The Sacred Journey." In *Hosts and Guests: The Anthropology of Tourism*, ed. Valene L. Smith, vi, 254. Philadelphia: University of Pennsylvania Press.

Greenblatt, Stephen. 1991. *Marvelous Possessions: The Wonder of the New World*. Chicago: Chicago University Press.

Grove, Richard H. 1995. *Green Imperialism: Colonial Expansion, Tropical Island Edens and the Origins of Environmentalism, 1600–1860*. Cambridge: Cambridge University Press.

Guha, Ranajit, and Gayatri Chakravorty Spivak, eds. 1988. *Selected Subaltern Studies*. Oxford: Oxford University Press.

Guide to Nassau, Island of New Providence, Bahamas, West Indies . . . with Meteorological Tables, and Other Statistics of Interest to Invalids and Travelers. 1876. New York: Lawrence and Allen.

Hakewill, James. 1825. *A Picturesque Tour of the Island of Jamaica*. London: Hurst and Robinson.

Hale, W. H. 1914. *The Island of Jamaica: An Illustrated Lecture*. Boston: United Fruit Steamship Company.

Hales, Peter. 1988. *William Henry Jackson and the Transformation of the American Landscape*. Philadelphia: Temple University Press.

Hanchard, Michael. 1994. *Orpheus and Power: The Movimento Negro of Rio de Janeiro and São Paulo, Brazil, 1945–1988*. Princeton: Princeton University Press.

Hanna, W. J. 1989. "Tourist Travel to Jamaica in the 1890s." *Jamaica Journal* 22, no. 3:12–20.

Hannaway, Patti. 1973. *Winslow Homer in the Tropics*. Richmond, Va.: Westover.

Haweis, Stephen. 1917. *The Book about the Sea Gardens of Nassau, Bahamas*. New York: P. F. Collier and Son.

Helsinger, Elizabeth K. 1997. *Rural Scenes and National Representation: Britain, 1815–1850*. Princeton: Princeton University Press.

Hezekiah, Gabrielle. 1998. "On the Outside Looking In?" *Fuse* 22, no. 1:29–35.

Hight, Eleanor M., and Gary Sampson. 2002. *Colonialist Photography: Imag(in)ing Race and Place*. London: Routledge.

Higman, Barry. 1988. *Jamaica Surveyed: Plantation Maps and Plans of the Eighteenth and Nineteenth Centuries*. Jamaica: Institute of Jamaica Publications.

———. 1999. *Historiography of the British West Indies*. London: Macmillan.

Holm, John. 1982. *Dictionary of Bahamian English*. New York: Lexik House.

Holt, Thomas. 1992. *The Problem of Freedom: Race, Labor, and Politics in Jamaica and Britain, 1832–1938*. Baltimore: Johns Hopkins University Press.

Hornsby, Clare. 2000. *The Impact of Italy: The Grand Tour and Beyond*. London: British School at Rome.

Howe, Edgar Watson. 1910. *The Trip to the West Indies*. Topeka: Crane.

Howe, Julia Ward. 1860. *A Trip to Cuba*. Boston: Ticknor and Fields.

Hulme, Peter. 1986. *Colonial Encounters: Europe and the Native Caribbean, 1492–1797*. London: Methuen.

———. 2000. *Remnants of Conquest: The Island Caribs and Their Visitors, 1877–1998*. Oxford: Oxford University Press.

Humphries, Steve. 1989. *Victorian Britain through the Magic Lantern*. London: Sidgwick and Jackson.

Hussey, Christopher. 1983. *The Picturesque: Studies in a Point of View*. London: F. Cass.

Hutchinson, William F., and Ellsworth Woodward. 1886. *A Winter Holiday*. Providence, R.I.: Providence Press.

Inden, Ronald B. 1990. *Imagining India*. Cambridge, Mass.: Basil Blackwell.

Issa, Suzanne, and Jackie Ranston. 1994. *Mr. Jamaica: Abe Issa*. Kingston: Suzanna Issa.

Ives, Charles. 1880. *The Isles of Summer; or, Nassau and the Bahamas*. New Haven: Charles Ives.

J. E. Williamson Collection. Department of Archives. Nassau, Bahamas.

James, Patricia C., and William R. Albers. 1988. "Travel Photography: A Methodological Approach." *Annals of Tourism Research* 15:134–58.

Johnson, Doris. 1972. *The Quiet Revolution in the Bahamas*. Nassau: Family Islands Press.

Johnson, Howard. 1986. "Social Control and the Colonial State: The Reorganization of the Police Force in the Bahamas, 1888–1893." *Slavery and Abolition* 7, no. 1:46–58.

———. 1991. *The Bahamas in Slavery and Freedom*. Kingston: Ian Randle Publishers.

Johnson, Howard, and Karl S. Watson. 1998. *The White Minority in the Caribbean*. Kingston: Ian Randle Publishers.

Johnson, William S. 1990. *Nineteenth Century Photography: An Annotated Bibliography, 1839–1879*. Boston: G. K. Hall.

Johnston, Harry. 1910. *The Negro in the New World*. London: Methuen.

Johnston, James. 1903a. *Jamaica, the New Riviera: A Pictorial Description of the Island and Its Attractions*. London: Cassell.

———. 1903b. *Optical Lantern Lectures on Jamaica, "The New Riviera."* Bristol: The "Dunscombe," Optical Lantern and Photographic Stores.

Jones, A. R., and Nancy Sefton. 1978. *Marine Life of the Caribbean*. London: Macmillan.

Judd, Dennis. 1999. "Constructing the Tourist Bubble." In *The Tourist City*, eds. Dennis Judd and Susan Fainstein, 35–53. New Haven: Yale University Press.

Kahn, Miriam. 2000. "Tahiti Intertwined: Ancestral Land, Tourist Postcard, and Nuclear Test Site." *American Anthropologist* 102, no. 1:7–26.

Karp, Ivan, and Corrine Kratz. "Reflections on the Fate of Tippoo's Tiger: Defining Cultures in Public Display." In *Cultural Encounters: Communicating Others*, eds. E. Hallam and B. Street, 194–228. London: Routledge.

Karp, Ivan, and Steven Lavine, eds. 1991. *Exhibiting Cultures: The Poetics and Politics of Museum Display*. Washington: Smithsonian Institution Press.

Kopytoff, Igor. 1986. "The Cultural Biography of Things: Commoditization as Process." In *The Social Life of Things: Commodities in Cultural Perspective*, ed. Arjun Appadurai, 64–91. Cambridge: Cambridge University Press.

Kupperman, Karen Ordahl. 1984. "Fear of Hot Climates in the Anglo-American Colonial Experience." *William and Mary Quarterly* 41, no. 2:213–40.

Landau, Paul, and Deborah Kaspin. 2002. *Images and Empires: Visuality in Colonial and Postcolonial Africa*. Berkeley: University of California Press.

Leader, Alfred. 1907. *Through Jamaica with a Kodak*. London: Simpkin Marshall Hamilton Kent.

Lefebvre, Henri. 1991. *The Production of Space*. Oxford: Blackwell.

Lenček, Lena, and Gideon Bosker. 1998. *The Beach: The History of Paradise on Earth*. New York: Penguin.

Lester, George. 1897. *In Sunny Isles: Chapters Treating Chiefly of the Bahama Islands and Cuba*. London: C. H. Kelly.

Levinson, Brent. 1997. The Death of the Critique of Eurocentrism: Latinamericanism as Global Praxis/Poiesis. *Revista de estudios hispanicos* 31:169–201.

Lewis, Gordon. 1968. *The Growth of the Modern West Indies*. London: Macgibbon and Kee.

Lewis, Reina. 1996. *Gendering Orientalism: Race, Femininity, and Representation*. London: Routledge.

Lindsay, Forbes. 1912. "In the West Indies." *Travel*, 57–58.

Lippard, Lucy R., and Suzanne Benally. 1992. *Partial Recall*. New York: New Press.

Löfgren, Orvar. 1999. *On Holiday: A History of Vacationing*. Berkeley: University of California Press.

Look Lai, Walton. 1993. *Indentured Labor, Caribbean Sugar: Chinese and Indian Migrants to the British West Indies, 1838–1918*. Baltimore: Johns Hopkins University Press.

Lovelace, Che. 2003. Personal interview. 26 July. Maturu, Trinidad.

Lowe, Lisa. 1991. *Critical Terrains: French and British Orientalisms*. Ithaca: Cornell University Press.

Lumsden, David. 1988. "History of Photography in Jamaica, 1840–1910." *Jamaican Historical Society Bulletin* 9, no. 12/13:191–98.

Lumsden, Joy. 2001. Personal communication. April 14. Mona, Jamaica.

Lutz, Catherine, and Jane Collins. 1993. *Reading National Geographic*. Chicago: University of Chicago Press.

Lyle, Eugene. 1906. "Captain Baker and Jamaica." *World's Work Magazine*, 7295–7309.

MacCannell, Dean. 1976. *The Tourist: A New Theory of the Leisure Class*. New York: Schocken Books.

Mackay, David. 1985. *In the Wake of Cook: Exploration, Science, and Empire, 1780–1801*. London: Croom Helm.

MacKenzie, John M. 1995. *Orientalism: History, Theory, and the Arts*. Manchester: Manchester University Press.

Mackie, J. Milton. 1864. *From Cape Cod to Dixie and the Tropics*. New York: G. P. Putnam.

Macleod, Dianne Sachko, and Julie F. Codell. 1998. *Orientalism Transposed: The Impact of the Colonies on British Culture*. Aldershot: Ashgate.

Macmillan. 1939. *The West Indies Past and Present*. London: W. H. L. Collingridge, Ltd.

Malone, Shelley Boyd, and Richard Campbell Roberts. 1991. *Nostalgic Nassau: Picture Postcards, 1900–1940*. Nassau: A. C. Graphics.

Markwick, Marion. 2001. "Postcards from Malta: Image, Consumption, Context." *Annals of Tourism Research* 28, no. 2:417–38.

Martin, Emile L. 1986. *Doctor's Cave Bathing Club 80th Anniversary, 1906–1986*. White Sands, Jamaica: Doctor's Cave Bathing Club.

Mason, Peter. 1990. *Deconstructing America: Representations of the Other*. London: Routledge.

———. 1998. *Infelicities: Representations of the Exotic*. Baltimore: Johns Hopkins University Press.

Maxwell, Anne. 1999. *Colonial Photography and Exhibitions: Representations of the "Native" and the Making of European Identities*. London: Leicester University Press.

Maxwell, John. 2003. Personal communication. 4 August. Kingston, Jamaica.

May, Stacy, and Galo Plaza Lasso. 1958. *The United Fruit Company in Latin America*. Washington: National Planning Association.

Mayer, Ralph. 1969. *A Dictionary of Art Terms and Techniques*. New York: Barnes and Noble Books.

McClintock, Anne. 1995. *Imperial Leather: Race, Gender, and Sexuality in the Colonial Contest*. New York: Routledge.

McCracken, Donald P. 1997. *Gardens of Empire: Botanical Institutions of the Victorian British Empire*. London: Leicester University Press.

Melman, Billie. 1992. *Women's Orients, English Women and the Middle East, 1718–1918: Sexuality, Religion, and Work*. Ann Arbor: University of Michigan Press.

Michasiw, Kim Ian. 1992. Nine Revisionist Theses on the Picturesque. *Representations* 38:76–100.

Mintz, Sidney. 1985. *Sweetness and Power: The Place of Sugar in Modern History*. New York: Viking.

Mitchell, Timothy. 1988. *Colonizing Egypt*. Cambridge: Cambridge University Press.

Mitchell, W. J. T., ed. 1994. *Landscape and Power*. Chicago: University of Chicago Press.

Mittelholzer, Edgar. 1958. *With a Carib Eye*. London: Secker and Warburg.

Mitter, Partha. 1977. *Much Maligned Monsters: History of European Reactions to Indian Art*. Oxford: Clarendon Press.

Mohammed, Patricia. 2001. The Emergence of a Caribbean Iconography in the Evolution of Identity. In *New Caribbean Thought*, eds. Brian Meeks and Folke Lindahl, 232–64. Kingston: University of the West Indies Press.

Moore, Brian. 1995. *Cultural Power, Resistance, and Pluralism: Colonial Guyana, 1838–1900*. Montreal: McGill-Queen's University Press.

Moss, Valeria Moseley, and Ronald Lightbourn. 1999. *Reminiscing: Memories of Old Nassau*. Nassau, Bahamas: R. G. Lightbourn.

Mudimbe, V. Y. 1988. *The Invention of Africa: Gnosis, Philosophy, and the Order of Knowledge*. Bloomington: Indiana University Press.

———. 1994. *The Idea of Africa*. Bloomington: Indiana University Press.

Munro, Sylvia. 2002. Personal interview. 16 January. Nassau, Bahamas.

Naipaul, V. S. 1962. *Middle Passage*. London: A. Deutsch.

———. 1979. *A Bend in the River*. New York: Knopf.

Nair, Supriya. 1996. "Postmodern Utopias and Expressive Countercultures: A Caribbean Context." *Research in African Literatures* 27, no. 4:71–87.

Nassau. n.d. [1890–1904] Nassau: n.p.

National Geographic. 1988. *Cameramen Who Dare*. Washington: National Geographic Society.

Nederveen Pieterse, Jan. 1995. *White on Black: Images of Blacks in Western Popular Culture*. New Haven: Yale University Press.

Neita, Hartley. 2003. Personal communication. 3 August. Kingston, Jamaica.

Neptune, Harvey. 2001. "Forging Trinidad, Facing America: Colonial Trinidad during the United States Occupation, 1937–1947." PHD diss., New York University.

Nochlin, Linda. 1983. "The Imaginary Orient." *Art in America*, 118–31.

North, Marianne, and Royal Botanic Gardens Kew. 1980. *A Vision of Eden: The Life and Work of Marianne North*. New York: Holt, Rinehart and Winston.

North, Marianne, Janet Catherine, and North Symonds. 1893. *Recollections of a Happy Life: Being the Autobiography of Marianne North*. New York: Macmillan.

Northcroft, George J. H. 1900. *Sketches of Summerland, Giving Some Account of Nassau and the Bahama Islands*. Nassau: Nassau Guardian.

Norton, Noel. 2003. Personal interview. 25 July. Port of Spain, Trinidad.

Norton, Trevor. 2000. *Stars beneath the Sea: The Pioneers of Diving*. New York: Carroll and Graf.

Novak, Barbara, and Timothy A. Eaton. 1996. *Martin Johnson Heade: A Survey, 1840–1900*. West Palm Beach, Fla.: Eaton Fine Art.

Ober, Frederick A. 1904. *Our West Indian Neighbors; the Islands of the Caribbean Sea, "America's Mediterranean": Their Picturesque Features, Fascinating History, and Attractions for the Traveler, Nature-Lover, Settler and Pleasure-Seeker*. New York: J. Pott.

One Love. 2001. Personal interview. 21 May. St. Thomas, Virgin Islands.

Oppermann, Martin. 1993. "Tourism Space in Developing Countries." *Annals of Tourism Research* 20, no. 3:535–56.

Osborne, Peter. 2000. *Travelling Light: Photography, Travel, and Visual Culture*. New York: Manchester University Press.

Ousby, Ian. 1990. *The Englishman's England: Taste, Travel, and the Rise of Tourism*. Cambridge: Cambridge University Press.

Panofsky, Erwin. 1967. *Studies in Iconology: Humanistic Themes in the Art of the Renaissance*. New York: Harper Torchbooks.

Parry, John. 1955. "Plantation and Provision Ground." *Revista de historia de America* 39:1–20.

Parsons, Alan. 1926. *A Winter in Paradise*. London: A. M. Philpot.

Pattullo, Patty. 1996. *Last Resorts: The Cost of Tourism in the Caribbean*. Kingston: Ian Randle Publishers.

Paul, Annie, and Krista Thompson, eds. 2004. "Caribbean Locales and Global Art Worlds." *Small Axe* 6.

Percy, Joan. 2001. *In Pursuit of the Picturesque: William Gilpin's Surrey Excursion: The Places He Passed and Their Claims to Fame*. Surrey: Surrey Gardens Trust.

Pérez, Louis. 1999. *On Becoming Cuban: Identity, Nationality, and Culture*. Chapel Hill: University of North Carolina Press.

Pevsner, Nikolaus. 1974. *The Picturesque Garden and Its Influence Outside the British Isles*. Washington: Dumbarton Oaks Trustees for Harvard University.

"Photo Jamaica." 1998. *Caribbean Beat*, 26–27.

Pigou-Dennis, Elizabeth. 1998. "The Myrtle Bank Hotel and Jamaica's Upper Class, 1914–1945." *Jamaican Historical Review* 20:1–6.

Pimlott, J. A. R. 1976. *The Englishman's Holiday: A Social History*. Hassocks, U.K.: International Publications Service.

Pinney, Christopher. 1997. *Camera Indica: The Social Life of Indian Photographs*. Chicago: University of Chicago Press.

Pinney, Christopher, and Nicolas Peterson. 2003. *Photography's Other Histories*. Durham: Duke University Press.

Pinson, Stephen C. 2002. "Trompe l'oeil: Photography's Illusion Reconsidered." *Nineteenth-Century Art Worldwide* 1, no. 1:1–31.

Poole, Deborah. 1997. *Vision, Race, and Modernity: A Visual Economy of the Andean Image World*. Princeton: Princeton University Press.

Poupeye, Veerle. 1998. *Caribbean Art*. London: Thames and Hudson.

Powles, Louis Diston. 1888. *The Land of the Pink Pearl; or, Recollections of Life in the Bahamas*. London: S. Low, Marston, Searle, and Rivington.

Pratt, Mary Louise. 1992. *Imperial Eyes: Travel Writing and Transculturation*. London: Routledge.

Preston, Rebecca. 1999. "'The Scenery of the Torrid Zone': Imagined Travels and the Culture of Exotics in Nineteenth-Century British Gardens." In *Imperial Cities: Landscape, Display and Identity*, eds. Felix Driver and David Gilbert, 194–211. Manchester: Manchester University Press.

Prochaska, David. 1991. "Fantasia of the Phototheque: French Postcard Views of Colonial Senegal." *African Arts* 24, no. 4:40–47.

Pullen-Burry, Bessie. 1905. *Ethiopia in Exile: Jamaica Revisited*. London: T. F. Unwin.

Pulsipher, Lydia Mihelic. 1994. "The Landscapes and Ideational Roles of Caribbean Slave Gardens." In *The Archaeology of Garden and Field*, eds. Naomi Frances Miller and Kathryn L. Gleason, 202–21. Philadelphia: University of Pennsylvania Press.

Ray, Romita. 1998. "The Memsahib's Brush: Anglo-Indian Women and the Art of the Picturesque, 1830–1880." In *Orientalism Transposed: The Impact of the Colonies on British Culture*, eds. Julie F. Codell and Dianna Sachko Macleod, 89–111. Hants, U.K.: Ashgate.

Redfield, Peter. 2000. *Space in the Tropics: From Convicts to Rockets in French Guiana*. Berkeley: University of California Press.

Redford, Bruce. 1996. *Venice and the Grand Tour*. New Haven: Yale University Press.

Reed, James. 1980. *Sir Walter Scott, Landscape and Locality*. London: Athlone Press.

Rhodes, Thomas. 1901. *Jamaica and the Imperial Direct West India Mail Service*. London: George Philip and Son.

R. J. 1879. "An Artist's Trip to the Bahamas." *Magazine of Art* 2:201–5.

Robertson, Glory. 1985. "Some Early Jamaican Postcards, Their Photographers and Publishers." *Jamaica Journal* 18, no. 1:13–22.

Rosa, Richard. 2001. "Business as Pleasure: Culture, Tourism, and Nation in Puerto Rico in the 1930s." *Nepantla* 2, no. 3:449–88.

Rosenthal, Michael. 1982. *British Landscape Painting*. Ithaca: Cornell University Press.

Rosenthal, Michael, Christiana Payne, and Scott Wilcox, eds. 1997. *Prospects for the Nation: Recent Essays in British Landscape, 1750–1880*. New Haven: Yale University Press.

Ryan, James R. 1997. *Picturing Empire: Photography and the Visualization of the British Empire*. Chicago: University of Chicago Press.

Sabga, Joseph Abdo. 2000. *A Journey of Memories: A Memorable Tour of Trinidad and Tobago Illustrated with Picture Postcards*. Trinidad: J. A. Sabga.

Said, Edward W. 1978. *Orientalism*. New York: Pantheon.

———. 1994. *Culture and Imperialism*. New York: Vintage.

Sampson, Gary. 2002. "Unmasking the Colonial Picturesque: Samuel Bourne's Photographs of Barrackpore Park." In *Colonialist Photography: Imag(in)ing Race and Place*, eds. Eleanor M. Hight and Gary Sampson, 84–106. London: Routledge.

Sandiford, Keith. 2000. *The Cultural Politics of Sugar*. Cambridge: Cambridge University Press.

Saunders, Diane Gail. 1985. "The Social History of the Bahamas 1890–1953." PhD diss., University of Waterloo.

———. 1997. "The Changing Face of Nassau: The Impact of Tourism on Bahamian Society in the 1920s and 1930s." *New West Indian Guide* 70, no. 1–2:21–42.

Schama, Simon. 1995. *Landscape and Memory*. New York: Knopf.

Schick, Irvin C. 1999. *The Erotic Margin: Sexuality and Spatiality in Alteritist Discourse*. London: Verso.

Schor, Nancy. 1992. "*Cartes postales*: Representing Paris 1900." *Critical Inquiry* 18, no. 2:188–243.

Scott, David. 1999. *Refashioning Futures: Criticism after Postcoloniality*. Princeton: Princeton University Press.

Sears, John F. 1989. *Sacred Places: American Tourist Attractions in the Nineteenth Century*. New York: Oxford University Press.

Shattuck, George Burbank. 1905. *The Bahama Islands*. New York: MacMillan.

Sheller, Mimi. 2003. *Consuming the Caribbean: From Arawaks to Zombies*. London: Routledge.

Shepherd, Verene. 1993. *Transients to Settlers: The Experience of Indians in Jamaica, 1845–1950*. Leeds: University of Warwick and Peepal Tree Books.

Sheridan, Richard. *William Beckford (1744–1799): Patron of Painters of Jamaica*. Kingston: West Indies Collection.

Sherlock, Philip. 1990. *Jamaica: The Way We Were*. Kingston, Jamaica: Jamrite Publications.

Shields, Rob. 1991. *Places on the Margin: Alternative Geographies of Modernity*. London: Routledge.

Silver, Kenneth E. 2001. *Making Paradise: Art, Modernity, and the Myth of the French Riviera*. Cambridge, Mass.: MIT Press.

Skidmore, Thomas. 1974. *Black into White: Race and Nationality in Brazilian Thought*. New York: Oxford University Press.

Smith, Astley. 1902. *Astley Smith's Tourists' Handy Pocket Guide to Jamaica*. Kingston: Times Printery.

Smith, Basil, ed. 1992. *Bahamian Art, 1492–1991*. Nassau: Finance Corporation of the Bahamas.

———. 2000. *The Bahamas in Black and White: A Pictorial Review of the Golden Age of Tourism in the Bahamas*. Nassau: Counsellors.

Smith, Bernard. 1969. *European Vision and the South Pacific, 1768–1850: A Study in the History of Art and Ideas*. London: Oxford University Press.

A Snapshot of Jamaica. c. 1907. London: Royal Mail Steam Packet Company.

Solkin, David H. 1982. *Richard Wilson: The Landscape of Reaction*. London: Tate Gallery.

Sontag, Susan. 1977. *On Photography*. New York: Farrar, Straus and Giroux.

Sprague, Stephen. 1978. "Yoruba Photography: How the Yoruba See Themselves." *African Arts* 12:52–59.

Stabenow, Cornelia. 1986. "Artificial Paradise." *Arts in Virginia* 26, no. 1:31–39.

Stafford, Barbara Maria. 1984. *Voyage into Substance: Art, Science, Nature, and the Illustrated Travel Account, 1760–1840*. Cambridge, Mass.: MIT Press.

Stark, James Henry. 1891. *Stark's History and Guide to the Bahama Islands . . . Including Their History, Inhabitants, Climate, Agriculture, Geology, Government, and Resources*. Boston: Photo-electrotype.

———. 1900. *Stark's History and Guide to the Bahama Islands*. Boston: Photo-electrotype.

———. 1902. *Jamaica Guide (Illustrated) Containing a Description of Everything Relating to Jamaica . . . Including Its History, Inhabitants, Government, Resources, and Places of Interest to Travellers, Fully Illustrated with Maps, Engravings, and Photo-Prints*. Boston: Stark.

Stebbins, Theodore E. 1975. *The Life and Works of Martin Johnson Heade*. New Haven: Yale University Press.

Stebbins, Theodore E., Martin Johnson Heade, Jim Wright, Janet L. Comey, Karen E. Quinn. 1999. *Martin Johnson Heade*. Boston: Museum of Fine Arts.

Stechschulte, Nancy. 1994. *The Detroit Publishing Company Cards*. Big Rapids, Mich.: Nancy Stickels Stechschulte.

Steet, Linda. 2000. *Veils and Daggers: A Century of* National Geographic's *Representation of the Arab World*. Philadelphia: Temple University Press.

Stepan, Nancy Leys. 2001. *Picturing Tropical Nature*. Ithaca: Cornell University Press.

Stewart, Susan. 1993. *On Longing: Narratives of the Miniature, the Gigantic, the Souvenir, the Collection*. Durham: Duke University Press.

Storer, Dorothy P. 1958. *Familiar Trees and Cultivated Plants of Jamaica; a Traveller's Guide to Some of the Common Trees, Shrubs, Vines and Crop Plants*. London: Macmillan.

Strachan, Ian G. 2002. *Paradise and Plantation: Tourism and Culture in the Anglophone Caribbean*. Charlottesville: University Press of Virginia.

Stuart, Villiers. 1900. *Adventures amidst the Equatorial Forests and Rivers of South America Also in the West Indies and the Wilds of Florida. To Which Is Added "Jamaica Revisited."* London: J. Murray.

StudioArt. 1997. *Photographs 1850–1940*. Kingston: StudioArt.

Suleri, Sara. 1992. *The Rhetoric of English India*. Chicago: University of Chicago Press.

Sullivan, Garrett A. 1998. *The Drama of Landscape: Land, Property, and Social Relations on the Early Modern Stage*. Stanford, Calif.: Stanford University Press.

Tagg, John. 1988. *The Burden of Representation: Essays on Photographies and Histories*. Minneapolis: University of Minnesota Press.

Talboys, W. P. 1875. *West India Pickles. Diary of a Cruise through the West Indies in the Yacht Josephine. (New York Yacht Club.)*. New York: G. W. Carleton.

Taves, Brian. 1996. "With Williamson beneath the Sea." *Journal of Film Preservation* 25, no. 52:1–8.

Taylor, Frank. 1993. *To Hell with Paradise: A History of the Jamaican Tourist Industry*. Pittsburgh: University of Pittsburgh Press.

Taylor, John. 1994. *A Dream of England: Landscape, Photography, and the Tourist's Imagination*. Manchester: Manchester University Press.

Thomas, Deborah. 2004. *Modern Blackness: Nationalism, Globalization, and the Politics of Culture in Jamaica*. Durham: Duke University Press.

Thompson, Anthony. 1979. *An Economic History of the Bahamas*. Nassau: Commonwealth Publications.

Thompson, Krista. 2002. "The Tropicalization of the Anglophone Caribbean: The Picturesque and the Aesthetics and Politics of Space in Jamaica and the Bahamas." PhD diss., Emory University.

———. 2003. *Bahamian Visions: Photographs, 1870–1920*. Nassau, Bahamas: National Art Gallery of the Bahamas.

Tobin, Beth. 1999. *Picturing Imperial Power: Colonial Subjects in Eighteenth-Century British Painting*. Durham: Duke University Press.

———. 2004. *Colonizing Nature: The Tropics in British Art and Letters, 1760–1820*. Philadelphia: University of Pennsylvania Press.

Tropical Holiday. 1902. Boston: Sherwood Publishing.

Trouillot, Michel-Rolph. 1995. *Silencing the Past: Power and the Production of History*. Boston: Beacon Press.

United Fruit Company. 1904. *Jamaica: The Summerland*. Boston: United Fruit Company Steamship Lines.

———. 1913. *Jamaica: British West Indies*. Boston: United Fruit Company.

———. 1929. *Cruises over the Golden Caribbean*. New York: United Fruit Company Steamship Service.

———. n.d. *The Call of the Caribbean: The Quest of Perpetual Youth*. Boston: United Fruit Company.

———. n.d. *Jamaica British West Indies and Myrtle Bank Hotel*. Boston: United Fruit Company.

Urbain, Jean-Didier. 2003. *At the Beach*. Minneapolis: University of Minnesota Press.

Urry, John. 1990. *The Tourist Gaze: Leisure and Travel in Contemporary Societies*. London: Sage.

Villard, Henry S. 1976. *The Royal Victoria Hotel*. Nassau: Henry S. Villard.

Wade, Peter. 1993. *Blackness and Race Mixture: The Dynamics of Racial Identity in Colombia*. Baltimore: Johns Hopkins University Press.

Walcott, Derek. 1995. "The Antilles: Fragments of Epic Memory." In *Caribbean Visions*, ed. Samella Lewis, 29–35. Alexandria, Va.: Art Services International.

Wallace, Mike. 1996. *Mickey Mouse History and Other Essays on American Memory*. Philadelphia: Temple University Press.

Walvin, James. 1978. *Beside the Seaside: A Social History of the Popular Seaside Holiday*. London: Allen Lane.

———. 1992. "Tourism and Material Consumption." *Revista/Review Interamericana* 22, no. 1–2: 208–25.

Ward, C. J. 1893. *Jamaica at Chicago: An Account Descriptive of the Colony of Jamaica*. New York: William J. Pell.

Webb, Virginia-Lee. 1995. "Manipulated Images: European Photographs of Pacific Peoples." In *Prehistories of the Future: The Primitivist Project and the Culture of Modernism*, eds. Elazar Barkan and Ronald Bush, 175–201. Stanford, Calif.: Stanford University Press.

Wilcox, Ella Wheeler. 1909. *Sailing Sunny Seas; a Story of Travel in Jamaica, Honolulu, Haiti, Santo Domingo, Puerto Rico, St. Thomas, Dominica, Martinique, Trinidad, and the West Indies*. Chicago: W. B. Conkey.

Williams, Antonia. 1908–1909. *West Indian Journal*. The University of West Indies Library. Kingston, Jamaica.

Wilmot, Fred. 2004. Personal communication. 27 July. Toronto, Canada.

Williamson, J. E. 1936. *Twenty Years under the Sea*. Boston: Ralph T. Hale.

Wong, Tony. 2004. "We Be Jammin: Retailers and Marketers Tap into the Popularity of Jamaica's Image," *Toronto Star*, 31 July, D1, D4.

Wood, Marcus. 2000. *Blind Memory: Visual Representations of Slavery in England and America*. New York: Routledge.

Wood, Roy. 1994. "Hotel Culture and Social Control." *Annals of Tourism Research* 21, no. 1:65–80.

Woody, Howard. 1998. "Delivering Views: Distant Cultures in Early Postcards." In *Delivering Views: Distant Cultures in Early Postcards*, eds. Christraud M. Geary and Virginia-Lee Webb, 13–45. Washington: Smithsonian Institution Press.

Wright, Julie Pritchard. 1989. "The Toured: The Cultural Impact of Tourism in Barbados." MA thesis, University of Southern California.

Yates, Anne. 1998. *Bygone Barbados*. St. Michael, Barbados: Black Bird Studio.

ILLUSTRATION CREDITS

FIGURES

1 Donkey, posed for photographs, at Dunn's River Falls (Ocho Rios, Jamaica), 2000. Photograph by the author.

2 *A Snapshot of Jamaica*, guidebook cover, c. 1907. Courtesy of the Maryland Province Archives, Box 23 Folder 7, Georgetown University Library, Special Collections Division, Washington, D.C.

3 H. S. Duperly, "An Expert for a Three Miles Race, Kingston, Jamaica," 1907-14, divided-back postcard, 5²/₈ × 3³/₈ in. Collection of the author.

4 Photographer unknown, "Chuh!!!," 1907-14, real-photo postcard, 3½ × 5½ in. Private collection, Kingston, Jamaica.

5 Page from a traveler's album. A. Duperly and Sons, "Coconut Palms," photograph framed by foliage, c. 1890, 9 × 7 in. David Boxer Collection of Jamaican Photography. Private collection, Kingston, Jamaica.

6 Marianne North, *A Night-Flowering Crinum Lily and Ferns, in Jamaica*, 1871, oil on canvas, 17⁶/₁₀ × 13¾ in. Courtesy of the Royal Botanic Gardens, Kew.

7 James Johnston, "Scene on the Rio Cobre," in James Johnston, *Jamaica, the New Riviera* (London: Cassell, 1903), 63.

8 James Johnston, "Royal Palms, Ravensworth, Spanish Town," 1903, in James Johnston, *Jamaica, the New Riviera* (London: Cassell, 1903), 68.

9 Photographer unknown, "Golden Vale," in United Fruit Company, *Jamaica: British West Indies* (Boston: United Fruit Company, 1913), 29.

10 James Johnston, "Domestics with Yams, Cocoanuts, Etc.," c. 1903. David Boxer Collection of Jamaican Photography. Private collection, Kingston, Jamaica.

11 Photographer unknown, "Rafting on the Rio Grande—A Stop for Lunch," c. 1910, albumen print, 6 × 8 in. Collection of the author.

12 Photographer unknown, "The New Jamaica. Coat of Arms," c. 1909, photograph, 8 × 10 in. Courtesy of the Photographs and Prints Division, Schomburg Center for Research in Black Culture, New York Public Library, Astor, Lenox and Tilden Foundations.

13 J. W. Cleary, "Banana Carriers—Jamaica," postmarked 1907, undivided-back postcard, 5½ × 3½ in. Collection of the author.

14 A. Duperly and Sons, "Castleton Gardens," in A. Duperly and Sons, *Picturesque Jamaica* (Kingston: n.p., 1908), 34.

15 James Johnston, "Hard Labour," c. 1903, in James Johnston, *Jamaica, the New Riviera* (London: Cassell, 1903), 49.

16 O. Milke, "Kingston, Beautiful Washerwoman," postmarked 1906, undivided-back postcard. 5½ × 3½ in. Collection of the author.

17 A. Duperly and Sons, "Cane Cutters," c. 1907. Courtesy of the National Gallery of Jamaica.

18 C. B. Webster, "A Typical Coolie Family," c. 1904, in United Fruit Company, *Jamaica: The Summerland* (Boston: United Fruit Company Steamship Lines, 1904), 4.

19 C. B. Webster, "Coolies Washing," postmarked 1906, undivided-back postcard, 3½ × 5½ in. Collection of the author.

20 William Henry Jackson, "Ceiba or Silk Cotton Tree, Nassau, Bahama Islands," 1900, photograph, 8 × 10 in. Courtesy of the Library of Congress, Prints and Photographs Division, Detroit Publishing Company Collection, LC-D4-13480 DLC.

21 William Henry Jackson, "Royal Palms, Cumberland Street, Nassau, W.I.," 1900, photograph, 10 × 8 in. Courtesy of the Library of Congress, Prints and Photographs Division, Detroit Publishing Company Collection, LC-D4-13482 DLC.

22 Jacob Frank Coonley, "On the Way to Market," 1888-1904, albumen print, 8 × 6 in. Courtesy of Brent Malone and the National Art Gallery of the Bahamas.

23 Photographer unnamed [Jacob Frank Coonley], "On the Way to Market," 1910, divided-back postcard, 5½ × 3½ in. Collection of the author.

24 Winslow Homer, *On the Way to the Market, Bahamas*, 1885, watercolor over pencil, 13¹⁵⁄₁₆ × 20¹⁄₁₆ in. Courtesy of the Brooklyn Museum, Gift of Gunnar Maske in memory of Elizabeth Treadway White Maske.

25 Winslow Homer, *Palm Tree, Nassau*, c. 1888-89, watercolor, 19³⁄₈ × 13³⁄₈ in. Courtesy of the Metropolitan Museum of Art, Purchase, 1910, Amelia B. Lazarus Fund.

26 Jacob Frank Coonley, "A Native African Hut," 1888-1904, albumen print, 6 × 8 in. Courtesy of Brent Malone and the National Art Gallery of the Bahamas. Reproduced in Stark 1900, 189.

27 William Henry Jackson, "Royal Victoria Gardens, Nassau, Bahama Island," 1900, photograph, 8 × 10 in. Courtesy of Library of Congress, Prints and Photographs Division, Detroit Publishing Company Collection, LC-D4-13460 DLC.

28 Jacob Frank Coonley, "Nassau Police Force," 1889-1904, albumen print, 6 × 8 in. Courtesy of Brent Malone and the National Art Gallery of the Bahamas.

29 Photographer unknown, "The Queen of Nassau," ca. 1930, 6⅞ × 4⅞ in. Courtesy of the Department of Archives, Nassau, Bahamas.

30 Jacob Frank Coonley, "Silk Cotton Tree," 1889-1904, albumen print, 6 × 8 in. Courtesy of Brent Malone and the National Art Gallery of the Bahamas.

31 "Map of Nassau," in James Henry Stark, *Stark's History and Guide to the Bahama Islands* (Boston: Photo-electrotype, 1900), 41.

32 "First Prize Junior Division Individual Entry, Hibiscus," published in *The Tribune* (Nassau), 27 December 1967. Courtesy of *The Tribune*, Nassau, Bahamas.

33 "A Christmas Masquerade," c. 1929, in Amelia Defries, *The Fortunate Islands; Being Adventures with the Negro in the Bahamas* (London: C. Palmer, 1929), opposite 41.

34 J. R. H. Seifert and Co., "Barbados, Cannibal Canal," 1901–7, undivided-back postcard, 3½ × 5½ in. Collection of the author.

35 The photosphere, designed by Williamson in 1914; photo c. 1914. J. E. Williamson Collection, Department of Archives, Nassau, Bahamas. Courtesy of Sylvia Williamson Munro.

36 J. E. Williamson with brother, George, taking camera into the photosphere; n.d. J. E. Williamson Collection, Department of Archives, Nassau, Bahamas. Courtesy of Sylvia Williamson Munro.

37 Diagram of two figures photographing marine life from inside the photosphere. J. E. Williamson Collection, Department of Archives, Nassau, Bahamas. Courtesy of Sylvia Williamson Munro.

38 *The Sea Gardens*, engraving, in James Henry Stark, *Stark's History and Guide to the Bahama Islands* (Boston: Photo-electrotype, 1900), 231.

39 "Sponge-Glasses," in Lady Annie Brassey, *In the Trades, the Tropics, and the Roaring Forties* (New York: Henry Holt and Company, 1885), 315.

40 William Henry Jackson, Untitled [Viewing the Marine Gardens through Bottom of Boat, Nassau, Bahamas], 1901, photograph, 8 × 10 in. Courtesy of the Library of Congress, Prints and Photographs Division, Detroit Publishing Company Collection, LC-D4-13497 DLC.

41 Jacob Frank Coonley, "A Native Diver," c. 1890–1904, in *Nassau* (Nassau, Bahamas: n.p., ca. 1890–1904), unpaginated.

42 J. E. Williamson, "Paradise Beach, Nassau, Bahamas," c. 1945, undivided-back postcard. 3½ × 5½ in. J. E. Williamson Collection, Department of Archives, Nassau, Bahamas. Courtesy of Sylvia Williamson Munro.

43 Stephen Haweis, *The Divers*, in Amelia Defries, *In a Forgotten Colony* (Nassau: St. Martin's, 1917), 186.

44 Williamson Submarine Film Corp., "The Divers," in Amelia Defries, *In a Forgotten Colony* (Nassau: St. Martin's, 1917), 185.

45 Winslow Homer, *The Gulf Stream*, 1899, oil on canvas, 28⅛ × 49⅛ in. The Metropolitan Museum of Art, Catharine Lorillard Wolfe Collection, Wolfe Fund, 1906 (06.1234).

46 James Valentine, "The Loch Ness Monster Obliges the Photographers, Invermoriston," n.d, divided-back postcard, 3½ × 5½ in. This postcard was collected by Williamson on his expedition to Scotland. J. E. Williamson Collection, Department of Archives, Nassau, Bahamas. Courtesy of Sylvia Williamson Munro.

47 Film still from Williamson's *Girl of the Sea* shot from the photosphere, c. 1920. J. E. Williamson Collection, Department of Archives, Nassau, Bahamas. Courtesy of Sylvia Williamson Munro.

48 Making landscape into seascape. Inside Atlantis's tanks and marine observation windows during construction of the hotel (Paradise Island, Bahamas), 1994. Photo by DaCosta Williams.

49 Visitors to Atlantis taking photographs of the underwater aquariums (Paradise Island, Bahamas), 2004. Photograph by the author.

50 A. Duperly and Sons, "Myrtle Bank Hotel—Kingston," 1891-1902, undivided-back postcard, 3½ × 5⅝ in. Collection of the author.

51 N. Richards, "Kingston, Jamaica. Myrtle Bank Hotel after the Earthquake, Jan. 14, 1907, at 3:30," 1907, divided-back postcard, 3½ × 5⅜ in. Collection of the author.

52 The New Myrtle Bank, the "pride" of Jamaica, opened in 1910. Photographer unknown, "Myrtle Bank Hotel, Kingston, Jamaica. B.W.I.," n.d., real-photo postcard, 3½ × 5½ in. Collection of the author.

53 A. Duperly and Son, "Myrtle Bank Hotel, Kingston," in A. Duperly and Son, *Picturesque Jamaica* (Kingston: n.p., 1908), 14.

54 A. Duperly and Son, "Cocoanut Grove, Myrtle Bank Hotel, Kingston," in A. Duperly and Son, *Picturesque Jamaica* (Kingston: n.p., 1908), 13.

55 Snapshot of the Myrtle Bank's "magnificent" saltwater pool, 1933-43, in *Jamaica British West Indies and Myrtle Bank Hotel* (United Fruit Company, n.d.), unpaginated.

56 Advertisement for the Myrtle Bank, "the Centre of Distinguished Social Life in Jamaica," *Planters' Punch* (1932-33), 51. Courtesy of the Institute of Jamaica, Museums Division.

57 Doctor's Cave Beach, Montego Bay, after its face-lift in the 1940s. Photographer unknown, real-photo postcard, c. 1950, 3½ × 5½ in. Collection of the author.

58 Denis Gick, "The Seabath, to the South of Which Sit Bathers and Spectators," photograph published in *Planters' Punch* 4 (1940-41), 8. Courtesy of the Institute of Jamaica, Museums Division.

59 Advertisement for the Myrtle Bank, *Spotlight* magazine (November 1950), advertising section. Courtesy of the Institute of Jamaica, Museums Division.

60 Photograph of journalist Evon Blake. Courtesy of Barbara Blake-Hannah.

61 "Creole Woman Plaiting Hair in the Yard," in Brian Moore, *Cultural Power, Resistance, and Pluralism: Colonial Guyana, 1838-1900* (Montreal: McGill–Queen's University Press, 1995), 96.

62 Cover of Cleveland Eneas, *Bain Town* (Nassau, Bahamas: C. and M. Eneas, 1976), based on Horace Wright painting, *Boy with Sugar Cane*, c. 1948-51 (see plate 27).

63 Photograph from David Bailey, *From Britain or Barbados or Both?* 1990. 12 × 10 in. Collection of the artist.

64 Che Lovelace, *Quantity of Pieces Found in a Packet of Cowboys and Indians* (detail), 1998, mixed media. Courtesy of the artist.

65 Las May, "Come to Jamaica and Feel Secure," editorial cartoon in *Jamaica Gleaner* (18 January 1999). Courtesy of the *Jamaica Gleaner*, Kingston, Jamaica.

1 Henri Rousseau, *The Dream*, 1910, oil on canvas, 6 ft 8½ in × 9 ft 9½ in. Museum of Modern Art, New York.

2 Thomas Sutherland after James Hakewill, *View of Port Maria*, 1820, engraving in aquatint, in James Hakewill, *A Picturesque Tour of the Island of Jamaica* (London: Hurst and Robinson, 1825).

3 Martin Johnson Heade, *Cattleya Orchid and Three Brazilian Hummingbirds*, 1871, oil on wood, 13¾ × 18 in. Gift of the Morris and Gwendolyn Cafritz Foundation, Board of Trustees, National Gallery of Art, Washington, D.C. Photograph by Lyle Peterzell.

4 Scrapbook of Miss Elizabeth and Miss Helen Riley, including postcards of Jamaica, 1934. Collection of the author.

5 Scrapbook of Miss Elizabeth and Miss Helen Riley, including postcards of Jamaica, 1934. Collection of the author.

6 and 6a Cleary and Elliott, "A Banana Field," ca. 1953, divided-back linen postcard, 3½ × 5½ in. Collection of the author.

7 James Johnston, "Motoring with a 'Stanley' in Jamaica," 1907–14, divided-back postcard, 3½ × 5½ in. Collection of the author.

8 H. G. Johnston [James Johnston], "Young Jamaica," 1907–14, divided-back postcard, 5½ × 3½ in. Collection of the author.

9 H. G. Johnston [James Johnston], "The Morning Toilet," 1907–14, divided-back postcard, 5½ × 3½ in. Collection of the author.

10 J. W. Cleary, "A Native Washerwoman, Jamaica," postmarked 1906, divided-back postcard, 5½ × 3½ in. Collection of the author.

11 E. Wells Elliott, "Types of Jamaica Peasantry," 1907–14, divided-back postcard, 3½ × 5½ in. Collection of the author.

12 Cleary and Elliott, "Jamaica Peasantry," 1907–14, divided-back postcard, 3½ × 5½ in. Collection of the author.

13 A. Duperly and Son, "Banana Carrier," 1907–14, divided-back postcard, 5½ × 3½ in. Collection of the author.

14 Detroit Photographic Company, "The Royal Victoria, Nassau," 1900, postmarked 1905, postcard, 3½ × 5½ in. Collection of the author.

15 Sand's Studio, "Victoria Avenue—Nassau, Bahamas," 1915–30, divided-back postcard, 3½ × 5½ in. Collection of the author.

16 W. R. Saunders and I. O. Sands, "Typical Gateway, Nassau, Bahamas," 1915–30, divided-back postcard, 5½ × 3½ in. Collection of the author.

17 City Pharmacy, Nassau, NP, "Two Natives, Nassau," 1907–14, divided-back postcard, 5½ × 3½ in. Collection of the author.

18 Jan Mostaert, *West Indian Landscape*, 1520–30, oil on panel, 34 × 60 in. Courtesy of the Frans Hals Museum, Haarlem.

19 Photographer unknown, "A Native of Congstown, Nassau, Bahamas," postmarked 1920, hand-colored postcard, 5½ × 3½ in. Collection of the author.

20 P. M. Lightbourn for the Bahamas Development Board, "Just a Pause under the Royal Poinciana Tree, Nassau, Bahamas," 1930–44, divided-back linen postcard, 3½ × 5½ in. Collection of the author.

21 The American News Co., "Nassau in the Bahamas," c. 1950, divided-back postcard, 3⅜ × 5½ in. Collection of the author.

22 Stephen Haweis, *The Sea Gardens through a Waterglass*, in Stephen Haweis, *The Book about the Sea Gardens of Nassau, Bahamas* (New York: P. F. Collier and Son, 1917), frontispiece.

23 Cover of *Science and Invention* issue devoted to Williamson, July 1928.

24 P. M. Lightbourn, "Silk Cotton Tree, Nassau, Bahamas," 1930–44, linen postcard, 3⅜ × 5⅜ in. Collection of the author.

25 United Fruit Company Steamship Lines, "The Ford of the Rio Grande, Jamaica," c. 1900, undivided-back postcard, 3½ × 5½ in. Collection of the author.

26 Cropped "Two Natives" postcard, in Shelley Boyd Malone and Richard Campbell Roberts, *Nostalgic Nassau: Picture Postcards, 1900–1940* (Nassau: n.p., 1991), 16.

27 Detroit Publishing Company, "Nassau, Bahamas," n.d., divided-back postcard, 5½ × 3½ in. Collection of the author.

28 Photograph from David Bailey, *From Britain or Barbados or Both?* 1990. 12 × 10 in. Collection of the artist.

29 David Smith, *Excerpts from the American Dream*, 1984, acrylic on canvas, 35 × 42 in. Collection of the artist, Los Angeles, California.

30 Irénée Shaw, *Neighbourhood*, from the *Gilded Cages* series, 1992, oil on canvas, 48 × 84 in. Fiedler Collection, Cologne.

31 Irénée Shaw, *Neighbour*, from the *Gilded Cages* series, 1992, oil on canvas, 20 × 20 in. Collection of Rene Bermudez, Port of Spain, Trinidad.

32 Christopher Cozier, *Wait Dorothy Wait*, 1991, mixed media, 7 × 7 in. Courtesy of the artist. Collection of the late Jeoffrey Stanford.

33 Christopher Cozier, *I am rendered speechless by your vision*, *Three Stains on Paper*, Cultural Autopsy series, 1995, mixed media on paper, 36 × 36 in. Courtesy of the artist.

34 Christopher Cozier, *Three Stains on Paper, I am rendered speechless by your reactions*, Cultural Autopsy series, 1995, mixed media on paper, 36 × 36 in. Courtesy of the artist.

35 Christopher Cozier, *I am rendered speechless by your idea of beauty*, *Three Stains on Paper*, Cultural Autopsy series, 1995, mixed media on paper, 36 × 36 in. Courtesy of the artist.

36 Dick Scoones, "Colours of Jamaica," postcard, 4¾ × 6¾ in. Collection of the author.

37 "Island Hopping," advertisement, The Islands of the Bahamas, 2004.

INDEX

KRISTA THOMPSON is assistant professor of art history and African American studies at Northwestern University.

Thompson, Krista A., 1972–
An eye for the tropics : tourism, photography,
 and framing the Caribbean picturesque /
 Krista A. Thompson.
 p. cm.
Includes bibliographical references and index.
ISBN-13: 978-0-8223-3751-5 (cloth : alk. paper)
ISBN-10: 0-8223-3751-7 (cloth : alk. paper)
ISBN-13: 978-0-8223-3764-5 (pbk. : alk. paper)
ISBN-10: 0-8223-3764-9 (pbk. : alk. paper)
1 Tourism—Caribbean Area.
2 Tourism in art.
3 Travel photography—Caribbean Area. I. Title.
G155.C35T53 2006
338.4′7917292045—dc22
 2006020428